THE PHOTOGRAPHY OF BEDFORD LEMERE & Co

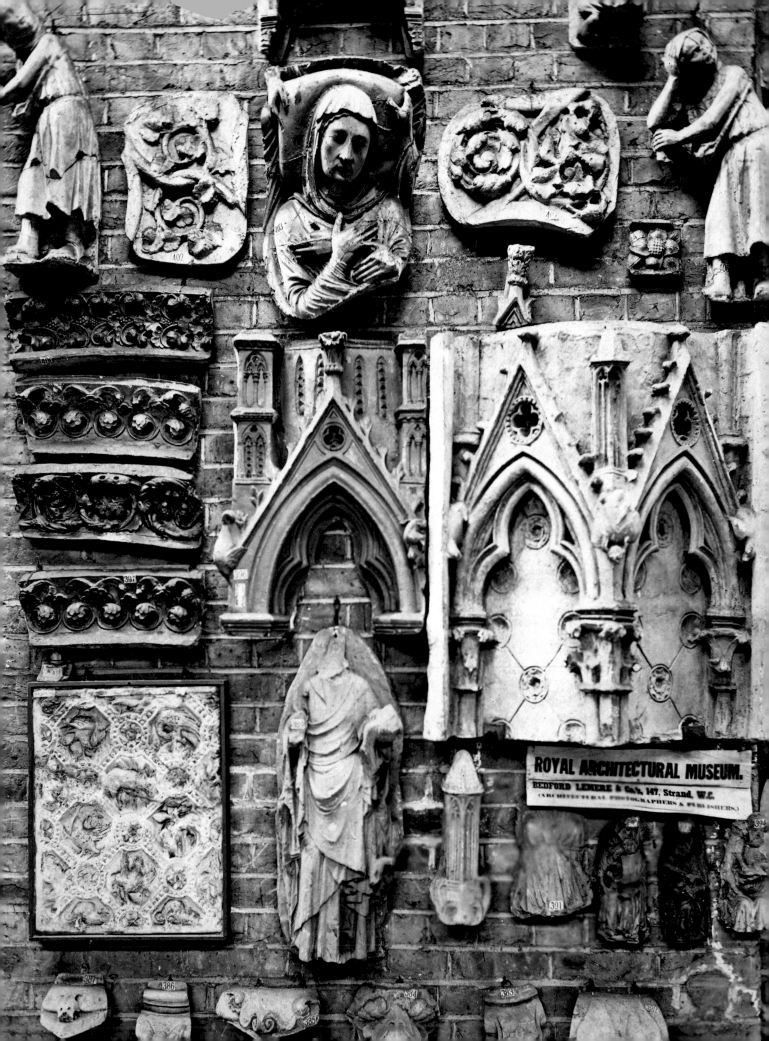

ROYAL ARCHITECTURAL MUSEUM.
BEDFORD LEMERE & Co., 147, Strand, W.C.
(ARCHITECTURAL PHOTOGRAPHERS & PUBLISHERS.)

THE PHOTOGRAPHY OF BEDFORD LEMERE & Co

NICHOLAS COOPER

ENGLISH HERITAGE

Published by English Heritage, The Engine House, Fire Fly Avenue, Swindon SN2 2EH
www.english-heritage.org.uk
English Heritage is the Government's statutory adviser on all aspects of the historic environment.

© English Heritage 2011

The reference numbers for English Heritage images are noted in square brackets in the captions.
Images (except as otherwise shown) are reproduced by permission of English Heritage.NMR.

First published 2011

ISBN 978-1-84802-061-0

Product code 51544

British Library Cataloguing in Publication data
A CIP catalogue record for this book is available from the British Library.

Application for the reproduction of images should be made to English Heritage. Every effort has
been made to trace the copyright holders and we apologise in advance for any unintentional
omissions, which we would be pleased to correct in any subsequent edition of this book.

For more information, contact Archives Research Services, The Engine House, Fire Fly Avenue,
Swindon SN2 2EH; telephone (01793) 414600.

Typeset in Charter 9.75 pt

Brought to publication by René Rodgers and Rachel Howard, Publishing, English Heritage

Edited by René Rodgers
Design by Doug Cheeseman

Printed in Belgium by Deckers Snoeck.

Frontispiece: Architectural casts, Royal Architectural Museum, 18 Tufton Street, London SW1,
photographed between 1870 and 1872. [BL00005/002]

CONTENTS

FOREWORD

In 1979 I won a school prize and was taken, together with my fellow prize winners, to Heffers bookshop in Cambridge. There I was allowed to choose a book up to the value of £10. I chose Nicholas Cooper's *The Opulent Eye*, a selection of Harry Bedford Lemere's photographs of Edwardian interiors. The book opened up, to a rather introverted teenager, a long-forgotten world of elegance, ostentation and, yes, opulence. I still thrill when I open the dog-eared pages of Nicholas's book. But it is now supplemented with another, bigger and more comprehensive, volume with Nicholas's excellent introduction and commentary.

This book does not stop at fashionable Victorian and Edwardian front doors – its photographs comprehensively capture a remarkable moment when Britain was the centre of the world: self-possessed, powerful, rich and influential. They capture the confidence of government, the pride of the citizenry, the hedonism of the rich, the entrepreneurialism of the industrialist, the invention of the architect and the muscle of the military.

Some of the most extraordinary images are particularly ephemeral such as the construction of County Hall on the Thames in 1913, the Red Cross Prisoners of War Parcels Department in 1917 or a room at the Savoy laid out for a private dinner in 1895. Others are of places that have now been demolished or destroyed, often needlessly – for instance, the Gaiety Theatre demolished in 1957 or Foots Cray Place burnt down in 1949. Together with pictures of places that will still be familiar to us today, these photographs are a bittersweet tour of a vanished world, a window on the life of society at the turn of the 20th century and a reminder that our past is a fragile and irreplaceable resource.

The images have been selected from around 25,000 of Bedford Lemere & Co's surviving photographic negatives and prints, one of many collections of historic photography cared for – and made accessible – by English Heritage.

I hope this book will inspire thousands of people in the way its predecessor inspired me 32 years ago.

Dr Simon Thurley
Chief Executive, English Heritage

PREFACE

The pictures in this book were chosen from some 25,000 surviving photographs taken by the professional photographers Bedford Lemere, his son Henry (Harry) and their colleagues between the 1870s and the late 1920s. Those selected are from the 1890s onwards, a period from which survival is more complete and from which negatives, rather than prints, still exist. Among the earlier photographs are very many of the greatest interest, but their survival has been piecemeal and it was decided to exclude them from this selection in order to give the book a coherence which would have been more difficult with pictures that covered a wider date range.

To choose images from the enormous archive held by English Heritage has not been easy. Some of these images have already been reproduced by other writers (some notable collections are listed in the bibliography), but their familiarity could not prevent the reuse of outstanding pictures of important subjects. The selection has inevitably been an arbitrary one but was made with certain aims in mind. One was to give an indication of the breadth of the archive and to demonstrate some of its particular strengths. Another was to suggest how the Lemeres and their colleagues recorded something of the life of the times and how the spirit of the age was reflected in its buildings. At the same time it was important not to lose sight of the fact that it was as architectural photographers that the firm was most highly regarded, and that it is these photographs of contemporary building that give the collection its unique value.

In arranging the book thematically, this has inevitably meant that some subjects have been covered briefly or even been left out. For instance, while photographs of domestic interiors have been included, only a few of the available ones have been chosen, largely because these were covered in *The Opulent Eye* – a book about changing tastes in interior decoration between 1890 and 1910 that was entirely illustrated with photographs taken by the firm. There are no views of the many suburban houses that the firm was commissioned to photograph, buildings generally of no architectural merit but nevertheless representative of their age. A number of interesting pictures have been omitted because they were not typical of the archive as a whole or because to have included them would have risked the book losing any coherence that it may have. Nevertheless, I hope that this collection will give some idea of the range of work and the approach of Britain's then foremost architectural photographers, working at the peak of their skills and when Britain itself was at the height of its prosperity.

A NOTE ON NAMES
In this book, the firm is referred to interchangeably as Bedford Lemere & Co and Lemere & Co. Henry (Harry) Bedford Lemere is referred to as Harry Lemere. He and his colleague Adolphe Boucher took many of the photographs in this book; where known, their initials (HBL or AAB) have been included in the caption header. Where the subject of the photograph is primarily architectural, the architect's name and date of build (where known) have been included in the caption header.

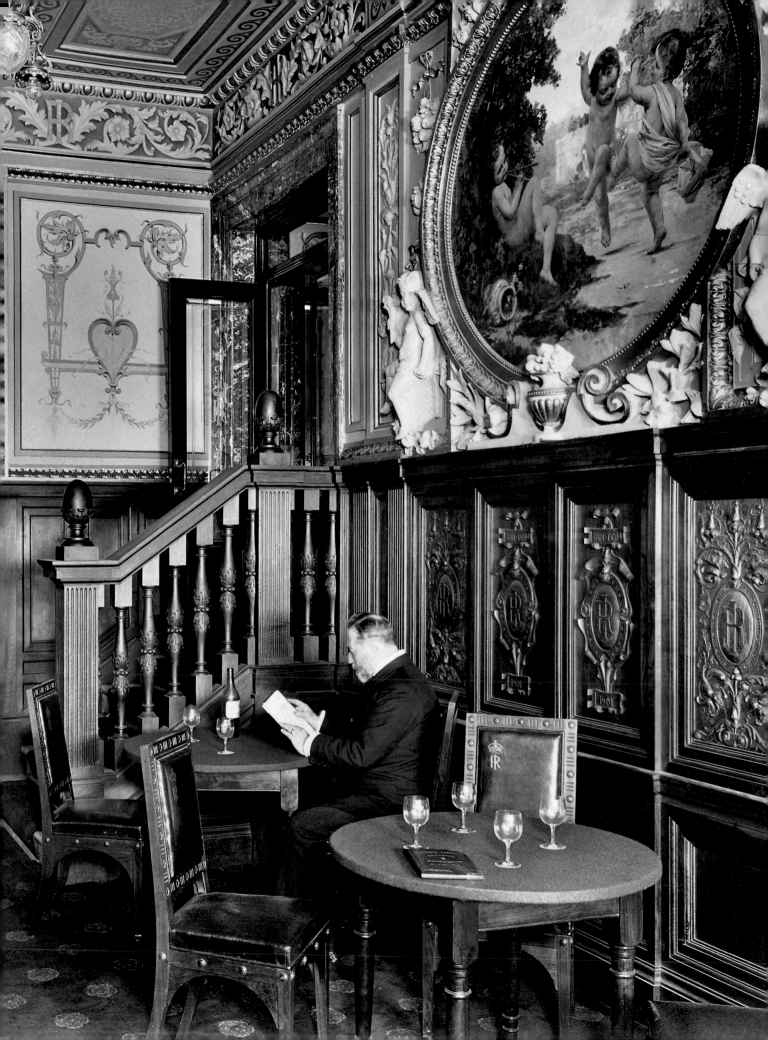

THE ARCHITECTURE
OF A CONFIDENT AGE

Bedford Lemere & Co were taking photographs at a time of extraordinary change and unparalleled optimism. Their clients were many of the leading architects and contractors of the day, and the principal architectural journals. Clients also included stores, banks, industrialists, estate agents, hoteliers and any others who wanted their property to be shown in the most flattering light. It was the nature of the firm's commissions that caused their photographs to accord so completely with the spirit of the age.

At the end of the 19th century, Britain was the richest country on earth and its empire the greatest ever known. British firms were active in every part of the world. It was by British banks that world trade was largely financed and almost half of this trade was carried round the globe in British ships. Successful businesses lavished money on their head offices, and their prosperity built and furnished the houses of those who owned and worked in them. The British Navy was larger than any other two together, and national pride and self confidence were at their zenith.

There were further reasons for hope. The years between 1890 and 1930 – the period covered by most of the photographs in this book – saw the invention, the introduction or the acceptance of innovations that the 20th century would take for granted. In technology these included motor cars, the telephone, deep-level tube railways, the aeroplane, electric light and wireless; in entertainment, this period saw

Bedford Lemere seated in the Imperial Restaurant, Regent Street, London W1, photographed by AAB in 1901. [BL16387/009]

the cinema, the building of many of London's leading theatres and the multiplication of restaurants and grand hotels. In public life, local government reforms and new civic responsibilities led to the building of new town halls, schools and libraries. Professional bodies and private clubs thrived. Expanding business, new official duties, new technologies and thriving institutions all called for new buildings, while building itself was revolutionised by the introduction of steel frames and reinforced concrete. The architecture of the age was the visible expression of this self-confidence.

At first glance, this architecture seems anarchic, with a bewildering variety of buildings drawing on a huge range of historic styles. This variety had troubled 19th-century architects and critics, and for many years there had been calls for an architecture that was appropriate to the modern era: to an age of technology and industrialism and for the buildings of a rich, democratic and Christian nation. In the 1860s and 1870s, a revival of Gothic – a national style, and one with its own structural logic – had seemed as though it might provide the answer, but when used with modern materials to build great town halls and large houses with modern conveniences, it often lacked the appeal of the original. Italian Renaissance had long been thought suitable for commercial and for many civic buildings, but in the hands of most architects the style was becoming tired and jaded. Many dreamed of a new synthesis – an architecture that drew on the best of historic styles to produce a style worthy of a civilisation that seemed to be the climax of global progress – but for the most part what was achieved was

an eclectic and often ill-digested mixture rather than the new architecture that architects hoped for.

From the 1880s a few architects had been trying to break away altogether from the constraints of historic precedents and to design buildings whose details and overall composition were more genuinely personal and original. Some of these were associated with the Arts and Crafts movement, whose adherents emphasised handcraftsmanship and the appropriate use of materials; however, such an approach was not well adapted to the public buildings, the city offices and the great country houses that the national wealth was creating. Nor did simplification appeal widely to clients who valued display. Instead, from the late 1880s onwards a reaction would set in from the exuberant stylistic chaos in favour of a purer use of historic models and, in particular, towards the disciplines of classical styles with their rules of proportion and composition.

One solution would be found in a revival of the English baroque of the late 17th and early 18th centuries, an architecture that was imposing, national, systematic and scholarly, and which appealed to all the values of the age. A Wren revival could be employed to create buildings grander than any by Sir Christopher Wren or his contemporaries. But stylistic evolution and invention cannot be arrested, particularly when clients' demands for buildings of individual prominence placed such pressure on architects. The English baroque would be supplemented by other classical models. From the early 1900s, the more academic classicism of 18th-century France and, in due course, the refined English neoclassicism of the Adam brothers and their successors would appear to add a distinguished restraint. In London, at least, the classicism that generally prevailed after 1900 provided buildings with a superficial coherence, even though the variety of classical sources available to architects was the equivalent of the stylistic variety of the 1870s. In London, too, building regulations and the widespread use of Portland stone also imposed some uniformity of scale and materials. Good architects rose to these challenges and designed buildings of power and integrity, on occasions using the classical vocabulary with great originality. Lesser architects, unable to master the classical rules to discipline their own invention or to digest the variety of sources that were still on offer, continued to produce buildings that were no more than a kit of parts.

But classical revivals were not the only drivers of the architecture of the period. Another was technological – the introduction of the steel frame and of reinforced concrete. Once building regulations had been altered to allow the full exploitation of these new methods, with walls no longer required to be load-bearing and architectural detail increasingly reduced to the mere cladding of the underlying structure, architects could break free from much of the original structural logic of traditional forms and exercise their invention more freely than ever before in the use of historic detail. However, it would be another generation before architects – and their clients – were prepared to jettison historic styles altogether and develop an architecture based solely on new materials and technologies. For the present, architects would make use of the new techniques to adapt classical models to the scale of modern building, and it is these – the grand hotels, the huge stores and the great offices in classical styles – that perhaps most fully express the spirit of the age.

The third driver of contemporary architecture was nostalgia, and architectural nostalgia already had a long history. For most people, the appeal of styles is associative, and in parallel with classicism's appeal to imperial self-confidence, there was also the idea of Old England – the idea of a more ordered society where the rich man was in his castle and the poor man was at his gate; a society where there were no grimy industrial cities, no money-grubbing businessmen or truculent workers. No matter that many of those to whom this romantic view appealed most strongly were those who had personally risen through the modern world, with all its grime and money-grubbing, until they were rich enough to live in a house that reminded them of an imagined past. Outside the cities where banks, offices and town halls were rising, many rich men continued to build houses that seemed to recall the elegance of the 18th century, the national pride of the Elizabethans or the feudal order of the Middle Ages. In town, the long association

of France with culture and taste encouraged the same people – as well as members of an older aristocracy who wanted to keep up with the fashions – to decorate houses that were often restrained on the outside with lavish displays of rococo ornament within.

The First World War did not wholly kill national self-confidence: Britain had won. But the nation was exhausted and the building that followed the war perhaps also expressed something of an exhaustion from the architectural excesses of the previous 30 or 40 years. Victory was followed by deep pessimism about the future of civilisation itself, and while classicism had appealed to confidence in imperial power, traditional home-grown styles appealed to a yearning for peace and quiet and a simpler way of life. This longing could be expressed in a new building or realised in an old one, and nostalgia would be reinforced. After the war, architectural invention sometimes seems constrained, and the ultimate reaction is to be found in buildings that not only employed vernacular styles but reused the actual materials of old buildings.

All of these architectural developments are captured in Bedford Lemere & Co's photographs. Their photographs also show streets with traffic and people, offices with the clerks who worked in them and factories with their workers and machinery. They include early power stations and underground railway stations. They include shops and places of entertainment – theatres, restaurants and the first cinemas – as well as workplaces and houses, and they occasionally include subjects that have little directly to do with building.

They should not be seen as a photographic survey of the life of the time. There were areas of contemporary life that the company seldom or never recorded, and the photographs in this book are a selection from commissions that were themselves arbitrary. For the same reason, they are not a comprehensive record of the architecture of the period, if only because there were important architects whose work the firm was never asked to photograph. Nonetheless, thanks to the reputation that the firm enjoyed, its commissions covered a very broad range of what would now be called the built environment: not only do they include a

great many of the most significant buildings of the age, but enough of the less good ones to provide a context for the best. Those in this selection are from a period of nearly 40 years, but for longer than that Bedford Lemere & Co were acknowledged as the leading architectural photographers in Britain.

BEDFORD LEMERE & CO, 1861–1947

Founded in 1861, and with its studio in London at 147 Strand from 1867 to 1947 (Fig 1), Bedford Lemere & Co worked throughout the British Isles and occasionally on the Continent.[1] Clients included not only architects but anyone who might need architectural photography: decorators, property companies, engineers and contractors, businesses needing photographs of their premises, house owners who wished for photographs of their homes, and publishers who wanted photographs of buildings for any of a wide variety of purposes. So extensive a range of clients sometimes led to commissions

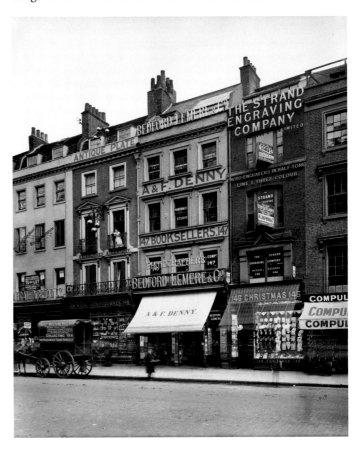

Figure 1. Bedford Lemere & Co's premises at 147 Strand, London WC2, photographed in 1907. [BL19976]

that were outside the firm's core repertoire. A notable, additional class of work was the photography of ocean liners for shipbuilders and shipping companies. It is not too much to claim that in realising and exploiting a market for architectural photography the founder of the firm, Bedford Lemere (1839–1911), effectively developed a new genre (Fig 2).

In the course of the company's existence, it is likely that some 100,000 photographs were taken. Of these, around 25,000 exist in the archive of English Heritage, mainly original glass negatives covering the period from around 1889 to 1930 but including a smaller number of prints and negatives from earlier and later years. These include many photographs of work by some of the principal British architects of the period. But their number, and the very wide range of clients, means that the photographs provide a far broader view of contemporary architecture than would any archive that concentrated solely on buildings by the leaders of the profession. It is this catholic range of subjects that gives the firm's photographs much of their value, reflecting the exuberance of British building at the height of the nation's prosperity.

The company's origins are obscure. Bedford Lemere's father, James Henry Lemere, was a grocer and draper in Maldon, Essex. How Bedford Lemere established himself as a photographer is not known, although he was probably typical of many Victorian practitioners who gravitated to photography from another occupation. The firm's catalogues state that Lemere had submitted work to the 1862 International Exhibition, but when his son Henry (always known as Harry) was born in 1865, Bedford Lemere was described as a commercial traveller, which might suggest that at least part of his own work in the business was selling photographs taken by other photographers working for the firm. Records of commissions before the late 1870s are incomplete;[2] Lemere's earliest known work is of buildings damaged in the Fenian explosion in Clerkenwell in December 1867, at which time he seems to have had some association with the photographer and photographic print dealer, Henry Hering.[3] The premises at 147 Strand had previously been occupied by Valentine Blanchard; Blanchard had been one of the earliest photographers to have

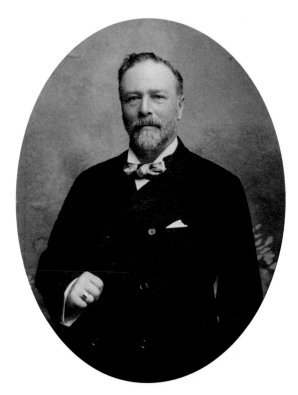

Figure 2. Bedford Lemere, undated.
[BB89/01370, Reproduced courtesy of Mr Tom Samson]

taken views of London streets and it may be that Lemere acquired some of Blanchard's business.

It may also be of significance for Lemere & Co's architectural work that the firm's first daybook records photography of drawings submitted for the competition for the new Law Courts in the Strand in 1866–7. Minutes of the commissioners administering the competition record that these were to be photographed and reproduced, 'by photo-zincography or otherwise', so that they could be more generally seen.[4] It is not certain that the daybook entry refers to this publication, but it seems likely. The earliest surviving work, of which a range of images remains, was the photography of casts of architectural detail at the Royal Architectural Museum in Tufton Street, Westminster, undertaken no earlier than 1870 (Fig 3 and *see* frontispiece). It is probable – particularly in view of the number of sets of prints that survives and two very favourable contemporary articles in *The Architect* by J P Seddon – that these brought the firm's work to wide notice.[5]

However, it is not clear how Lemere obtained either of these commissions. In any case, although most of the casts in the Royal

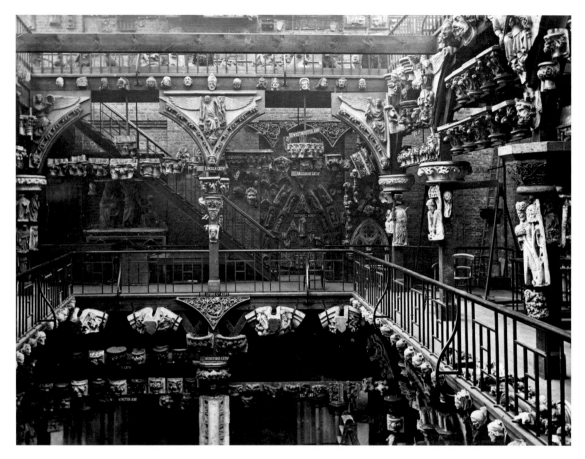

Figure 3. Royal Architectural Museum, 18 Tufton Street, London SW1, photographed between 1870 and 1872. [BL00029]

Architectural Museum were of Gothic detail, the firm never photographed many churches and in the following years the daybooks record less photography of architectural details and more of actual buildings. By the mid-1870s Bedford Lemere & Co were photographing buildings by John Norton, Matthew Digby Wyatt, R Norman Shaw and F P Cockerell; a little later the list would include Ernest George and Harold Peto, Arthur Blomfield, E R Robson, E W Godwin and Alfred Waterhouse.

In very many cases, however, photography seems to have been commissioned not by the architect but by the architect's own client, who might be a public body, a business, a property company, the building firm concerned or a private owner. And commissions might lead into unpredictable territory. Owners whose houses were photographed might ask the photographer to take pictures of themselves and their family while he was there (Fig 4). For the architect George Devey, Lemere & Co photographed houses that received very little publicity but which included the homes of many of Devey's upper-class and financier clients. These included

several members of the Rothschild family, with whom Bedford Lemere and his son clearly established close professional relations so that in due course they would be asked to photograph such non-architectural subjects as a meet of stag hounds, a stud of champion shire horses and a giant tortoise. Around 1880 Bedford Lemere photographed the state rooms at Windsor Castle, and in 1889 his son twice visited and photographed Sandringham (Fig 5). In building up the business, a reputation among influential owners was probably as valuable as was the respect of the architectural profession. Of equal importance was work for interior decorators, and here Bedford Lemere & Co will have been helped by the rapidly growing middle- and upper-class concern with the 'artistic' decoration of houses. Already in the 1870s the firm was undertaking work for H & J Cooper, Maples and other leading furnishers; these would remain its clients and lead to other commissions.

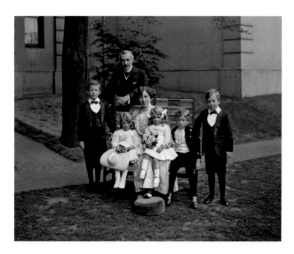

Figure 4. The architect R Frank Atkinson and family, photographed in 1912. [BL21638/002]

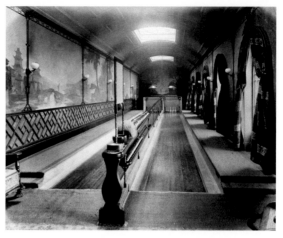

Figure 5. The bowling alley, Sandringham House, Norfolk, photographed by HBL in 1889. [BL09138]

From 1875 to 1877 the firm also maintained premises in Manchester. These were soon relinquished, but for the next 40 years Lemere & Co maintained a strong presence in the north-west and Scotland, photographing the work of many local architects and a variety of civic, commercial and domestic buildings. Work in the north-west also illustrates how client networks may have been built up. Already before 1880, work had been commissioned by Gillow's of Lancaster and S J Waring & Sons of Liverpool, both leading and long established furnishers and decorators; in 1897, when the two firms combined to form Waring & Gillow, it was natural for Lemere & Co to work for the joint company. With the establishment of the Waring-White Building Company, pioneers in the construction of large steel-framed buildings such as the Ritz Hotel and Selfridges store in London, Harry Lemere (who had by then taken over from his father) and his colleagues would photograph a number of their works. They would go on to photograph Waring & Gillow's munitions factories during the First World War and private commissions for Samuel Waring himself. Bedford Lemere & Co continued to be involved in the Liverpool nexus of architects, builders and patrons. They had photographed buildings for the Liverpool architect Francis Doyle, and buildings designed by Doyle's pupil R Frank Atkinson. Waring employed Atkinson on his own house in Kent and on his firm's London store, and the company photographed

both. Doyle designed Thornton Manor for W H Lever, later Lord Leverhulme; Lemere & Co photographed not only Lever's house but his ideal industrial village, Port Sunlight, and the factory at its centre (*see* pp 106, 122–5). They also photographed the houses of the other great Birkenhead soap manufacturer, R W Hudson (*see* pp 208–9).

It may have been through work for interior decorators that Bedford Lemere & Co first undertook what for 50 years would be an important part of its business: the photography of ocean liners. Steam ships were rapidly growing in size, speed and comfort from the 1840s, and rival lines competed on all three fronts. While steerage – the cheapest accommodation – would remain spartan, first-class passengers would demand increasingly luxurious cabins and public rooms, work that was contracted by the shipyards to outside firms. The firm's photographs of the interiors of passenger liners (almost all now at the National Maritime Museum, Greenwich) are the most complete existing record of this progress. Photography in often confined and ill-lit spaces demanded special skills and experience, and it is clear that the Lemeres and their assistants possessed them.

But work on ships was connected with other commissions. Harry Lemere also photographed Dawpool, Wirral (*see* p 202), which R Norman Shaw (whose cousin was a director of the Shaw Savile shipping line) had designed for Thomas

Ismay, the head of the White Star Line. Besides the company's ships, he photographed Harland & Wolff's shipyard where they were built (*see* p 114), and his colleague Adolphe Boucher recorded the 1911 coronation decorations adorning Oceanic House, the firm's shipping office in London (*see* pp 164–5). It was probably Harry Lemere who photographed the Liverpool home of Ismay's partner, William Imrie (*see* p 192), while Boucher later photographed the London house of Bruce Ismay, Thomas's son (*see* p 199). The many interconnections between the firm's clients, and the multifarious nature of many of their enterprises, makes it in most cases impossible now to discover how the Lemeres originally obtained introductions and work, but in the end they can only have merited employment through their professional ability.

In an age when contemporary architecture was based almost entirely upon historic styles – however freely interpreted – and before the invention of cheap and satisfactory photo-mechanical reproduction, photography was the most economical means of illustrating the actual appearance of a building. It may have been the success of the Royal Architectural Museum photographs that led Bedford Lemere to recognise and exploit a specialist market for architectural and other images as exemplars. From 1881, and possibly earlier, he produced a printed catalogue of available photographs, with annual supplements thereafter. Individual photographs could be ordered from these catalogues, while for customers who needed illustrations of particular themes, separate lists were available of photographs selected from the existing stock to meet their needs. In 1881 these specialised lists included 'Old Half-timbered and Stone Mansions' and 'Old and Modern Queen Anne Residences, Schools etc.', and over the next 20 years many more selections would be available including 'Town and Country Houses and Mercantile Buildings', 'England's Homes: Blenheim, Hatfield, Haddon, Hardwicke [*sic*] etc.' and several series of furniture and woodwork (Fig 6). An assemblage of period furniture, engraved from one of Bedford Lemere & Co's photographs, was reproduced in *The Builder* in 1878 (Fig 7).

The sets and series available to the public seem to have been made up partly of selections from clients' photographs, and partly from photographs taken on the firm's own account. The Gothic details from the Royal Architectural Museum were in due course supplemented by photographs of classical ornament taken from casts in the Royal Academy Schools. Many of the firm's clients must have been willing for

Figure 6. Bedford Lemere & Co catalogue with testimonials from 1881. [DP119182]

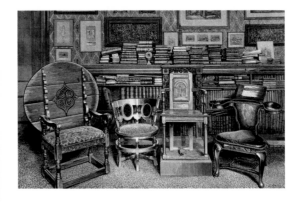

Figure 7. Engraving from *The Builder* (1878), based on a photograph by Bedford Lemere & Co. [DP085768]

photographs of their buildings to be advertised and sold on the open market, although many photographs were not included in the issued catalogues and some are marked 'private' in the daybooks. Those that were available included internal and external views of country houses, old and new, and of great London houses such as Chesterfield House, Grosvenor House and the town houses of the Earl of Aberdeen, Lord Brassey and Lord Carrington. The 1893 catalogue announced: 'We are now engaged in photographing many of the BEST "SOCIETY" HOUSES in London, adding to our series splendid examples of latest Art Furniture and Decoration, especially applied to Reception and Domestic Rooms.' In addition, if a job took a photographer out of London, he might take the opportunity to photograph some other building in the neighbourhood if it met a likely sale. Thus in 1884 Bedford Lemere photographed the 17th-century swept and pedimented gables of Fairfax House, Putney, when he had been commissioned to photograph another building nearby; such gables were the model for a favourite motif of architects in the currently fashionable 'Queen Anne' style.

The firm seems also to have been in possession of other photographers' negatives, though it is not certain how many. For many years the printed lists included 'Pugin's Continental Sketches: Churches, Figures, Heraldry, etc.'. These must be those copied by Stephen Ayling, a photographer who specialised in the photographic reproduction of works of art and who published a collection of 500 of A W N Pugin's drawings in 1865. The daybooks also include photographs of foreign architecture. The daybook covering 1867–83 lists negatives of a number of modern American buildings, including works by McKim, Mead & White, Peabody & Stearns and H H Richardson; it also includes negatives of French chateaux. A number of photographers at the time had reciprocal arrangements whereby they sold each others' work; these foreign negatives may have been obtained on that basis in the hope of selling prints to an English market. The series of 'French, German and Dutch Decorative Furniture etc.' and 'Italian, Romanesque and Renaissance Details, Wood Carvings etc.' may have been largely or wholly supplied in this way.

It is clear that at a time when many branches of design – and not only architecture – were heavily dependent on historical models, there was a demand for illustrations of actual examples, which Bedford Lemere set out to satisfy. The firm's catalogues included testimonials from John Ruskin: 'I am perfectly ready to recommend the purchase of your beautiful photographs … for every Art School in the Kingdom', and from Norman MacLeod of the Science and Art Department, South Kensington, dated 1875: 'If any School of Art should apply for your Architectural Photographs, this Department would give its usual aid towards their purchase.' Another testimonial, from the prolific firm of architectural sculptors Farmer & Brindley (whose work included the Albert Memorial), stated that Lemere's Royal Architectural Museum photographs 'are very useful. Please send two complete sets for the use of our carvers.'[6]

Albums, containing proofs of most of the firm's work, could be seen by visitors to the first floor of 147 Strand between nine in the morning and seven at night. The address was close to the offices of many practising architects in the Adelphi and other streets off the Strand, and probably at least as many architects resorted to the firm's showrooms to see and buy prints as to commission photography of their own work. The use of photographs as architectural reference in the 19th century, and the possible influence of their ready availability on the stylistic diversity of the 1880s and 1890s, needs further exploration. The presence of many of Lemere & Co's photographs among George Devey's papers suggests that other architects whose working archives do not survive may have used them for suggestions and information.

By 1900 the firm was advertising that 50,000 photographs were available. Charges seem to have remained steady over a long period. For new commissions, they would charge per day £2 2s for the first negative and £1 1s for each one thereafter, with 'horse hire, and travelling expenses extra'. Prints (12 x 10in) from existing negatives seem to have been priced at 3s, with reductions for quantities. Bound sets were available at special prices. In 1881 albums of 50 and 60 photographs from the Royal Architectural Museum ('the largest collection of gothic detail

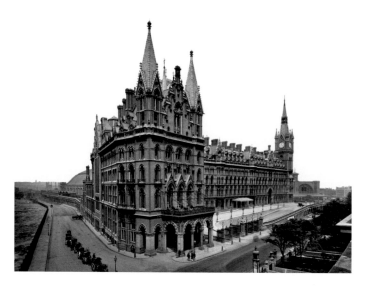

Figure 8. St Pancras Hotel (also known as the Midland Grand Hotel) (Sir George Gilbert Scott, 1868–76) and Station, London NW1, photographed in 1881. [BL01101]

Figure 9. Cabinet card portrait of an unknown man and woman produced by Bedford Lemere & Co in the 1870s.
[DP119183, Reproduced courtesy of Gary Winter]

in the world') were priced at £7 7s each; a portfolio with 20 photographs of Sir George Gilbert Scott's St Pancras Hotel was offered for £5 5s (Fig 8). In addition, presentation albums seem often to have been made up to order, containing the views taken on particular commisions. A number of these are known to survive and others are probably to be discovered.

Bedfore Lemere & Co also carried on some of the business of a general commercial photographer at 147 Strand. Portraits were taken, using the formats commonly used in the later 19th century (Fig 9). Close to the Law Courts, the firm undertook a certain amount of legal work, making photographic copies of documents. It undertook photography of objets d'art, generally delivered to the studio on the premises. This may have been the origin of the elder Lemere's work for the great antique dealer Joseph Joel Duveen, though Duveen also worked as a decorator and the connection may have originated in Lemere's photographing houses that Duveen had been employed to furnish.

In 1881 Bedford Lemere was joined in the firm by his son Harry (1865–1944), who from then on took an increasingly active part in the business (Fig 10).[7] The younger Lemere joined the Royal Photographic Society two years later and it is therefore likely that he was already a skilful practitioner. By 1888 he was the firm's

leading photographer, and he had probably assumed the day-to-day management of the company well before his father's death in 1911. Inevitably, as a younger man, Harry Lemere will have had and developed a different range of contacts and clients. His arrival seems to have marked a subtle shift in the focus of the firm's work, though it is uncertain how much this was due to him and how much to changing circumstances.

From the 1890s onwards there is a falling-off in the photography of older buildings and historic houses. This may in part be due to changing architectural taste – to a slow evolution from the eclectic stylistic confusion of the 1880s towards a more rigorous use of precedents that was based on a closer study of a more limited, and mainly classical, choice of styles. Although architectural education had long encouraged the detailed recording of historic models by means of measured drawing, and architects had long measured and sketched buildings in which they might find suggestions

Figure 10. Harry Lemere, undated.

[BB89/01371, Reproduced courtesy of Mr Tom Samson]

and inspiration, an increasingly rigorous professional training may have reduced the market for the more superficial record provided by photography. Certainly, the printed lists seem to have been discontinued in or soon after 1908. Probably soon thereafter most of the first 10,000 or so of the firm's negatives (covering the period up to the late 1880s) were destroyed. It is likely that by then, with classical styles dominating contemporary architecture, there was less demand for photographs of Gothic or Old English buildings from the earlier lists, and certainly less for photographs of once-modern buildings and decorative schemes that were by then hopelessly unfashionable. But in any case, the introduction of the half-tone block for the high-quality illustration of books and periodicals offered alternative means of making high-quality images of architecture widely available.

With so wide a range of clients, in the years around 1900 the firm was pre-eminent in its field, and Bedford Lemere & Co would remain prominent among architectural photographers until the Second World War. But from the 1880s the ease of working with the new dry photographic plates and, in the 1890s, a new

market for photography in the books and magazines illustrated by new techniques of photo-mechanical reproduction encouraged others to enter the market. And as the expanding market promised business for anyone with the right skills, by the first decade of the new century many others were doing work that might once have been commissioned from the Lemeres.

The work of this new generation of photographers is not always easy to attribute, due to the loss of original archives and the frequency with which pictures were published without being credited. This anonymity means that the names of very many other photographers have been forgotten, and the loss of studio archives means that a vast volume of comparable work has been destroyed. The largely indistinguishable character of much of the best published architectural photography from the 1890s onwards demonstrates that many photographers shared the Lemeres' aims and methods. Of these, some seem to have carried on, like Bedford Lemere & Co, a fairly general practice; the new market enabled others to specialise still further.

A leading position in the photography of historic buildings would be taken by Charles Latham, whose photographs – reproduced in collotype – illustrated J A Gotch's two 1894 folio volumes *Architecture of the Renaissance in England*. Two years later a series of views of London churches by him were similarly reproduced in George Birch's *London Churches of the XVIIth and XVIIIth Centuries* – symptomatic of a rapidly growing interest in the historic buildings of later periods than the Gothic and Tudor. Latham went on to work as the principal architectural photographer for *Country Life*, founded in 1897 specifically to exploit the high-quality, high-volume reproduction made possible by the half-tone block, and from the first including photographs of old houses. In praising Latham, Gotch had written that 'the art of fitly illustrating architecture by means of the camera has not been widely acquired',[8] but several different photographers contributed to Thomas Garner and Arthur Stratton's 1911 *The Domestic Architecture of England During the Tudor Period*, volumes similar to Gotch's in lavishness and scope. By that time there were

many practitioners with skills and knowledge to enable them to take informative photographs of old buildings, though none would achieve the remarkable longevity of Bedford Lemere & Co.

The company had taken, and would continue to take, very many photographs of houses; in addition to the architects who employed them, they were still extensively employed by firms of interior decorators. But by 1910 probably the leading photographer of up-to-date domestic architecture was Thomas Lewis of Birmingham, who with Latham was singled out by Hermann Muthesius as one of only two men who could photograph architecture well.[9] Albert Richardson employed Edwin Dockree to take the photographs for his lavish *Monumental Classic Architecture in Great Britain and Ireland* of 1914, and travelled round Britain with him directing his choice of shots. Dockree had earlier published a long series of views of cathedrals – a class of subject that Lemere & Co seldom touched. He also photographed buildings of other kinds, new as well as old, as did S P Bolas whose work was also widely reproduced.

Some journals used Bedford Lemere & Co's photographs more than others. They remained prominent in *The Architect and Contract Reporter*; however, while in 1900 every photograph of a new building published in the magazine was by the firm, by 1914 this had fallen to 50 per cent. Its work was published in *The Builder*, but no more often than that of Dockree, Bolas and several others. *The Architectural Review*, which like *Country Life* was founded to exploit the possibilities of the half-tone block (rather than the cheaper but cruder techniques employed by most of the weekly periodicals), used the firm's photographs sparingly.[10] Many of *The Architectural Review*'s photographs are credited to the magazine's own photographic bureau, whose photographers are not identified. The five annual volumes of *Recent English Domestic Architecture* published by *The Architectural Review* between 1908 and 1912 included 39 by its own photographers, 32 by Lewis, 14 each by Lemere & Co and Cyril Ellis (who had contributed many of the pictures to Garner and Stratton's volumes), 6 by Dockree and 4 by Bolas; however, out of the 360 buildings illustrated the photographer is given for only 136. One may sometimes recognise Lemere

& Co's photographs, unattributed, published elsewhere; in these cases it is likely that they will have been supplied to the publisher by the original client who, having commissioned the work, owned the copyright and required no further acknowledgement of the photographer. They seem never to have been credited when included in the illustrated brochures published by the many furnishing companies – Heal & Sons Ltd, Maples and Waring & Gillow among others – who commissioned photography specifically for the purpose.

The photographs included in this book include none taken after 1928; few negatives survive from after 1930. It seems likely that by then the firm was already in decline. Harry Lemere was born in 1865; a 12 x 10in plate camera, his preferred instrument (described in more detail on p 22) is not something to be lightly handled by an older man, nor are the glass plates that it took. Adolphe Boucher, his principal and long-term colleague, was only three years younger. There is evidence that around this time Lemere took to using a more manageable, whole-plate camera (with plates approximately 6 x 8in), but the reasons for decline are probably deeper than that. Other factors may have been competition from other and younger photographers, perhaps more in sympathy with more modern styles of architecture; the depression after the First World War and the slump after 1930, which substantially reduced the amount of building and seriously affected the decorating and furnishing trades; and perhaps too a dependence on business rather than on architectural clients, who may not always have appreciated architectural photography of the highest quality and in difficult times may have been reluctant to spend money on it. However fine the results achieved by Harry Lemere and his colleagues, their painstaking techniques will have appeared slow and old-fashioned to those more used to photographers who, with lightweight cameras and film, took multiple images and printed whichever one seemed to have turned out best.

Clients clearly found both Lemeres easy and pleasant to work with. The elder Lemere was a Mason – a member of the Lodge of Confidence No 193, which generally met in the area around Holborn and Newgate Street – from 1875 to

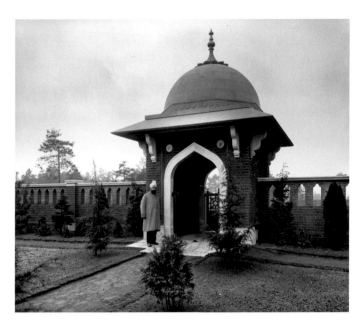

Figure 11. Muslim burial ground (T Herbert Winney (India Office Surveyor), 1917), Woking, Surrey, photographed by AAB in 1917 for the India Office. [BL23738/006]

1886, when he resigned; the younger was a very active member of the London Rotary Club. Such contacts will have been valuable in further building up the business. But for the two Lemeres to have recorded grand hotels, factories, banks, country houses and royal palaces, to have built up considerable business in the Midlands, Lancashire and Scotland, and to have photographed not only churches but synagogues and a Muslim cemetery (Fig 11), suggests not only professional and organisational skills but perhaps a breadth of sympathy that was out of the ordinary.

Harry Lemere's close contemporary and long-term colleague Adolphe Boucher died in 1937, and Harry Lemere in 1944, sitting in his office chair at 147 Strand where he had worked all his life. There were generous tributes to Lemere in the trade press, noting his human qualities as well as his professional skills. He had been a member of the Royal Photographic Society for over 60 years – elected a fellow in 1895 and an honorary fellow in 1933 – and had been awarded the Society's Hood Medal in 1941. He was president of the Professional Photographers Association in 1930. Known throughout the professional community as 'Pa', obituarists praised his friendliness to everyone and his

solicitude for other people's happiness (and recalled how as president of the Association he would on occasion surreptitiously pass around the table a bag of sweets). He himself described his favourite occupation as 'cheering people up' (Fig 12). Census returns show him living first in Deptford and later in Lewisham, from where it would have been easy to get a train to Charing Cross or Waterloo for the walk to his office.

By the time of Harry Lemere's death there was already some interest in the archival and historic value of the collection. The National Buildings Record (NBR) had been established in 1941 to record – with photographs and measured drawings – buildings in England and Wales that were at risk in the Second World War. The NBR commissioned the firm to photograph a number of London churches and made a first purchase of prints from Lemere & Co's negatives, probably of the halls of City livery companies. A personal link between the NBR and Harry Lemere existed in that W H Godfrey, the NBR's first director, had worked many years before for James Williams, partner of George Devey for whom Bedford Lemere had supplied photographs in the 1880s; in 1943 Godfrey wrote to George Hargreaves, then chairman of Bedford Lemere & Co, that 'the ultimate custody of the unrivalled series of negatives which you possess is a matter of national concern, and I should be most gratified if they could become the possession of the nation'.[11]

Though he had been early to recognise the significance of certain Victorian buildings at a time when anything of the period was highly unfashionable, John Summerson, the NBR's assistant director, considered that Hargreaves – in his pricing of the negatives – placed 'an absolutely fictitious value on the firm's negatives … . As I have combed the register books and found only about 450 negs of real architectural value this is absurd.'[12] Summerson felt that commercially the whole collection was probably worth no more than £200 (which, he might have added, may have been less than the value of the negatives, cleaned off, as horticultural glass). In April 1945, after commissioning some fresh photography for the NBR, Summerson had to reject the results as 'miserably bad … alas, for the reputation of Bedford Lemere – Twilight of the Gods'.[13]

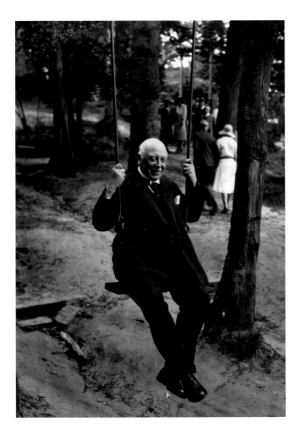

Figure 12. 'Pa' (Harry Lemere) on a swing, photographed *c* 1940. [OP06500, Reproduced courtesy of Mr Tom Samson]

In 1947 the firm moved from 147 Strand, where it had been established since 1867, to 3 Park Lane, Croydon. That the surviving photographs and negatives were not then disposed of may be due in part to the company's continuing hope that a market might be found for them, but perhaps also to the continuation in the firm of Louis de Baudot, a relation of Lemere's, who had joined Lemere & Co in 1909 at the age of 17 as an assistant, would later be studio manager and in 1947 was a director. Though a substantial number of negatives – including almost all those from before 1889 – had already been destroyed, the glass negatives taken to Croydon still weighed 11 tons. Over the following years some further purchases of prints were made by the Guildhall Library and the City of Westminster Public Library as well as by the NBR, but matters seem to have come to a head in 1955, in anticipation of the firm's move to new premises in Croydon and its unwillingness to care for its old negatives any longer.

The greater part of the firm's negatives were acquired by the NBR in November 1955 for £100; virtually all of the remainder by 1962. The daybooks essential for the identification of the negatives were initially loaned and later acquired from Archie Handford Ltd, Bedford Lemere & Co's successor company. So also were some 40 albums of proof prints, no doubt the original albums that would have been shown to visitors at 147 Strand. They are now held in Swindon, in the public archive of English Heritage; a further note about English Heritage's holdings of Bedford Lemere & Co material is on page 284.

APPROACHES AND TECHNIQUES
Architectural photography was far from unknown when Bedford Lemere founded his business – indeed the slow speeds of early photographic emulsions meant that architecture and topography had featured largely among the generally static subjects of pioneer photographers – but photographers had tended to favour the antique, the picturesque and the exotic rather than the new. It was in his specialised recording of contemporary building that Bedford Lemere was a pioneer, and perhaps still more notably in the then difficult photography of interiors.

Little is known of the photographic techniques or apparatus used by Bedford Lemere, though he will have used those available to his contemporaries. Early work was done using the wet-plate process, in which sheets of glass were coated with a solution of collodion (gun cotton dissolved in ether) and sensitised with silver nitrate. The process was cumbersome: the photographer had to carry with him his chemicals and a dark tent to prepare them in if there was no other dark room available, and the plates had to be exposed immediately, before they dried. A few of the firm's wet plates survive, but it is likely that Lemere will have adopted the dry-plate process as soon as this became generally available in 1879, and his son will probably have used dry plates from the first.

Harry Lemere's photographic methods were probably little different from those of his father, save for the adoption of improved lenses and photographic emulsions as these became available.[14] His regular camera was made in

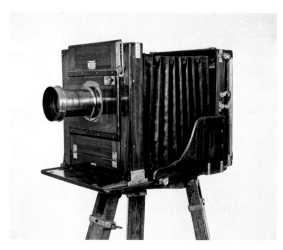

Figure 13. Bedford Lemere & Co's Meagher camera. [BB89/01372, Reproduced courtesy of Mr Tom Samson]

the 1890s by P Meagher of Southampton Row, taking 12 x 10in glass plates – the format of virtually all of the firm's surviving negatives (Fig 13). He would seldom have used camera movements other than a rising front, but a high viewpoint was sometimes necessary in order to cover the full height of a building across a narrow street. He used a variety of lenses, which he liked to stop down to f.45 to give the depth of field and the range of detail that he sought, and though preferring a lens with a long focus, architectural subjects often called for a wide angle of view. It is likely that printing was carried out by studio staff; the broad, north-facing attic window of 147 Strand implies that this was done on the premises.

For interior photographs Harry Lemere used natural light wherever possible, though occasionally using flash to illuminate the darkest corners or at the end of a very long exposure in a particularly difficult environment. With the small aperture that he preferred, this might necessitate exposures of up to 30 minutes in length. He never used a light meter, relying entirely on his own experience. He used filters only occasionally, mainly to achieve greater clarity in hazy conditions. Glare might be reduced by covering windows with a cloth for most of a long exposure and removing it towards the end. In printing, shadows and dark objects could be lightened by applying a layer of tissue to the negative. This might be cut away from significant objects, such as

the bowl, pictures, ornaments and fire-hood in figure 14, to allow greater clarity of detail through increased exposure. An adhesive fluid was sometimes applied to negatives before printing in order to block out unwanted details or to create the appearance of a uniform sky that enhanced the contrast between a building and its surroundings. It could also be dabbed onto the glass plate to simulate clouds (*see* p 114). The result was a photograph that included everything that the client wished to see. Buildings in Lemere & Co's photographs are idealised and it was this ability to flatter that recommended the firm to its patrons.

The Lemeres – father and son – did not work on their own; the elder Lemere did not himself take all the photographs that the company undertook and in the days of wet plates an assistant will have been almost essential to help with the apparatus. But it is only from late 1888 onwards that the daybooks which record the work of the firm regularly include the initials of the photographer who took the picture. At the same time, these books begin more systematically to record information about clients. Several photographers' initials occur in the 1889 daybook which do not appear thereafter, nor is there any later record of photography undertaken by the elder Lemere. It seems likely that there may have been a change of organisation at around this time, perhaps

Figure 14. A negative from 1897 masked with tissue paper, which has been removed from selected objects – the bowl, pictures, ornaments and fire-hood – to allow greater clarity of detail in printing (*see* p 188 for a print made from this negative). [BL14017]

with the management being assumed by Harry Lemere who had been noted as working for the firm since 1881.

While some initials only occur briefly (and in some cases the initials may refer not to a staff member at all, but to a photographer to whom a job had been contracted out), some assistants stayed with the company for many years, guaranteeing a consistency of quality and approach. The initials JWC occur from 1904 to 1922 with a break between 1916 and 1919, perhaps for war service; WW occurs until 1894 and AGP from 1923 to 1931. Only one of these assistants – AAB – can at present be identified, as Adolphe Augustus Boucher (1868–1937) who joined the firm in 1889 and continued to work as Harry Lemere's principal colleague until his death. For much of this time, Boucher seems to have executed most of the firm's London architectural jobs while Lemere concentrated on ships and out-of-town work. But the work of the Lemeres and their assistants seems indistinguishable and other firms operated in a similar manner. When the photographer L Tennant Woods applied for a job with Fratelli Alinari, the great Italian firm of architectural and topographical photographers, he was able to tell his potential employer that he could work to Lemere's standards.[15] What firms like Bedford Lemere & Co or Alinari required from their staff was not individual interpretations of their subjects, but photographs whose character and quality could be predicted and relied on by their clients.

How one views the architecture of a period is determined in part by its images – by those made at the time and by images made subsequently – and in viewing the firm's photographs it is important to relate them to what was required of them when they were taken. Images made of a building many years later may not necessarily bring out the qualities that were valued when it was first built; understanding is affected not only by fresh historical perceptions but also by tastes that may be less in sympathy with those of an earlier age. Although the images made when a building was new may be no more objective, their maker is perhaps more likely to have subscribed to the same aesthetic as the building's designer and to a similar view of what should be the

building's visual function in the contexts of its setting and society at large. Bedford Lemere & Co's architectural photographs are both expansive and minutely detailed: they depict the architecture of a self-confident era. Even the most ordinary of the buildings that the company photographed has a presence that often belies its banality.

Proof in the clients' eyes of the validity of the firm's approach to the photography of individual buildings may be found when they are compared to the firm's street views. London scenes, such as Boucher's photograph of the north side of High Holborn (*see* p 37), show streets of disparate monuments unified only by the heights and building lines enforced by law, by storey heights determined by similar use, and by the densities of texture common to most historicist architectural styles. But these are enough to blur the differences between them. Such a parade of equally magniloquent buildings diminishes them individually. Those photographs that, by contrast, show buildings on their own and decontextualised must have conformed more closely to the architect's own notion of the impact he was trying to achieve. And to the architect one can add other clients: the builder and the decorator celebrating their creations, the promoter boosting his new premises or the agent trying to sell it.

A further characteristic of the firm's photographs is that they are static. Perhaps this is clearest in two of its most striking images, both of staircases: that at the National Liberal Club and that at the John Rylands Library (Figs 15 and 16). The first, the simpler, which may be by the elder Lemere, is perhaps the more astonishing: an almost abstract arrangement of pure pattern and form, in which there is no sense that the stair itself is leading anywhere. In the second, taken by Harry Lemere, the patterns are more complex, the textures more varied, the image is altogether richer and there are indications of spaces beyond. But in both the composition is paramount, and the viewpoint is chosen not so much to indicate passage through the building as the experience to be gained at a particular point within it.

Viewpoints were chosen with the utmost care (any photographer knows how a shift of position of even a few inches can transform

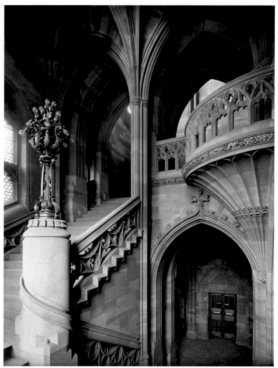

Figure 15. Staircase, National Liberal Club (Alfred Waterhouse, 1884–7), Whitehall Place, London SW1, photographed in 1887.
[BL08404]

Figure 16. Staircase, John Rylands Library (Basil Champneys, 1890–1900), Deansgate, Manchester, photographed by HBL in 1900.
[BL15862]

one's understanding of a building). This evocation of internal space is complementary to an external sense of monumentality and is, of course, most powerful in the largest buildings. But in many small domestic interiors too – where Harry Lemere would painstakingly rearrange the furniture if need be (and to lessen the visual confusion, particularly necessary in the dense interiors of the 1880s and 1890s) – careful composition contributes greatly to an appreciation of their scale and contents. The rooms in these pictures are self-contained: one's attention is concentrated on their decoration, their arrangement and their contents.

The firm's street scenes also have this static character. Urban spaces are often photographed from a high viewpoint from which the world can appear remote. Roads are not empty of traffic but what there is moves rationally and calmly; there is seldom a hint of the traffic jams that are so often seen in other contemporary views. Even crowds, though seldom depicted, seem almost unnaturally orderly. Public spaces are dignified by the behaviour of the people in them.

This idealisation of public space parallels the idealisation of buildings themselves.

It has been said that people seldom appear in the firm's pictures. It would be more accurate to say that they seldom appear when they are not needed. Enough of the scale and purpose of a building is usually apparent from a photograph of it, without the need for people. But when they add to the impression, the Lemeres and their colleagues often included them. The slow emulsions and wet plates of the early days made it difficult to include people in interior photographs taken with natural light and needing long exposures. But once it was possible to people locations such as the kitchen of a London restaurant, the telephone office of a grand betting agent or the work of a factory, the occupants are often included to great advantage – as in Boucher's photograph of the children's hairdressing salon at Harrods (Fig 17). Where in such a situation people are absent, this is probably at the behest of the client rather than because the photographer did not want them.

This idealisation of the subject matter means

that one does not often sense the minutiae of daily life: the many irrelevant incidents and incongruities that occur constantly in every house and in every public space – although the Heath Robinson electric wiring, the typist's chaotic desk and the nonchalant proofreader at the offices of *The Morning Post* are a joy (*see* p 133). However, the clarity of these photographs means that, inevitably, much fascinating detail – irrelevant and unintended – is included. On the upper floor of a commercial building in Clerkenwell (*see* p 134), one can see toy sailing boats hanging in the windows; the antics of steeplejacks on the scaffolding for a power station chimney (*see* p 170) would certainly fall foul of health and safety laws a century later.

But the inclusion of the commonplace is generally incidental, and both in subject and purpose Bedford Lemere & Co's photographs are rather different from those of such firms as Francis Frith and George Washington Wilson – large businesses by the end of the 19th century, whose staff travelled around towns and villages to produce the kind of pictures that, before the advent of cheap, do-it-yourself photography, were already wanted by tourists. Other firms, more locally based but serving the same market, would grow rapidly in numbers with the introduction of picture postcards at the end of the century. These photographers mainly sold general views and shots of such old and picturesque buildings as might have interested visitors. The latter are seldom of interest now unless the building concerned has been demolished; however, the appeal of everyday street views a century later is that these seem to show still-familiar places in an earlier guise and glimpses of the ordinary life of the past. In Lemere & Cos' work, such glimpses occur more often in their photographs of factories and other work places than in the architectural photographs for which they are mainly known.

It is tempting to see in the work of yet other photographers, of those who recorded back streets and tenements rather than public places and the homes of the rich, a still closer involvement with daily life. In John Thomson's photographs of London street life, the photographs taken between 1875 and 1886 for the Society for Photographing Relics of Old London, Thomas Annan's records of the old

courts and wynds of Glasgow, Frank Meadow Sutcliffe's photographs of Whitby fishing folk, Frederick Emerson's photographs of East Anglia, and Eugene Atget's views of the old lanes of Paris, the realism of photography seems to offer a moment of intense awareness of scenes that are utterly vanished and people that are totally forgotten. The modern appeal of these views is in part subversive, as one believes one has found the people and the places that official history has written out of the record. Yet the apparent objectivity and realism of documentary photography are highly deceptive. These photographs were taken for particular reasons just as the Lemeres' were, and just as the firm's views may have flattered their subjects, other photographers were equally selective and often took photographs for purposes that were no less personal or polemical. Bedford Lemere & Co's idealising photographs embody an attitude to their world that was as central to it as were the slums of the Gorbals or Seven Dials.

Nor is there any trace of contemporary movements in artistic photography in the work of the firm. Bedford Lemere & Co's photographs appeal now because of the apparently factual quality of their detail and definition, even though such qualities were only painstakingly achieved through careful selection and total technical mastery. But in the years around the turn of the 19th and 20th centuries, few

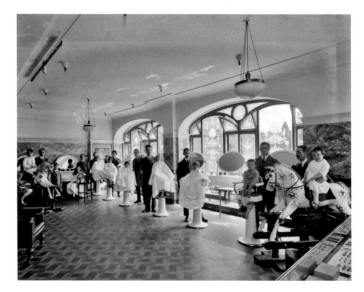

Figure 17. Children's hairdressing salon, Harrods, Brompton Road, London SW1, photographed AAB in 1921. [BL25611/002]

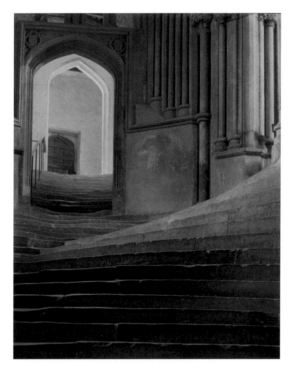

Figure 18. Chapter house stairs, Wells Cathedral, entitled 'A Sea of Steps', photographed by Frederick Evans in 1903.

[National Media Museum/SSPL]

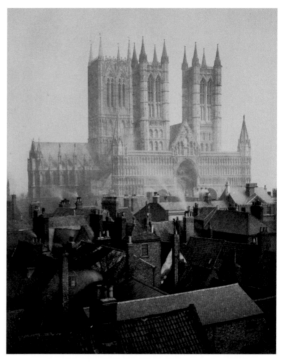

Figure 19. Lincoln Cathedral from the castle, photographed by Frederick Evans in 1898.

[National Media Museum/SSPL]

'art' photographers would have admired the company's work for anything save its technical proficiency, and members of the so-called Pictorialist movement aspired to the creation of autonomous works of art rather than images which they would have regarded as mere representation.

The Pictorialists, using such techniques as soft focus, silhouetting, highly selective composition and sometimes esoteric printing methods, sought a kind of image-making that they felt was denied both by the mechanical nature of modern instant photography and by the demands of the professional market. But it is instructive to compare Harry Lemere's view of the staircase at the John Rylands Library (*see* Fig 16) with Frederick Evans's famous view of the chapter house stairs at Wells Cathedral (Fig 18). Evans, a near contemporary, was a prominent member of the movement and, unusually among its English adherents, photographed buildings. Lemere places the spectator at a fixed point from which he can contemplate a perfect composition of lines, masses and voids. Any shift in position would

shatter the symmetry. Evans's photograph, by contrast, draws the viewer in and on; the shadowy spaces around are undefined and might extend for ever. Perhaps the architect of the John Rylands Library – Basil Champneys – might have wished for a touch more of Evans in Lemere's photograph; anyone wanting information about Wells Cathedral would certainly want more of Lemere in Evans's. Yet while Evans was certainly more conscious of his quest for an autonomous image, in the geometrical perfection of Lemere's photograph there exists an image very different but equally strong.

In the photographs of French chateaux that Evans took for *Country Life* and which were published in book form in 1915 as *Twenty-five Great Houses of France*, the possibilities of the Pictorialist approach to architecture are demonstrated further.[16] Evans's photographs are as pin-sharp as the Lemeres', but while the Lemeres' pictures show size and space by their inclusiveness, Evans's evoke the same qualities by exclusion: through a narrower field of view, by oblique and partial glimpses through distant openings, and in the way in which architectural

features are frequently curtailed. Evans succeeds by knowing what to imply and how much thereafter to leave to the viewer's imagination. Yet the contrast between the two approaches may be as much a product of circumstances as of temperament: Lemere and Evans, and their publics, simply wanted different things. There is a strange similarity between yet another of Evans's pictures – Lincoln Cathedral soaring through misty smoke over the roofs of the town (Fig 19) – and Lemere & Co's view of construction cranes above the City of London (*see* p 28). Given different requirements, each might have taken the other's photograph.

Pictorialism was on the wane by 1910 and, despite the power of Evans's French views (and despite his acclaim by Alfred Stieglitz as the finest of architectural photographers), his photographs are ultimately limited as architectural records. Although by 1930 Harry Lemere's business too was in decline, architectural photography itself was not. Photographers' approaches would be increasingly diverse, with photographers like Dell and Wainwright whose analytical, often partial, images of buildings of the modern movement was in perfect sympathy with the reductive geometry of many of their subjects, or Eric de Maré whose evocative views seem to blend something of the Pictorialists' approach to composition with something of the f.64 Group in their rendition of telling detail. Bedford Lemere & Co kept to the same formulas and the same approach throughout the 80 years of the firm's effective existence. For all the idealising of their subjects, their photography was perhaps too literal and too objective for an age which increasingly wished to see photographs themselves as works of art, and Harry Lemere disavowed any such pretensions. But it is the combination of sympathy with their subject matter and precision in their record that makes the photographs taken by the Lemeres and their colleagues such perfect illustrations of the buildings of their age.

NOTES

1 The firm's 20th-century stationery variously gives 1861 and 1865 as the date of foundation. However, advertisements in *The Architect and Contract Reporter* **XCI**, 1914, state 'established 1862'.

2 From 1881 onwards the firm's daybooks record each commission. Earlier daybook entries seem to be an attempt to list previous work by cataloguing older negatives that were still held at that date. These older jobs seem to be only roughly arranged in chronological order.

3 Blackmore 1989, 369–71.

4 *Report of the Commissioners … for the New Courts of Justice*, 1871, 50, 53. No copies of the photographs taken for the commissioners have been traced; therefore, their authorship remains in doubt.

5 Seddon 1872; Seddon 1873.

6 The testimonials in this paragraph are taken from Bedford Lemere & Co's catalogues of 1875 and 1881.

7 Haile 1944, 357–8. It may have been Harry Lemere who undertook the rationalisation of the firm's daybooks (*see* Note 2 above).

8 Gotch, J A 1894 *Architecture of the Renaissance in England*, Vol I. London: Batsford, iii.

9 Elwall 2004, 90.

10 In 1914 *The Architectural Review* (**XXXV** (Jan–Jun, 87–110) published an article by A T Bolton on 'The Architecture of Liners', in which many of Lemere & Co's photographs were used.

11 From the correspondence file held in the English Heritage archive.

12 Ibid.

13 Ibid.

14 Anon 1927; Anon 1931, 96. In the latter Harry Lemere records that he used panchromatic plates, with their greater sensitivity to the colour red, for photographing brick buildings. These had only been available commercially since 1906.

15 Elwall 1994, 22. There is no record of Woods' initials in Bedford Lemere & Co's post-1889 daybooks.

16 A selection was more recently published as Binney, M 1994 *The Chateaux of France: Photographs by Frederick H Evans from the Archives of Country Life*. London: Mitchell Beazley.

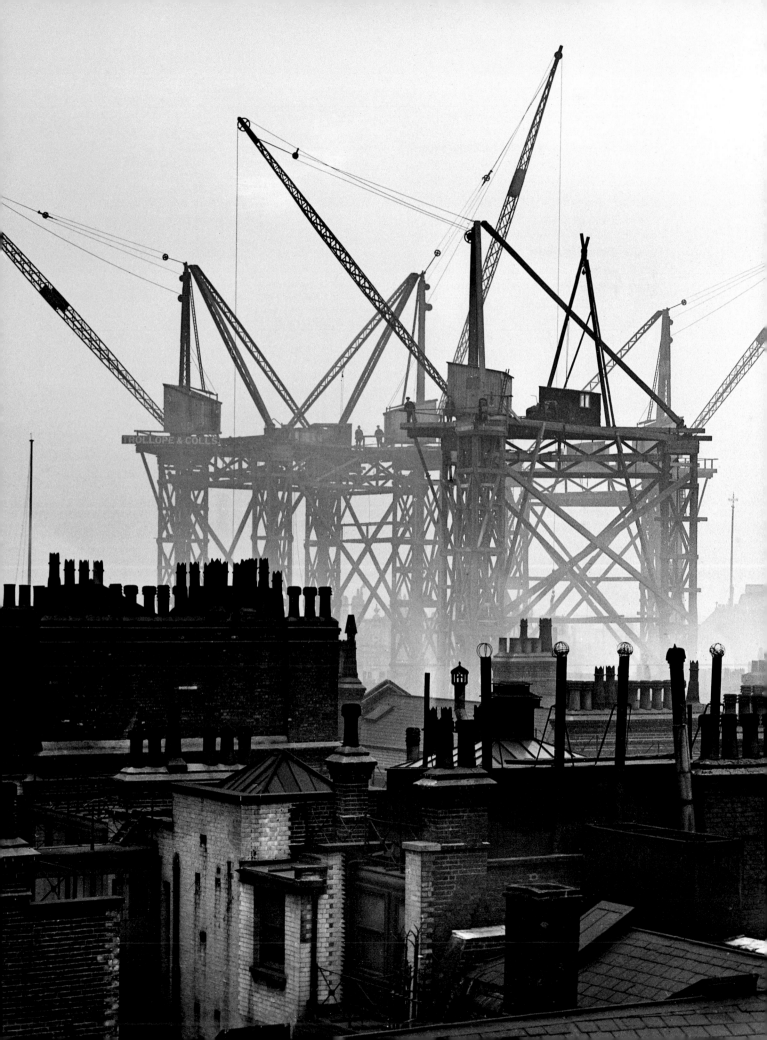

LONDON REBUILT

Between 1870 and 1914 as much of central London was pulled down and rebuilt as would be lost and replaced during and after the Second World War. Such demolition and replacement was, of course, not undirected: whole streets were laid out, great estates embarked on systematic programmes of renewal, old established businesses rebuilt their premises in competition with their commercial rivals, and many new public buildings were put up. A city that until well into the second half of the 19th century had still been largely preserved on an 18th-century scale was in many areas transformed. The difference between old and new often comes out forcefully where both are included in the same view.

This rebuilding provided the firm with many commissions, mainly to photograph new buildings but sometimes to record what was to go. Sometimes, too, clients wanted a record of the progress of work, particularly when new structural techniques were being employed. In other great cities a similar transformation was taking place. However, located as the firm was in the Strand in London – midway between the City and the West End and situated conveniently for clients almost anywhere in the metropolis – Bedford Lemere & Co's London views have, in the years between 1890 and the First World War, a comprehensiveness that their views elsewhere do not.

These London photographs are also unusually wide ranging in the quality of the buildings recorded. They include buildings by some of the leading architects of the day, but also buildings of no distinction. Yet these undistinguished buildings are just as representative of the architecture of their age, and thus a few are included here.

SCOTCH CRANES AT FURNESS HOUSE, headquarters of the Furness Withy Shipping Group, Leadenhall Street, London EC3, photographed in 1920. [BL24824A]

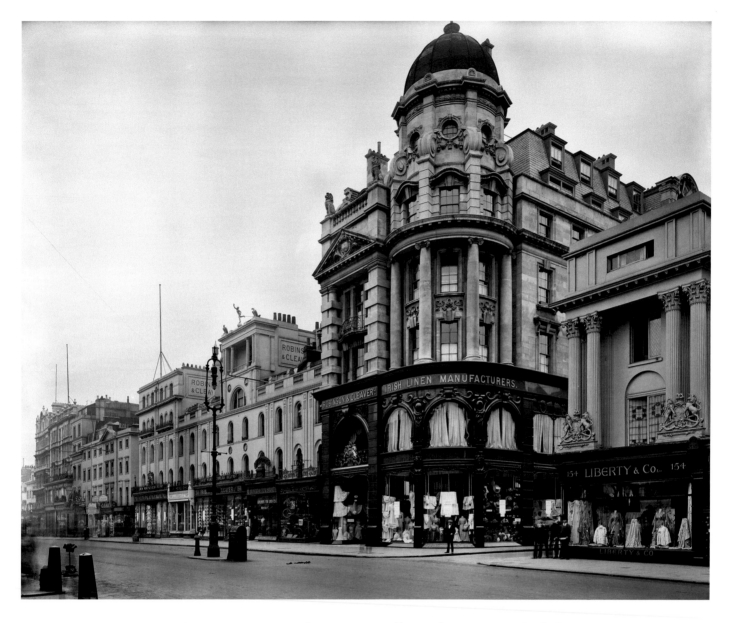

THE EAST SIDE OF REGENT STREET, from Great Marlborough Street to Oxford Circus, London W1, photographed in 1910 for John Murray. [BL20981/044]

Regent Street was originally developed in 1810 by the Commissioners of Woods and Forests (the managers of Crown lands), by acquiring land between Crown property at its northern and southern ends and creating a great new street to link them. By 1910 most of the original 99-year leases were coming to an end and the old shops had become too small for modern business. Despite a powerful campaign led by *The Architectural Review*, the Commissioners embarked on its comprehensive rebuilding. Robinson & Cleaver, linen drapers, have already taken over much of the range in the centre of the picture and have started to rebuild on a scale to match their needs and to meet the conditions regarding height and materials laid down by John Murray, the Surveyor to the Commissioners. Liberty's, on the near right, would soon follow with a classical block to Regent Street itself in the style determined by the Commissioners and a fake half-timber block round the corner (*see* p 71).

 Murray commissioned Bedford Lemere & Co to photograph the entire street.

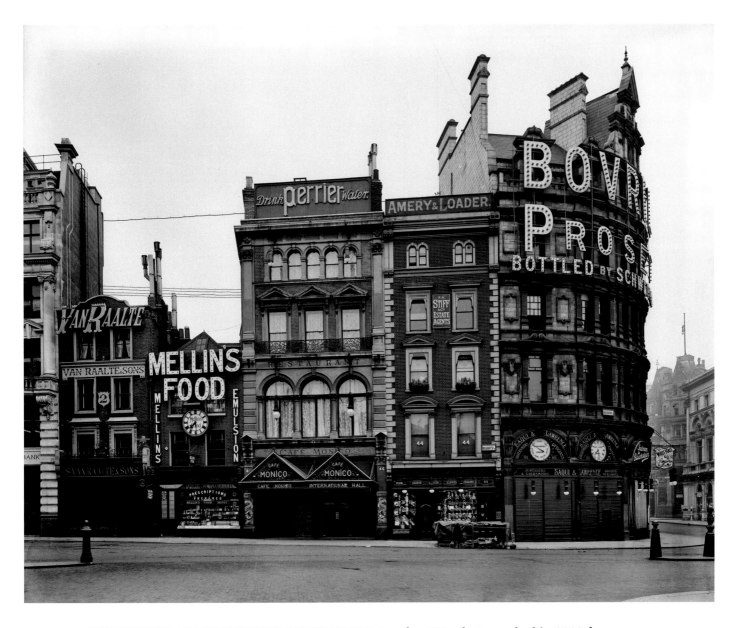

THE NORTH-EAST SIDE OF PICCADILLY CIRCUS, London W1, photographed in 1910 for John Murray. [BL20981/036]

An object lesson in the changing scale of London buildings – from the three modest floors of the pharmacist of *c* 1800 to the five colossal storeys of the 1885 building at the angle of Shaftesbury Avenue on the right.

The building of the new street in 1878–86 brought about the demolition of the original north-east quadrant of John Nash's Piccadilly Circus and revealed the fronts of buildings that had formerly faced onto Tichborne Street. This was an unexpected gift for the Café Monico (centre; *see* pp 228–9), which suddenly found itself opening directly off the most famous space in central London. Divided ownerships meant that this side of Piccadilly Circus was never coherently developed and is now entirely concealed by illuminated advertisements whose beginnings can be seen here.

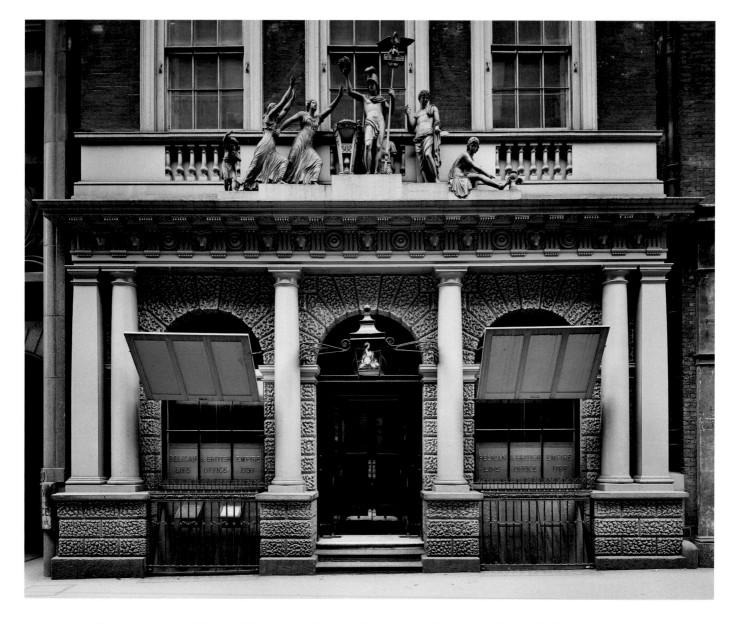

OFFICES OF THE PELICAN LIFE INSURANCE COMPANY ((Sir) Robert Taylor, 1756), 70 Lombard Street, London EC3, photographed by HBL and AAB in 1904. [BL18161A]

A good example of the domestic scale of business premises before the very general rebuilding of City offices in the 19th and early 20th centuries. Built as a private house, 70 Lombard Street was taken as an office by the Pelican Life Insurance Company in 1797.

Insurance companies seem to have been particularly fond of allegorical representations of the virtues of their business (*see* pp 41 and 65) and the Pelican building boasted a Coade stone group designed by Lady Diana Beauclerk and executed by the Coade factory's principal sculptor, John de Vaere. At the centre, a Roman vexillarius holds a standard with the initials PLIO (in place of the SPQR of ancient Rome) and surmounted by a pelican (in place of the imperial eagle). To the left, poor widows appear to be rushing for his assistance; the figures to the right may represent orphans whom he has protected (though the seated figure, at least, looks distinctly ungrateful). Although the building has been demolished, the group itself survives at the Museum of London.

The suspended boards that appear in very many old photographs of city offices were mirrors, angled to reflect the greatest amount of light into the ill-lit rooms within.

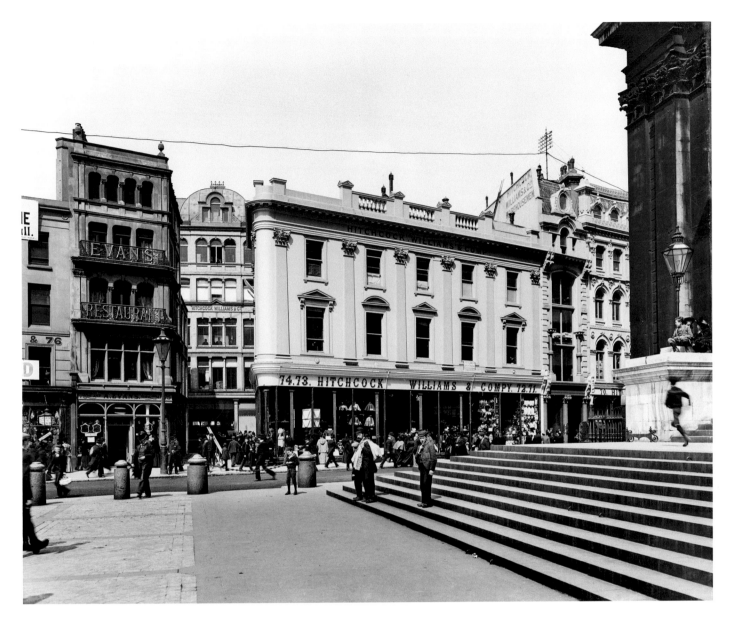

HITCHCOCK, WILLIAMS & CO (*c* 1820), St Paul's Churchyard, London EC4, photographed by AAB in 1897. [BL14068]

A handsome building in an extremely prominent location opposite the west end of St Paul's Cathedral. The rebuilding of the City of London in the 19th century had been proceeding as rapidly as that of the West End. Apart from a glimpse of St Paul's Cathedral, black with centuries of smoke, virtually all the other buildings in the photograph were built after *c* 1850.

The Williams of the Hitchcock Williams partnership was Sir George Williams, the founder of the Young Men's Christian Association – the YMCA (*see* p 101) – who had come from Somerset to work as an assistant in Hitchcock's draper's business. Marriage with his employer's daughter and a partnership in the firm provided him with the wealth with which to support the organisation.

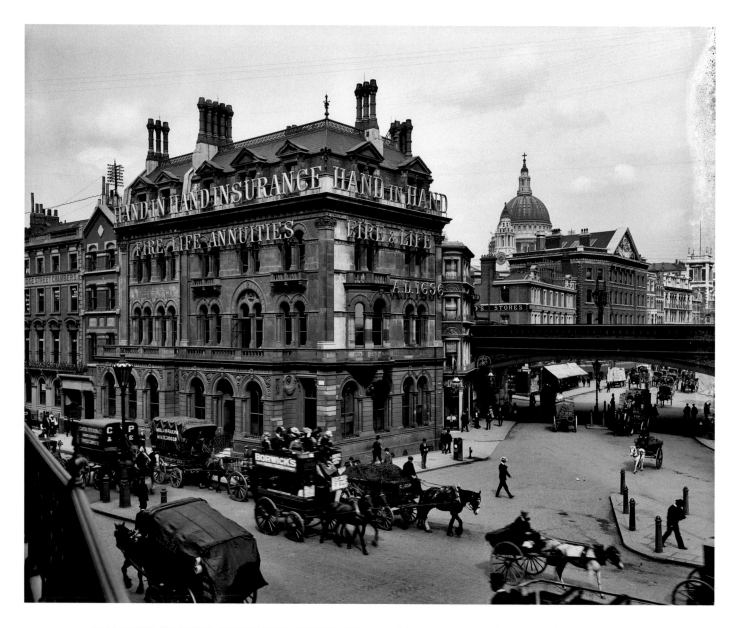

THE HAND-IN-HAND INSURANCE COMPANY, New Bridge Street, London EC4, photographed by AAB in 1904. [BL18505]

Representative mid-Victorian buildings in the City of London. On the right is Queen Victoria Street, laid out in 1867–71, one of the major 19th-century programmes of street improvement. Almost every building in this view has since disappeared save four: St Paul's Cathedral, the tower of St Andrew-by-the-Wardrobe Church on the extreme right, the railway bridge and – just visible between the bridge and the insurance office – the eastern end of the Black Friar public house, soon to be remodelled as the most remarkable Arts and Crafts pub in London.

The Hand-in-Hand Insurance Company was established in 1696 and advertised itself as the oldest insurance office in the world. It merged with the Commercial Union Assurance Company in 1904 and this photograph may commemorate the passing of a City institution.

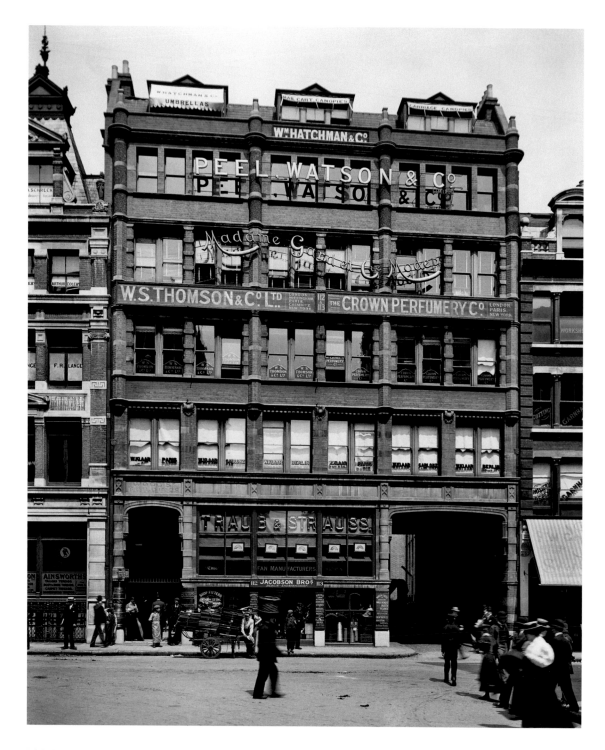

WOOD STREET BUILDINGS, Fore Street, London EC2, photographed by AAB in 1899 for J Boyce, Consolidated London Properties Ltd. [BL15466]

A utilitarian building of no architectural distinction and of a kind which, for all its ubiquity, is easy to overlook. Wood Street Buildings may be taken as representative of an area of the City of London and of a class of commercial buildings that suffered particularly severely in the Second World War and later. The tenants – their names displayed on the façade – include textile wholesalers, manufacturers of baby linen, wholesale milliners, corset makers, a perfumery company, fan makers and a shopfitter.

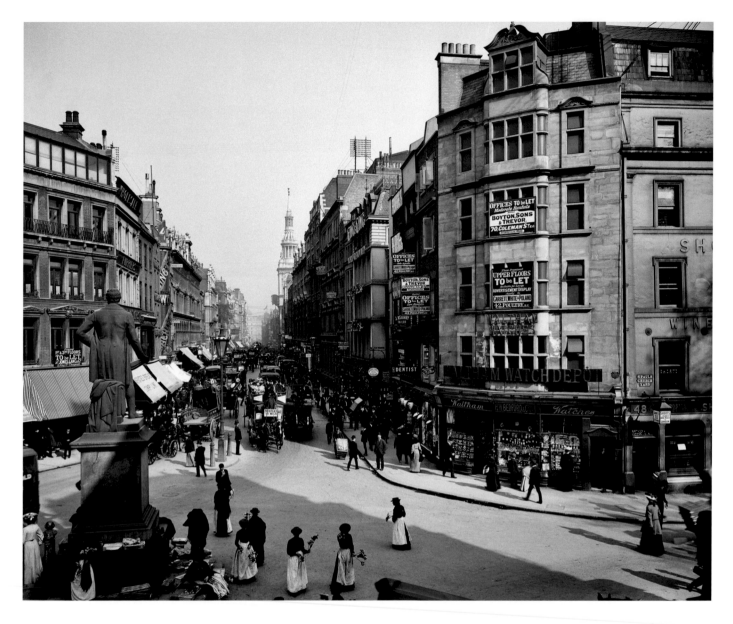

LOOKING ALONG CHEAPSIDE, London EC4, photographed by HBL and colleague in 1905 for the National Mutual Life Assurance Company. [BL18813/008A]

The new office building on the right-hand corner, by the prolific architect Delissa Joseph, represents much contemporary, safe but uninspiring building for businesses and property companies.

Flower girls throng the street around William Behnes' 1855 statue of Sir Robert Peel, removed after the Second World War.

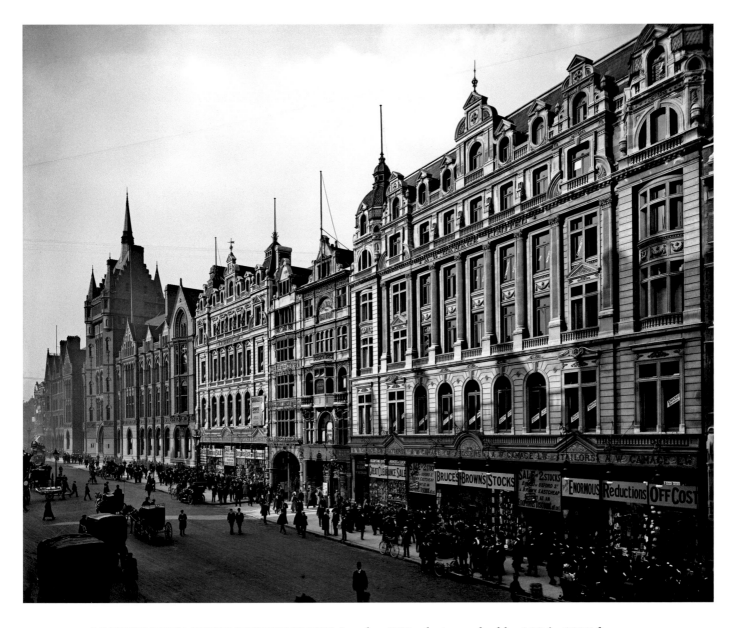

LOOKING WEST ALONG HIGH HOLBORN, London EC4, photographed by AAB in 1907 for the National Radiator Company. [BL20065]

In the distance is Alfred Waterhouse's Prudential Assurance Building, built of red brick, terracotta and polished red Peterhead granite; it was begun in 1879 but only completed – following the original design – in 1906. Waterhouse was a master of efficient planning, which is probably the reason why the company persisted with a Gothic design that was by then wildly old-fashioned. In the foreground are the two Portland stone blocks of Gamages Department Store (1885–1906) by the architect Joseph Sawyer. The store's regular façades gave a superficial unity to a labyrinth of rooms, the result of Albert Gamage's gradual buying-up of adjoining premises, but the parts are divided by a street and smaller buildings that Gamage had not been able to acquire.

THE SITE OF THE WAR OFFICE, Whitehall, London SW1, photographed by AAB in 1898 for HM Office of Works. [BL14794]

In the course of the 19th century, the state would assume ever increasing powers. Earlier in the century, the west side of Whitehall had been transformed by new buildings for the Treasury, the Foreign Office and the India Office. The area between Whitehall and the River Thames, still largely residential in the 1890s, would soon be similarly redeveloped. Adolphe Boucher's unfamiliar view of Whitehall, taken for the Office of Works from the third floor of the former Hotel Metropole on the north side of Great Scotland Yard, looks across houses that were about to be demolished for the building of the new War Office.

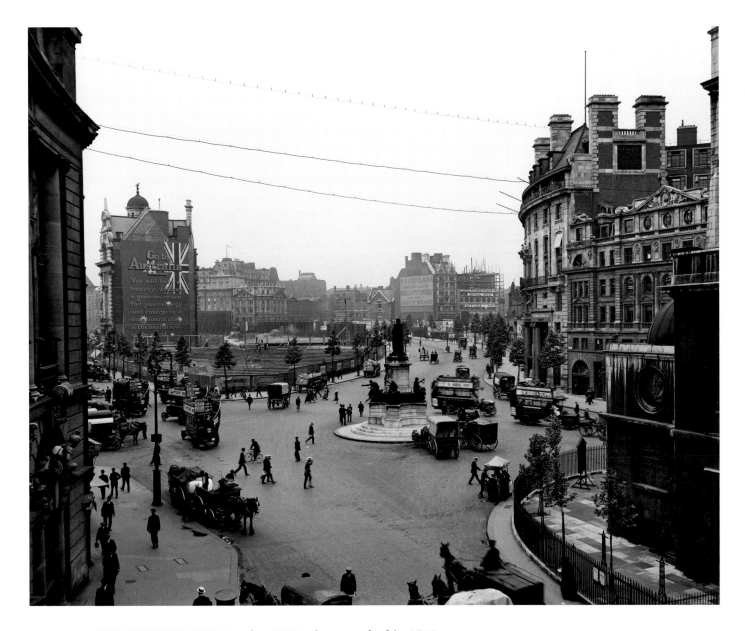

THE ALDWYCH SITE, London WC2, photographed in 1913. [BL22225]

Kingsway, with the Aldwych (*see* p 52) at its southern end, was the last of the great Victorian schemes of urban improvement, forming a much-needed north–south link and involving the clearance of notorious (though picturesque) slums. Laid out in 1898–1900 and grandly opened in 1905, it was some time before the new streets were built up, particularly at the southern end where the half-moon site of the Aldwych – shown here, still largely bare – demanded buildings of an appropriate scale and formality.

 The monument is Hamo Thornycroft's statue of W E Gladstone, unveiled in 1905. Gladstone is in his robes as Chancellor of the Exchequer; the figures on the base of the plinth represent Aspiration, Brotherhood, Courage and Education.

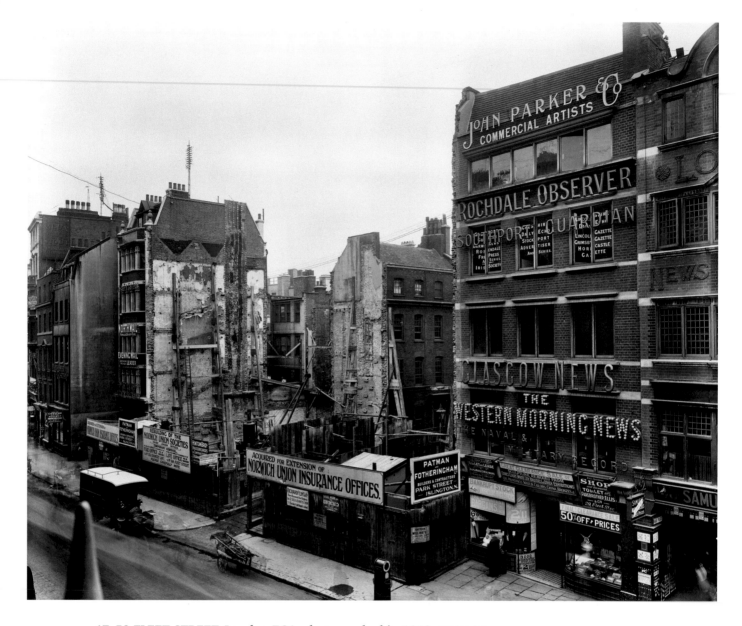

47–53 FLEET STREET, London EC4, photographed in 1912. [BL21769]

The site on which the London office of the Norwich Union Insurance Company would be built. The address (seven street numbers) and the size of the remaining buildings (themselves not old) in comparison with the new building (*facing page*), all indicate the scale of development that wealth and steel frames were making possible.

Fleet Street was the heart of the newspaper industry. Four country newspapers have their London office in the building on the right, at a time when the provincial press was thriving and local papers still carried national news.

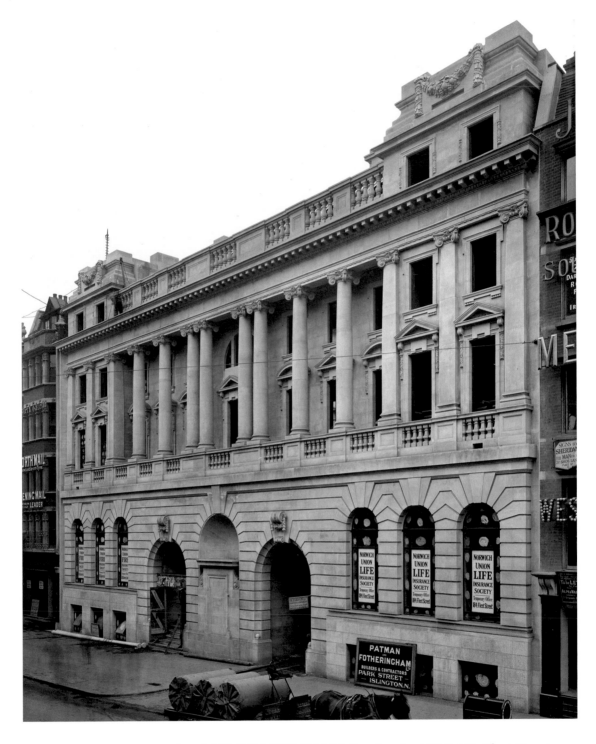

THE NORWICH UNION INSURANCE COMPANY (J McMullen Brooks, 1912–13), Fleet Street, London EC4, photographed by AAB in 1913. [BL22268]

Built on the site shown in the preceding view and an ingenious solution to a difficult design problem. An off-centre public right of way running through the site was paired with the office's main entrance and bridged over to produce a symmetrical façade. A sculptural group by A Stanley Young – depicting Justice and Insurance, surmounted by a cherub intended to represent the benevolence of the company – would be inserted into the central ground-floor niche.

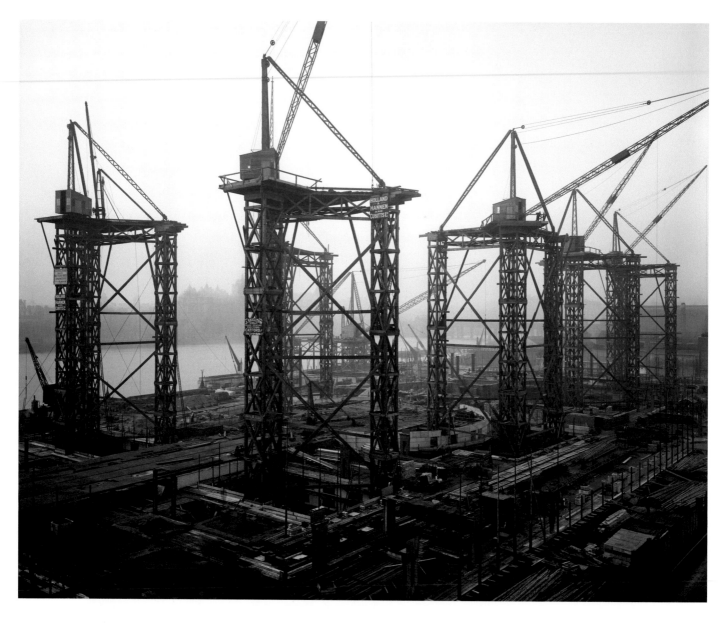

COUNTY HALL UNDER CONSTRUCTION (Ralph Knott, 1908–33), Belvedere Road, London SE1, photographed by AAB in 1913 for Holland & Hannen, structural engineers. [BL22441/003]

The competition for a new building for London County Council (LCC) was won in 1908 by Ralph Knott – an architect still young – but what with modifications to the design and the interruption of the First World War, the building was not completed until 1933.

Before the introduction of tower cranes, a 'Scotsman' or Scotch crane on a three-legged scaffold was the standard heavy lifting plant used in the erection of large buildings. The towers are of timber, the larger or king leg carrying the crane, the queen legs providing stability. The building would rise around them, and they would be dismantled once the structure was complete.

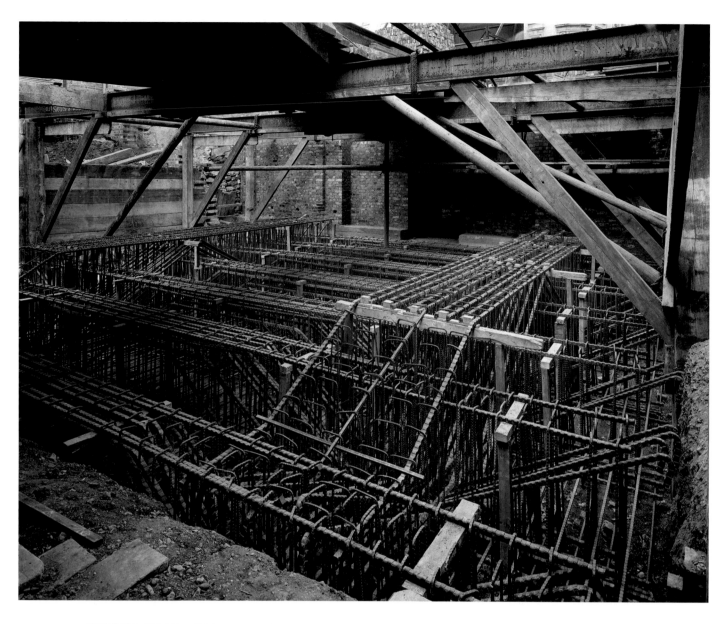

REINFORCEMENT FOR THE FOUNDATIONS OF HOLY TRINITY CHURCH (Belcher & Joass, 1910), Kingsway, London WC2, photographed by AAB in 1910. [BL20964]

Holy Trinity Church was the successor to an earlier church whose structure had been severely weakened by the building of the Piccadilly Line; this may be the reason why the foundations of the new building appear so massive.

By this time, reinforced concrete was very commonly used in the foundations of any large building. These foundations appear to employ the Hennebique system, in which reinforcing rods are linked vertically by stirrups. The formwork has yet to be erected and the concrete poured.

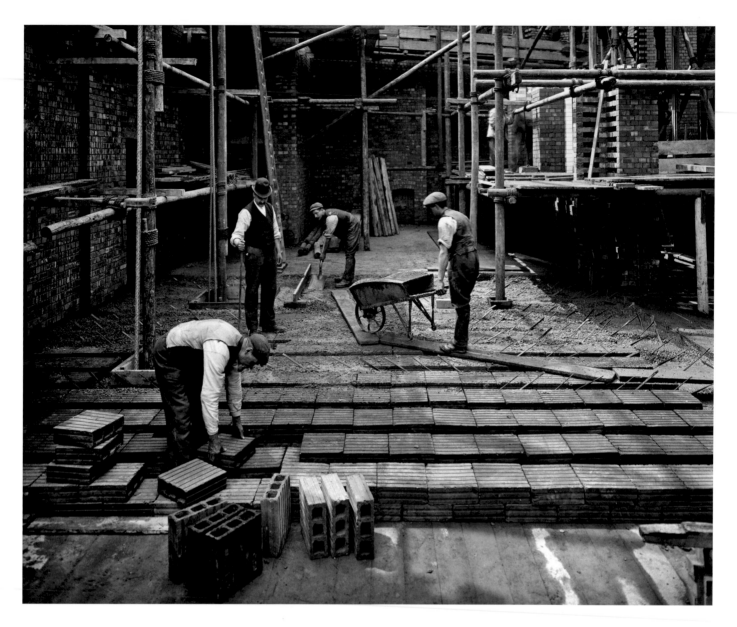

LAYING A HOLLOW POT CONCRETE FLOOR AT 8 LLOYDS AVENUE (R Norman Shaw, 1907), London EC3, photographed by AAB in 1907 for Holland & Hannen, structural engineers.
[BL19950A]

The Kahn system, invented by Julius Kahn in 1903, was much used for floors. In it, lines of hollow 'pots' with keyed faces are laid on timber formwork. Reinforcement bars are placed between these lines of pots, with flanges that are cut and bent diagonally upwards. Concrete is then poured which encases the bars; when set the concrete forms beams that are reinforced by the enclosed steel and engage with the keying of the pots. On completion, the formwork can be removed.

 This was Shaw's last building, put up for Associated Portland Cement Manufacturers Ltd, who seem to have been keen to employ what was still a very new material in building their headquarters.

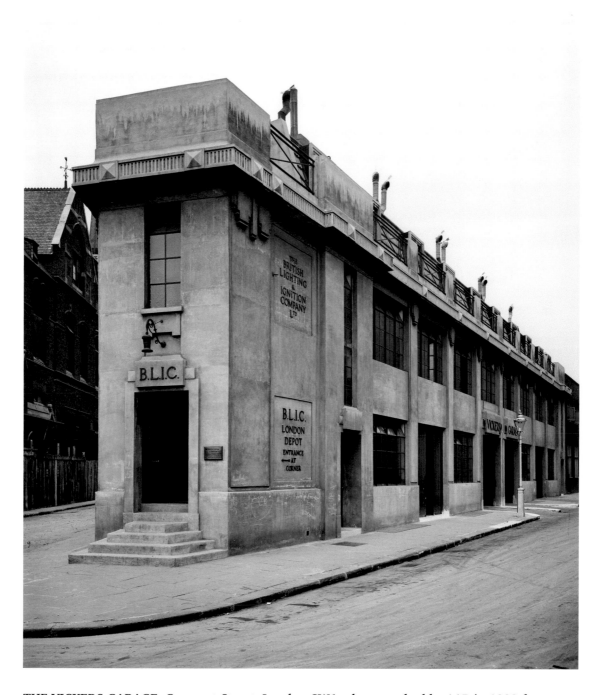

THE VICKERS GARAGE, Greycoat Street, London SW1, photographed by AAB in 1923 for Stitson White & Co, plumbing and heating contractors. [BL26639]

Reinforced concrete frames had been gaining ground since the turn of the century, but buildings in which the concrete included the external ornament, as here, were relatively rare.

The Vickers Garage may represent some modest diversification by its owners, the great shipbuilding firm of Barrow in Furness, hit by a collapse of warship orders after the First World War and with few orders for merchant ships coming in on account of the recession. The British Lighting & Ignition Company, occupier of the near corner of the building, possibly supplied components to the cars that Vickers garaged or serviced.

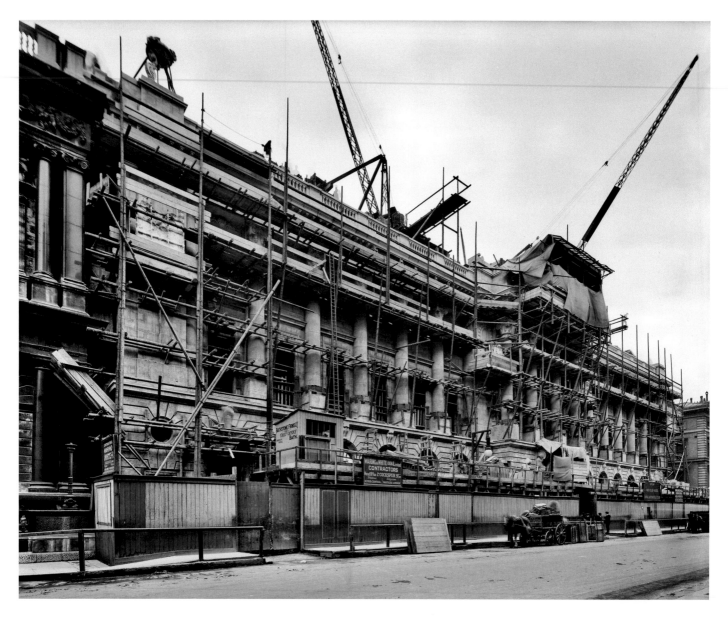

THE ROYAL AUTOMOBILE CLUB UNDER CONSTRUCTION (C Mewès & A J Davis, 1908–11), Pall Mall, London SW1, photographed in 1910. [BL20923]

The latest, grandest and largest of the clubs on Pall Mall, occupying the site of no less than 13 demolished buildings. The club's luxurious interior was fitted out in a variety of 18th-century styles, and a swimming pool, a squash court and even a shooting gallery were built in the basement.

The building is steel framed. Steel frames had been used in the USA from the 1880s; in London the pioneer of steel-framed construction was the Swedish-American Sven Bylander, chief engineer of the Waring-White Building Company and the designer of the frames of the RAC, Gordon Selfridge's store (*facing page* and *see* p 58) and the Ritz Hotel (*see* p 53). At the Ritz, London building regulations – intended to regulate traditional construction – had still required that walls should have load-bearing capacity despite the building's steel-framed construction. By the time the RAC was built, the regulations had been altered to recognise the new material's potential, and here the building's external masonry is no more than an outer skin. However, at this time the builders' scaffolding is still of wood rather than steel.

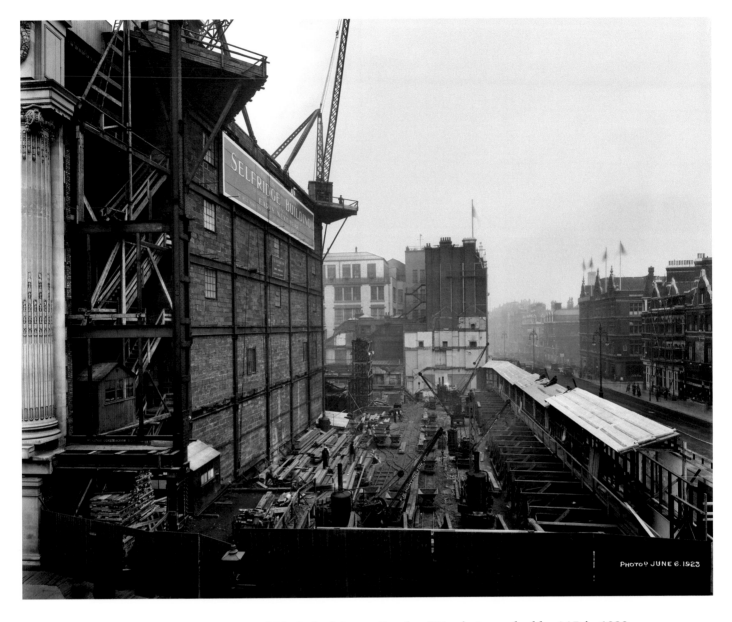

THE EXTENSION OF SELFRIDGES, Oxford Street, London W1, photographed by AAB in 1923 for the contractors F D Huntington as part of a series recording the progress of building.
[BL26600/002]

Gordon Selfridge's store was first completed in 1909 (*see* p 58), but his retailing skills led to two stages of expansion after the First World War. The steel frame carries a temporary brick wall to protect the areas of the shop that were already working. The plant of a contemporary construction site is clearly shown – including steam cranes for unloading wagons, running on a short length of contractor's railway.

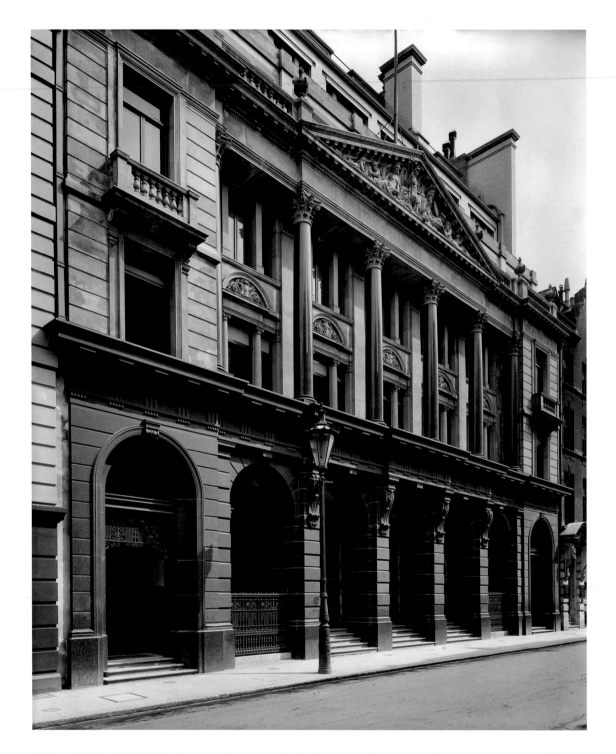

THE BALTIC EXCHANGE (T H Smith of Smith & Wimble, 1901–3), St Mary Axe, London EC3, photographed by AAB in 1903. [BL17659]

The Baltic Exchange was built on a new site to replace an 18th-century building, following the amalgamation of the Baltic with the London Shipping Exchange. The new building was the last in the City to be built with a traditional trading floor.

Damaged by the IRA bomb of 1992, it was demolished to make way for Norman Foster's Swiss Re building – 'The Gherkin'. However, the façade and much of the interior architectural detail were salvaged and in 2006 were acquired for re-erection in Tallinn in Estonia.

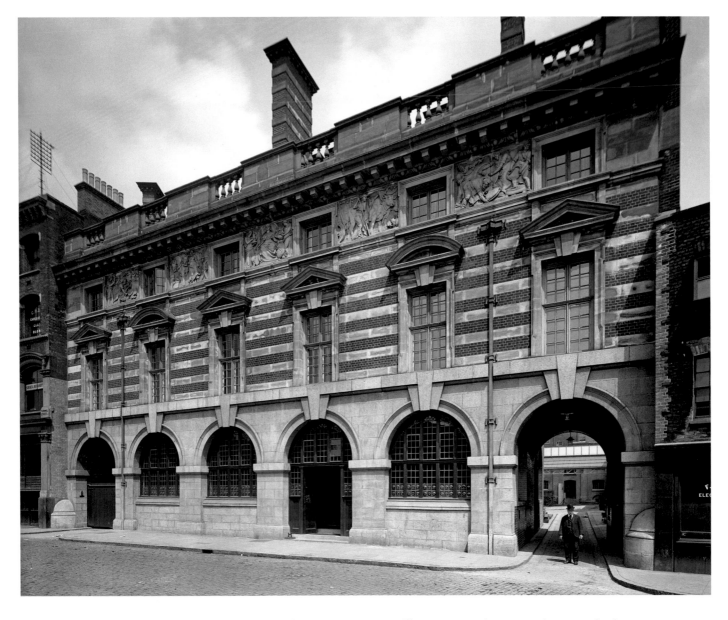

BOOTH'S DISTILLERY (E W Mountford, 1901), Turnmill Street, London EC1, photographed in 1902. [BL17158]

One of Mountford's very best buildings and a particularly successful instance of the Arts and Crafts movement's belief in combining architecture and sculpture. Above stripes of red brick and Portland stone is a carved frieze showing the process of gin-making carved by F W Pomeroy, who worked with Mountford on a number of the architect's commissions including the Central Criminal Court and Sheffield Town Hall.

In 1973 the façade was taken down and re-erected in Britton Street nearby, as the frontispiece to a development by Yorke, Rosenberg & Mardall.

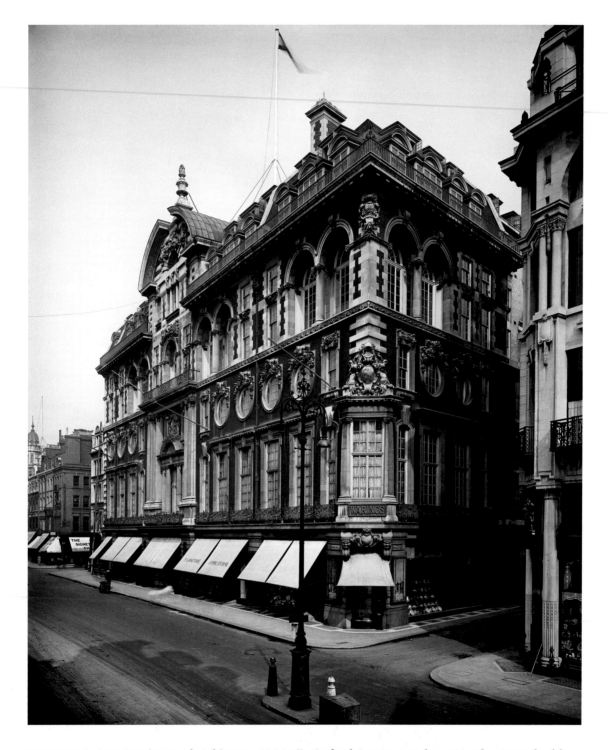

WARING & GILLOW (R Frank Atkinson, 1901–6), Oxford Street, London W1, photographed by AAB in 1917. [BL23861]

A baroque extravaganza. The line of round windows, deriving from Hampton Court, was a favourite contemporary motif, though Sir Christopher Wren might have found some of the other elements a trifle indigestible. The building has since been altered, with the coats of arms over the windows at the corners replaced by strange motifs resembling the prows of galleons and making the building more flamboyant still.

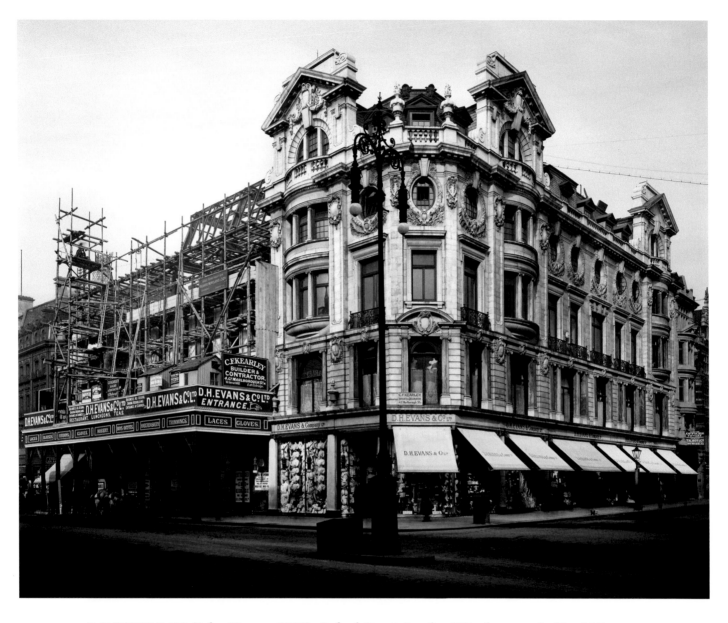

D H EVANS & CO (John Murray, 1909), Oxford Street, London W1, photographed by AAB in 1909 for the Waring-White Building Company. [BL20468/003]

Many of the same architectural elements as in R Frank Atkinson's slightly earlier building for Waring & Gillow (*facing page*) but differently arranged. John Murray carried on an independent practice in parallel to his official appointment as Surveyor to the Commissioners of Woods and Forests, but in his official role he oversaw the redevelopment of Regent Street (*see* p 30) on a similar scale to his shop for D H Evans & Co.

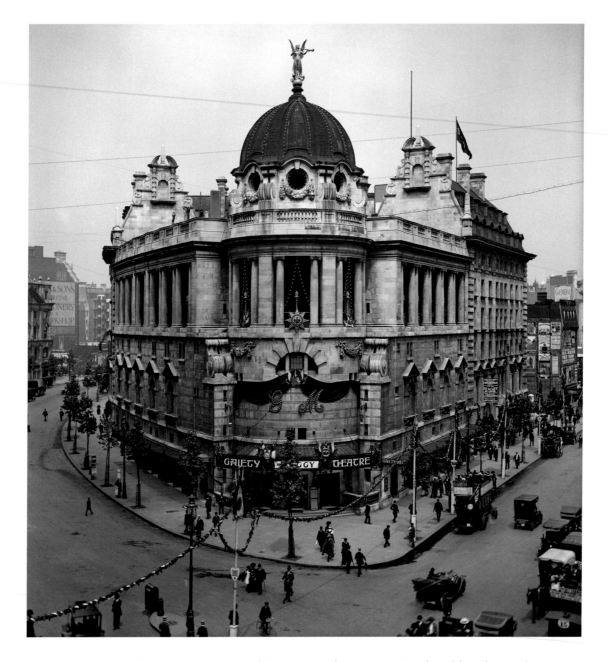

THE GAIETY THEATRE (Ernest Runtz and R Norman Shaw, 1901–3), The Aldwych, London WC2, photographed in 1911. [BL21288]

The redevelopment of the Aldwych for London County Council (LCC) presented problems for the authorities in reconciling an ideal layout with existing property interests. The owners of the Gaiety had already commissioned the architect Ernest Runtz to design a new theatre for them at the site's west end. However, when the LCC proceeded to organise a limited competition for designs for the elevations of the whole of the new block, with Shaw as the assessor, Runtz's scheme was not placed. Shaw was able to mollify him by sympathetic improvements to his original design and it is not certain how much of the finished building was Shaw's and how much was Runtz's.

The building is seen here decorated for the coronation celebrations in June 1911. The Gaiety Restaurant, soon to become the head office of the Marconi Wireless Company (*see* pp 131 and 176), can be seen to the right, behind the theatre. The theatre was closed in 1939 under the threat of yet further road schemes and pulled down in 1957.

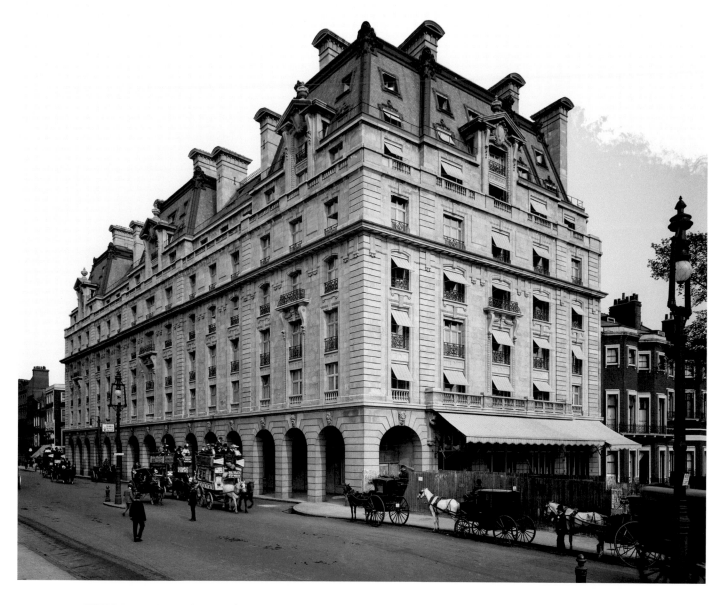

THE RITZ HOTEL (C Mewès & A J Davis, 1903–6), Piccadilly, London SW1, photographed in 1906 for the Ritz Hotel. [BL19668]

Arthur Davis had trained in Paris at the École des Beaux-Arts and, with his French partner Charles Mewès, was highly influential in introducing into England the disciplines of 18th-century French classicism. The Ritz was the first London building with a complete steel skeleton, even though in order to conform to the 1894 London Building Act the walls still had to be of load-bearing thickness (*see* p 46).

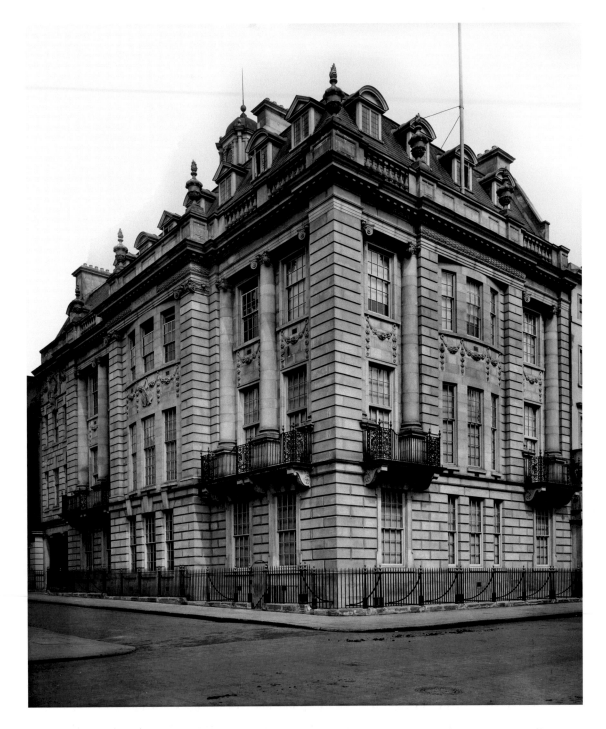

THE UNITED UNIVERSITY CLUB ((Sir) Reginald Blomfield, 1906–7), Suffolk Street, London SW1, photographed in 1907. [BL19898]

Many of the leading architects of the age had a deep knowledge of historic styles of architecture. Blomfield progressed from a close involvement with the Arts and Crafts movement in his youth (with the Art Workers Guild and Kenton & Co), through the later English Renaissance (writing in 1897 *A History of Renaissance Architecture in England*, the first serious study of the later 17th and 18th centuries), and then on to France (with studies of French architecture in the same period). In the design of the United University Club his architecture has made the same progression, from the English baroque of some of his previous buildings to the French of Louis XVI.

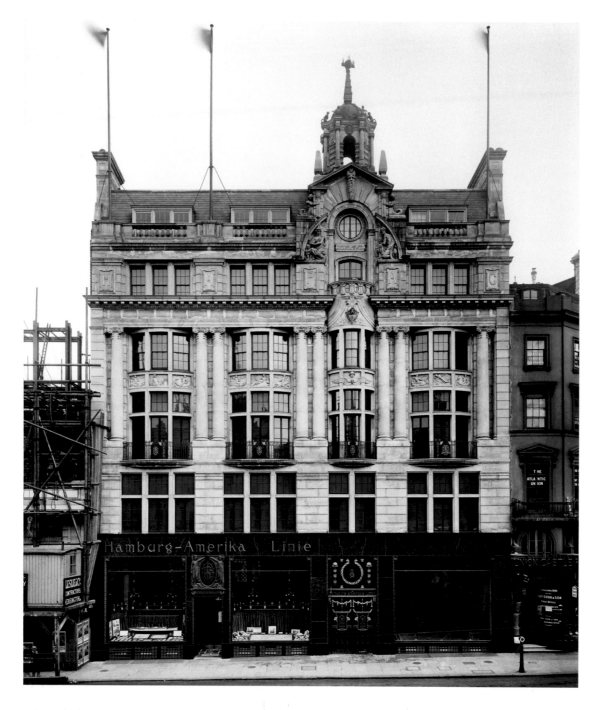

OFFICES OF THE HAMBURG-AMERIKA LINE (Henry Stock and A T Bolton, 1906–8), 14–16 Cockspur Street, London SW1, photographed by AAB in 1908. [BL20274/001]

Cockspur Street, on the south-west side of Trafalgar Square, was where most of the major shipping companies had their West End offices, and those of the German Hamburg-Amerika Line were among the grandest. As first built – and as shown in Adolphe Boucher's photograph – there were bronze figures over the door by J W Rollins representing Amerika [*sic*] and Germania, but when the building was taken over by the Peninsular and Oriental Line ('P & O') as reparations after the war, these were replaced with figures by E G Gillick of Britannia and Asia, with the motto 'quis separabit' ('who will separate [us]'). The building was completed by Arthur Bolton after the death of the original architect. (For interior *see* p 126.)

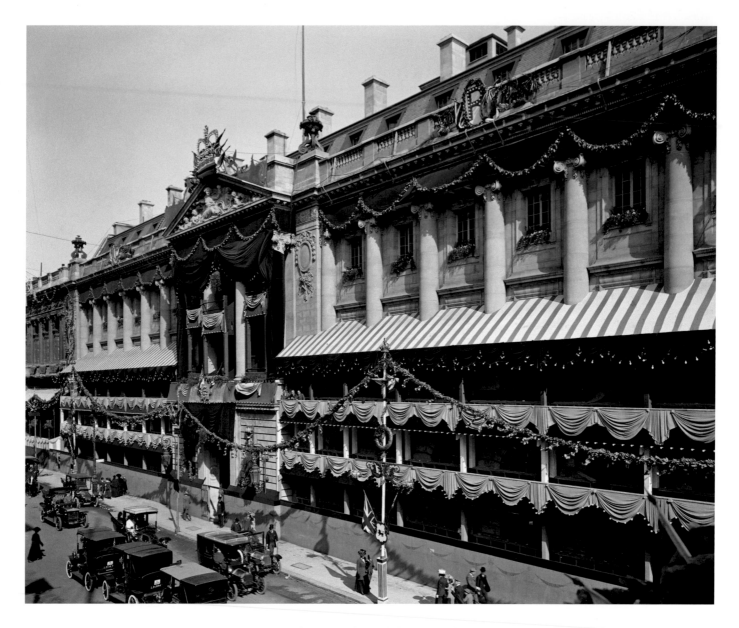

CORONATION DECORATIONS, Royal Automobile Club (C Mewès & A J Davis, 1908–11), Pall Mall, London SW1, photographed in 1911. [BL21284]

In Mewès & Davis's best French manner, though the Royal Automobile Club is hardly visible beneath lavish decorations and the three tiers of stands put up for members and their guests to watch the coronation procession of King George V and Queen Mary.

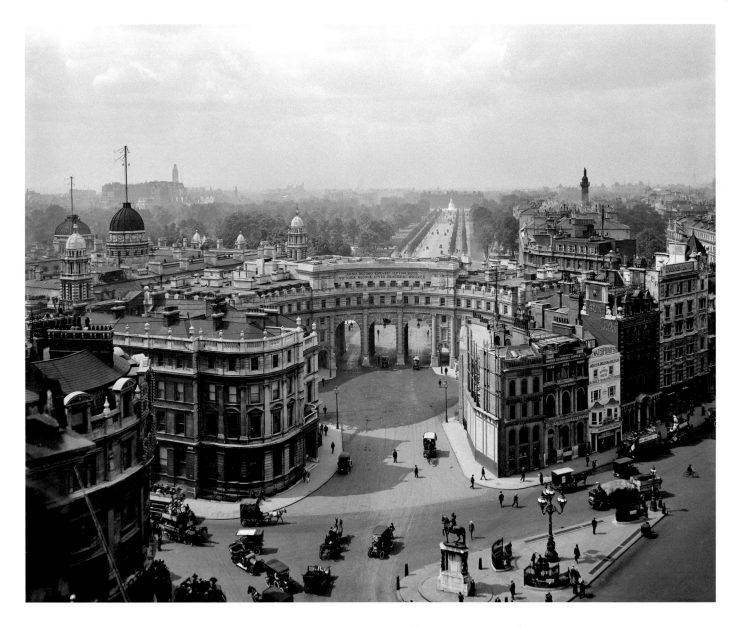

THE ADMIRALTY ARCH AND THE MALL (Sir Aston Webb, 1909–10), London SW1, photographed _c_ 1910–11. [BL26970/009]

In 1901 Webb won a government competition for improvement to The Mall, as a memorial to Queen Victoria. The Mall leads from Trafalgar Square to Buckingham Palace, from the monument to the man revered as the British nation's greatest hero to the palace of the head of the British Empire and the Queen's monument that stands in front of it. At one end stands a triumphal arch; at the other, Webb would re-case Edward Blore's dull 1840 façade of Buckingham Palace in gleaming Portland stone. Even though the concept was partly inspired by the great Paris boulevards of Baron Haussmann – with which London had nothing to compare – the scheme remains an enduring celebration of national self-confidence.

 The photograph seems to have been taken from the roof of the Grand Hotel at the western end of Northumberland Avenue. Exceptionally, it appears out of sequence in the firm's daybooks, but can be dated to _c_ 1910–11 by internal evidence.

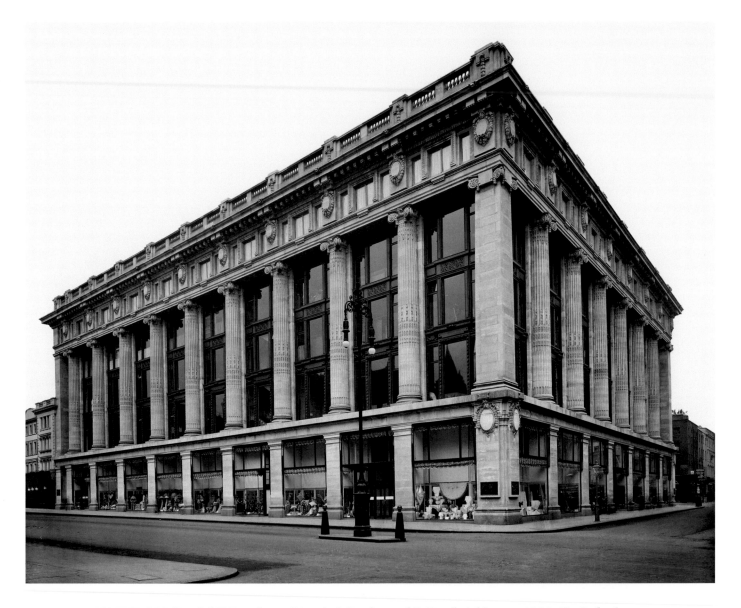

SELFRIDGES (Daniel H Burnham, Francis S Swales and R Frank Atkinson, 1908–9), Oxford Street, London W1, photographed by HBL in 1909 for the Waring-White Building Company.
[BL20582/001]

Gordon Selfridge, an American, had risen from humble beginnings to become retail manager of the great Chicago store of Marshall Field & Co before he was 30. Failing to persuade the firm to open a London branch, he determined to open a London shop himself, applying American notions of retailing in which window displays should entice and shopping should be enjoyable. To promote the business, he persuaded Louis Blériot to exhibit the aeroplane used in his pioneering cross-Channel flight at the new store.

The architectural origins of Selfridge's store are complicated. The giant ranks of columns derive from the Tuileries in Paris, but their use here owes much to the grandiose classicism of contemporary America: both Burnham, whom Selfridge consulted, and Swales, whose concept the building was, were Americans. The steel frame, which made possible the great glazed windows and the open plan, was designed by the Swedish-American Sven Bylander, but the store was put up by the Waring-White Building Company whose architect, R Frank Atkinson (who had himself worked in America), provided further input. The shop would be greatly enlarged after the First World War (*see* p 47).

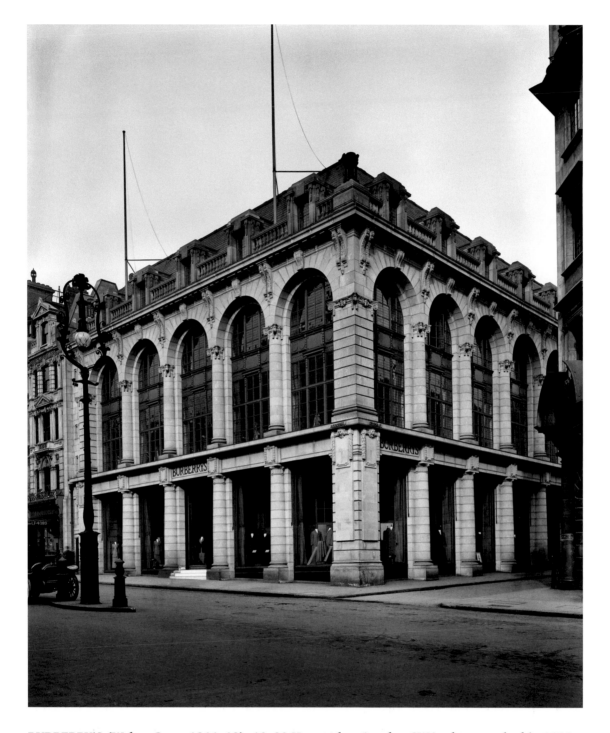

BURBERRY'S (Walter Cave, 1911–13), 18–20 Haymarket, London SW1, photographed in 1913 for *The Architectural Review*. [BL22026]

A simple and elegant way of providing the greatest possible amount of window space. Classical elements are reduced to bare essentials in order to create, effectively, two superimposed loggias.

The Burberry name would enter the English language (as 'a Burberry') when war broke out in the following year and the firm's trench coat – made to their own design from a tightly woven, weatherproof gabardine fabric – would be adopted by the War Office as a standard for officers and senior NCOs.

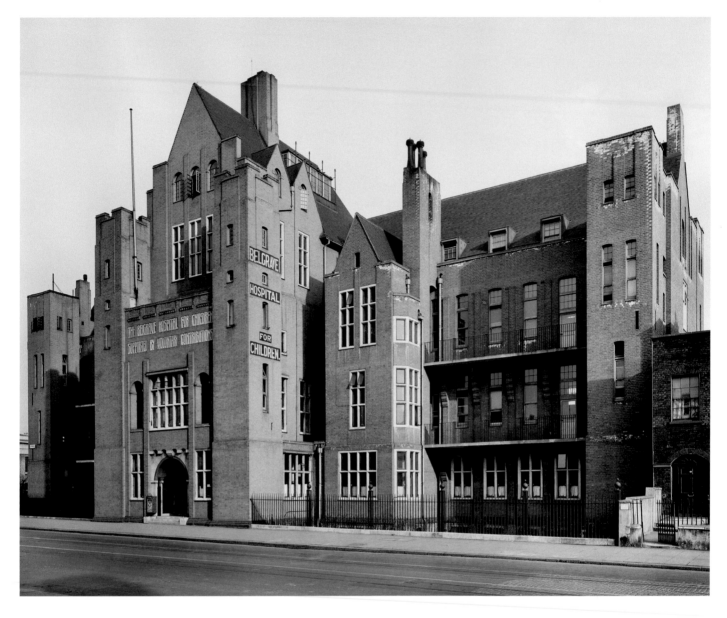

THE BELGRAVE HOSPITAL FOR CHILDREN (C Holden of P Adams & C Holden, 1903 (central block), 1924–6 (wings)), Clapham Road, London SW9, photographed in 1928. [BL29494A]

A striking 'free style' composition. The main elements of the design (the steeply pitched roofs, mullioned windows and a species of towered gatehouse to the entrance) have historic precedents, but are assembled with a novel freedom and detailed without regard to period models.

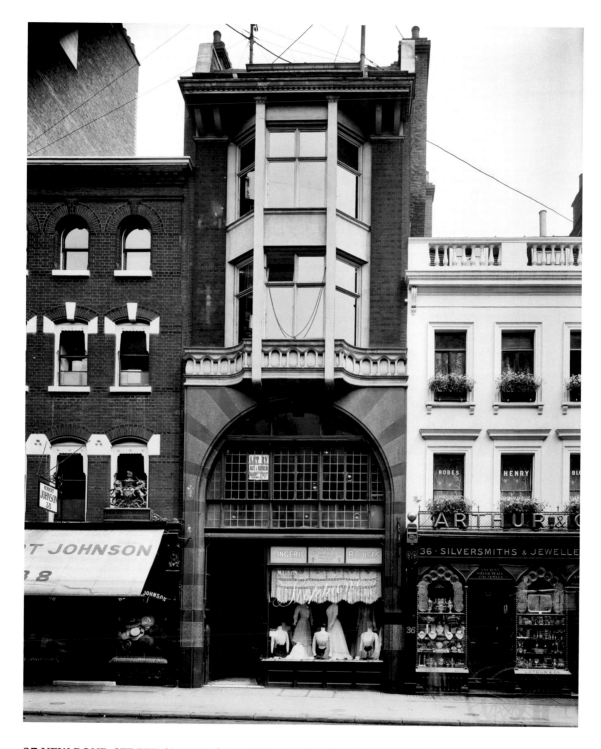

37 NEW BOND STREET (C H Worley, 1901), London W1, photographed in 1909. [BL20646]

A 'free style' commercial building, its elements are fairly remote from historic precedents in scale and detail, and in dwarfing the mid-Victorian hatter to the left and the early Victorian jeweller to the right.

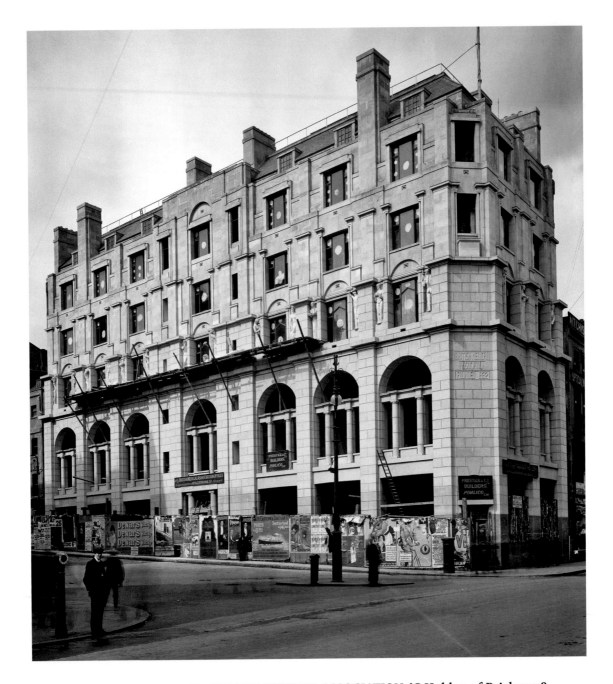

THE HEADQUARTERS OF THE BRITISH MEDICAL ASSOCIATION (C Holden of P Adams & C Holden, 1906–8), The Strand, London WC2, photographed by AAB in 1908 for the British Medical Association. [BL20320A]

In his elevation for the British Medical Association (BMA) building, Charles Holden reduced the classicism that at the time dominated most official and institutional architecture to a modular articulation of essential forms – doing much the same for classical architecture that he had done with other models at the Belgrave Hospital for Children (*see* p 60). When built, the BMA building attracted comment not only for the striking originality of its design but also for the second-floor nude figures by Jacob Epstein depicting *The Ages of Man*, which some observers felt were offensive. Damaged over time through having been placed where the full force of the weather would be channelled onto them, in 1938 they were systematically decapitated lest fragments of stone should fall on the heads of passers-by.

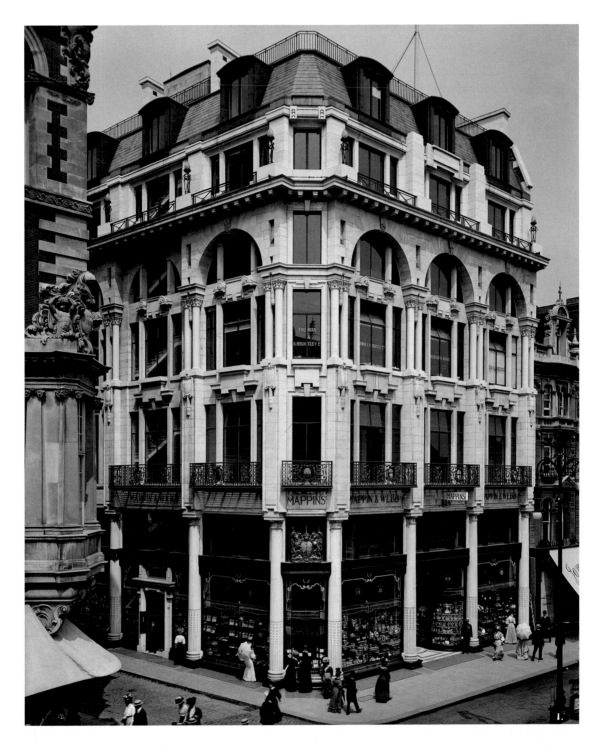

MAPPIN & WEBB'S SHOWROOMS (J J Joass of Belcher & Joass, 1906–8), 158–162 Oxford Street, London W1, photographed by AAB in 1908. [BL20231/001]

Classical detail, recognisable as such but strangely stylised and attenuated. The slim columns to the lower storeys seem far too slender to carry the busy structure above them, but the building shows clearly how a steel frame made possible a huge area of glazing. The masonry cladding was Pentelikon marble. The corner of Atkinson's Waring & Gillow building (*see* p 50) can be seen on the left.

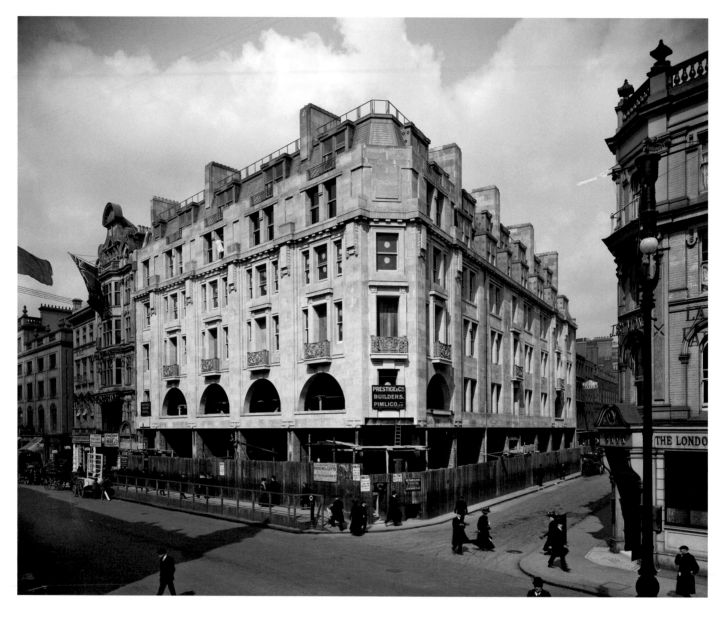

EVELYN HOUSE (C Holden of P Adams & C Holden, 1909), Oxford Street, London W1, photographed by AAB in 1910 for Ware & Co, estate agents. [BL20843]

A further demonstration of what could be done thanks to a steel frame. The Portland stone facing seems to hang in the air, entirely supported on the brick-clad steel piers visible on the ground floor.

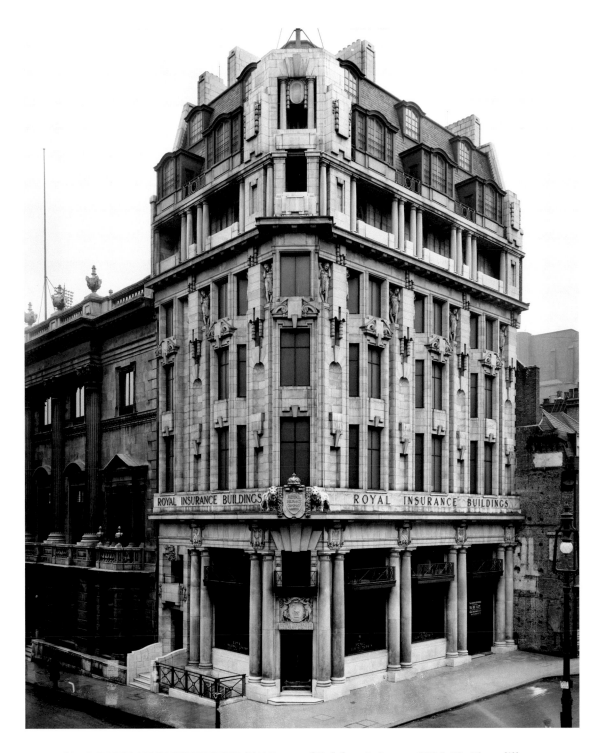

THE ROYAL INSURANCE BUILDINGS (J J Joass of Belcher & Joass, 1906–8), Piccadilly, London SW1, photographed in 1910. [BL20496]

In his Royal Insurance Buildings Joass's mannerism reached its limits. Classical elements are still recognisable as such, in contrast to Charles Holden's Evelyn House and the BMA headquarters (*see* pp 64 and 62), where only some contrapuntal rhythms had survived. Here they are both exaggerated and simplified to an astonishing degree. In symbolism appropriate for an insurance company, figures have left their exposed niches below to shelter for protection under the cornice – a message probably too subtle for many. But it has saved them from the fate of those on Holden's building for the BMA.

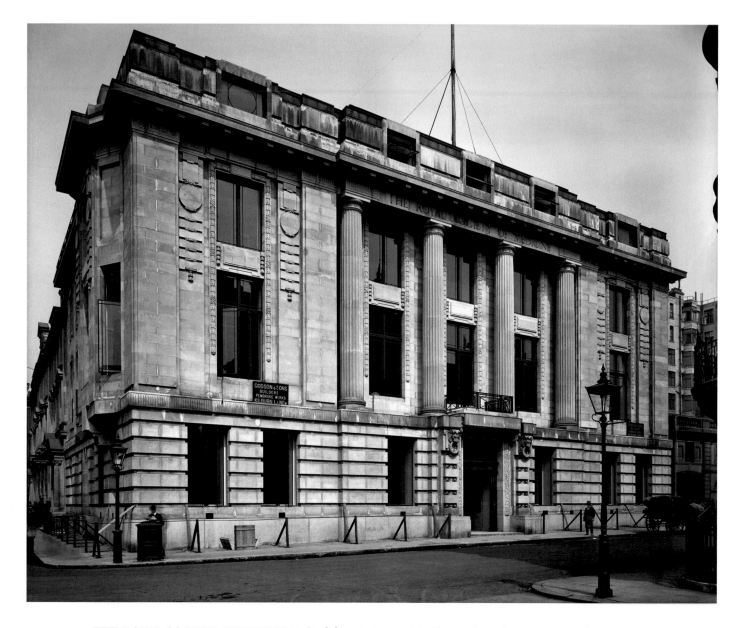

THE ROYAL SOCIETY OF MEDICINE (Belcher & Joass, 1912), 1 Wimpole Street, London WC2, photographed by AAB in 1912. [BL21575]

The principal floor contained the library, with lecture halls below and administrative offices above. In the Royal Society of Medicine, the architects have assimilated something of the French styles whose leading exponents had been Mewès & Davis (*see* pp 46, 53 and 56). Classical elements are interpreted with freedom, but the giant order and the plain pilasters at the angles give the building a solidity very different from the nervous energy of Joass's Royal Insurance Buildings of four years before (*see* p 65).

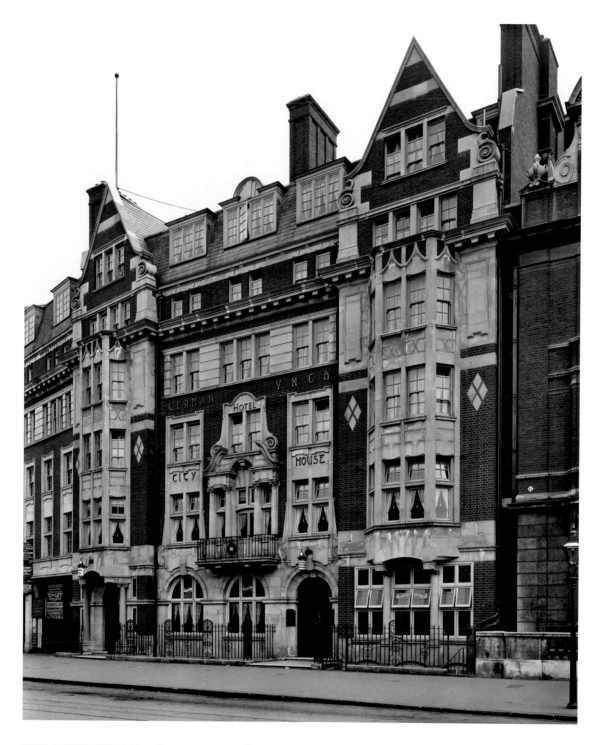

THE GERMAN YMCA, City House Hotel (George Waymouth, 1908–10), 158–160 City Road, London EC1, photographed in 1910. [BL20918]

A striking mélange of varied elements. There is a good deal of the Arts and Crafts enjoyment of contrasting materials and some very free baroque in the central window. The German Sailors' Home in West India Dock Road by the same architect (*see* p 100) is more digestible, but less fun.

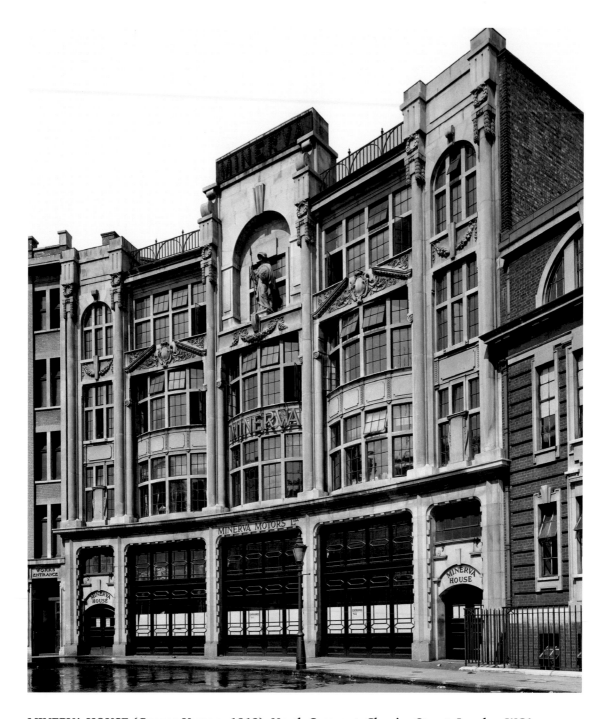

MINERVA HOUSE (George Vernon, 1912), North Crescent, Chenies Street, London WC1, photographed by AAB in 1918 for the architect. [BL24259]

The showrooms of the Belgian Minerva motor company, empty due to the war. The inventions of leading architects quickly provided others with motifs. For the Minerva building's façade, Vernon might have borrowed the recessed bay windows from Arthur Bolton (*see* p 55), Reginald Blomfield (*see* p 54) or several other architects; the windows with moulded surrounds and the low doors flanking them probably from Leonard Stokes (*see* p 174); the plain arches in the top storey perhaps from Charles Holden (*see* p 64); and the slender piers with hanging swags from J J Joass (*see* p 65). Overall, there presides – perhaps with some impudence – Minerva, the goddess of wisdom.

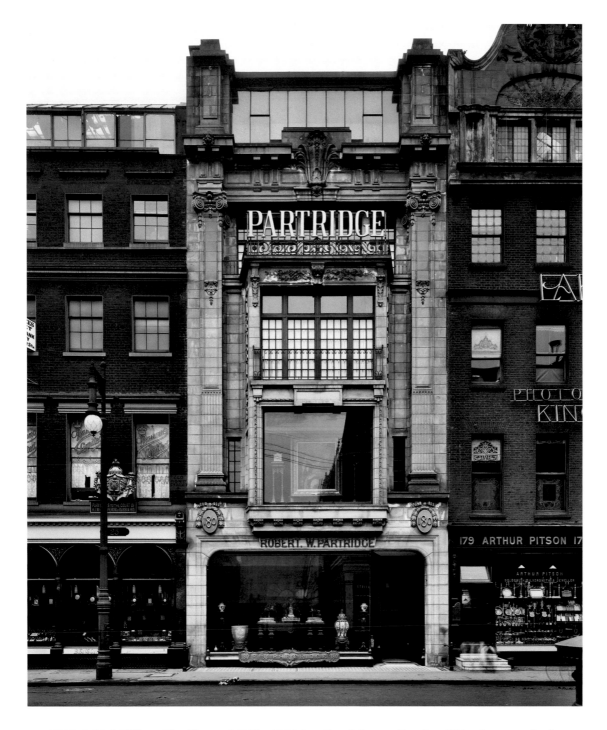

PARTRIDGE'S (William Flockhart, 1908), 180 New Bond Street, London W1, photographed in 1910 for Dewynters Ltd, advertising agents. [BL20830]

A strange adaptation of classical forms, reduced to little more than a giant frame for the windows within it – an enormous benefit in a narrow street and in the smoky atmosphere of Edwardian London. Architectural detail is in terracotta, also a favoured material in cities for the way it throws off dirt and surface pollution.

Although built as a speculation, Partridge's – leading dealers in fine art and antiques – made good use of the enormous windows.

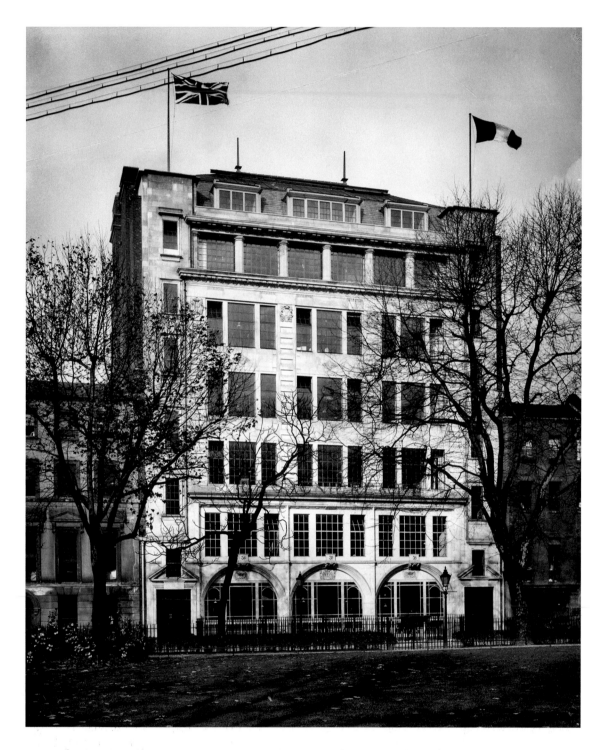

GAGNIÈRE & CO LTD (Leonard Stokes, 1913–15), 34–36 Golden Square, London W1, photographed by AAB in 1915 for Gagnière & Co Ltd. [BL23234]

An office for Gagnière & Co, woollen and silk merchants, a short distance from Stokes's office for the National Telephone Company (*see* p 174) and developing the same design formula: arcaded ground floor and flanking doors with broken pediments, mullioned windows and lines of cornice. However, the period details are even fewer and even freer, and the façade is framed by lines of staircase windows that introduce a counterpoint. Art Deco is not very far off.

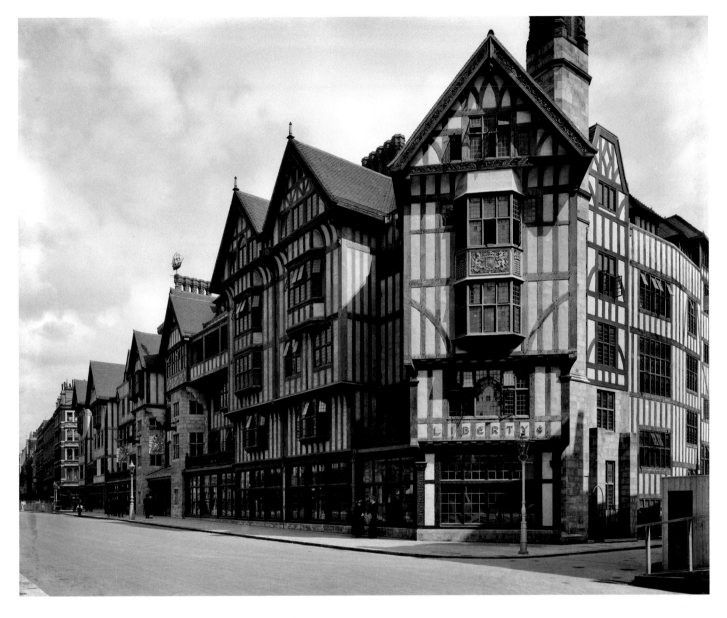

LIBERTY'S NEW BUILDING (E T Hall and E S Hall, 1923–4), Great Marlborough Street, London W1, photographed by AAB in 1924 for Higgs & Hill, builders. [BL27070/016]

Liberty's had been founded for the sale of oriental goods in the first great vogue for *japonaiserie* in the 1870s, and although the firm had branched out into furnishings and clothes, it continued to attract an artistic clientele.

Its original store on Regent Street was in a leasehold property to be rebuilt in Portland stone on the grand scale determined by the Commissioners of Woods and Forests. For some years, however, the firm had been buying up freeholds to the rear, where they would build what they felt was a shop more suited to their business. The new building was wholly of timber, made of old oak from two training ships (*Hindustan* and *Impregnable*) broken up under the Admiralty's post-war economy drive. It was a remarkable reaction in the name of art from the classically dressed steel-framed buildings that had housed major new stores for the previous 20 years.

The architect E T Hall was known as 'bye-law Hall' from his close knowledge of building regulations and presumably understood how to get such a structure accepted by the authorities.

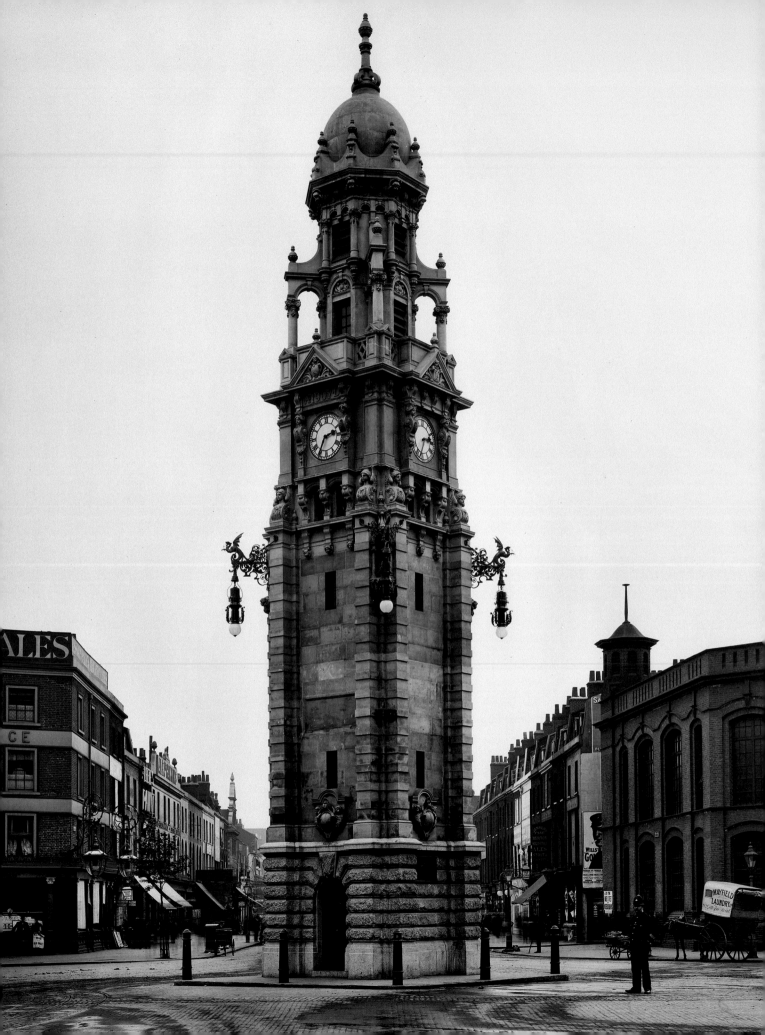

PUBLIC BUILDINGS AND PRIVATE INSTITUTIONS

In the course of the 19th century, England had changed from being a mainly rural country into a mainly urban one. Towns and (in particular) the industrial and commercial cities had grown fast. This growth had created the need for better government and administration, and prompted the formation of all kinds of voluntary and private institutions.

Successive Acts of Parliament had transformed government, reformed old institutions and established new, and had required both local and national authorities to provide services that had never been available before. New state responsibilities stimulated public involvement to ensure that services were managed wisely and well; civic pride promoted public buildings, while fine new buildings encouraged civic pride.

The reform and expansion of public services was able to draw on the education and public spirit of the large middle class that the growth of trade and industry had brought into being. Educational and technological advances were also leading to a greatly increased professionalisation in many areas of work: in engineering, medicine, architecture, science and the arts, for which professional bodies and improved training would be established or expanded to serve their practitioners.

There was also a significant amount of church building in the period covered here, even though some falling off from its 19th-century high point. Bedford Lemere & Co photographed few churches in these years, but the lavish redecoration of the Guard's Chapel and St Peter's Church, Eaton Square, as well as the building of Westminster Cathedral, are witness to the continued importance of Christian worship at almost every level of society.

**THE CLOCK TOWER (Jan F Groll, 1907),
St George's Circus, London SE1,
photographed in 1907.** [BL19990A]

73

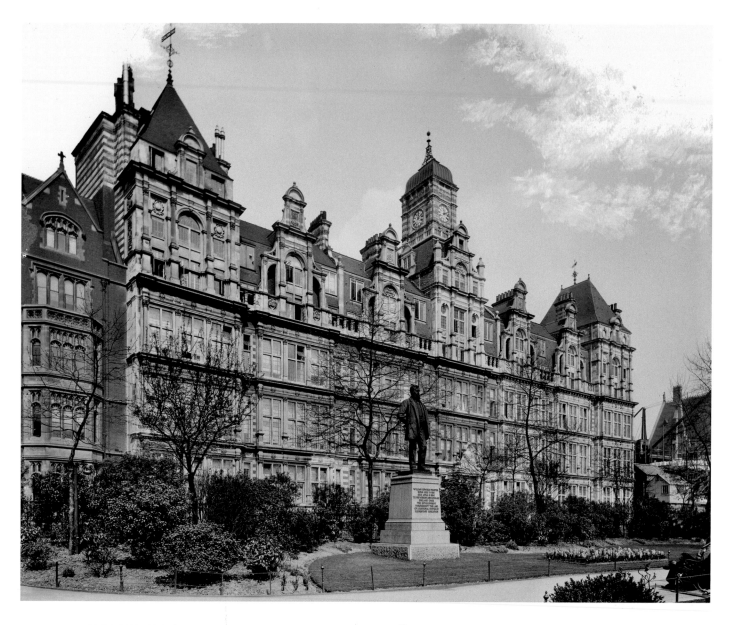

THE OFFICES OF THE LONDON SCHOOL BOARD (Bodley & Garner, 1874), Victoria Embankment, London EC4, photographed by AAB in 1894. [BL12607A]

The passing of the 1870 Elementary Education Act, for the first time providing universal and compulsory primary education up to the age of 12, led to the building of a very large number of new schools in London and the establishment of the administration to run them. Bodley & Garner designed the central offices of the London School Board in a style that probably owed as much to the early French Renaissance as to anywhere else. The building was pulled down in 1929.

The statue in the foreground – by H Richard Pincker – is of W E Forster, the government minister who had devised the act (often referred to as Forster's Act) and successfully negotiated its passage in the face of a good deal of very diverse opposition.

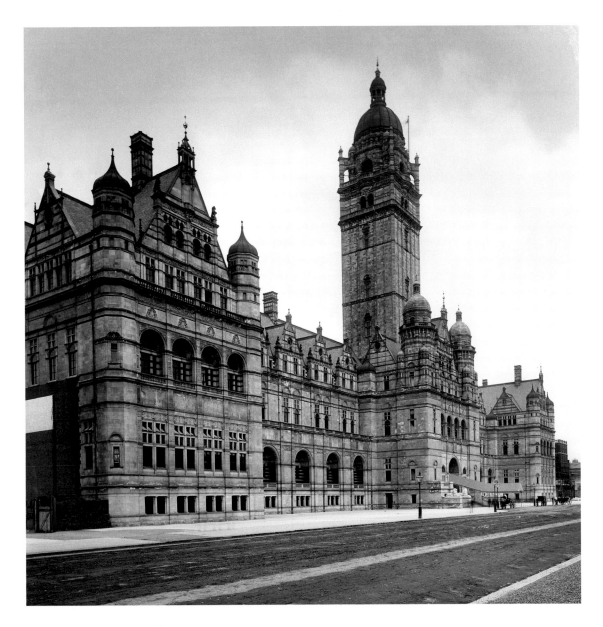

THE IMPERIAL INSTITUTE (T E Collcutt, 1887–93), Imperial Institute Road, London SW7, photographed in 1892. [BL11577/005]

Built as a celebration of the Golden Jubilee of 1887 and to provide a permanent venue for the kinds of activities – lectures, exhibits and conferences – that had taken place at the Colonial and Indian Exhibition of 1886. The Institute never fulfilled the ambitions of its promoters (who included the Prince of Wales); part of it was taken over by London University almost at once and the whole by the Ministry of Education in the 1950s. All that now survives is the tower.

The style of Collcutt's competition-winning design was a free hybrid of the Northern European Renaissance that was typical of the age, but handled with great panache. Perhaps too there was meant to be a hint of the orient in the little domes on the angles.

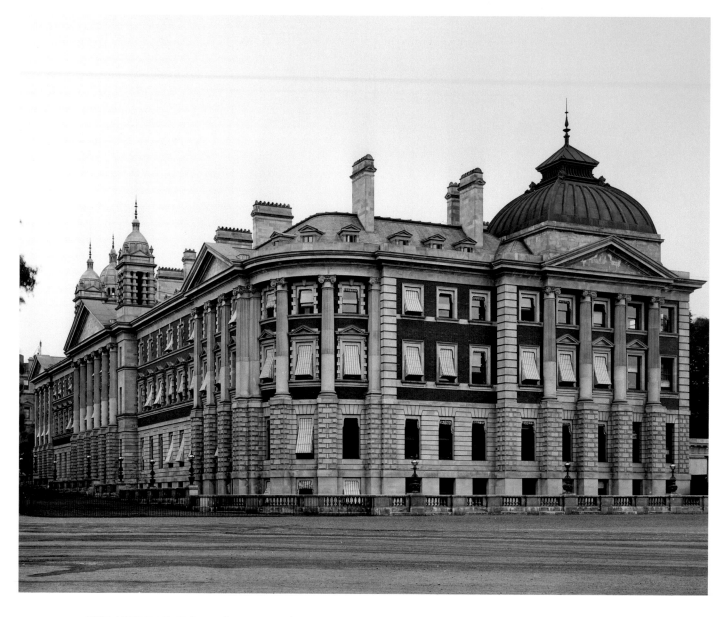

THE ADMIRALTY (Leeming & Leeming, 1894–5), Horse Guards Parade, London SW1, photographed by AAB in 1896. [BL13744]

The huge growth of the Royal Navy in late Victorian England required commensurate growth in its administrative machinery, and 126 architects entered for the competition for the new Admiralty building. The winners' entry was an early example of the revival of an English classicism of two centuries before, but not a very distinguished one. The building survives, but enlarged and altered.

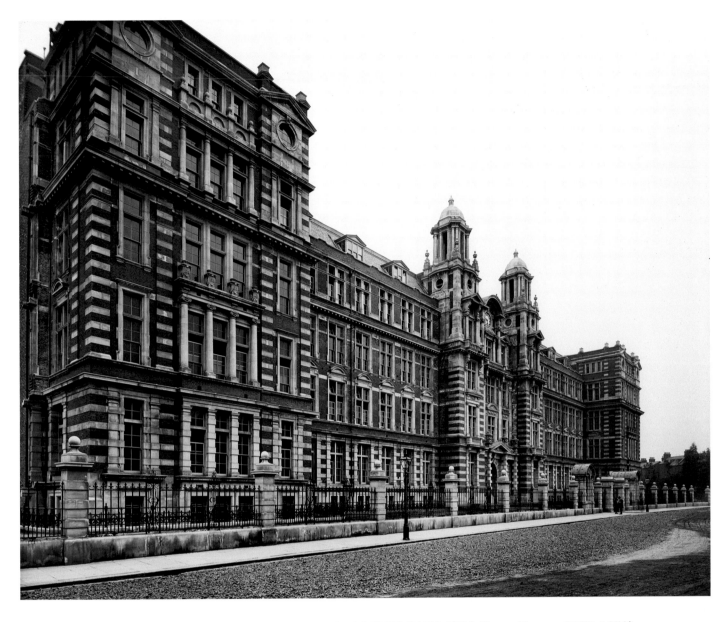

THE HEADQUARTERS OF THE POST OFFICE SAVINGS BANK ((Sir) Henry Tanner, 1899–1903), Blythe Road, London W14, photographed by AAB in 1903 for HM Office of Works. [BL17682]

The Post Office Savings Bank was established in 1861, whereby people with small incomes could save securely and conveniently through their local Post Office. By 1900 there were 8.4 million account holders, with an average of £16 2s in each account. In the days when all transactions had to be processed by hand, there was need for a corresponding army of clerks and a building to house them. The headquarters at Blythe Road housed a staff of 4,000.

The building is now used by the South Kensington museums as a store.

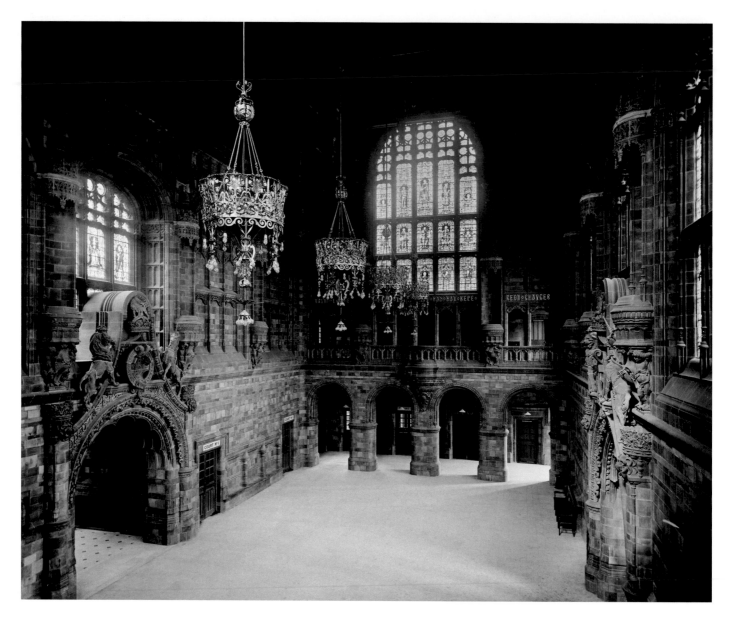

THE GREAT HALL, The Victoria Courts ((Sir) Aston Webb, 1887–91), Corporation Street, Birmingham, photographed by HBL in 1891. [BL11045/005]

A riot in hard Ruabon terracotta – the material and the style that gave many of the principal buildings of late Victorian Birmingham their unique and unmistakeable character. Webb's stylistic progress was typical of the age, ranging from an extravagant Gothic, as here, to the imperial classicism of the Admiralty Arch (*see* p 57) by way of the indescribable mixture of the Victoria and Albert Museum.

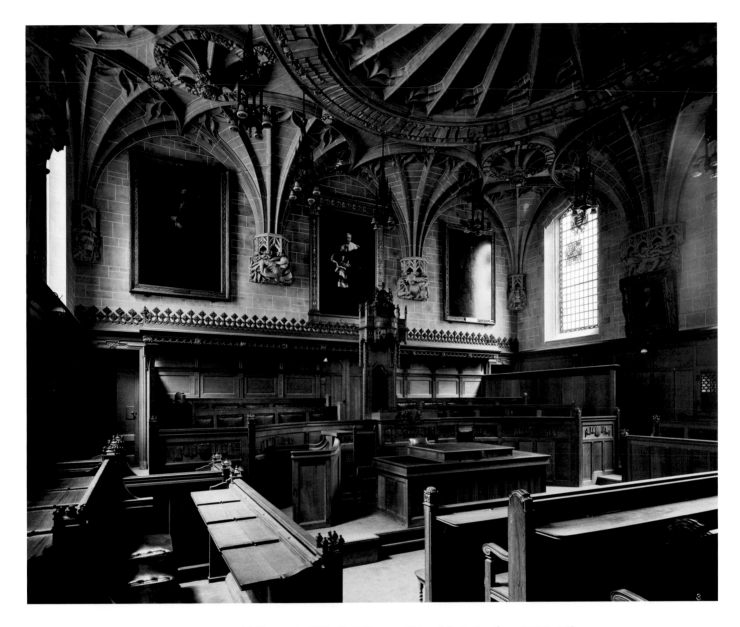

NUMBER ONE COURT, Middlesex Guildhall (Gibson, Skipwith & Gordon, 1912–13), Parliament Square, London SW1, photographed by AAB in 1914. [BL22793/003]

Proximity to the Houses of Parliament and Westminster Abbey determined the choice of Gothic for the Middlesex Guildhall, but Peyton Skipwith here employed the style with as much inventiveness as his senior partner, J C Gibson, had used Renaissance ornament at West Ham nearly 20 years before (*see* p 84).

Following the creation of the Greater London Council in 1971 the building became a Crown Court; in 2008–9 it was further altered as the Supreme Court Building of the United Kingdom. The vault remains; the fittings have been replaced.

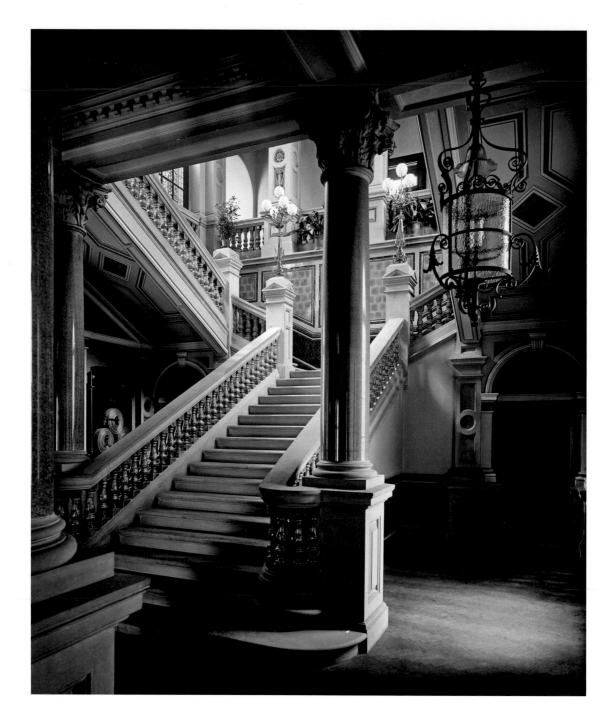

THE ENTRANCE HALL AND THE GRAND STAIR OF SUNDERLAND TOWN HALL
(Brightwen Binyon, 1889–91), Fawcett Street, Sunderland, Tyne & Wear, photographed by
HBL in 1891. [BL10942]

Sunderland's population, based on shipbuilding and glass making and on nearby iron and coal
mines, grew from 12,500 in 1801 to 146,000 a century later. The building of the Town Hall ended
almost 20 years of debate about where it should be built and who should design it, and coincided
with Sunderland becoming a county borough in 1888.

 Almost from the first it was too small to house the ever growing functions of local government.
However, its demolition in the 1970s was much resented locally, and the difficult operation of
lowering the bells from the Town Hall's clock tower was said to have been a very noisy business.

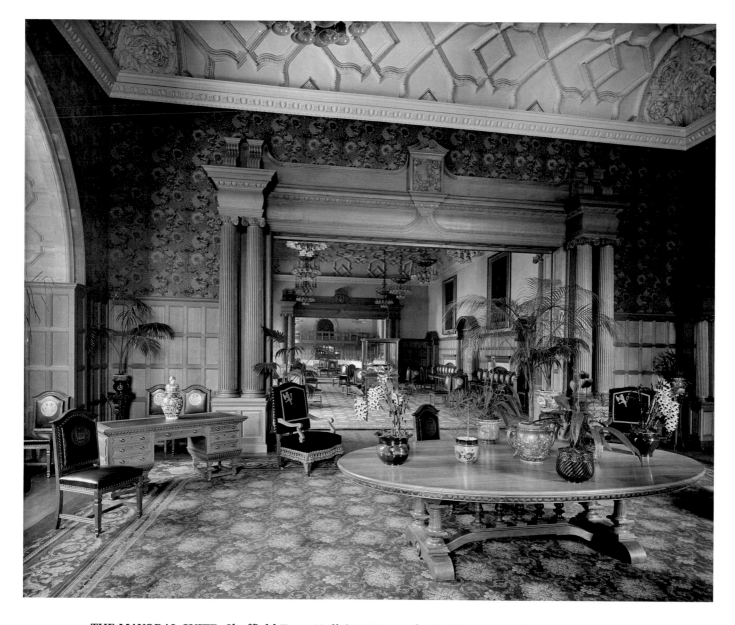

THE MAYORAL SUITE, Sheffield Town Hall (E W Mountford, 1890–7), Sheffield, West Yorkshire, photographed in 1896. [BL13711]

The Mayoral Suite was photographed on the occasion of the new building's opening by the queen. In 1890 Sheffield had been one of the few major British cities without a town hall commensurate with its wealth and importance, and the competition for its design attracted no less than 179 competitors.

The Mayoral Suite occupied the whole first floor on the principal front of the building and comprised an interconnecting suite of dining room, reception room and the mayor's parlour.

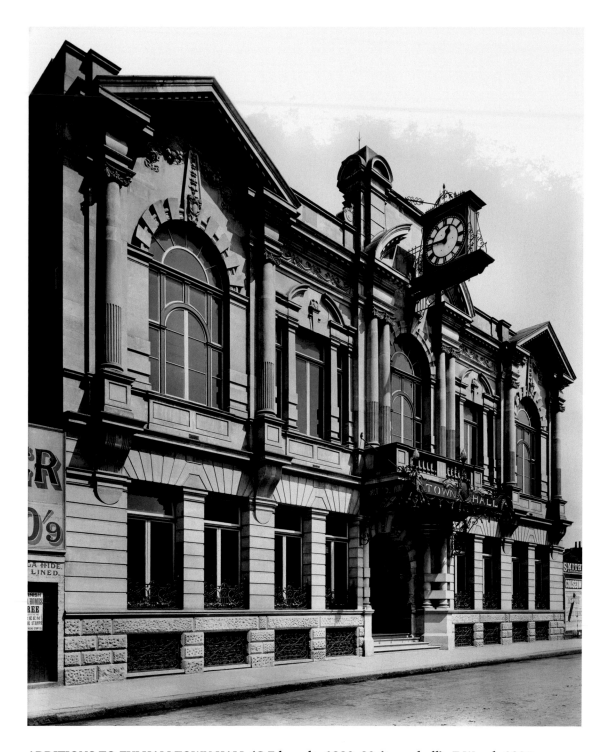

ADDITIONS TO FULHAM TOWN HALL (G Edwards, 1880–90 (town hall); F Wood, 1905 (additions)), Harwood Road, London SW6, photographed by AAB in 1906. [BL19372]

The 1905 additions to Edwards' building were designed by Francis Wood, the borough engineer, in the grand manner currently popular for town halls, in order to provide an improved entrance and a concert hall on the first floor.

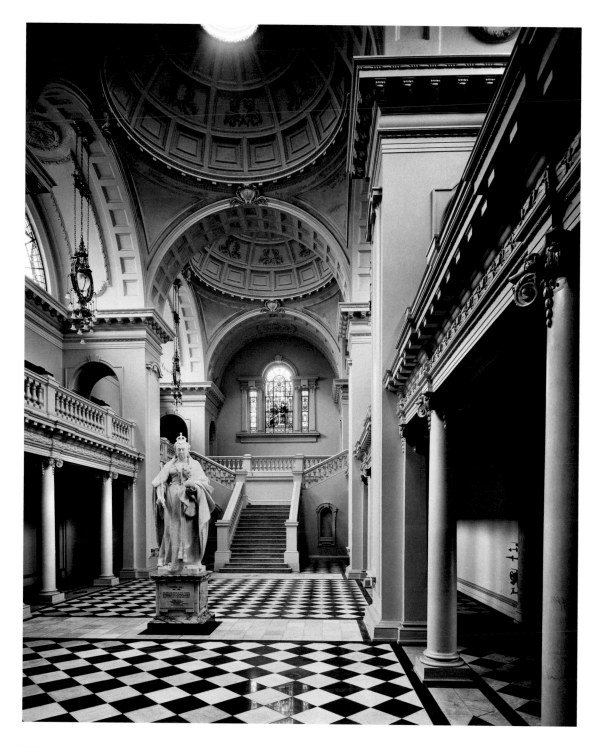

**THE ENTRANCE HALL, Woolwich Town Hall ((Sir) Alfred Brumwell Thomas, 1906–8),
Wellington Street, London SE18, photographed by HBL in 1906.** [BL19680/010]

Brumwell Thomas had achieved early success as a purveyor of civic magnificence with his winning
entry, in 1898 at the age of 30, for the Belfast City Hall competition. Woolwich Town Hall is a
remarkable piece of baroque splendour for a relatively poor borough.

 He had earlier submitted an almost identical entry in the competition for the town hall in
the neighbouring borough of Greenwich, in which he had been placed second to the design by
Lanchester & Rickards.

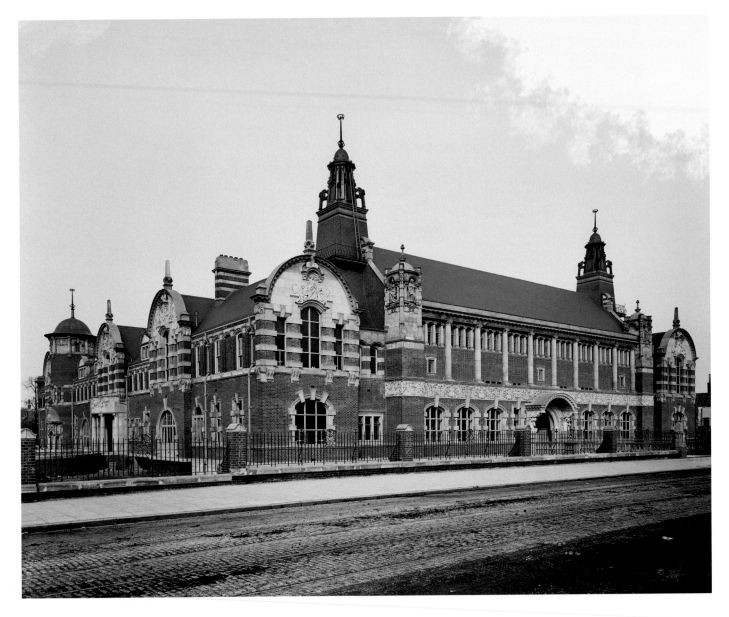

WEST HAM TECHNICAL INSTITUTE (J C Gibson & S B Russell, 1895–1900), Romford Road, London E15, photographed by AAB in 1898. [BL15051]

By the later 19th century technical education in Britain was lagging behind that in Germany and France; following an enquiry in 1881 the Technical Instruction Act of 1889 empowered local authorities to set up technical schools, financed by a local tax on drink sales ('the whisky tax').

This is a marvellously exuberant and inventive building, designed with great freedom of form and decoration. One has a slight sense, however, that while the architects were eager to escape from precedents, they were still looking for somewhere to go.

West Ham Technical Institute is now the University of East London, Stratford Campus.

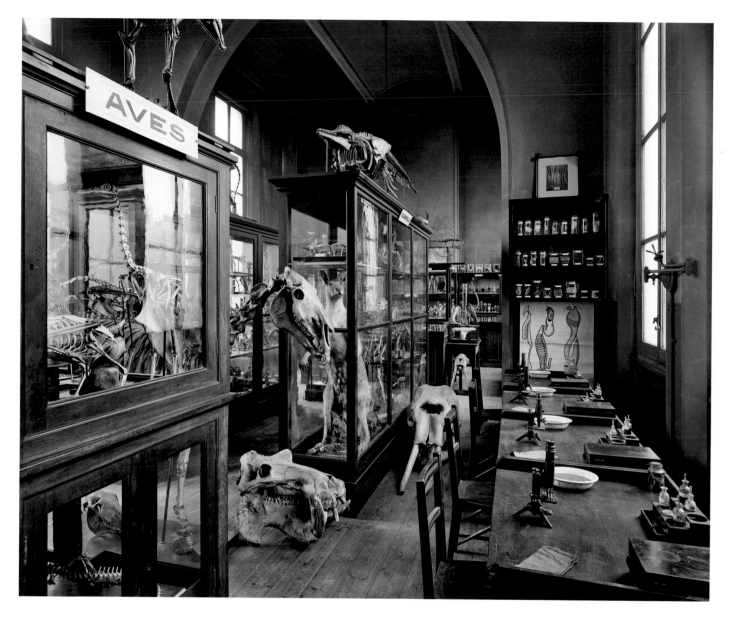

A NATURAL HISTORY MUSEUM, Mason's College, Birmingham, photographed by HBL in 1897.
[BL14248]

Birmingham in the 19th century was home to an enormous variety of manufacturing trades, but in general, technical and scientific training was limited to what could be learnt on the job. The pen-nib manufacturer and philanthropist Josiah Mason endowed his college – designed by local architect J A Cossins and opened in 1880 – in an endeavour to provide the kind of education that was needed. In 1900 it merged with the newly established Birmingham University.

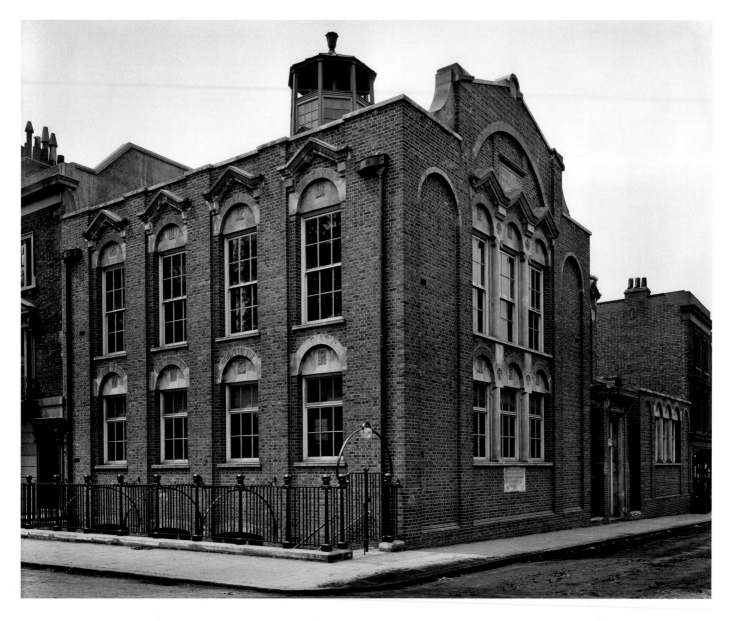

THE PUBLIC LIBRARY (Beresford Pite, 1906–8), Thornhill Square, London N1, photographed in 1907. [BL19984]

A relatively minor, but most attractive, work by a perennially inventive architect – a characteristically mannerist combination of industrial post-and-panel walls and Michelangelesque pedimented window heads, all surmounted by a light-hearted look-out on the roof.

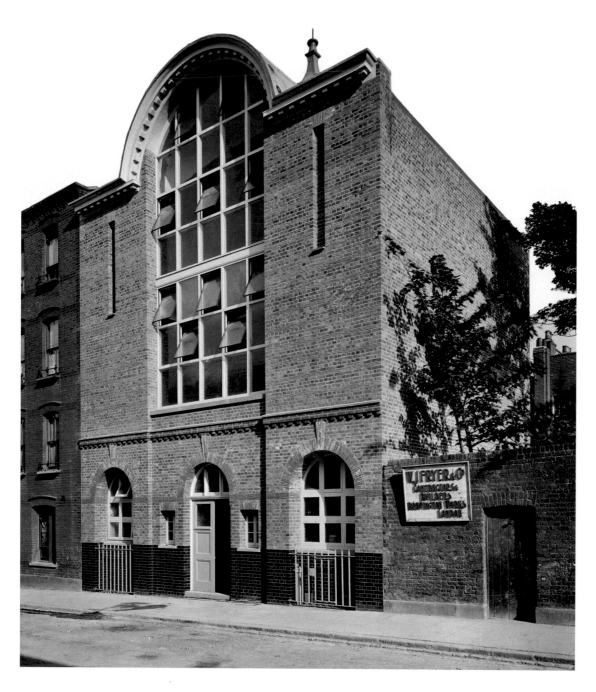

**THE BYAM SHAW SCHOOL OF ART (T P Figgis, 1910), 70 Campden Street, London W8,
photographed in 1910 for W J Fryer.** [BL20855]

Built for Reginald (Rex) Vicat Cole, the third of four generations of landscape painters, and co-
founder of the school with J L Byam Shaw. Vicat Cole's London home was at 9 New Road, Campden
Hill, close to the school and in an area of London that had long been popular with artists and their
patrons. The art school moved to north London in the 1990s and the original building was turned
into flats.

The name board of W J Fryer, contractor, who commissioned the photograph, hangs outside, in
suitably Arts and Crafts lettering.

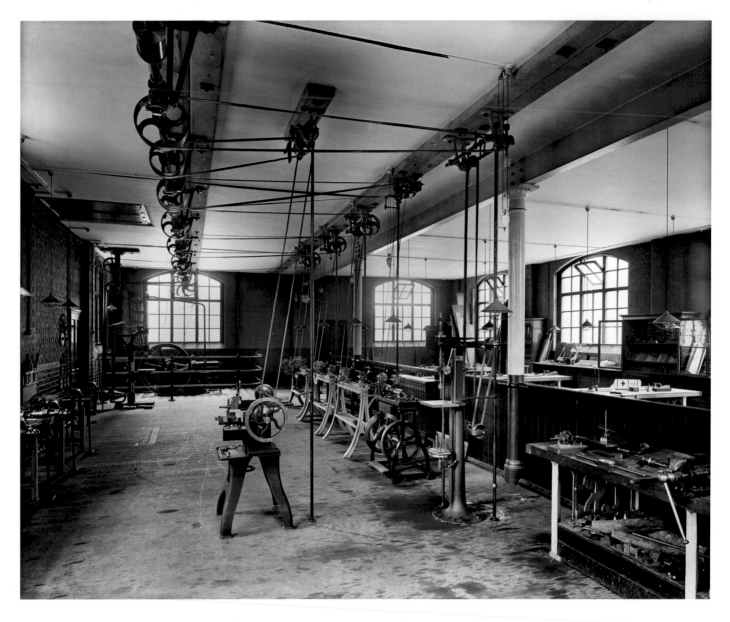

AN ENGINEERING WORKSHOP, St Olave's Grammar School (E W Mountford, 1893), Tooley Street, London SE1, photographed by AAB and colleague in 1899. [BL15378]

St Olave's Grammar School in Southwark was founded in 1571, and in 1893 acquired new buildings in Tooley Street, close to the junction with Tower Bridge Road. Though teaching a full academic curriculum, the provision of an engineering workshop showed the importance that technical education was beginning to assume. Here are a series of lathes, a pillar drill and other machinery all driven by a gas engine in the corner.

The school moved to Orpington in 1968 and maintains an outstanding academic record. The Victorian buildings now house a branch of South Thames College.

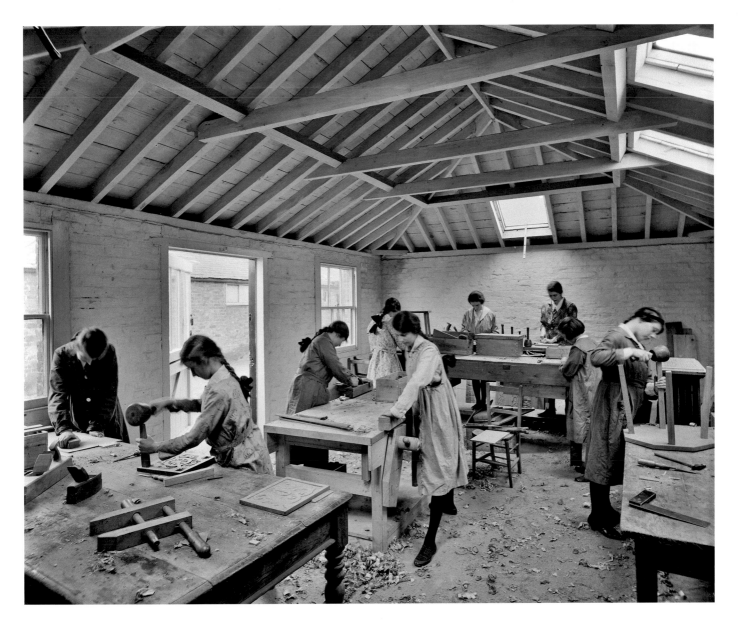

THE CARPENTRY WORKSHOP, West Heath School, Ham Common, Richmond-upon-Thames, Surrey, photographed by HBL in 1923 for Misses Lawrence and Skeat. [BL26554/005]

West Heath School was founded in Reading in 1865, and moved to Ham Common in 1879 where it remained before relocating – driven out by advancing suburbia – to Sevenoaks in 1932. In 1923 the joint principals were Emma Elizabeth Lawrence (not to be confused with her exact contemporary, the pioneer of Froebel teaching, Esther Ella Lawrence) and Frances Skeat, daughter of an eminent Cambridge philologist. A much later pupil of the school at Sevenoaks was Diana, Princess of Wales.

Housed in a much-enlarged Georgian villa, which had earlier been the home of the Duc de Chartres, West Heath was a school for the daughters of the upper classes. Nevertheless it is clear from the photograph that it was conducted on the excellent principle that even if its aristocratic pupils might never themselves need to put up a shelf or mend a chair, they ought to know how these things were done.

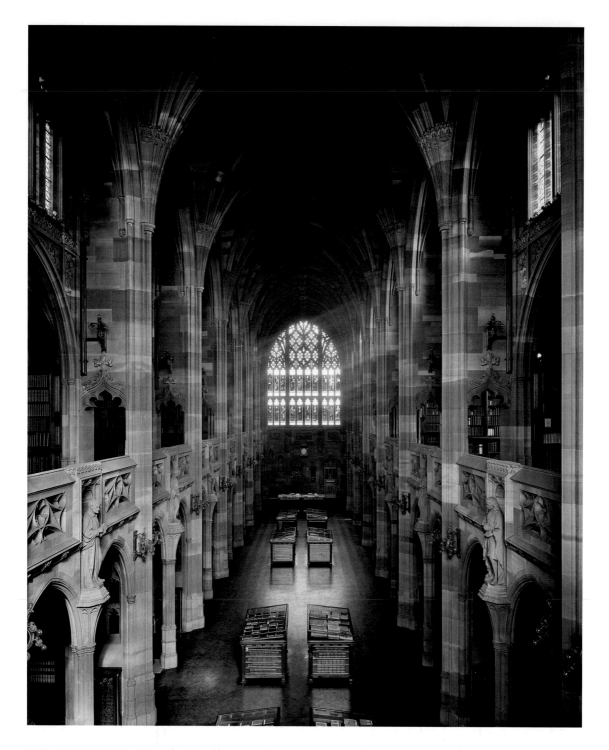

THE GREAT HALL OF THE JOHN RYLANDS LIBRARY (Basil Champneys, 1889–99), Deansgate, Manchester, photographed by HBL in 1900. [BL15845]

Not a church, but one of the finest achievements of late Victorian Gothic. The library was founded by Enriqueta Rylands, in memory of her husband John Rylands (1801–88), a devout Christian, philanthropist, model employer and the first millionaire and then multi-millionaire in the textile industry. Open to the public from the beginning, and housing the remarkable collection of books acquired from the library at Althorp (*see* p 206), it is now part of the library of the University of Manchester.

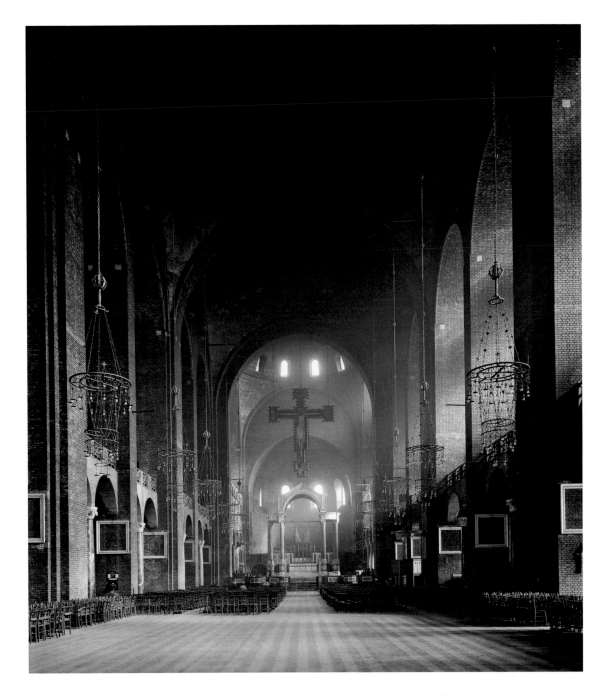

WESTMINSTER CATHEDRAL (J F Bentley, 1895–1903), London SW1, photographed in 1914.
[BL22621/003]

One of the greatest buildings of the age. The Roman Catholic diocese of Westminster had been established in 1850, but it was long before a site and funds were found for a cathedral.

The style chosen – by Bentley and Cardinal Vaughan, Archbishop of Westminster, who toured Italy together looking at exemplars – was a free Byzantine, executed in brick for speed of erection and making possible the building's later internal decoration, in marble and mosaic, as opportunities arose. The freedom with which historic forms were used, the sensitivity shown towards the visual effects of even simple materials, and the opportunities offered to craftsmen in many different media to enhance the building without impairing its overall form, make the cathedral the finest expression on a large scale of the principles of the Arts and Crafts movement.

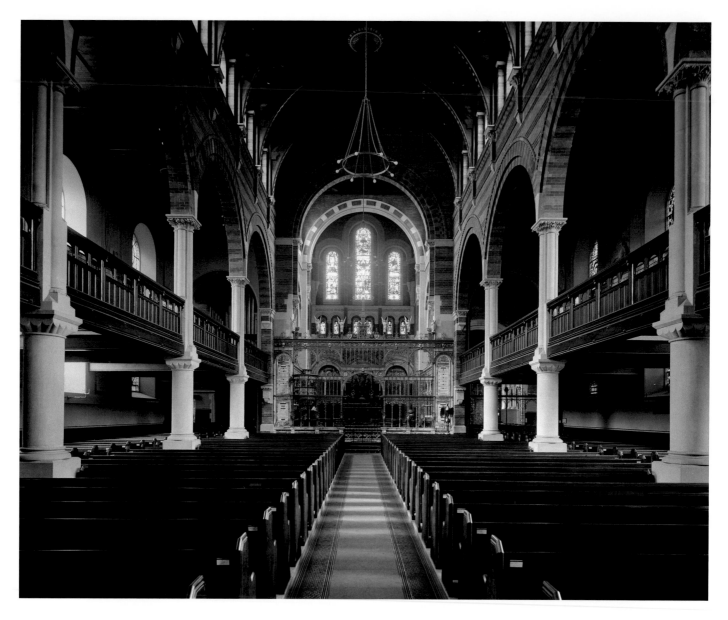

ST PETER'S CHURCH (Henry Hakewill, 1824–7; C Jearrad and Henry Hakewill, 1837; Sir Arthur Blomfield, 1872 and 1875), Eaton Square, London SW1, photographed by HBL in 1895.
[BL13371]

One of the two most fashionable churches in late Victorian London (St George's, Hanover Square, was the other). Originally built by Hakewill in a plain classical style, it had been considered 'unsightly and undignified' when in 1870 the charismatic preacher George Howard Wilkinson was presented to the living. Wilkinson immediately succeeded in raising the money to build first a chancel and then to rebuild the nave, retaining galleries in order to accommodate the huge congregations of both rich and poor who came to his services. Though holding 1,650 people, it was often necessary to bring in extra seating.

The chancel was decorated in 1891 and repainted in 1895 when electric light and an elaborate metal screen were installed – the occasion, no doubt, for Harry Lemere's photograph. The church was burnt out by an arsonist in 1987 and rebuilt three years later to a new design by the Braithwaite Partnership.

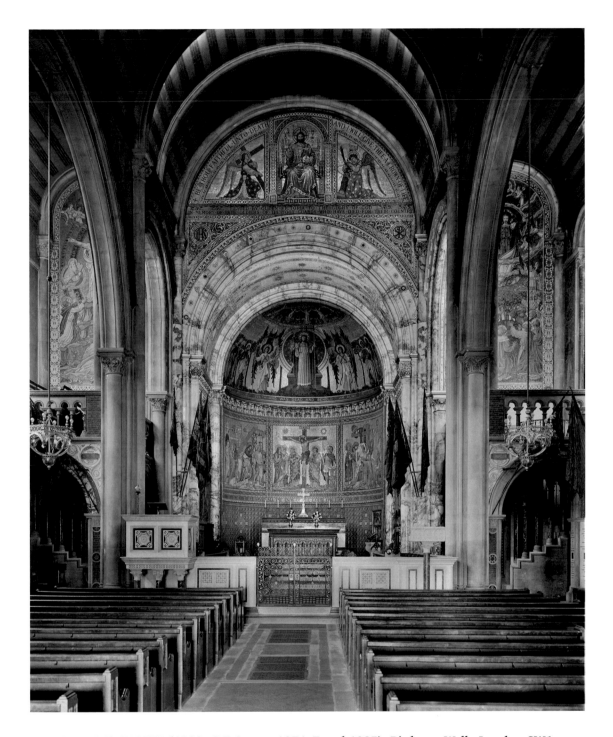

THE GUARDS' CHAPEL (1838; G E Street, 1874–7 and 1885), Birdcage Walk, London SW1, photographed in 1905 for Clayton & Bell. [BL19191]

The Guards' Chapel, at the Wellington Barracks, was built in 1838, and later enlarged in a Romanesque style probably thought to be sympathetic to the classical manner of the original; the mosaic shown here, made by Burke & Salviati, was designed by the firm of church decorators and stained-glass artists, Clayton & Bell, who commissioned the photography. Other work was done by the terracotta artist George Tinworth.

The chapel was destroyed by a flying bomb on the morning of Sunday 18 June 1944, leaving 260 dead and wounded.

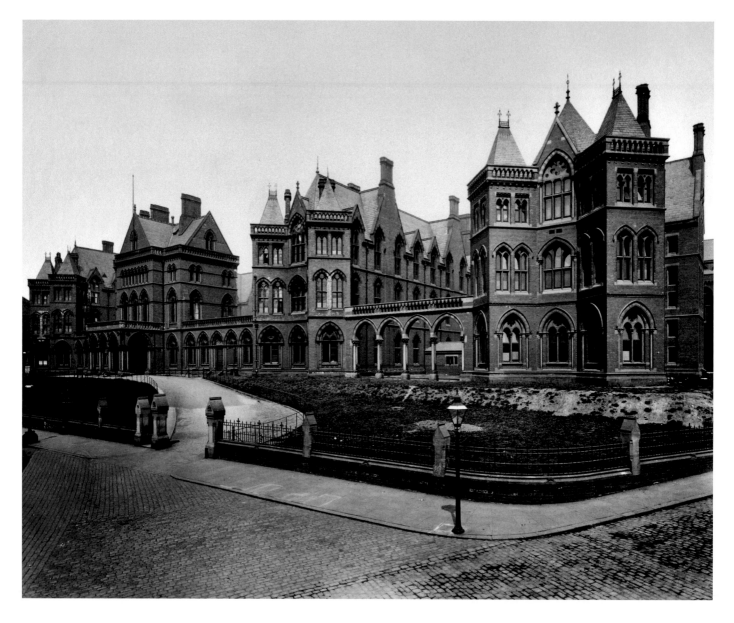

**THE GENERAL INFIRMARY (Sir George Gilbert Scott, 1863–80; George Corson, 1895),
Great George Street, Leeds, West Yorkshire, photographed by HBL in 1895.** [BL13201]

Harry Lemere's photograph records the recent enlargement of Scott's hospital by the local architect
George Corson. His adoption of the same style as the original building is perhaps surprising at a
time when very few architects were still designing in Gothic, but his tact produced a much more
satisfactory result than any alternative approach is likely to have done.

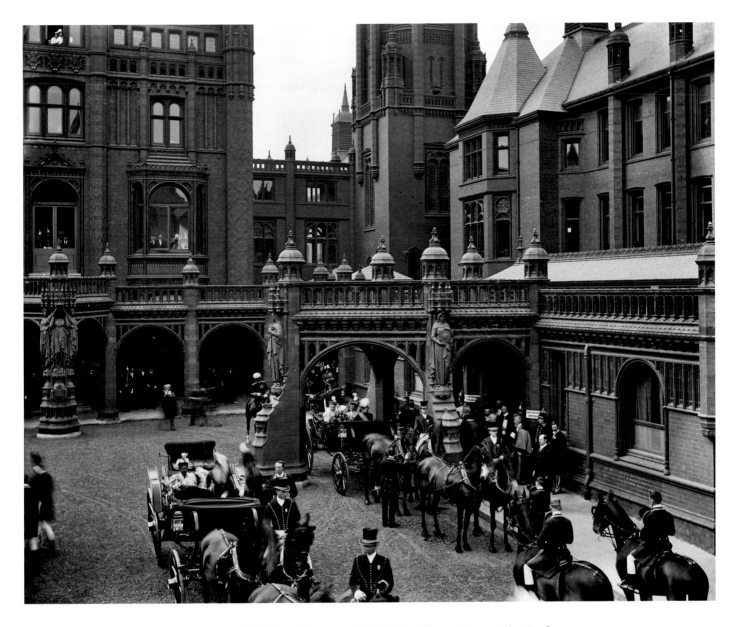

THE GENERAL HOSPITAL (William Henman, 1897), Steelhouse Lane, Birmingham, photographed by HBL in 1897. [BL14150/001]

Photographed on the occasion of the hospital's opening in July 1897. It was probably hoped that the queen might open the building, but after the Diamond Jubilee celebrations in London the previous month this was probably too much to expect. In the event, the ceremony was undertaken by the queen's third daughter, Helena, Princess Christian of Schleswig-Holstein, who came to Birmingham with her party by special train – Harry Lemere's view shows either her arrival or her departure. The route from the station was lined with the decorations that had embellished St James's Street in London for the Diamond Jubilee.

The General Hospital is now known as the Birmingham Children's Hospital.

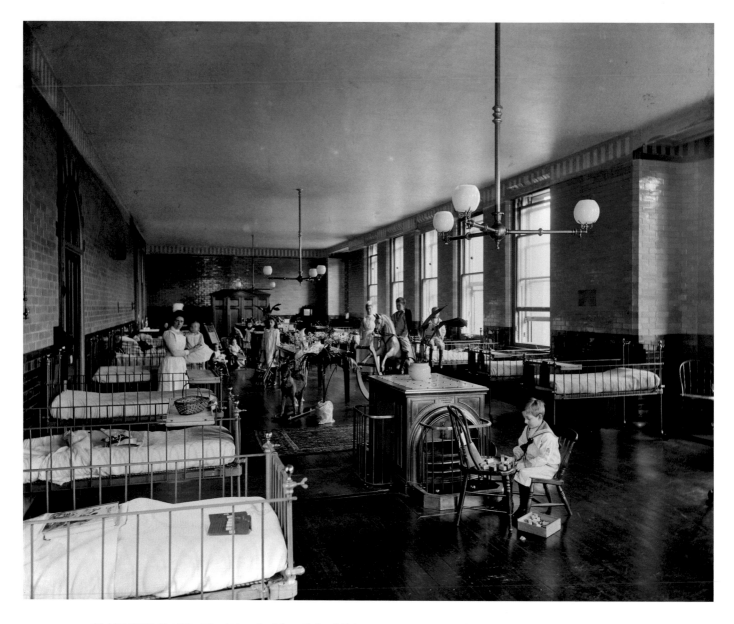

CLARENCE WARD, The Hospital for Sick Children, Great Ormond Street, London WC1, photographed by AAB in 1893 for Adrian Hope, secretary to the hospital. [BL12177]

Until the foundation of The Hospital for Sick Children in 1851, there was no hospital in London providing especially for the needs of children. Established originally in two Georgian houses, these were supplemented by new buildings in the 1870s and replaced in 1893 by the block containing the medical ward shown here.

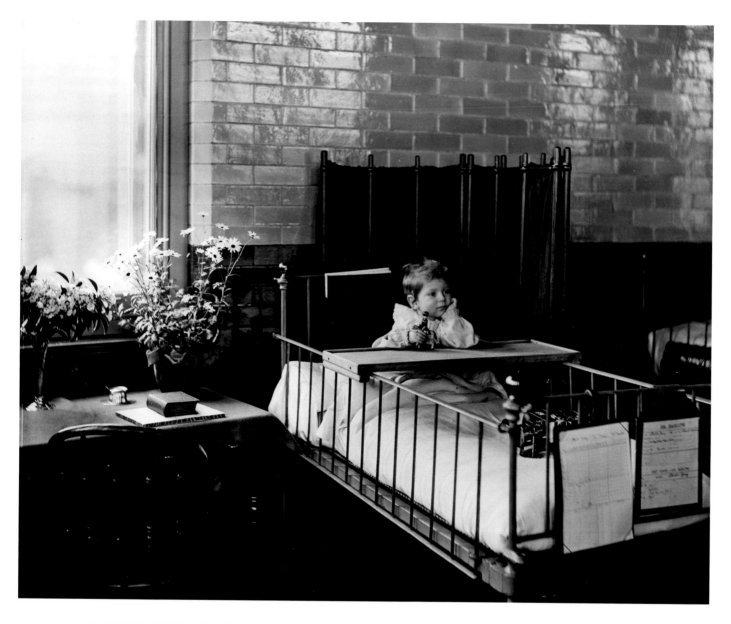

CLARENCE WARD, The Hospital for Sick Children, Great Ormond Street, London WC1, photographed by AAB in 1893 for Adrian Hope, secretary to the hospital. [BL12178/001]

A young patient holds a toy soldier on a horse.

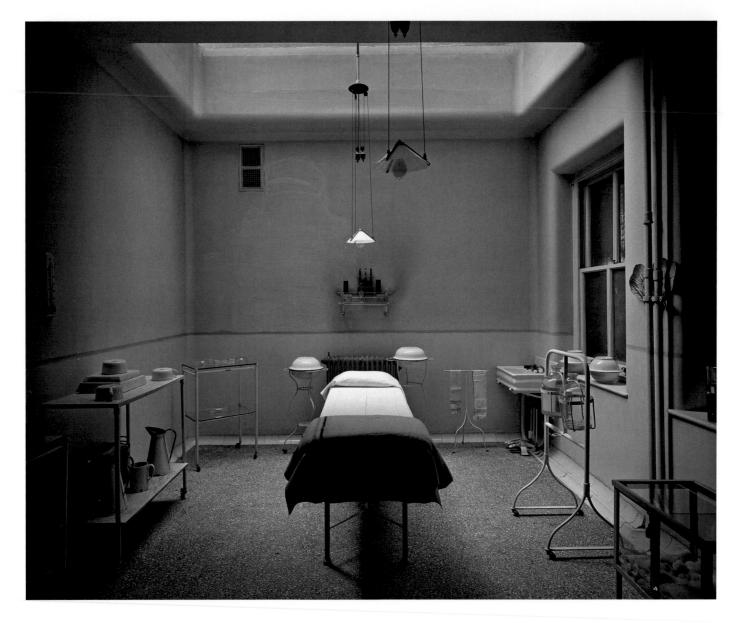

THE OPERATING THEATRE OF THE ITALIAN HOSPITAL (T W Cutler, 1898), Queen Square, London WC1, photographed by HBL in 1903. [BL17920/004]

The Italian Hospital was founded in 1884 to serve the large immigrant Italian colony of Holborn and Clerkenwell. Initially established in a private house on the south side of the square (and very close to The Hospital for Sick Children on Great Ormond Street), this was replaced in 1898 by a new building by Cutler on the same site. Staffed by nuns, the hospital still exists, though outside the National Health Service.

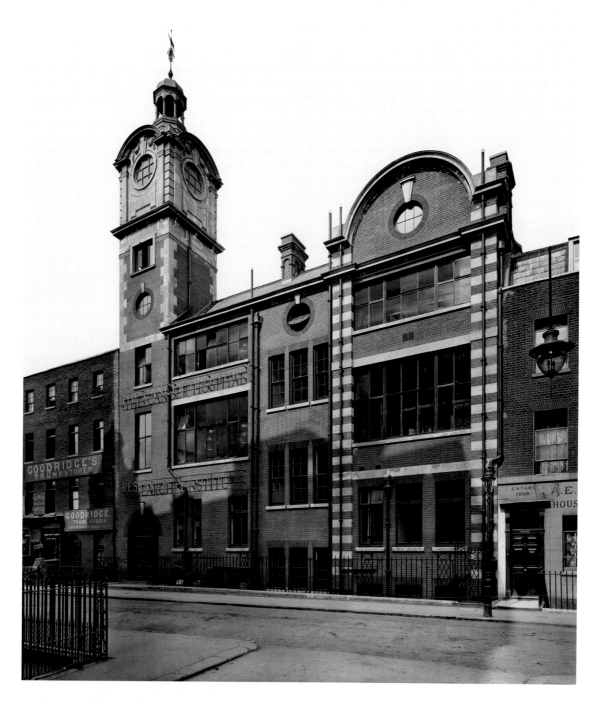

THE CANCER HOSPITAL RESEARCH INSTITUTE (E T Hall, 1910–11), Dovehouse Street, London SW3, photographed by AAB in 1911. [BL21257]

The research institute was built to the rear of the Royal Marsden Hospital on the Fulham Road. The free architectural treatment attempts to give a unity to a building where functional considerations took priority. Large windows provide the laboratories with the maximum light. The building survives in part, somewhat mutilated.

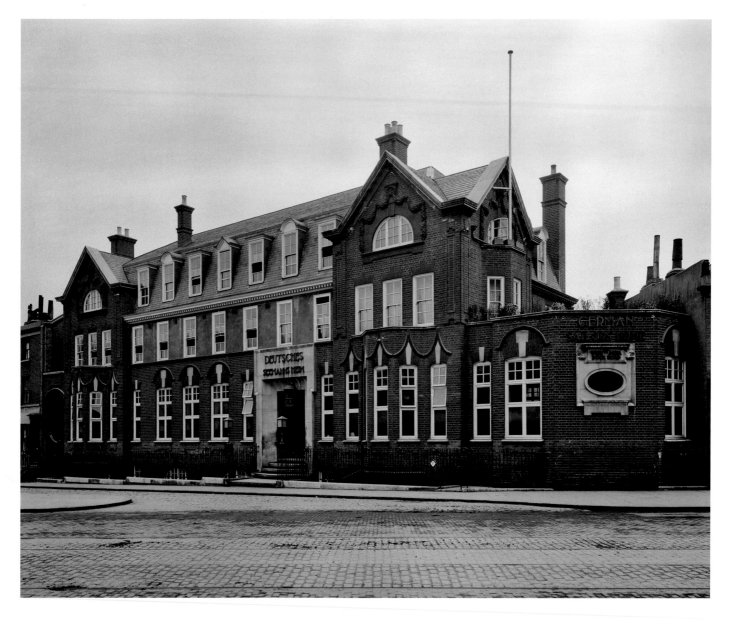

THE GERMAN SAILORS' HOME (George Waymouth, 1910), West India Dock Road, London E14, photographed in 1910. [BL20856]

Few of the firm's photographs relate to the vast complex of the London docks, but such institutions as the German Sailors' Home would have offered familiar comforts to men from far away.

There is a touch of 'free style' in the main entrance and of baroque in the gables, but there was clearly no call here for the lavish architectural display of the same architect's German YMCA (*see* p 67).

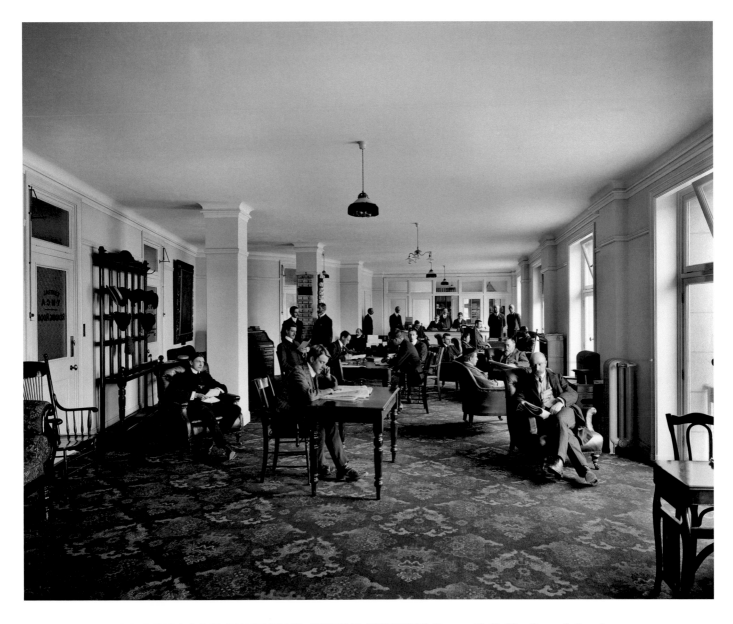

THE READING ROOM AT THE YMCA CENTRAL BUILDING, Exeter Hall, The Strand, London WC2, photographed by HBL in 1907 for the YMCA. [BL20046]

The Young Men's Christian Association (YMCA) was founded in 1844 by (Sir) George Williams, then a draper's assistant (*see* p 33), to provide Christian fellowship for City clerks and shop assistants; it rapidly spread to serve a much wider public. Its extraordinary success at a time of huge urban expansion is easily explained by the comment of the evangelist Dwight Moody – 'A good warm grasp of the hand, a kindly word and a smile, will do more for a young man who comes for the first time to the City than two thousand of the most eloquent sermons.'

Exeter Hall was built in 1829 for holding scientific and religious meetings, but had been the headquarters of the YMCA since 1880. It was demolished and replaced by a new headquarters in the year Bedford Lemere & Co took their photographs.

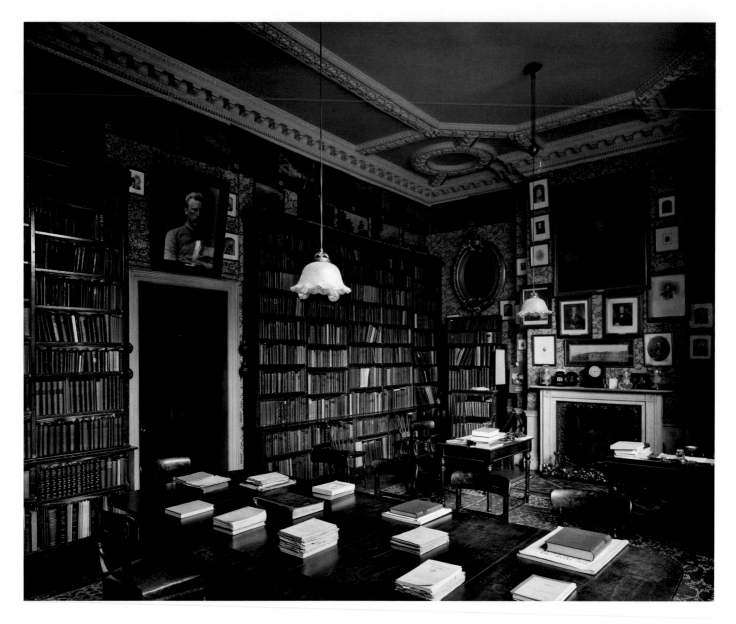

THE LIBRARY, The Royal Geographical Society, 1 Savile Row, London W1, photographed in 1912. [BL21540/003]

The former premises of the Royal Geographical Society, dating from 1731 and photographed just before their move to Kensington. Over the door hangs a portrait of the polar explorer Fridtjof Nansen; over the fireplace, a portrait of David Livingstone by Alexander Craig. The pictures on the upper wall on the left are by Thomas Baines who accompanied expeditions to Australia and southern Africa in the mid-19th century.

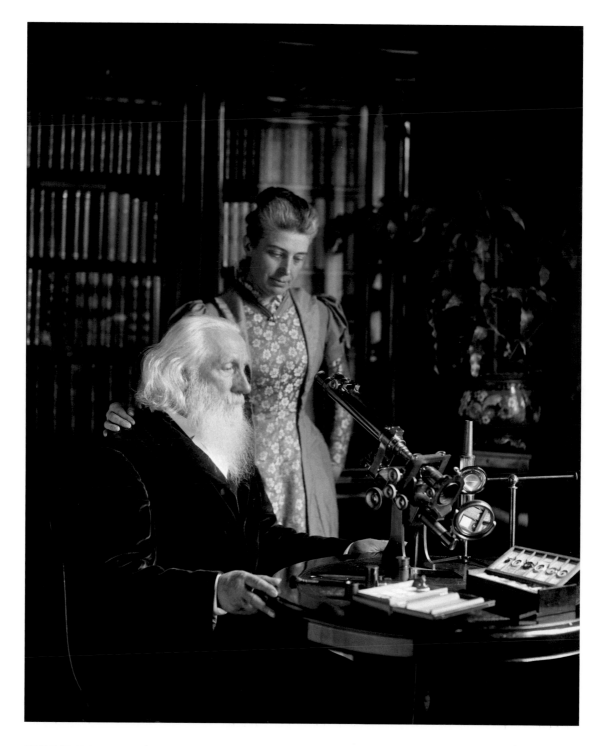

FREDERICK FITCH AT 40 HIGHBURY NEW PARK, London N5, photographed by AAB in 1892.
[BL11864C]

The teaching of science in English universities was still recent (Cambridge had only introduced a degree in natural science in 1852) and much valuable work was still done by amateurs. One such was Frederick Fitch, an entomologist whose money came from the family firm of provision merchants. He had provided David Livingstone with supplies for his expeditions and was himself a member of the Royal Geographical Society. Here he poses with his very fine Ross microscope and a selection of his own slides. The woman with him is probably his daughter Emma.

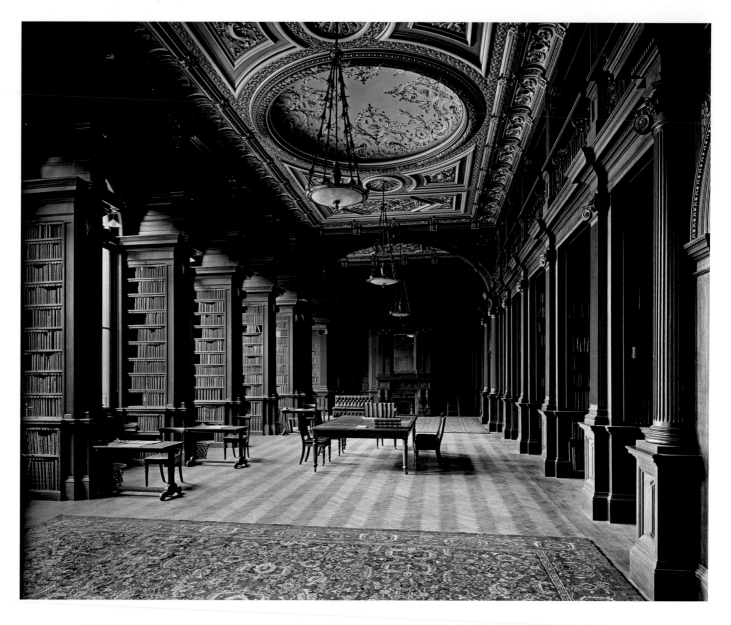

THE LIBRARY AT THE INSTITUTION OF CIVIL ENGINEERS (Charles Barry Jnr, 1896), Great George Street, London SW1, photographed by HBL in 1896 for J H T Tudsbery, secretary to the Institution. [BL13728]

The Institution of Civil Engineers ('The Civils') was founded in 1818 and remains the profession's leading professional body, with a world-class library. Barry's Italianate building was a trifle old-fashioned when compared with the more overtly British classicism that younger architects were bringing in. However, it had a short life, being pulled down in 1910 to make room for an extension to James Brydon's new government offices (originally the Department of Education, now the Treasury) and to be replaced by a still more imposing building (*facing page*) on the other side of the road.

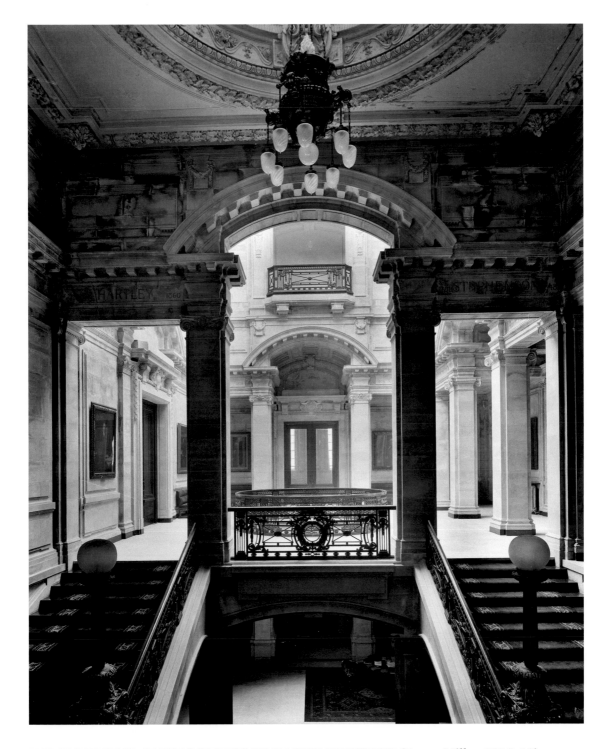

THE GREAT STAIR AT THE INSTITUTION OF CIVIL ENGINEERS (James Miller, 1910–13), Great George Street, London SW1, photographed in 1914. [BL22426]

The approach to the library and great hall on the first floor of the building that replaced that by Charles Barry Jnr – a suitably magnificent home for a profession in which British engineers were active in every part of the world.

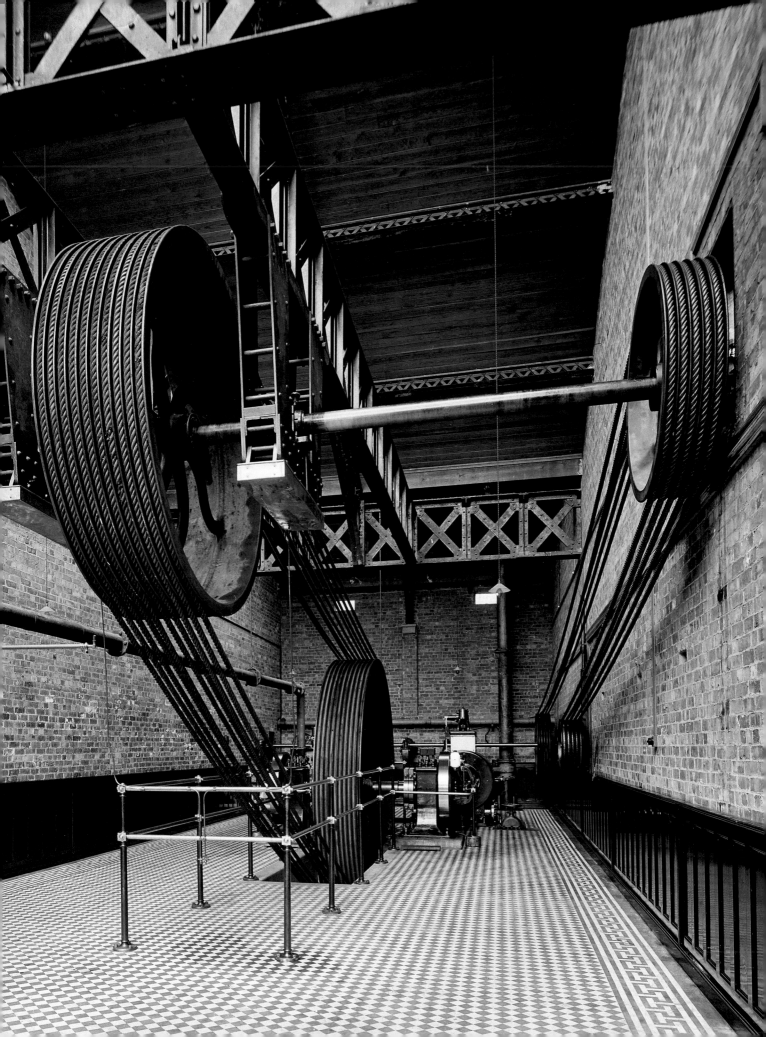

COMMERCE
AND INDUSTRY

At the height of Britain's imperial and industrial prosperity in the years around 1900, most British people probably believed that it was national character and divine providence that had made the nation great. Such self-congratulation will have been good for the country in many ways, but the truth is that the nation's prosperity was founded on coal, iron and geography, and on a political system that encouraged their exploitation. It was due too to the concentration of national wealth that London became the centre of global finance. Britain was where money had been made and London was where it might be raised.

The physical scale of heavy industry can be seen in Bedford Lemere & Co's photographs of shipyards, where vast sheds contain enormous components and huge machines. But much manufacturing was still highly labour intensive, and its human scale can be seen in the numbers of workers engaged in manual tasks. Office work, too, depended on armies of clerks in banks and businesses when almost all transactions were still recorded by hand. By 1900 telephones and typewriters were beginning to speed the work, but neither reduced the need for office staff.

A further, large employment sector was retailing, with many areas growing fast to serve the spending power of a middle-class public. A notable development was the growth of great department stores, which provided everything beneath one roof. Female employment outside the home was increasing, but for the most part remained confined to lower-grade clerical work until the shortage of manpower in the First World War made it necessary for women to work in ever greater numbers in industry and transport.

**THE CENTRAL ENGINE HOUSE, Port Sunlight,
Wirral, photographed by HBL in 1897 for
Lever Brothers.** [BL14041/018]

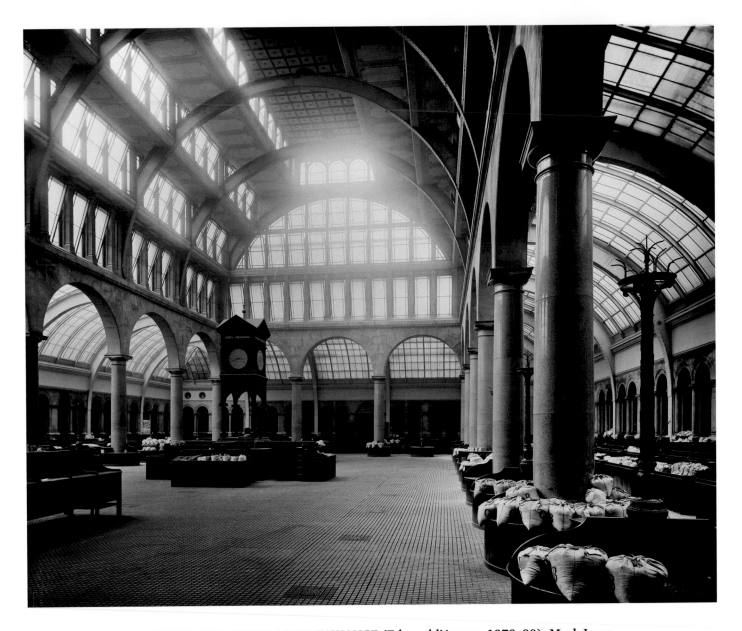

THE TRADING FLOOR OF THE CORN EXCHANGE (Edward l'Anson, 1879–80), Mark Lane, London EC3, photographed by HBL in 1890. [BL10277/003]

With industrialisation and the growth of great cities, wheat imports had grown enormously since the first Corn Exchange was established in the mid-18th century and the Exchange had been rebuilt more than once to accommodate an ever-expanding business. Although there were by this time numerous provincial corn exchanges where local production was traded, bulk imports were almost entirely dealt in London where samples could easily be delivered from the docks and cargoes discharged to rail or lighter.

The main hall was 60ft wide, with 20ft aisles on three sides, and rose nearly 70ft to the apex. The great wrought iron ribs that carried the roof were tied by iron girders beneath floor level. William Barlow, engineer of the train shed at St Pancras Station, had advised on the structure, which had been load-tested on a quarter-scale model.

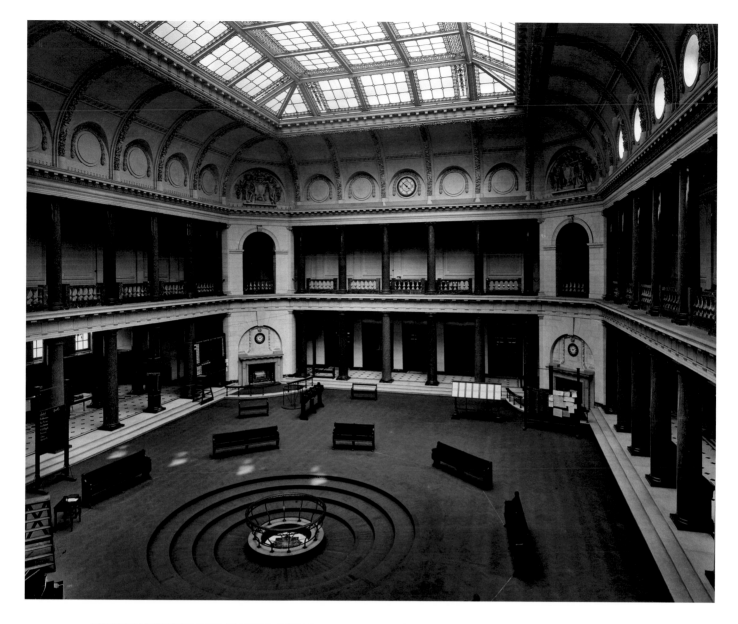

THE TRADING FLOOR OF THE COTTON EXCHANGE (Matear & Simon, 1906), Old Hall Street, Liverpool, photographed by HBL in 1907. [BL20061/031]

Most of the cotton used in the Lancashire cotton industry was imported through the Port of Liverpool, and it was at the Cotton Exchange that cargoes were traded. Fronted by a long classical portico, the centre of the building was occupied by a vast, top-lit trading floor with offices off it. The galleries that overlooked it were carried on columns of Norway granite polished in Aberdeen; other materials were equally opulent. The building was steel framed, and a notable feature of the design – remarked on at the time – was the fact that the north elevation was clad not in masonry but in cast iron to allow traders to inspect cotton samples with light from the widest possible windows. Another innovation was the telephones by which separate offices could dial each other direct rather than having to be switched through manually by a central exchange.

Matear & Simon were a local firm. The building survived the Second World War but was demolished in 1967 except for the rear block containing the tiered ranks of cast-iron windows.

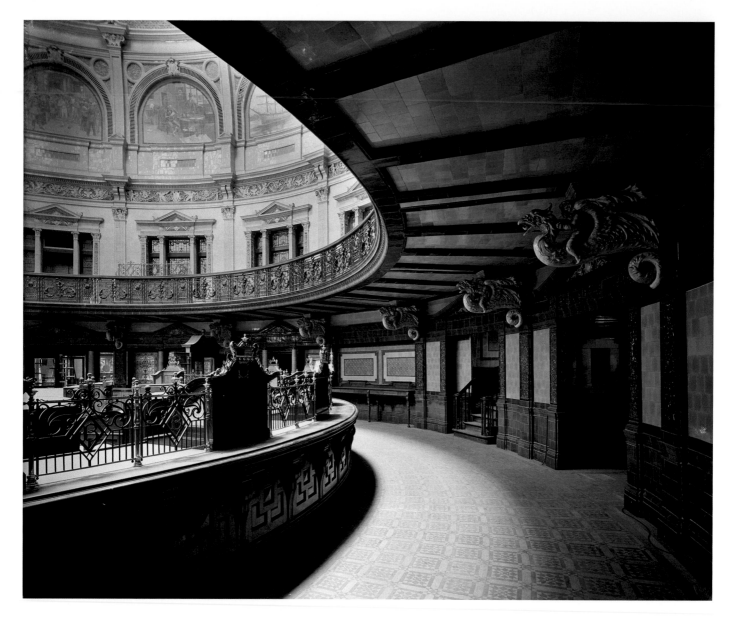

THE BANKING HALL OF THE BIRKBECK BANK (T E Knightley, 1895–6), Southampton Buildings, Chancery Lane, London WC2, photographed by AAB in 1899 for the architect. [BL15413]

Nikolaus Pevsner described the Birkbeck Bank as 'a phantasmagoria'. It was the most lavish of all contemporary bank buildings, with a great galleried and glass-domed banking hall entirely faced in polychrome Carrara Ware majolica by the Doulton factory of Lambeth. Set into the internal decorative scheme were scenes of historic industry and invention; round the outside were portrait medallions of inventors, industrialists, writers and artists – of wealth creators and those whose creativity wealth had made possible.

As an independent business the Birkbeck Bank failed in 1911 and was taken over by the forerunner of the National Westminster Bank who demolished the building in 1965 – at the time, a famous cause célèbre for the growing movement for the preservation of Victorian buildings. Three of the brackets shown here are preserved inside the building that replaced it.

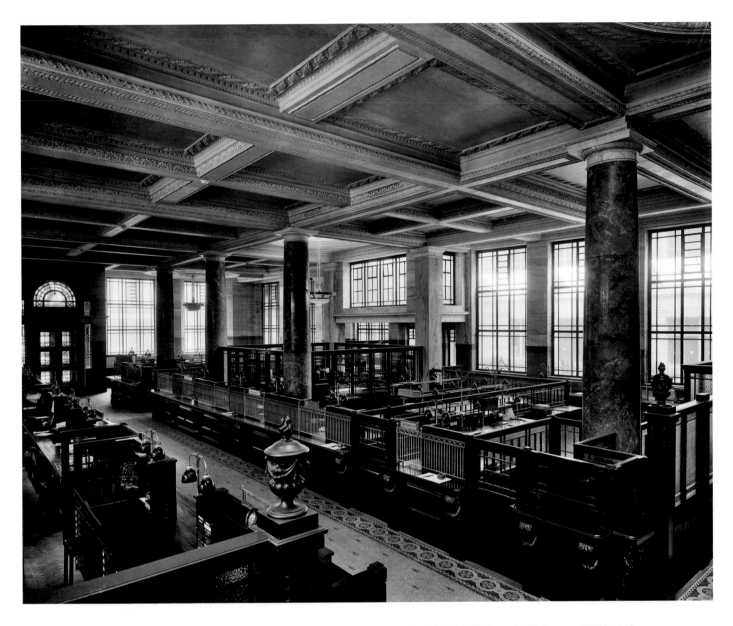

THE BANKING HALL OF THE HONG KONG & SHANGHAI BANK (W Campbell-Jones, 1912–13), **Gracechurch Street, London EC3, photographed by AAB in 1913.** [BL22394]

Adolphe Boucher's high-level view of the banking hall shows very well the complex compartmentalisation of the bank's different departments within an overall, open space. Such arrangements were characteristic of contemporary banks and offices.

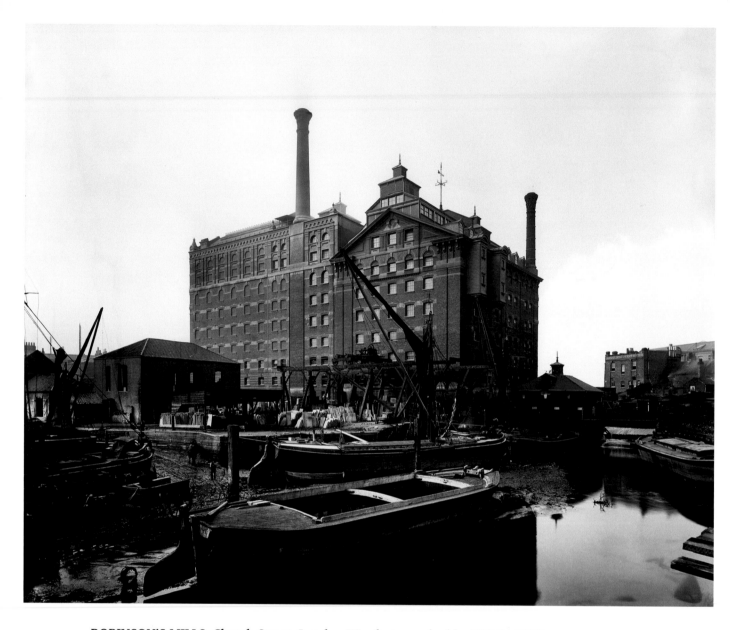

ROBINSON'S MILLS, Church Street, London E3, photographed by HBL in 1896. [BL13789X]

James and Henry Robinson's great steam mill stood on Deptford Creek, on the south bank of the River Thames. Its origin was as a tide mill, though long superseded by modern machinery. However, the location remained highly convenient for the unloading of grain cargoes directly from lighters, as well as coal for the milling engines.

Here lighters and Thames barges are floating or lie aground at low tide in the creek. On the dockside, paving stone has been stacked beneath a simple wooden gantry.

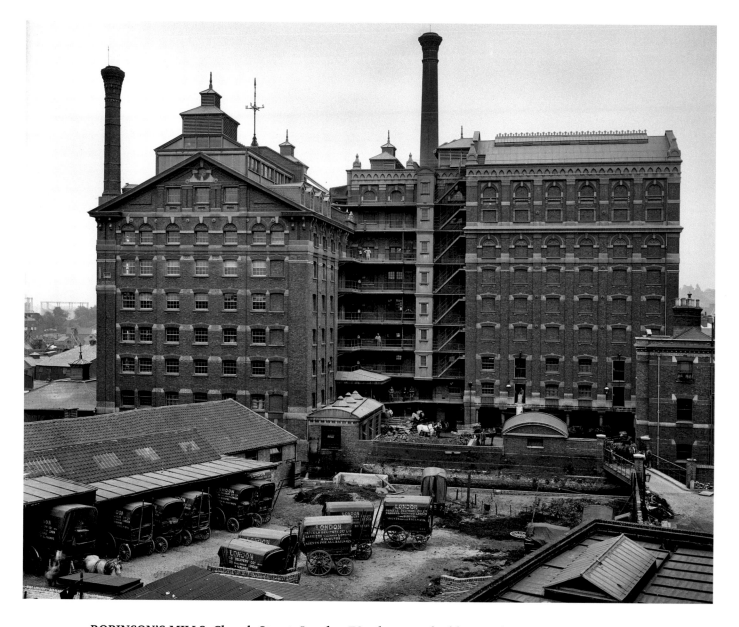

ROBINSON'S MILLS, Church Street, London E3, photographed by AAB in 1896. [BL13788]

An integrated operation. On the landward side of Robinson's Mills, flour was loaded directly into the firm's own waggons. Adolphe Boucher's photograph probably records a recent enlargement of the building.

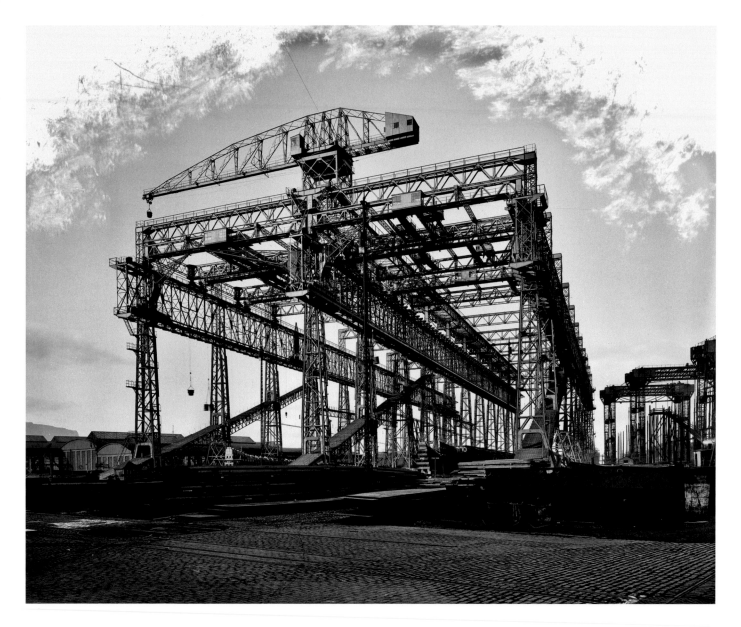

THE ARROL GANTRY, Harland & Wolff, Belfast, photographed by HBL in 1909. [BL20480]

In 1907 the White Star Line, financed by J P Morgan & Co, resolved to build a new fleet of three transatlantic liners. These were completed as *Olympic*, *Titanic* and *Britannic* (*see* pp 166–7). Two new slipways and a giant gantry, 840ft long and over 200ft high, were built for Harland & Wolff (with whom the line had long had a special relationship) to make possible their construction. In this view the keel plates of *Olympic* have been laid down on the right-hand slip; *Titanic* would soon be started on the left. Sir William Arrol & Co of Glasgow built the gantry to the shipyard's designs.

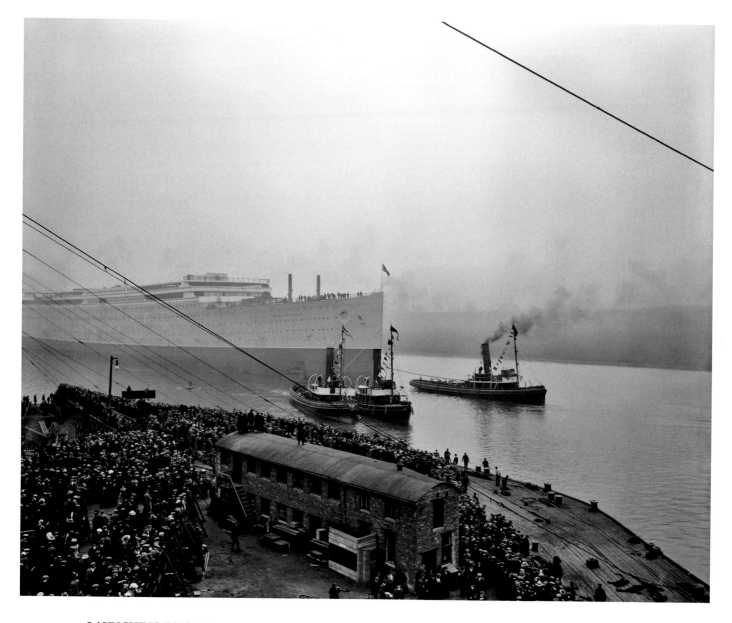

LAUNCHING RMS *AQUITANIA* AT JOHN BROWN & CO'S SHIPYARD, Clydebank, Scotland, photographed by HBL in 1913. [BL22100/027]

In the years immediately before the First World War, the Cunard and White Star Lines were rivals in speed and luxury on the transatlantic run, and though the Cunard vessels were marginally faster and the White Star slightly more luxurious, no other companies could match them on either count. *Aquitania* was built to give the Cunard Line a third great ship (joining the slightly earlier *Mauretania* and *Lusitania*) to compete with the White Star's *Olympic*, *Titanic* and *Britannic*. The interiors would be fitted out to the designs of the architects C Mewès & A J Davis.

 Aquitania survived longer than any other of the grand pre-First World War passenger liners, serving as a troop ship in both world wars and finally being broken up in 1950. She is seen here on her launch on 21 April 1913, painted in dockyard grey before fitting out.

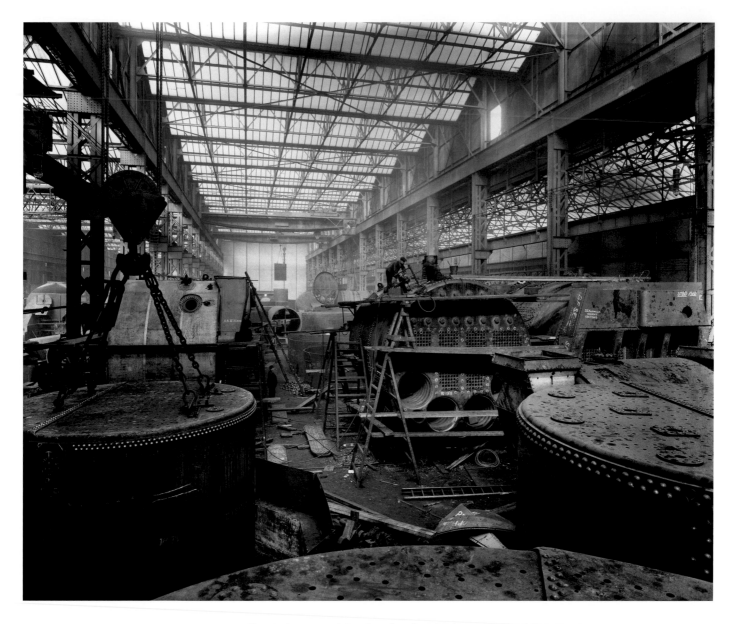

THE BOILER SHOP, Cammell Laird & Co, Birkenhead, Wirral, photographed by HBL in 1913.
[BL22201/014]

Laird's had been founded in 1824 and amalgamation with the steel-maker Charles Cammell in 1903 had made the firm the fourth largest shipbuilder in Britain. Here workmen (probably drilling rivet holes with a portable electric drill – a very modern piece of factory equipment) are dwarfed by the ships' boilers they are working on.

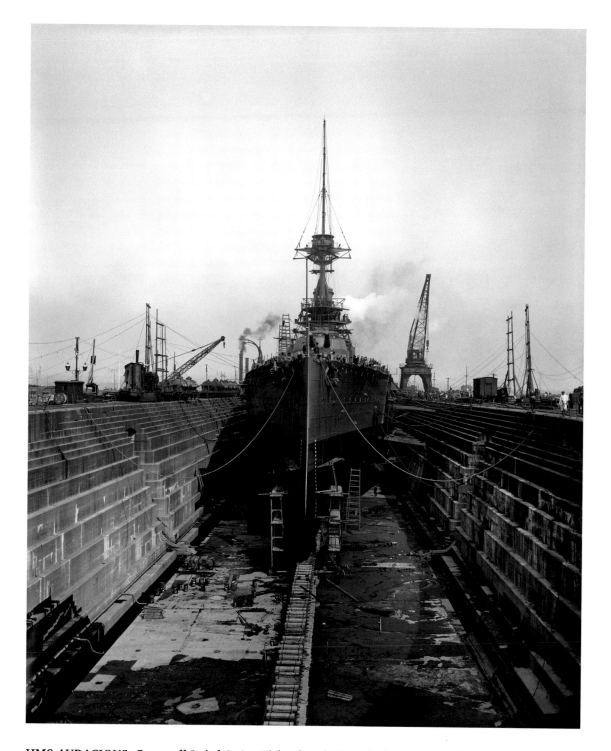

HMS *AUDACIOUS*, Cammell Laird & Co, Birkenhead, Wirral, photographed by HBL in 1913.
[BL22201/012A]

The battleship *Audacious* – 23,600 tons and with 10 13½in guns – is here being fitted out in a graving dock. *Audacious*, mined at Loch Swilly in October 1914, was the first serious naval loss in the First World War.

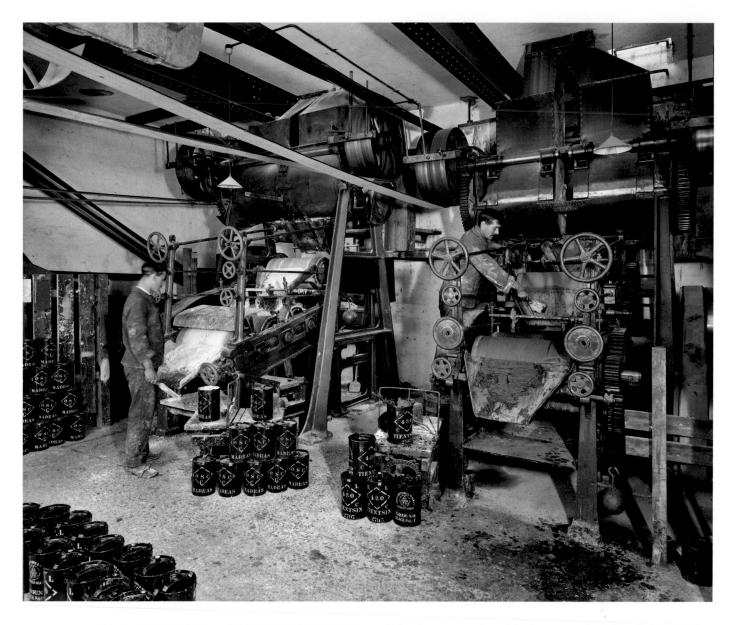

GROSS, SHERWOOD & HEALD'S PAINT WORKS, Jenkins Lane, London E6, photographed by HBL and AAB in 1910. [BL21001/006]

Striking (by modern standards) is how exposed much of the machinery is in the firm's industrial views, with workers in close proximity to innumerable belts and gears revolving at high speed. Not until the 1961 Factories Act was it laid down that 'every dangerous part of every machine must be securely fenced' although earlier laws had given employees some protection against employers' negligence.

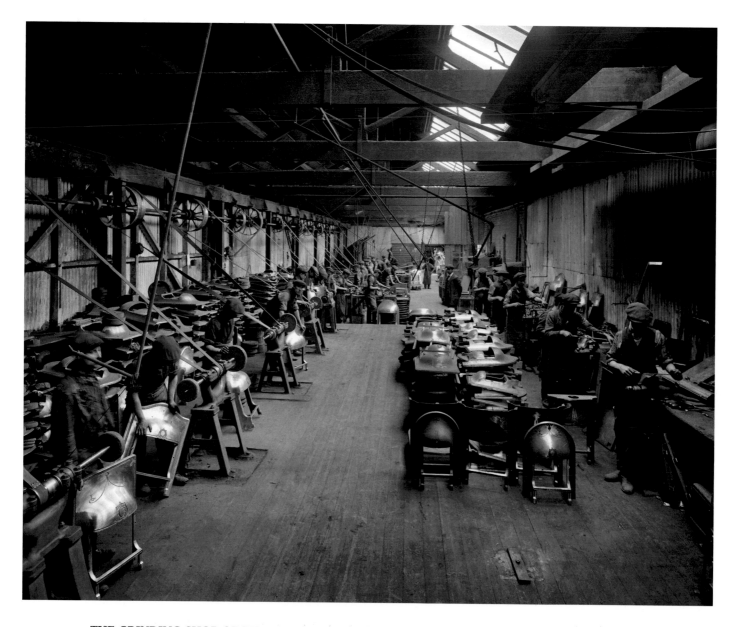

THE GRINDING SHOP OF THE DAVIS GAS STOVE CO, Diamond Foundry, Luton, Bedfordshire, photographed by AAB in 1913 for the company. [BL22178/010]

Hand finishing the fittings for gas fires and polishing the metal reflectors. Although primitive electric fires already existed, not many houses were as yet wired for electricity and gas was still very much cheaper for both heating and lighting.

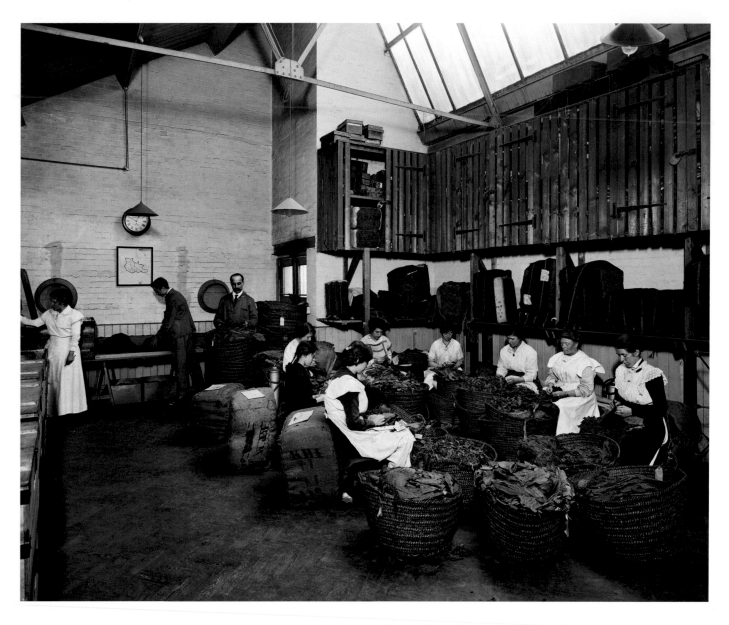

THE TURKISH LEAF ROOM OF TEOFANI & CO, 32 Chryssell Road, London SW9, photographed in 1916 for the company. [BL23660/007]

One of a series of views recording the processes of cigarette manufacture at the Teofani cigarette works in Brixton. Here women sort tobacco leaf by hand.

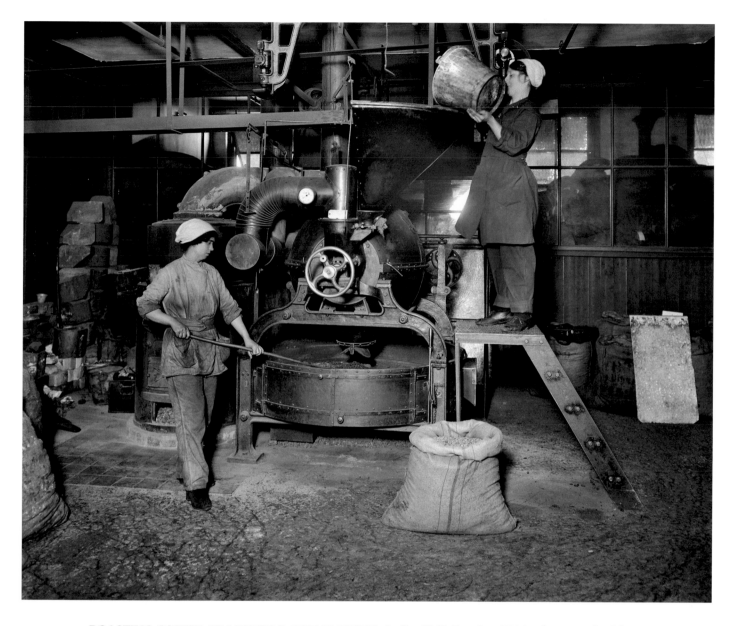

ROASTING COFFEE AT J LYONS & CO'S FACTORY, Cadby Hall, London W14, photographed by AAB in 1918 for the company. [BL24300/001]

The caterers J Lyons & Co (*see* pp 238–40) kept their prices down by large-scale production in their own Hammersmith factory. The war compelled very many businesses to employ women on jobs where they would formerly have employed men. Here, girls are apparently pouring coffee beans into a 'Sirocco' roasting machine – a good demonstration of how many industrial processes were as yet very far from wholly mechanised.

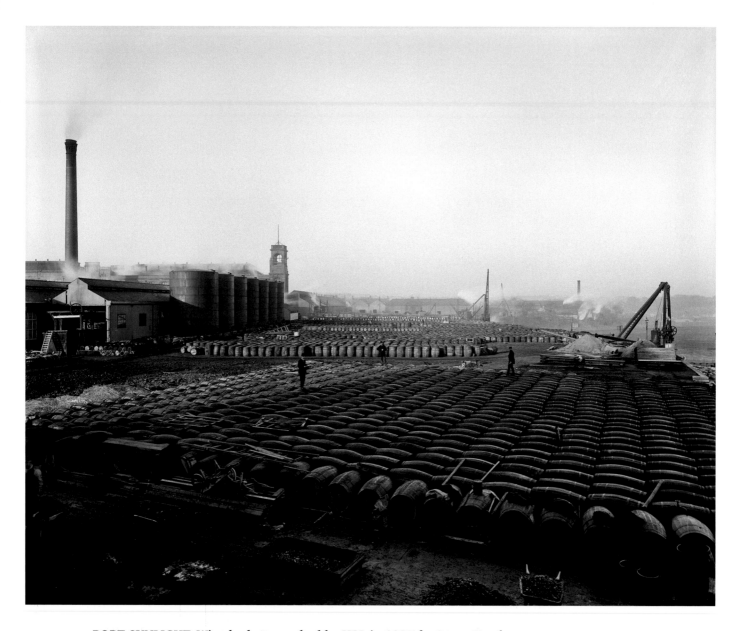

PORT SUNLIGHT, Wirral, photographed by HBL in 1897 for Lever Brothers. [BL14041/005]

The consumption of soap had increased enormously in the second half of the 19th century, with the removal of the soap tax in 1853, the growing availability of piped water in major towns, the growing provision of bathrooms in quite modest houses and the rapid rise of a middle class. W H Lever, 1st Lord Leverhulme, had introduced Sunlight Soap in 1884 – a blend of palm oil, cottonseed oil, resin and tallow – and its instant and fast-growing success created the need for a new factory. Buying the site of Port Sunlight on the Mersey in 1887, he proceeded to have it laid out as a factory town, with its own works, docks, offices and housing for his employees.

The bulk of the raw materials had to be imported – hence the perhaps 2,000 barrels on the quay which can be seen here.

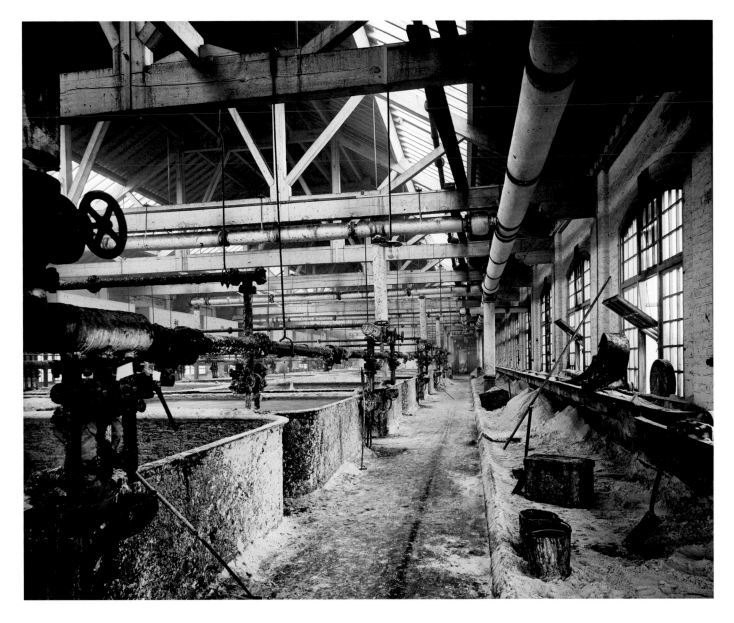

SOAP PANS AT PORT SUNLIGHT, Wirral, photographed by HBL in 1897 for Lever Brothers.
[BL14041/020]

W H Lever made soap on an industrial scale, but the basic processes involved (the mixing of fats with alkali) seem here to have remained primitive.

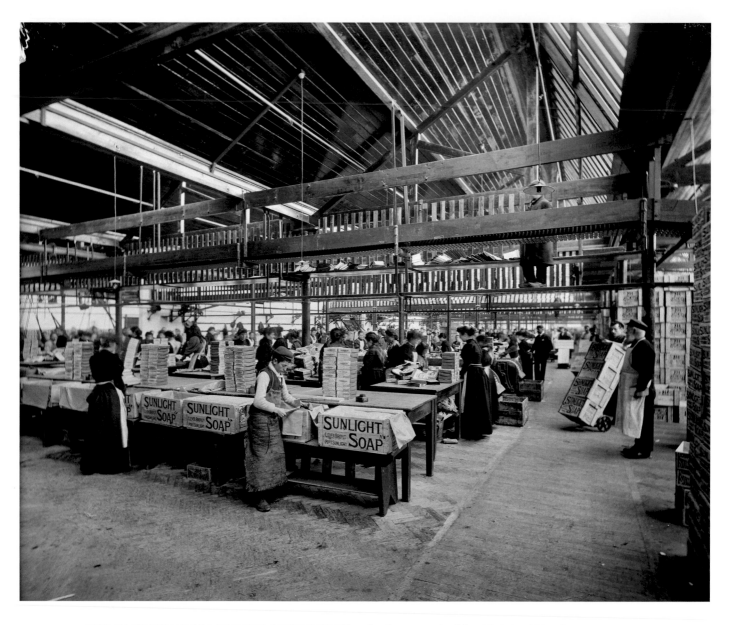

THE PACKING ROOM AT PORT SUNLIGHT, Wirral, photographed by HBL in 1897 for Lever Brothers. [BL14041/027]

The output of W H Lever's soap business rose from 3,000 tons a year in 1886 to over 14,000 tons four years later and continued to grow for years at a similar rate, led by his best-selling Sunlight Soap, here being packed for dispatch. An overseer is supervising the work from an upper walkway.

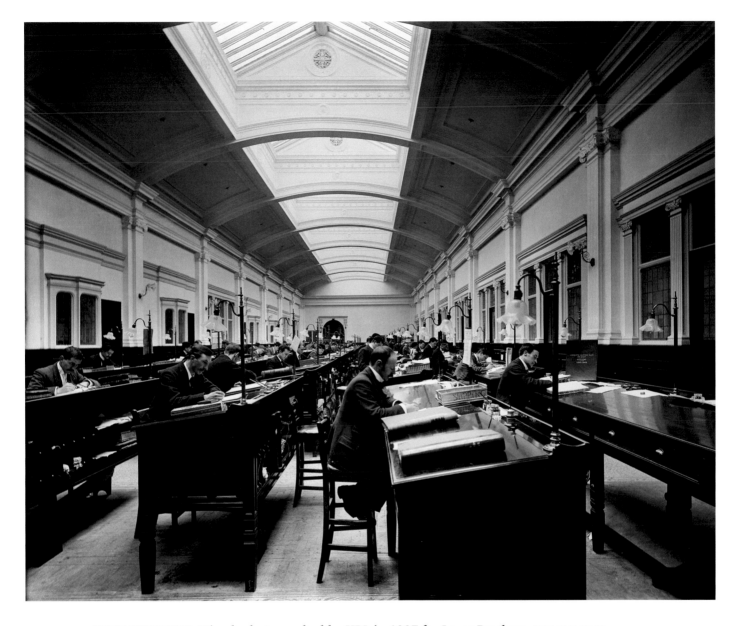

PORT SUNLIGHT, Wirral, photographed by HBL in 1897 for Lever Brothers. [BL14041/013]

All large enterprises required huge office staff when the accounts were still kept by hand; here are bookkeepers seated at rows of desks.

The 1st Lord Leverhulme ran his business with a dictatorial paternalism. Though believing in profit-sharing, he did not trust his employees to spend such profits wisely. Instead, while paying a normal level of wages, he provided them with superior working conditions, facilities of every kind for education and self-improvement, and cottages far better than the industrial norm. The business was enormously successful. In the decade in which Bedford Lemere & Co's series of photographs was taken, the firm introduced products that, for a century, were household names, including Vim household cleaner, Lifebuoy soap and Lux soap flakes.

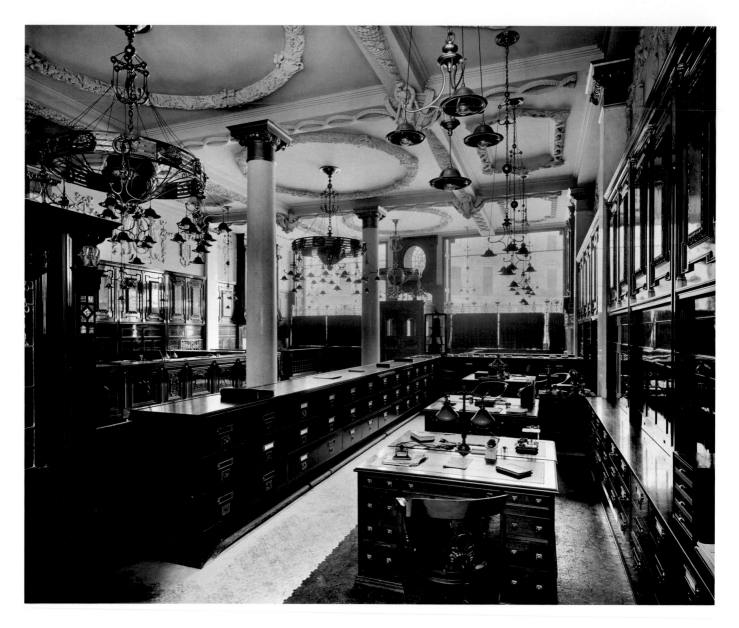

**OFFICES OF THE HAMBURG-AMERIKA LINE (Henry Stock and A T Bolton, 1906–8),
14–16 Cockspur Street, London SW1, photographed by AAB in 1908.** [BL20274/005]

The exterior of the office is on p 55. Perhaps the most remarkable thing about the interior, fitted out by Waring & Gillow, is the lighting.

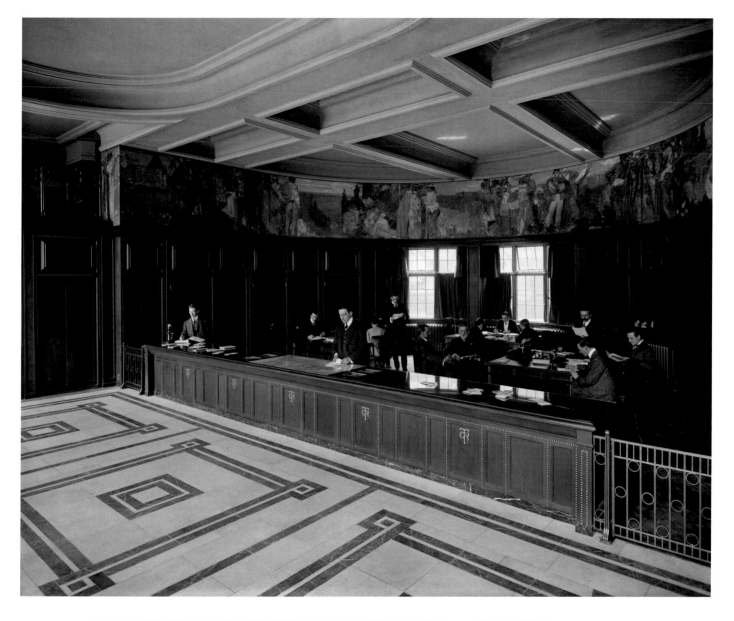

OFFICES OF THE GRAND TRUNK RAILWAY OF CANADA (Sir Aston Webb, 1907), 17–19 Cockspur Street, London SW1, photographed by AAB in 1909. [BL20591/002]

The offices of the Grand Trunk Railway of Canada were conveniently situated close to the offices of major shipping companies. The company commissioned the hugely acclaimed artist Frank Brangwyn to paint in tempera the 72ft-long frieze that runs around the upper part of the wall. In 1910 *The Studio* magazine (vol 48, p 40) described it as depicting 'the strife of the world of modern energy … of the making of the great highways of commerce, of the engineer and of the strong arm of labour, of the navvy and the roadman, with the bewildered braves and Red Indian warriors … . Through it all and dominating all is the glorification in the victory of man's hard work.'

The frieze was removed in 1975 and is now in the antechamber of the Canadian Government Conference Centre (formerly the Grand Trunk Railway Station), Ottawa, Canada.

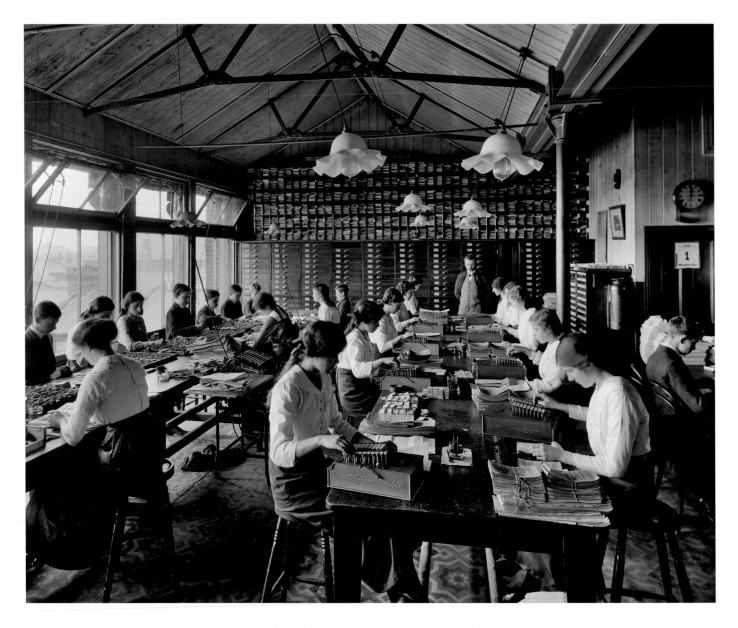

THE COMPTOMETER ROOM OF THE STRATFORD CO-OPERATIVE SOCIETY, Bow Road, London E3, photographed in 1914 for Felt & Tarrant, makers of the comptometer. [BL22762]

The co-operative retail movement, in which members share the society's profits on purchases that they buy, was (and remains) extremely successful. Calculating the individual members' dividends ('the divi') required the processing of vast quantities of receipts for small amounts. The staff here – girls and young boys (the school leaving age was then 12 and most of the boys will probably have aspired to move on in due course to better office jobs than the girls) – are working on model 'E' comptometers. The comptometer, the first successful manual calculating machine, had been patented in 1887 by Dorr Felt, an American.

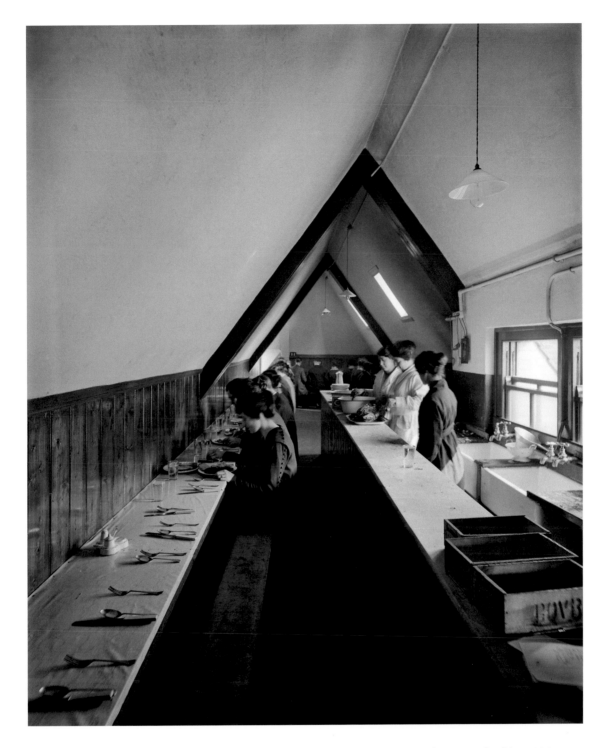

THE STAFF CANTEEN AT PEN CORNER, 41 Kingsway, London WC2, photographed in 1920.
[BL24881/012]

Pen Corner, owned by L G Sloan Ltd, was a large shop, selling and repairing Watermans and other pens. It is uncertain whether their staff lived in; it had been common practice in the drapery trade and often in other businesses, but the canteen here may have been only a lunch room. The photograph is one of a series.

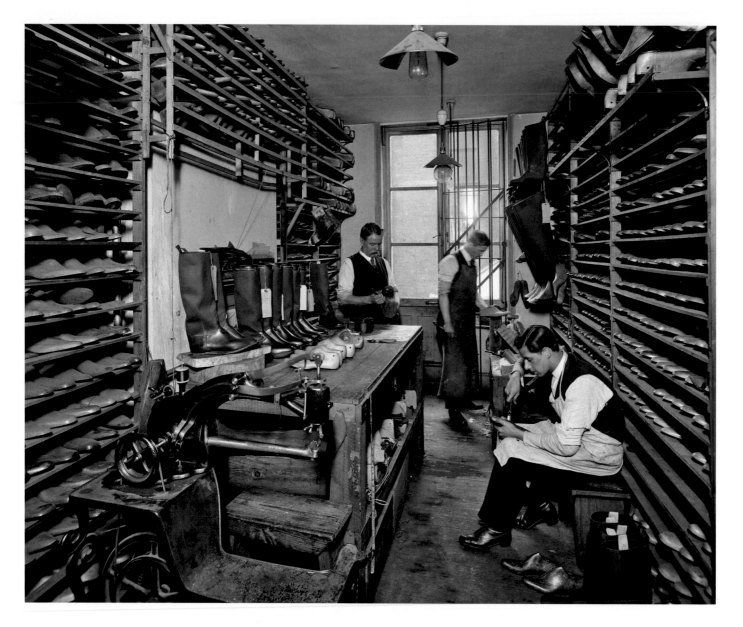

THE BOOT LAST WORKSHOP OF J C CORDING & CO, Kingly Street, London W1, photographed by AAB in 1915 for the company. [BL23018]

John Cording, outfitter and waterproofer, opened a shop in the Strand in 1839. The business moved to Piccadilly in 1877 where it remains, although it passed out of the hands of the family in 1971.

In their workshop a few minutes' walk away in Kingly Street, Soho, racks are filled with the lasts for customers' handmade boots and shoes, while cavalry boots wait on the bench.

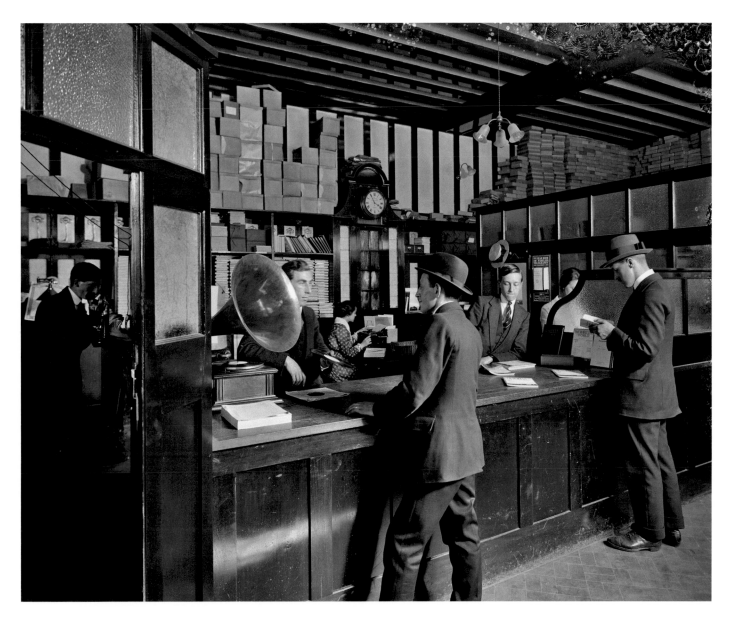

THE SALES OFFICE OF *WIRELESS WORLD*, Marconi House, The Strand, London WC2, photographed by AAB and colleague in 1916 for Marconi Wireless Co. [BL23577]

Wireless World was founded in 1911 (as *The Marconigraph*), the first journal devoted to the new science of radio. A (hand-wound) gramophone provides entertainment for the staff and their customers.

This view was photographed for the Marconi Wireless Company at Marconi House, which was originally built as the Gaiety Restaurant to the rear of the Gaiety Theatre (*see* p 52).

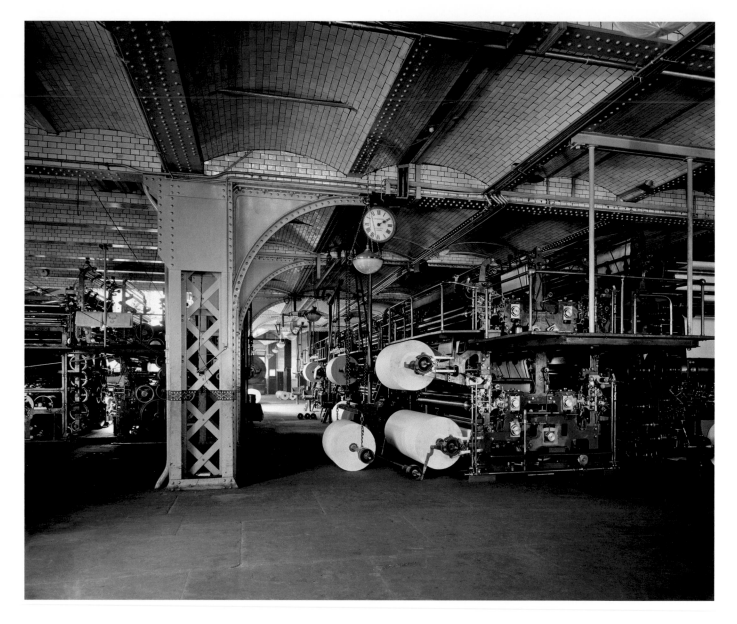

THE MACHINE ROOM OF *THE DAILY TELEGRAPH* PRINTING WORKS, Fleet Street, London EC4, photographed in 1913. [BL22128/008]

It is not clear why in 1913 Bedford Lemere & Co made a photographic record of the offices and printing works of *The Daily Telegraph*, then housed in Peterborough Court off Fleet Street. At the time, the paper was entering a long period of slow decline, influenced by competition from the populist *Daily Mail* and a reviving *Times*, its awkwardly large paper size and a forbidding appearance, an elderly editor, and a chief proprietor (the 2nd Lord Burnham) who was concerned more with his serious public duties than with the minutiae of newspaper management and who was reluctant to invest. Nevertheless its editorial standards were high and despite steadily falling sales the paper survived to be revitalised following its sale in 1927 to William Berry, later 1st Lord Camrose.

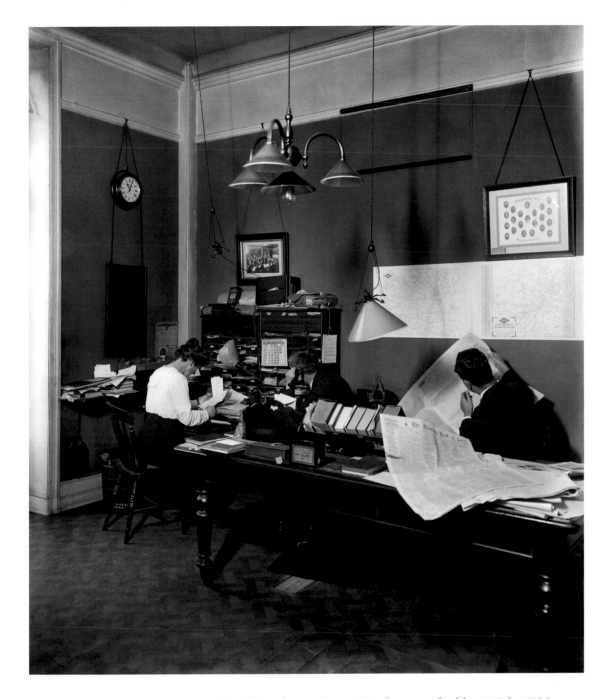

THE MORNING POST OFFICES, The Aldwych, London WC2, photographed by AAB in 1920.
[BL25220/013]

The hectic life of a newspaper office. To the left a secretary reads mail at a chaotic desk; at the centre, another member of staff is on the telephone; on the right an editor or a proofreader scans the paper, all oblivious to the photographer. It was normal at that date to power low voltage electrical appliances from light sockets – hence the dangling wires over the secretary's head.

The Morning Post was the oldest daily newspaper in Britain and, though housed since 1908 in a splendid new building on the Aldwych by C Mewès & A J Davis, it was at this time entering its final years, with a steadily declining circulation. It was a deeply conservative paper in every sense, vastly respected but with few readers, and its sales had sunk to well below 100,000 when it was bought by Lord Camrose in 1933 to merge with his rejuvenated *Daily Telegraph*.

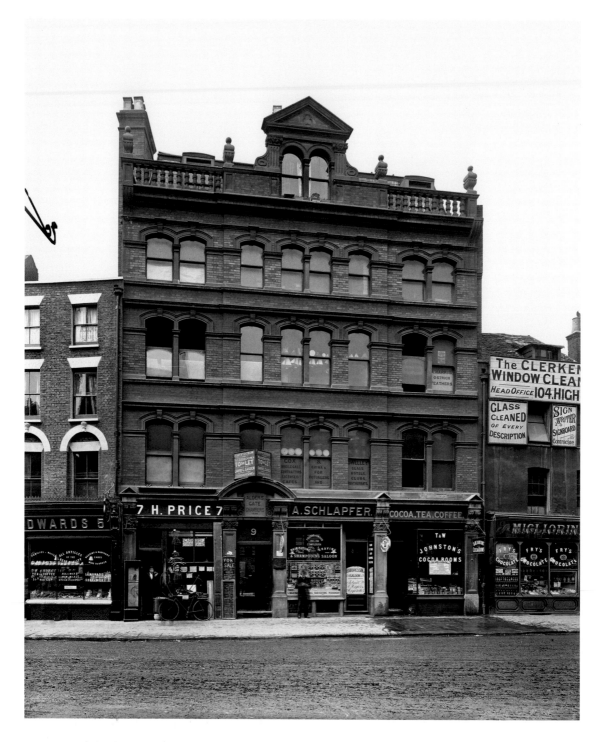

ALDERSGATE CHAMBERS, Goswell Road, London EC1, photographed in 1899 for City & West End Properties Ltd. [BL15327]

A nondescript commercial building of a ubiquitous type, perhaps built around 1880. The shops are those of H Price, shopfitters; Alfred Schlapfer, hairdresser; and Thomas & Walter Johnston's coffee rooms. The other occupants of the building were a manufacturing and a wholesale stationer, a basket maker, a tie maker, an accountant, a ruche maker, two straw hat dealers, a trimmings manufacturer, a leather goods dealer and a china merchant. Unidentified is whoever may have hung a string of toy boats in the second-floor window.

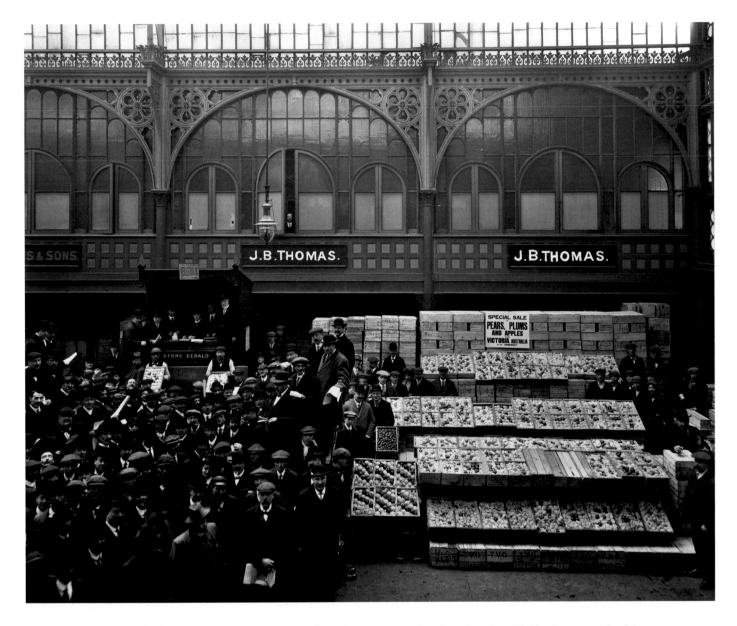

J B THOMAS'S DISPLAY IN THE FLORAL HALL, Covent Garden, London WC2, photographed in 1913 for J B Thomas. [BL22087]

J B Thomas described himself as 'fruit broker' and his address as Covent Garden Foreign Fruit Market. A crowd of individuals whose status is clearly marked by their hats and coats waits for the auction of Thomas's 'pears, plums and apples from Victoria, Australia', while the auctioneer himself, the right-hand figure in the booth, waits with his gavel in his hand.

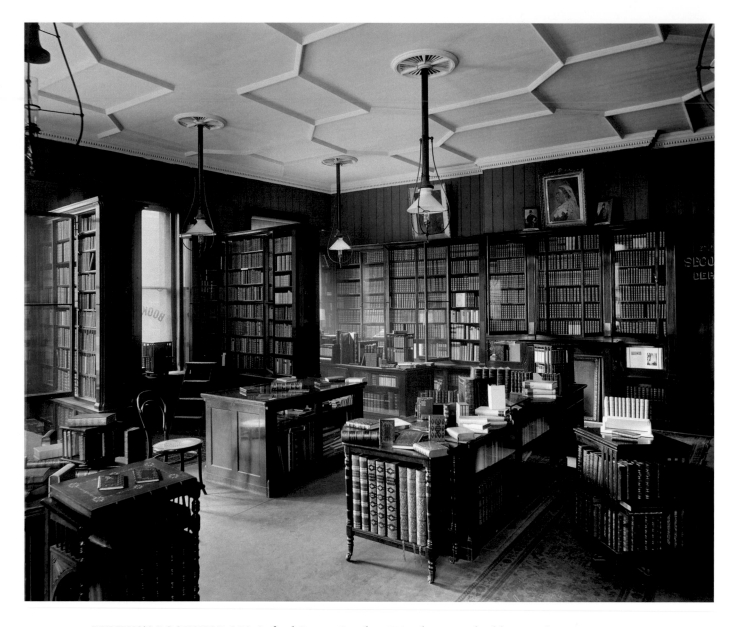

BUMPUS'S BOOKSHOP, 350 Oxford Street, London W1, photographed by AAB in 1894.
[BL12931B]

The highly regarded bookselling firm of John & Edward Bumpus Ltd was established in the 1790s. New books were sold on the ground floor of their Oxford Street premises, antiquarian books displayed on the first (shown here) and their less distinguished stock housed on the higher floors. Lighting is still by gas.

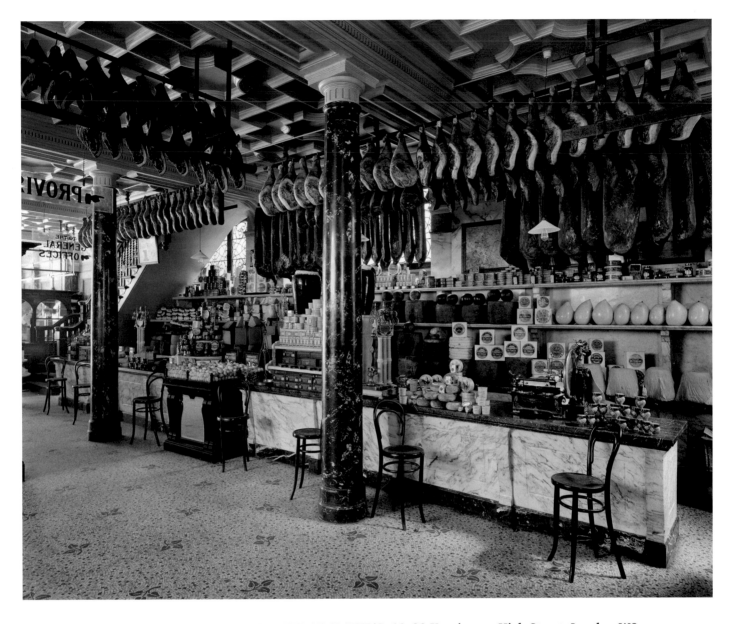

THE CHEESE AND BACON COUNTER AT SLATER'S, 18–20 Kensington High Street, London W8, photographed by AAB in 1909. [BL20640/003]

A high-class provision merchant in a part of London that had been becoming increasingly fashionable in the previous decades. Other counters photographed by Adolphe Boucher sold meat, fish, and jams and pickles.

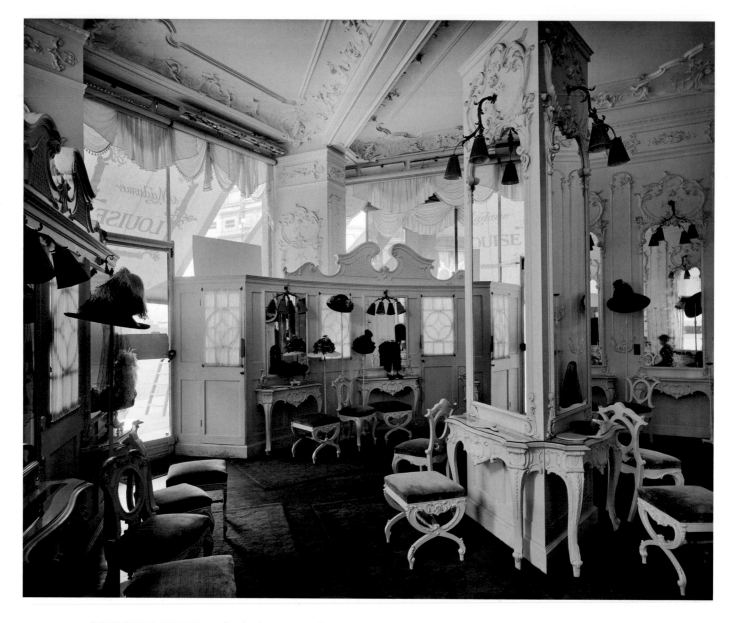

'MADAME LOUISE', Oxford Circus, London W1, photographed in 1912 for Bovis Ltd, building contractors. [BL21724]

'Madame Louise' had two shops in Regent Street: at no. 252 and at Oxford Circus, where she described herself as 'The First Milliner in Europe'. The decoration is French rococo, with its associations of fashion and wealth. Both shops would be redeveloped in the course of the Regent Street rebuilding scheme.

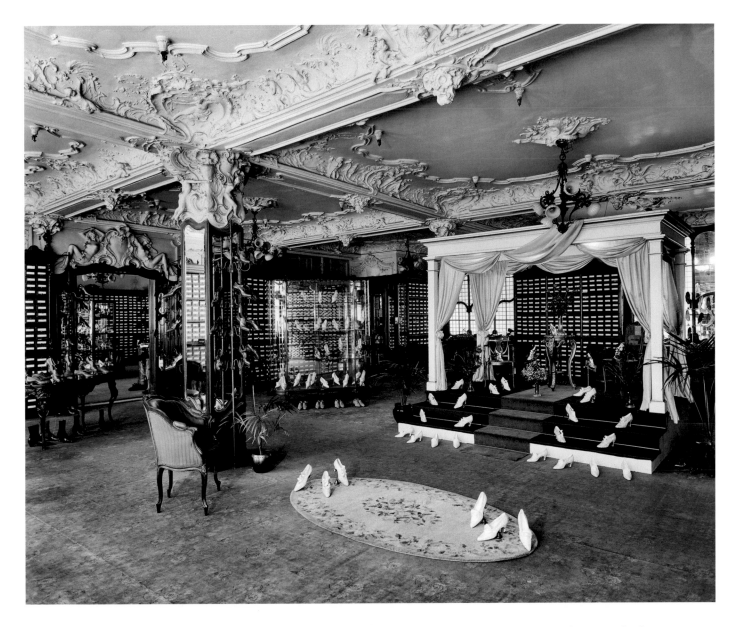

THE LADIES' BOOT DEPARTMENT AT HARRODS, Brompton Road, London SW1, photographed by AAB in 1919 for Mr Chandler. [BL24450/021]

Harrods had been rebuilt in 1901–5 by C W Stephens and in 1919 still retained its original interior decoration; here, *amorini* disport among particularly lively rococo plasterwork. At Harrods, built before the imminent change in building regulations allowing the greater use of load-bearing steelwork, the necessary use of transverse masonry walls made for a layout with physically separate departments rather than the more open spaces shortly achieved at Selfridges (*see* pp 47 and 58).

In this display, a flight of steps leads up to a shrine where a shop assistant will attend to her customer's desires.

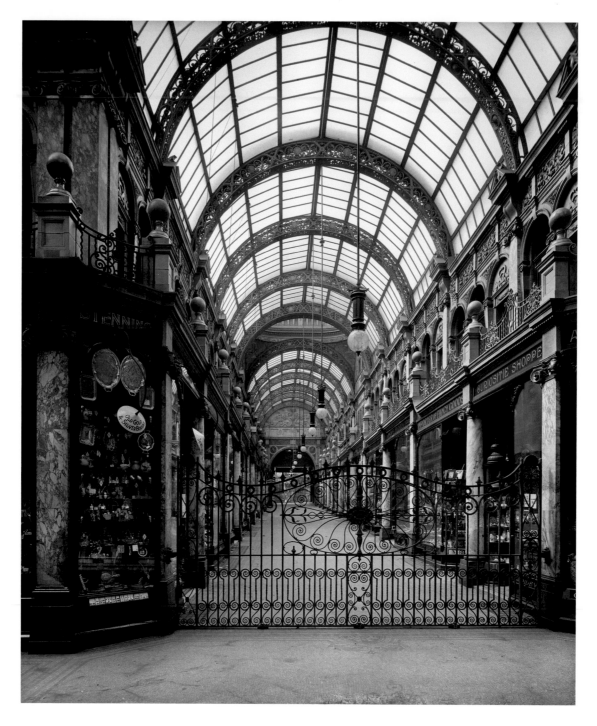

THE COUNTY ARCADE (Frank Matcham, 1898–1900), Leeds, West Yorkshire, photographed by HBL in 1904 for the Leeds Fireclay Company. [BL18252]

What Manchester was as the centre of the Lancashire cotton industry, Leeds was for the woollen trades, and the lavish rebuilding of a substantial area of the city centre in 1898–1904 reflected the huge wealth of the region. Architect for the development was Frank Matcham, much employed as a theatre designer, and his County Arcade is rich with Siena marble, mosaic and faience.

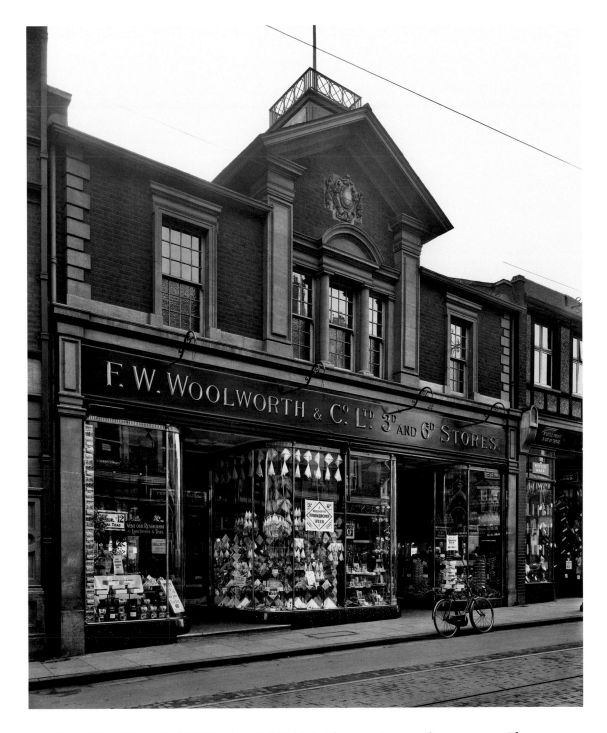

F W WOOLWORTH & CO (S V North & C C Robin), Clarence Street, Kingston upon Thames, Surrey, photographed in 1920 for W J Wilsdon. [BL25186]

A subsidiary of the American firm, Woolworth's opened its first English store in 1909 in Liverpool, and by the 1920s was opening new shops at a rate of almost two a month. For many years the sales formula – selling everything for 3d or 6d – was the same as the 'five and ten' of its parent.

The shop in Kingston upon Thames – probably recently built – is advertising 'handkerchief week' with an artistic window display.

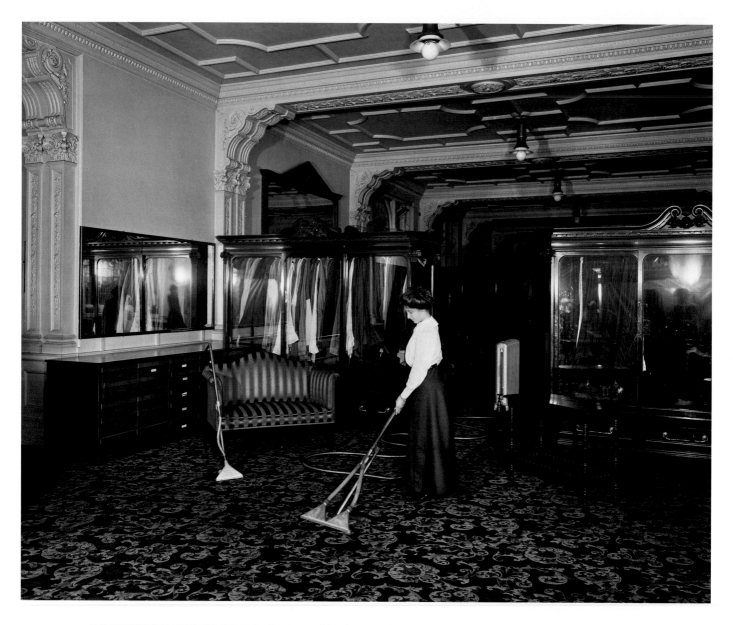

GORRINGE'S DEPARTMENT STORE, Buckingham Palace Road, London SW1, photographed by HBL in 1910. [BL21028]

Department stores were a phenomenon of the second half of the 19th century, and would come to sell almost anything that might be needed by the members of the fast-growing middle class – by ladies in particular, with respectable homes to furnish and to maintain, with families to provide for and with servants who left them with time on their hands. Shop owners would spend the profits made possible by economies of scale by providing settings of reassuring magnificence. Besides being able to buy all their needs under one roof, in the department store customers could find deferential shop assistants and decorous refreshment when they had finished.

Vacuum cleaners had been invented three years earlier. Gorringe's Department Store, close to Buckingham Palace, is said to have been much patronised by ladies of the Royal Household.

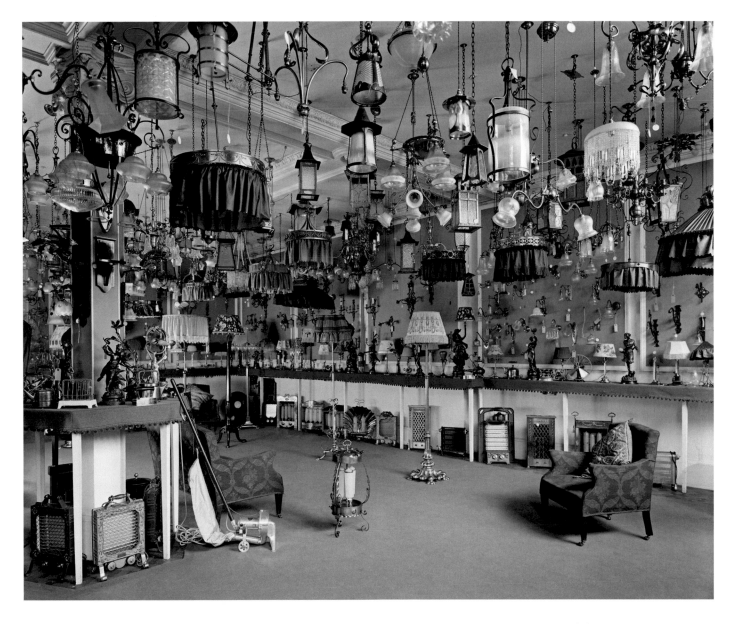

THE ELECTRICAL DEPARTMENT OF BARKER'S DEPARTMENT STORE, Kensington High Street, London W8, photographed by AAB in 1913 for Barker & Co. [BL21977]

Although electric light fittings in a bewildering variety of styles are the principal things on sale, other electrical appliances are already appearing, including electric fires, electric kettles and a vacuum cleaner.

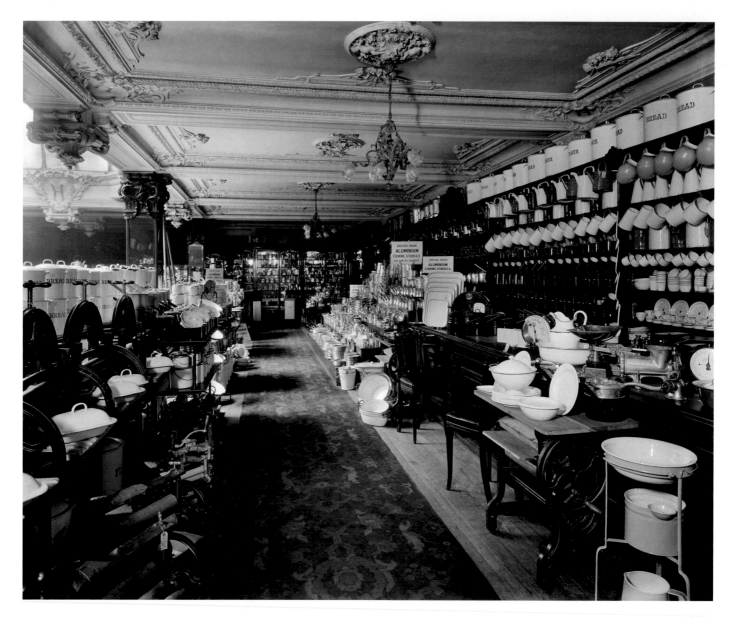

THE IRONMONGERY DEPARTMENT OF HARRODS, Brompton Road, London SW1, photographed by AAB in 1919 for Mr Chandler. [BL24450/001]

Many of the objects on offer here could well have been on sale 50 years before. There are mangles for wringing laundry, lidded jugs (high on the right) for servants to carry hot water to bedrooms and quantities of other enamel ware. However, 'British made aluminium cooking utensils' are prominently displayed to the rear right: it was only in the previous few years that aluminium had been available cheaply enough to be used for such everyday purposes.

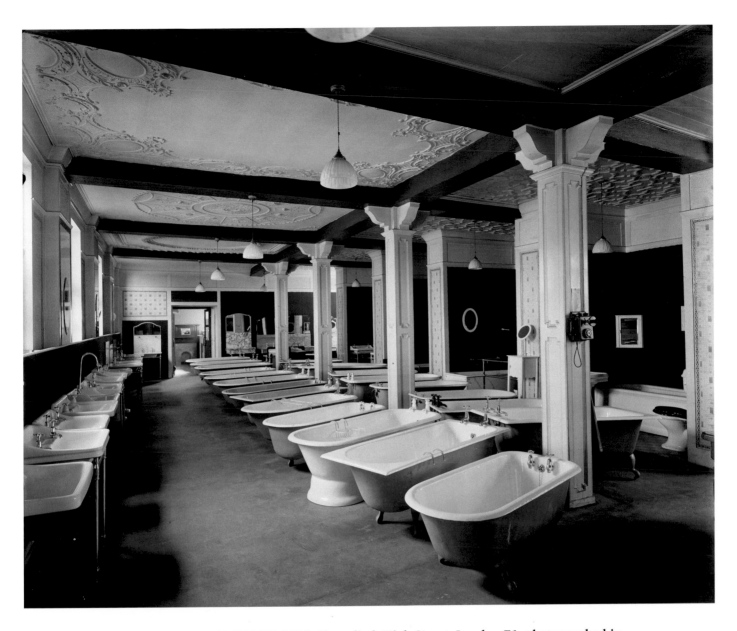

NICHOLLS & CLARKE'S SHOWROOM, Shoreditch High Street, London E1, photographed in **1928.** [BL29676]

Baths and basins at Nicholls & Clarke, wholesale and retail ironmongers of Shoreditch High Street and Blossom Street.

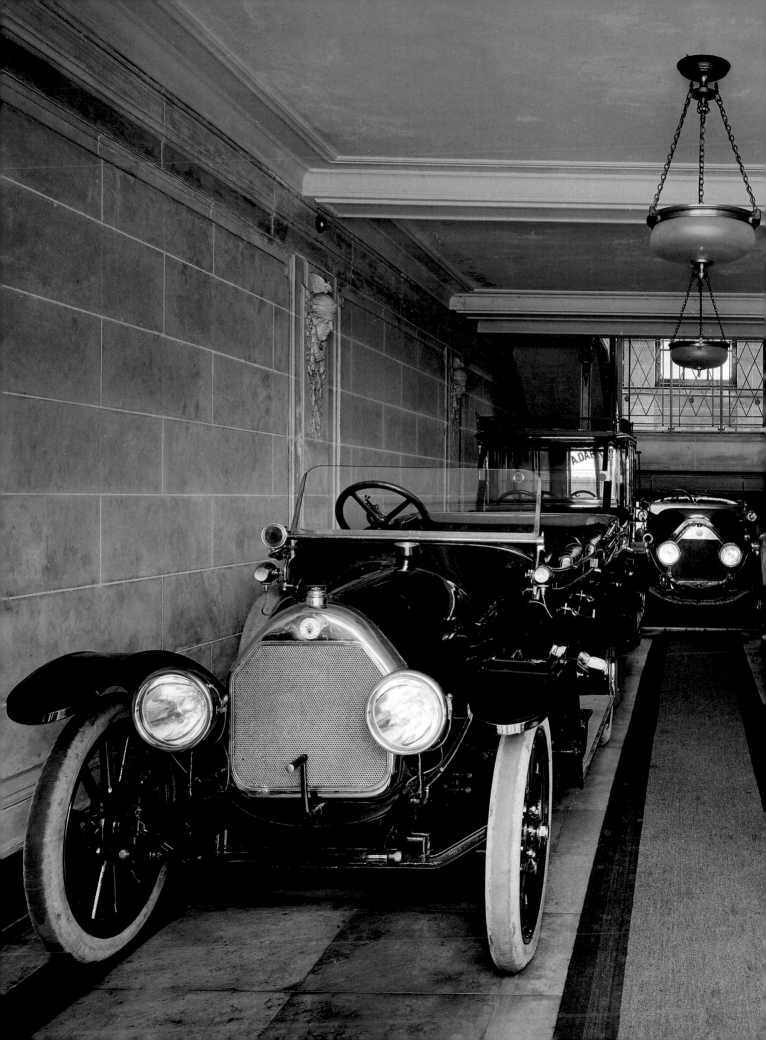

TRANSPORT
AND TECHNOLOGY

Innovations in transport and technology opened up new opportunities for photographers, which Bedford Lemere & Co – already working for firms that were branching out into these new fields – were in a position to exploit. For much of the firm's history, trains and horses had been the universal mode of transport for goods and people, and they would remain significant for many years to come. But these years also saw the coming of the motor car and the first buildings, at first adapted and then purpose-built, for their storage and servicing. Bedford Lemere & Co were also the leading photographers of the ocean liners built in British yards – liners which were growing steadily in speed, size and comfort.

Power supply was also changing. While gas had been readily available in most towns from the mid-19th century, electricity was slowly advancing from the late 1880s for lighting in the home and the office, for power in industry and to drive London's underground railways. And in communications, the period saw the rapid growth of the telephone and the invention of wireless.

CARS IN THE DARRACQ SHOWROOM
(R Frank Atkinson), New Bond Street, London
W1, photographed in 1914. [BL22664]

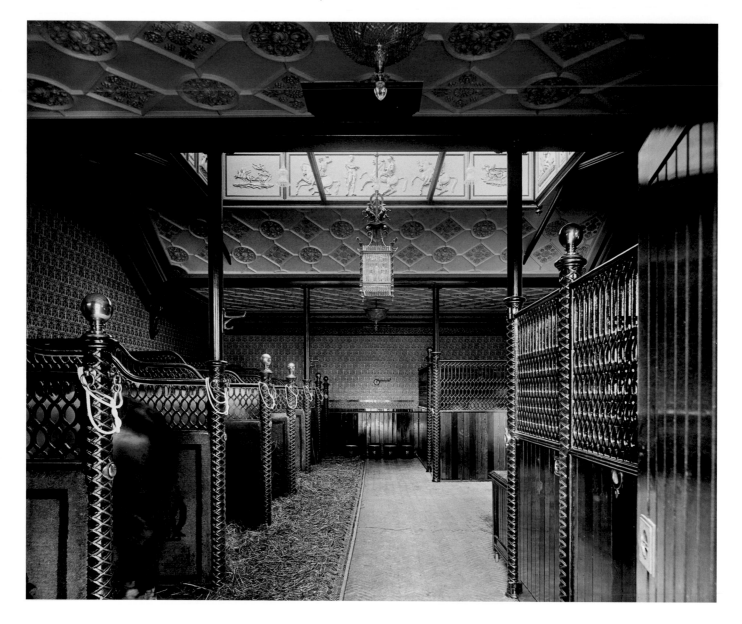

STABLES, 33 PALMEIRA MANSIONS (H J Lanchester, 1883), Church Road, Hove, East Sussex, photographed by HBL in 1893. [BL12321]

33 Palmeira Mansions was built by the local architect H J Lanchester (father of the more famous H V Lanchester, architect of Cardiff City Hall, and G H Lanchester, a notable motor engineer) for A W Mason, an ink manufacturer. The relief-patterned ceiling covering in the luxurious stables may have been carried out in embossed metal, widely used in the USA as a fireproofing (though only occasionally in England).

Significantly, the stables were later converted to a car showroom. At the time of writing, the shell of the building survives, with the frieze of prancing horses around the roof lantern still intact.

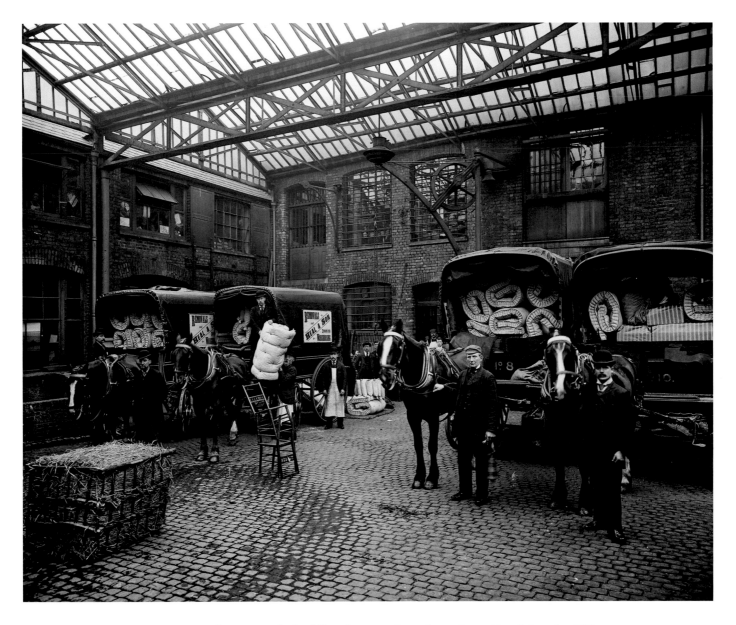

DELIVERY VANS, Heal & Son Ltd's bedding factory, Tottenham Court Road, London W1, photographed by AAB in 1897 as part of a series for Heal's. [BL14021]

Heal's was founded as a mattress makers, and beds and mattresses remained an important part of the firm's business. Made in Heal's own workshops, here they are being loaded into the firm's vans for delivery.

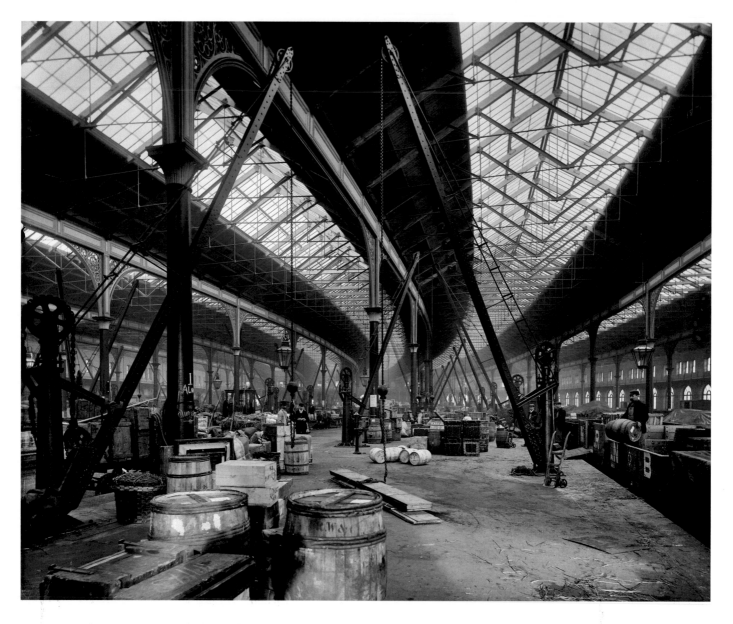

MECHANISED GOODS HANDLING AT FORTH BANKS GOODS STATION, North British Railway, Pottery Lane, Newcastle upon Tyne, photographed by HBL in 1893. [BL12500/002]

By the end of the 19th century, hydraulic power – pioneered by William Armstrong in Newcastle – was very widely employed in docks and warehouses. At the Forth Banks Goods Station – built by William Bell – ranks of hydraulic cranes are used for handling a diversity of cargo at a time when the railways carried goods of every kind and loads of all sizes.

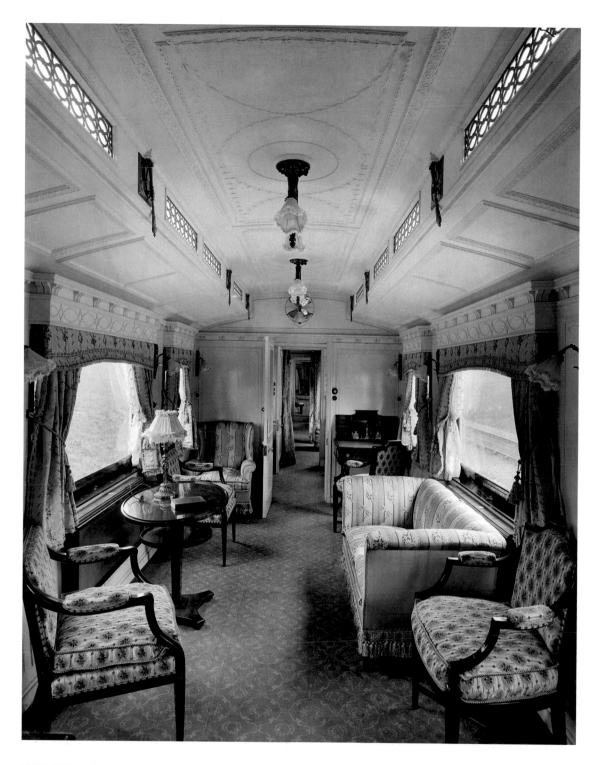

THE QUEEN'S DAY SALOON, The Royal Train, London & North Western Railway, photographed by HBL in 1902. [BL17421/005]

Most of the major railway companies had their own royal trains, and several built new ones for the new reign. The furnishing style of the London & North Western train is a good illustration of how far, at the beginning of the new century, a taste for diminished clutter had already progressed at the smartest levels of society. The king's and queen's saloons were virtually identical, differing only in the colour schemes of the upholstery.

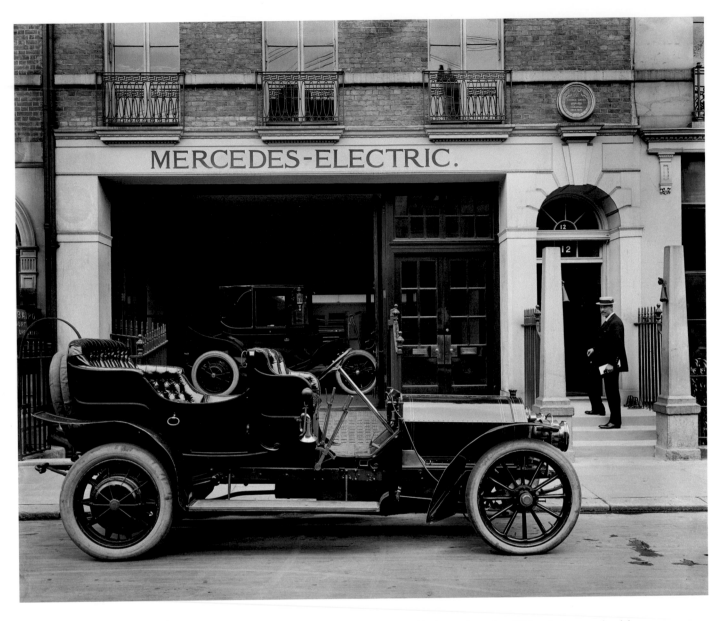

THE MERCEDES-ELECTRIC MOTOR SHOWROOM, 12 Savile Row, London W1, photographed by AAB in 1907 for Dewynters Ltd, advertising agents. [BL19996/001]

A Georgian house with its ground floor knocked out. When motoring was still largely the preserve of the rich, it was important that showrooms should be conveniently located for their clients. Savile Row is better known for its fashionable tailors, established here for the same reason. A (petrol-engined) touring car stands in the road; in the showroom is an electric Brougham, a town car whose convenience, silence and ease of operation were compensations for its limited range.

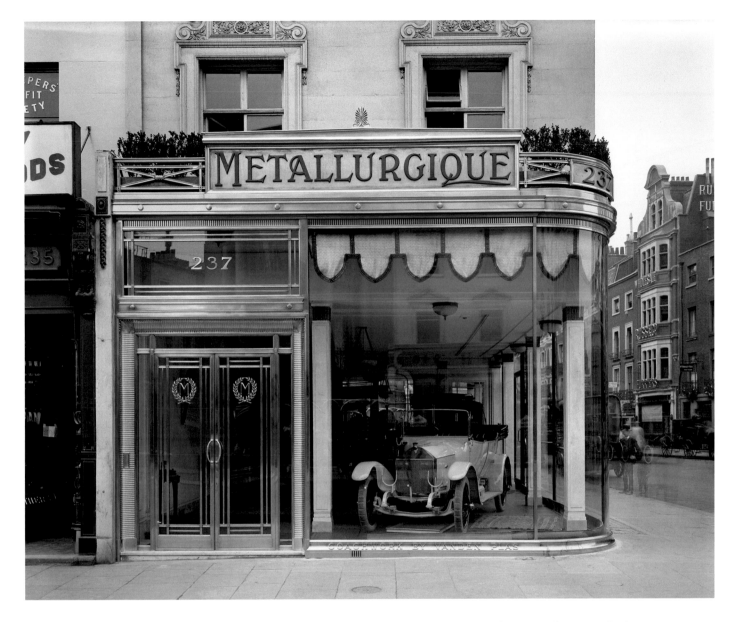

THE METALLURGIQUE MOTOR SHOWROOM, 237 Regent Street, London W1, photographed by AAB in 1913 for *The Architectural Review*. [BL22290]

Like the Mercedes-Electric showroom in Savile Row *(facing page)*, the Metallurgique motor showroom was located in the smartest part of town. Metallurgique was a Belgian company, though England accounted for a good deal of the market for its often innovative cars. The window sill announces 'coachwork by Vanden Plas' – another originally Belgian firm, which built the bodies of many cars at the luxury end of the market.

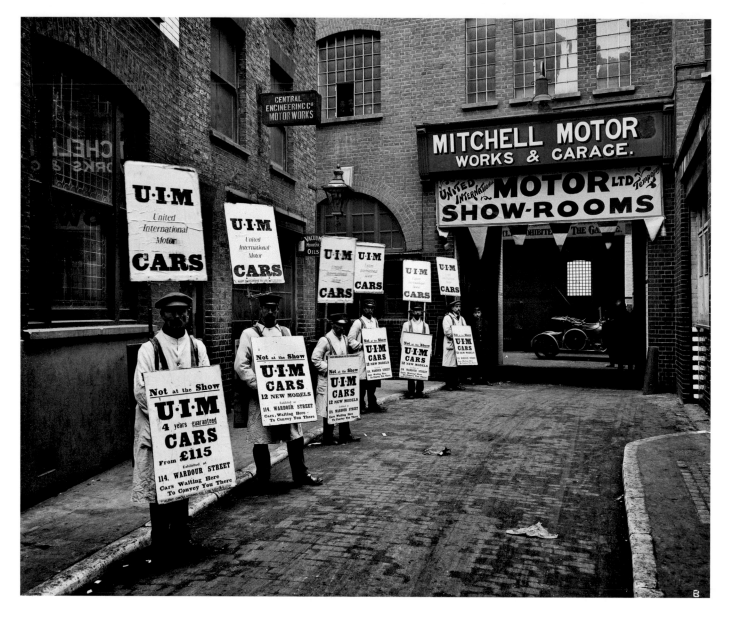

SANDWICH MEN AT MITCHELL MOTOR WORKS & GARAGE, 114 Wardour Street, London W1, photographed by AAB in 1910. [BL21037B]

In the early days of the motor industry numerous small firms failed for want of working capital. UIM – 'United International Motor' – was the English arm of the United States Motor Company which sought to bring together a number of small manufacturers in order to pool resources and sales. The variety of models on offer from the different manufacturers in the group, and the expense of a single-make stand at the Olympia Motor Show, are probably the reasons why UIM chose to show at Mitchell's Motors in Soho. £115 was around the price of the cheapest cars made in Europe at the time.

The number of cars on British roads was growing quite fast – from 8,500 in 1904 to 53,000 in 1910; in 1909 *The Motor* claimed that there were 40,000 cars in London. This was certainly an exaggeration, but it reflected the fact that motoring was as yet an activity for the rich. Mass motoring would have to wait for mass production (Henry Ford established his first English plant in 1911) and the many small manufacturers of cheap cars could not yet have supplied a large demand.

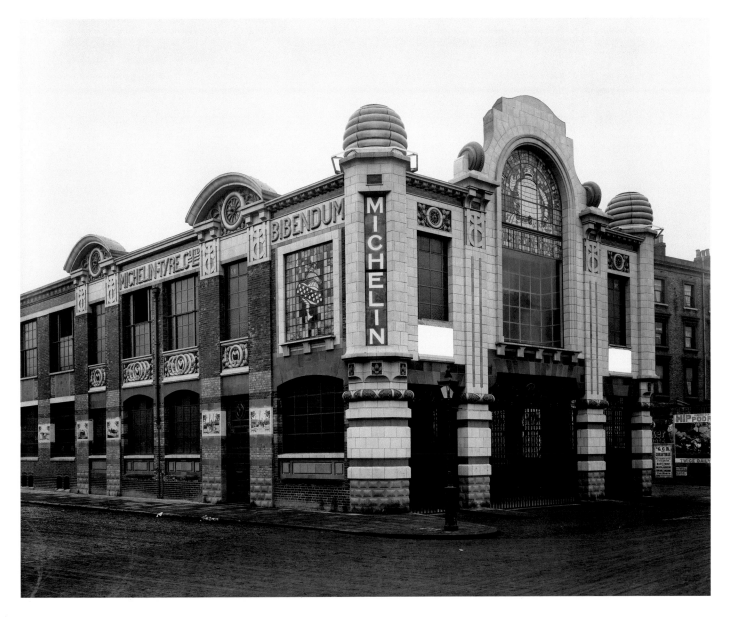

THE MICHELIN TYRE COMPANY (François Espinasse, 1905, extended 1910), 81 Fulham Road, London SW3, photographed in 1910 for the Leeds Fireclay Company. [BL21077]

Very witty, and very un-English. Domes on the corner turrets represent stacks of different-sized tyres, while Monsieur Bibendum, the Michelin Man, seems to strike a god-like pose in the stained-glass window at the centre. Above him is the company motto 'nunc est bibendum' from an ode by the Roman poet Horace –

> *Nunc est bibendum, nunc pede libero*
> *Pulsanda tellus.*
> (Now for drinking; now to beat the ground with feet set free.)

The Michelin building was sensitively restored and put to new use as a restaurant in 1985–6 by Conran Roche and the architects Yorke, Rosenberg & Mardall – an appropriate use in view of the motto and the fact that Monsieur Bibendum is holding a glass of wine in his hand.

The structure of the building is reinforced concrete, faced with polychrome Burmantofts tiles by the Leeds Fireclay Company (*see also* pp 140, 173 and 238). Plaques on the long side wall of the building depict races in which winning cars had been shod with Michelin tyres.

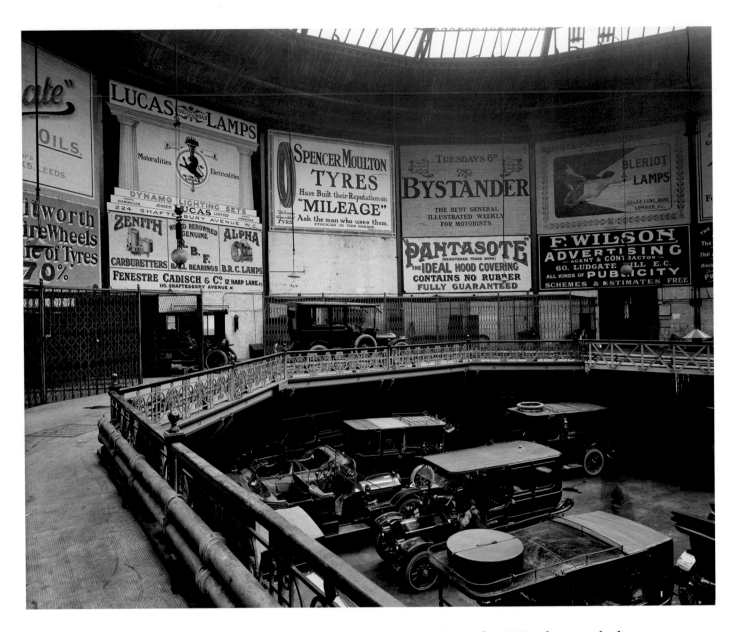

THE WOLSELEY GARAGE, Petty France (formerly York Street), London SW1, photographed by AAB in 1913 for the Wolseley Tool and Motor Car Co Ltd. [BL22169/001]

The growth of motoring made great demands on accommodation for cars, particularly in London, at a time when their mechanics and bodywork did not allow them to be kept in the open. The Wolseley Garage was established in the Niagara Hall, a skating rink built in 1890 where a huge panorama of Niagara Falls was installed to provide an appropriate background in 1895. In 1902 it closed for skating and opened as a garage – initially for the City & Suburban Electric Carriage Co and from 1906 by the Wolseley Tool and Motor Car Co – for the storage and repair of customers' cars.

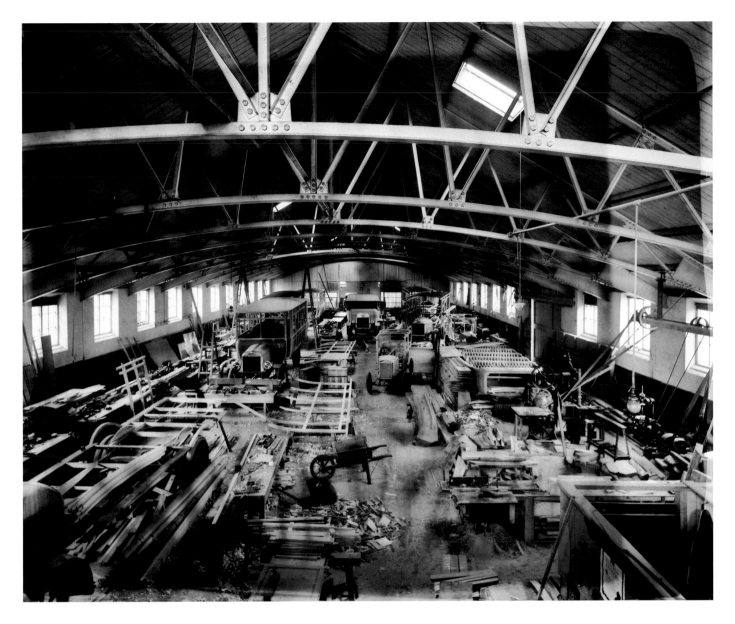

F M THOMPSON & SONS' MOTOR BODY WORKS, Ramsgate Road, Louth, Lincolnshire, photographed in 1920 for the company. [BL25222]

F M Thompson & Sons described themselves as 'Builders, joiners & contractors & coach & motor body builders'. The ever-expanding market provided many opportunities for enterprising firms to enter the motor business.

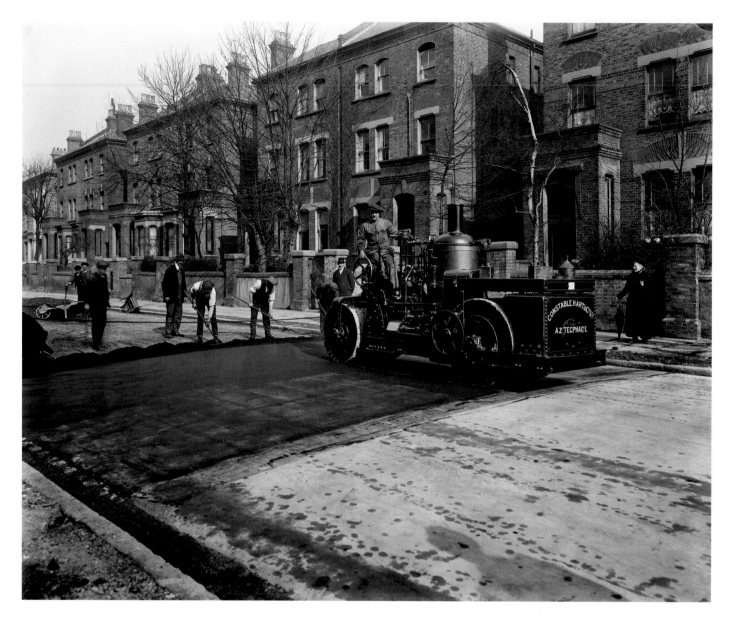

ROAD MAKING, Constable Hart & Co, London, photographed in 1920 for the company.
[BL24939/004]

Constable Hart & Co (described as 'Tar Paviours') exercise their American-made, Buffalo Springfield vertical boilered, gear-drive steamroller on a job somewhere in London.

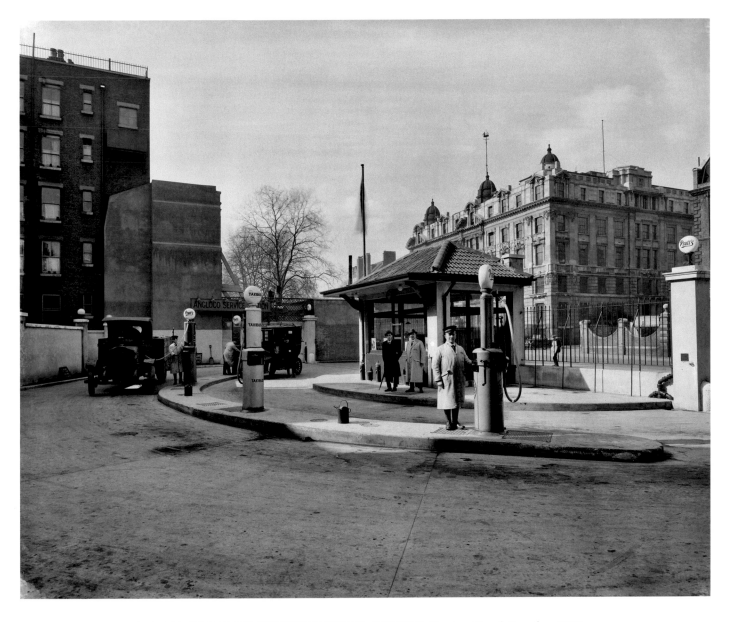

THE ANGLO-AMERICAN OIL COMPANY PETROL STATION, Euston Road, London WC1, photographed by AAB in 1922 for F D Huntington, building contractors. [BL26025]

Until very recently, petrol had been sold only in cans. Petrol pumps (hand-cranked, as here) were first introduced in the USA; the first in England are said to have been installed in 1919. In this superior and purpose-built petrol station, laid out for two-way traffic, petrol was delivered by a uniformed attendant. Anglo-American changed its name to Esso in 1951.

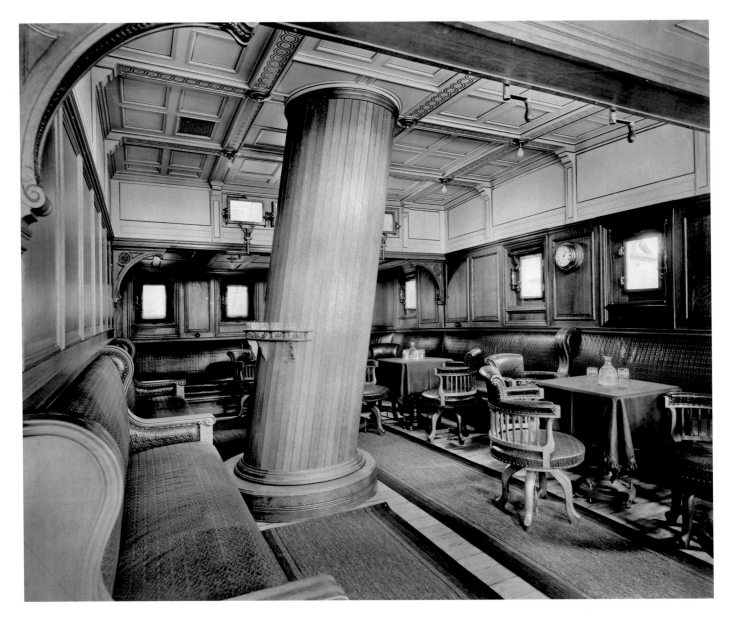

THE SMOKING ROOM, RMS *Dunottar Castle*, photographed by HBL and colleague in 1897.
[BL14400]

Dunottar Castle was built in 1889 by the Fairfield Ship Building Co at Govan on the Clyde; with the Castle Line in the 1890s she set new records for the passage to South Africa. During the Boer War (1899–1902) she carried at one time or another the commander of British forces, Sir Redvers Buller; his replacement, Lord Roberts; Lord Kitchener; Colonel Baden-Powell, the defender of Mafeking and founder of the Boy Scouts; and a young war correspondent, Winston Churchill.

The raking pillar in the photograph is the lower part of the ship's mainmast, its weight carried down to rest on the vessel's keel plates. Among the last generation of steam ships to be built with additional wind power, *Dunottar Castle*'s sails had been removed at a recent refit, but the masts remained, the yards useful for cargo handling.

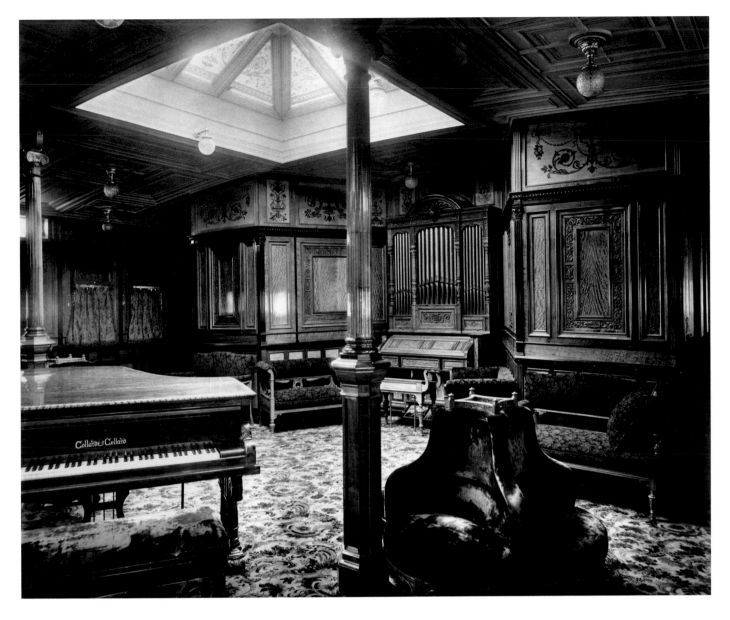

THE SALOON, RMS *Lucania*, photographed by HBL in 1893 for Cunard Steamship Co Ltd.
[BL12386]

When built, the Cunarder *Lucania* was the fastest liner on the North Atlantic, in 1894 recording times of only five days and eight hours for both east-bound and west-bound voyages. The ship was destroyed by fire in 1909.

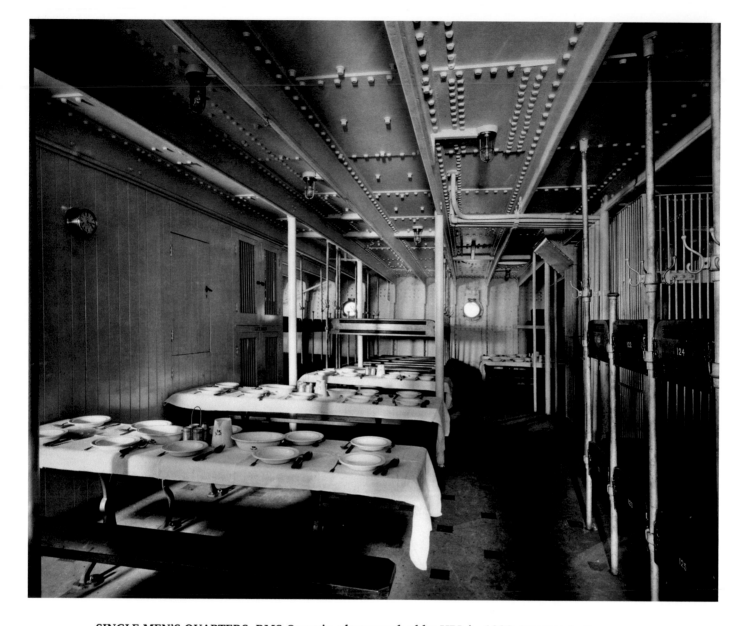

SINGLE MEN'S QUARTERS, RMS *Oceanic*, photographed by HBL in 1899. [BL15581/059]

The White Star *Oceanic*, launched in 1890, was at the time the most luxurious liner on the North Atlantic run. None of that luxury percolated down to the steerage, where passengers ate their meals in the place where they slept in double-tiered bunks.

Converted as an armed merchant cruiser at the outbreak of war, *Oceanic* was shipwrecked off the Shetlands in 1914.

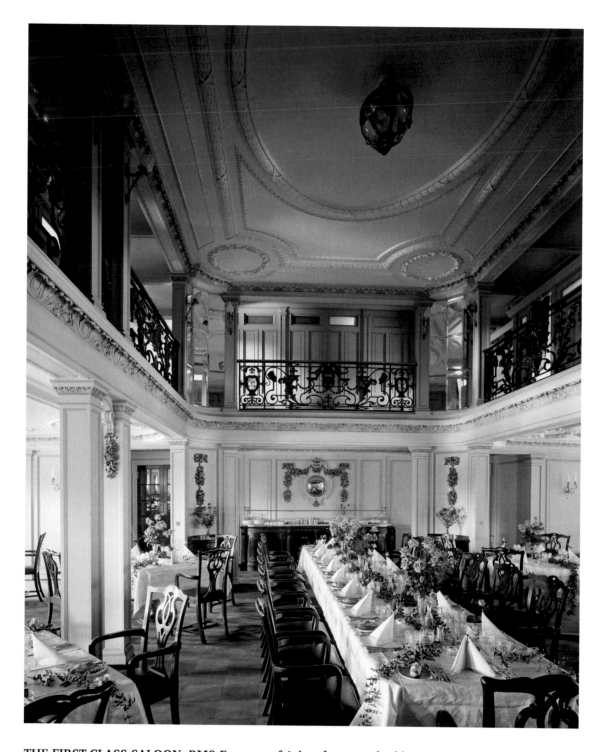

THE FIRST-CLASS SALOON, RMS *Empress of Asia*, photographed by HBL in 1913. [BL22181/001]

Built on the Clyde in 1913 for the Canadian Pacific Line's Pacific service. She had an eventful career during the First World War as an armed auxiliary cruiser and troop carrier, and was lost to Japanese aircraft in February 1942 when sailing from Bombay to Singapore carrying 2,000 troops.

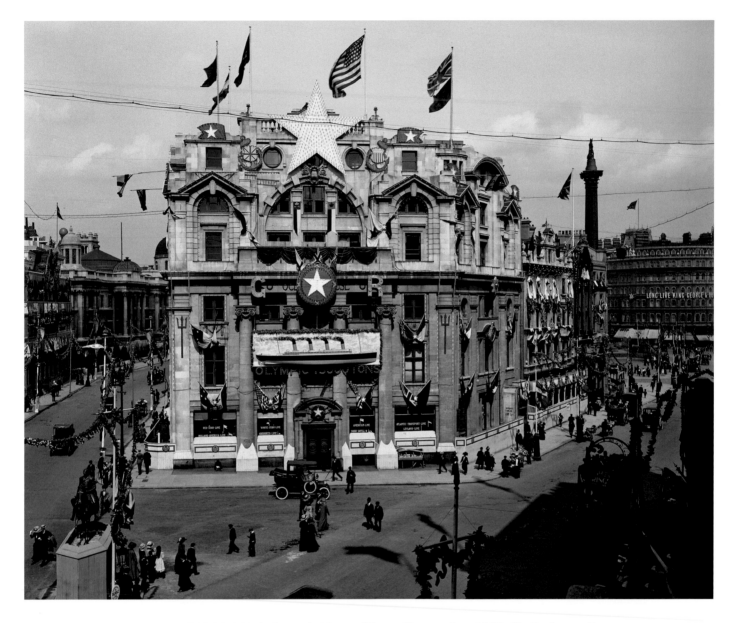

CORONATION DECORATIONS, Oceanic House (Henry Tanner Jnr, 1903–6), Cockspur Street, London SW1, photographed by AAB in 1911. [BL21285]

Most of the West End's shipping offices were located in the area of Trafalgar Square. Oceanic House was built for the International Shipping Company, the trust which controlled (among others) the White Star Line. A model of the company's newest liner, RMS *Olympic*, forms a prominent part of the decorations as does a white star.

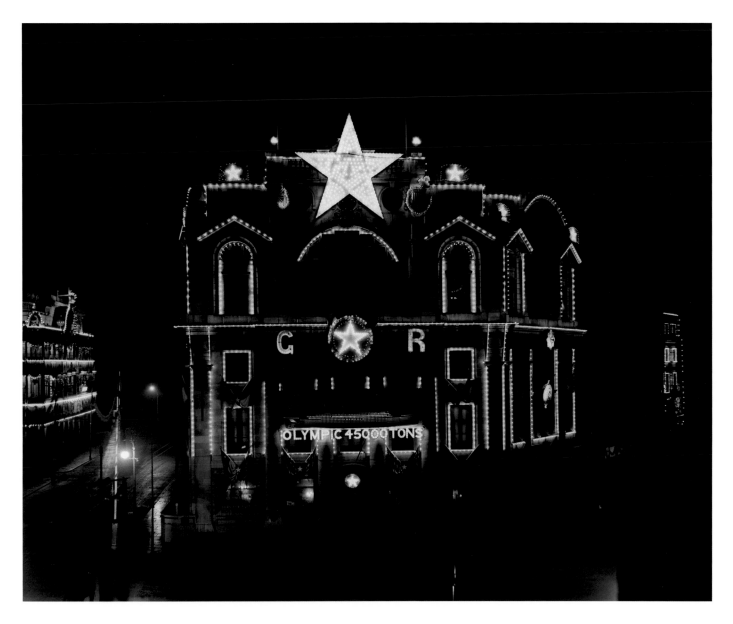

CORONATION DECORATIONS BY NIGHT, Oceanic House (Henry Tanner Jnr, 1903–6), Cockspur Street, London SW1, photographed by AAB in 1911. [BL21289]

Noted by *The Illustrated London News* as among the most spectacular of the celebratory decorations. The façade was lit by 3,000 electric lights, mostly green, and surmounted by a huge white star 30ft across.

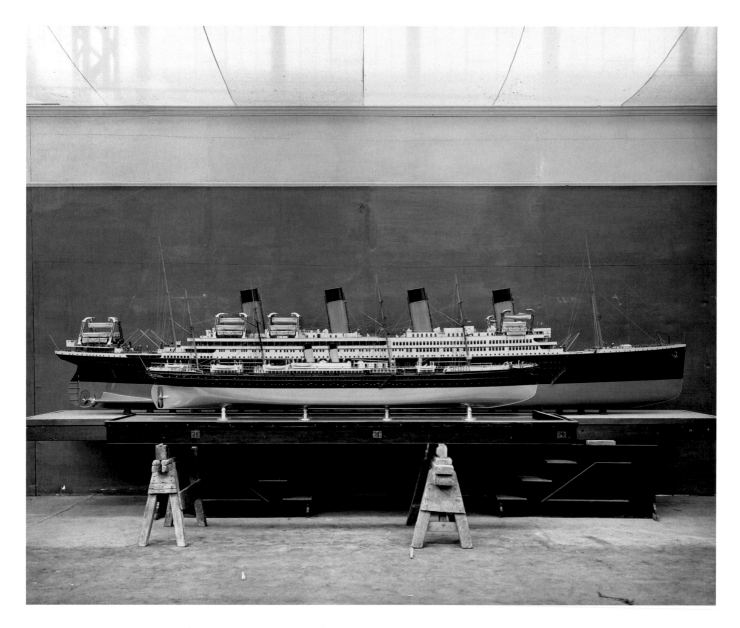

MODELS OF THE FIRST AND SECOND RMS *BRITANNIC*, photographed by AAB in 1914.
[BL22820/005]

A model of the White Star *Britannic* of 1874, shown with the *Britannic* of 1914 (a model built to the same scale) to demonstrate the growth of the company's ocean liners in 40 years.

The second *Britannic* was the third of the White Star's trio of Atlantic liners – with *Olympic* and *Titanic* – projected in 1907 to enable the line to run a weekly service to New York. *Britannic* incorporated a number of modifications to the hull and to the lifeboat arrangements in consequence of the *Titanic* disaster. However, she never sailed on the Atlantic run, being taken over by the Admiralty and adapted as a hospital ship, with berths for 3,100, as soon as she was completed. On 21 November 1916, she struck a mine off Mudros in the Aegean and sunk with the loss of at least 21 lives; it was fortunate that she was not then full of wounded. The wreck was discovered by Jacques Cousteau in 1975; in 2008 a scheme was proposed to establish a *Britannic* museum on shore.

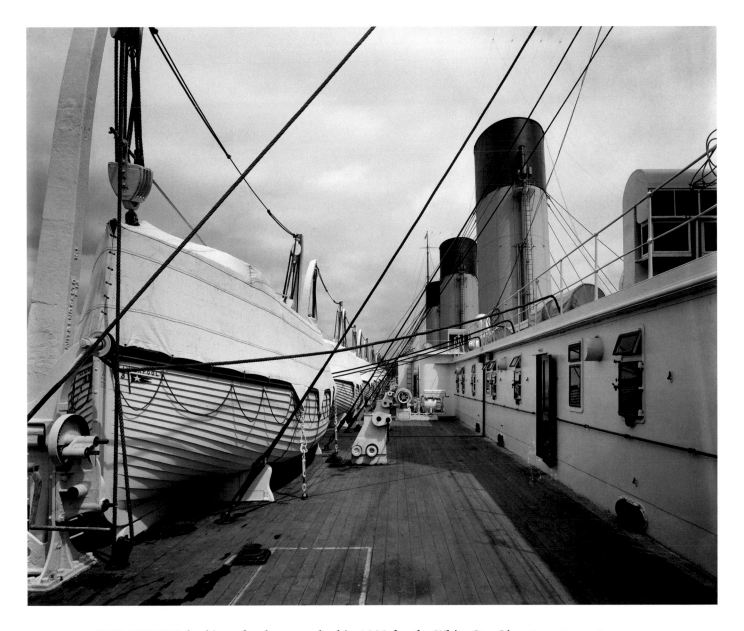

RMS *OLYMPIC*, looking aft, photographed in 1920 for the White Star Line. [BL24990/021]

By 1920 *Olympic* (built 1912) was the only ship of the White Star Line's three huge transatlantic liners, launched on the eve of the First World War, to survive. In 1935, following the merger of the White Star and Cunard Lines, she was sold to be broken up as superfluous to the company's needs.

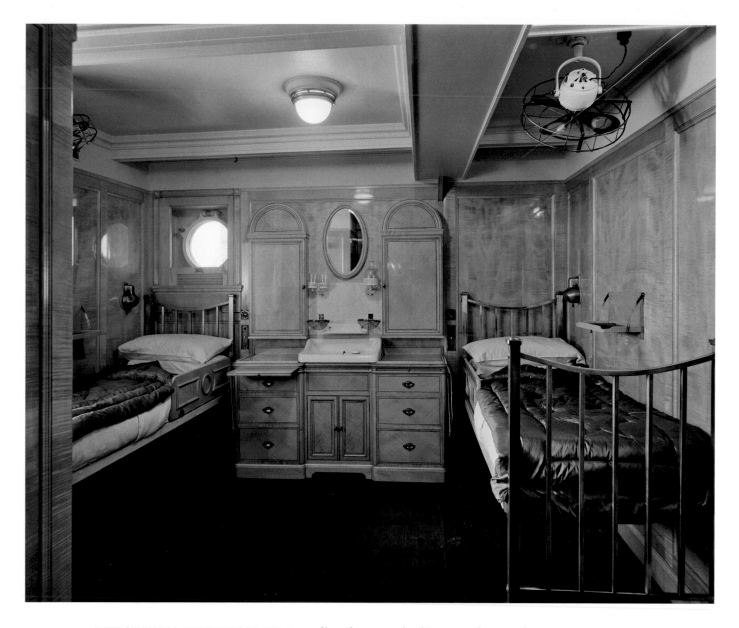

A FIRST-CLASS STATEROOM, SS *Mongolia*, photographed in 1924 for B Cohen & Sons, furniture manufacturers. [BL26972/002]

Mongolia, financed and built in America in 1904 but sailing out of the Port of London under the British flag, belonged to the Atlantic Transport Line, a shipping company specialising in fast cargo liners – ships that were primarily freighters but sailing to a regular schedule and carrying passengers as well.

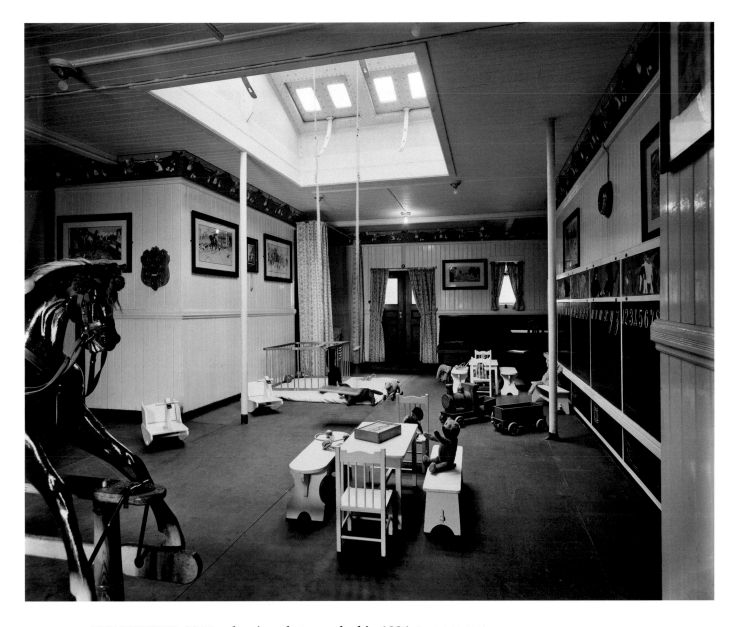

THE NURSERY, SS *Montlaurier*, photographed in 1924. [BL27040/011]

Montlaurier had started life in 1908 as the Norddeutscher Lloyd Line's transatlantic liner *Prinz Friedrich Wilhelm*. Allocated to Britain in war reparations, she was bought by the Canadian Pacific Line in 1921 and refitted.

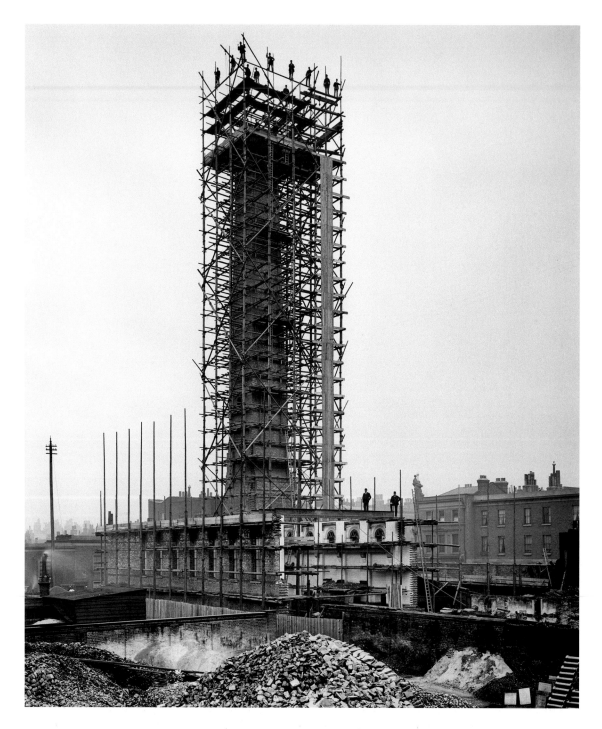

BUILDING THE NEW POWER STATION OF THE CHELSEA ELECTRICITY SUPPLY CO (Alfred Roberts, 1896–1901), Flood Street, London SW3, photographed by AAB in 1896 for Holliday & Greenwood, builders. [BL13839A]

Electric lighting had first become a practical proposition in the mid-1880s. However, for many years electricity generation could only be profitable where there were customers rich enough to afford the very considerable price difference between electric light and gas; as a consequence, very many of the first power stations were in the more prosperous areas of London. By 1920 there were no less than 70 in the London area, generally serving their own immediate localities and operating almost as many different systems of supply. Only in the 1930s were the many undertakings gradually brought together.

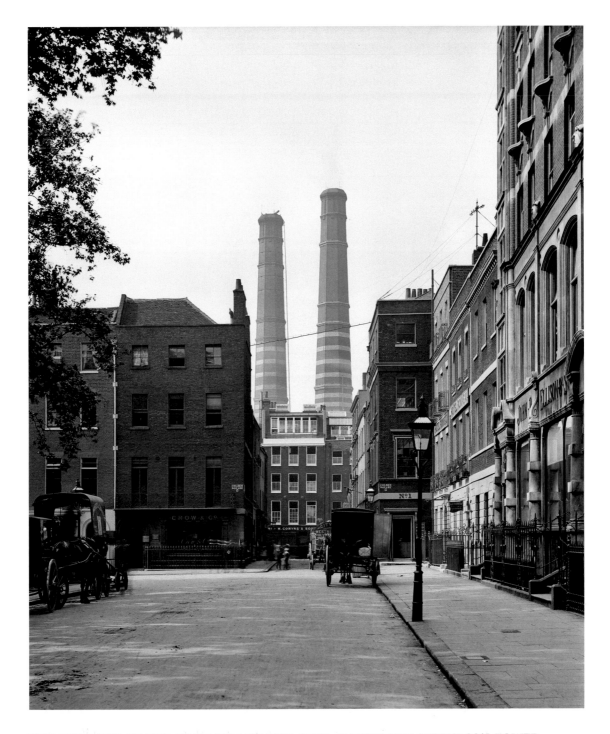

THE CHIMNEYS OF THE ST JAMES AND PALL MALL ELECTRICITY SUPPLY CO'S POWER STATION, Marshall Street, London W1, photographed by AAB in 1902. [BL17225]

Seen from Golden Square to the south. The Marshall Street power station opened in 1893 and closed in 1923. After slow (and, for many of the companies, unprofitable) beginnings, demand for electricity was beginning to grow and the two chimneys suggest that at some date since the power station's building it had been enlarged. It is not known when they were demolished.

Engineer to the St James company was (Sir) Alexander Kennedy, previously Professor of Engineering at University College, London. It is likely that Kennedy's friend Stanley Peach, architect for several early generating stations (*see* p 172), was involved with the design.

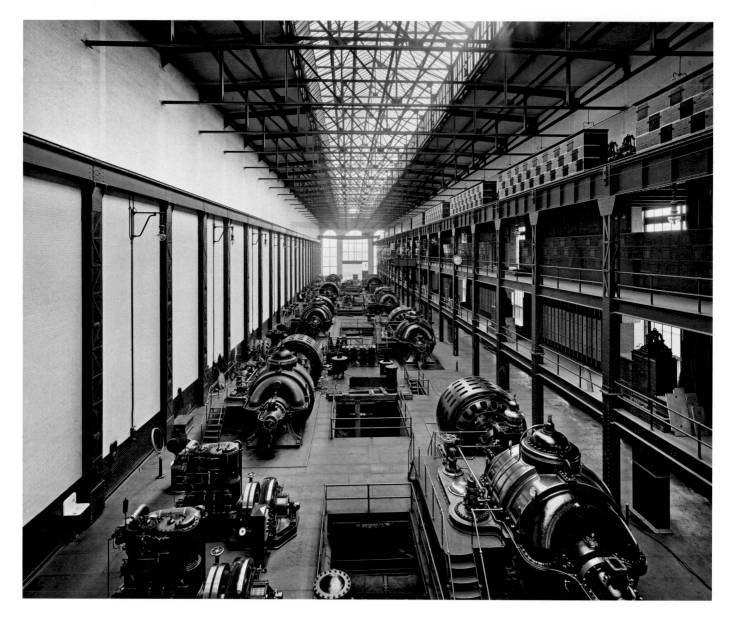

LOTS ROAD POWER STATION (Stanley Peach, 1902–5), London SW10, photographed in 1905 for *Tramway and Railway World*. [BL18939]

London's Metropolitan District Line Railway was electrified between 1902 and 1905, and Lots Road was built to provide the power. It also served the Great Northern, Piccadilly & Brompton Railway and the other underground lines controlled by the American entrepreneur Charles Yerkes, and was at the time the largest electric transport power station in the world. In 1908–10 the original British Westinghouse turbo generators shown here were replaced with equipment by Parsons.

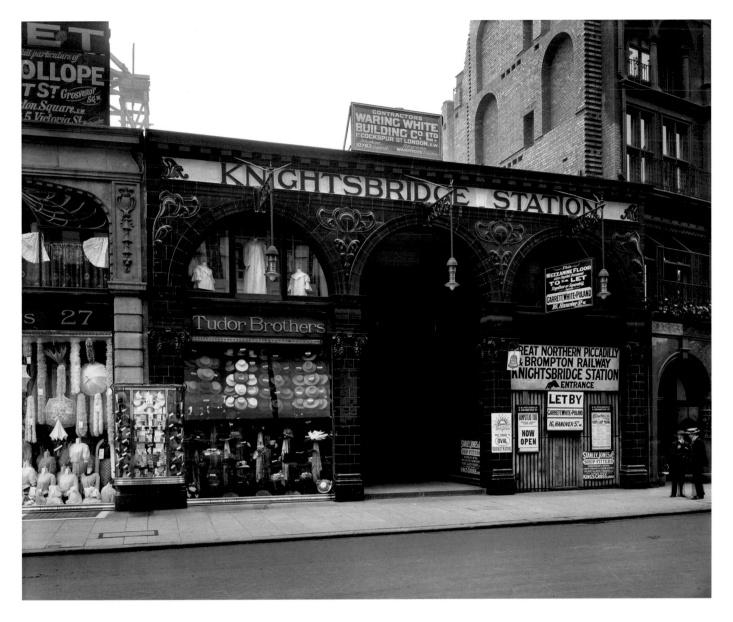

KNIGHTSBRIDGE TUBE STATION (L W Green, 1906), Brompton Road, London SW7, photographed in 1907 for the Leeds Fireclay Company. [BL20042/005]

The tube station for the Great Northern, Piccadilly & Brompton Railway – the present Piccadilly Line – recently completed. Its façade – with glazed terracotta tiles supplied by the Leeds Fireclay Company (*see* pp 140, 155 and 238) – is characteristic of the stations on this line but with more ornament than at outlying stations in poorer parts of the capital.

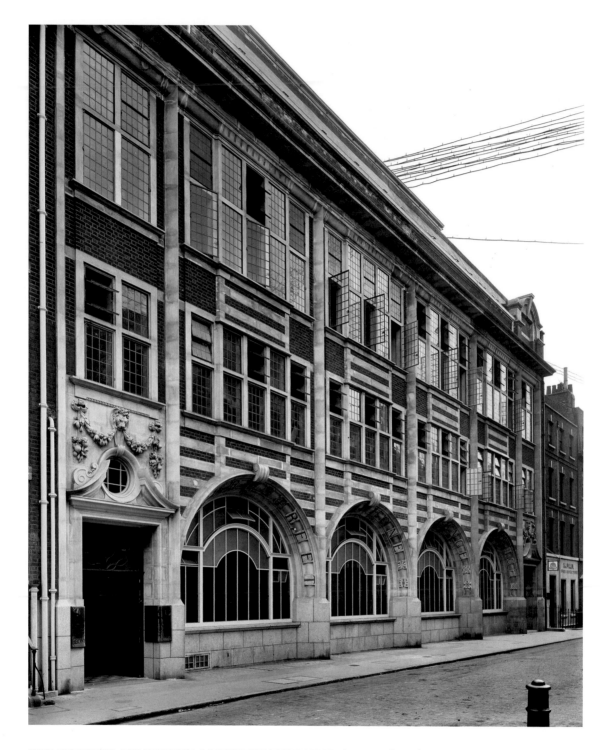

THE NATIONAL TELEPHONE COMPANY'S EXCHANGE (Leonard Stokes, 1907–8), Gerrard Street, London W1, photographed in 1908. [BL20326]

The great mullion-and-transom windows perhaps recall the huge windows of Elizabethan mansions, but are so shorn of period detail as to be hardly recognisable as such. The name of the company was inscribed on the voussoirs of the ground-floor windows.

In 1898 the architect, Leonard Stokes, had married the daughter of the company's general manager and thereafter did much work for the firm.

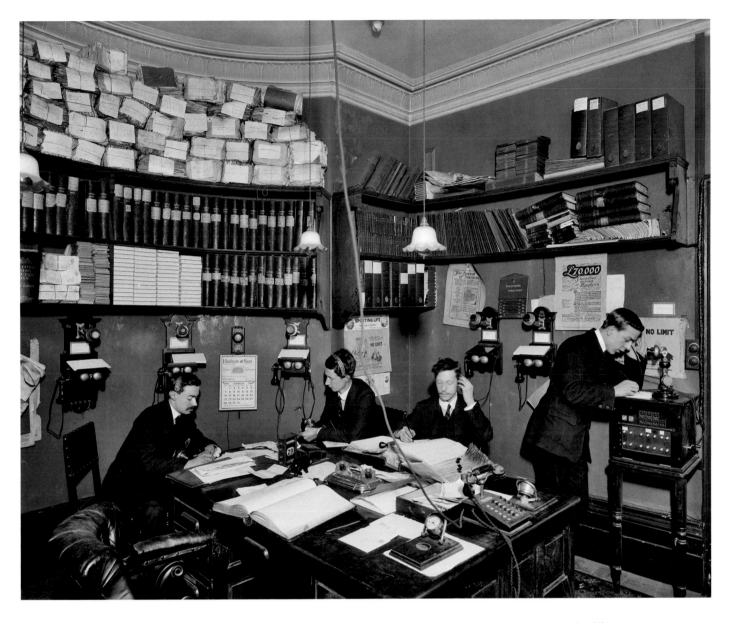

STAFF AT THE OFFICE OF DANIEL GANT, 25 Conduit Street, London W1, photographed by AAB in 1909. [BL20490/003]

In the days when it was illegal to take off-course cash bets on horse races, such betting could only be done on credit – which in effect meant that only the better-off and credit-worthy could legally engage in it. The office of Daniel Gant, commission agent, was on the edge of Mayfair, but it is clear that he made the best use of telephones. In 1910 there were six lines listed, four local lines and two for long-distance-trunk calls.

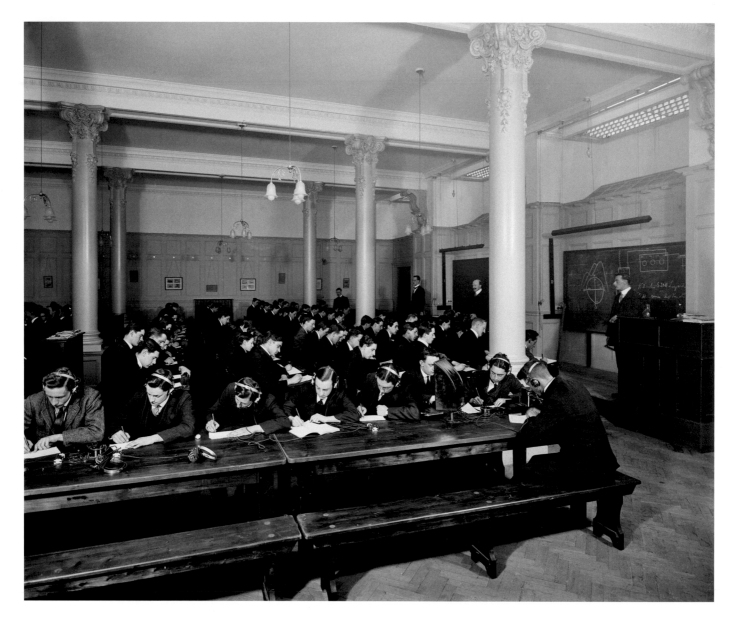

TRAINEE RADIO OPERATORS AT MARCONI HOUSE, The Strand, London WC2, photographed in 1913 for the Marconi Wireless Co. [BL22054]

Guglielmo Marconi, the radio pioneer, was as formidable a businessman as he was an inventor. By this date a number of well-publicised incidents (not only the loss of the *Titanic* and the arrest of Dr Crippen, though now the best known of these) had demonstrated the value of ship-to-shore radio to the public at large; however, the commercial value of radio reports of shipping and cargo movements was of much greater significance. The Royal Navy had been installing radio in its ships since the beginning of the century, and in 1912 Marconi had persuaded the British government to award his firm the contract for an Imperial Chain of wireless stations.

As a consequence there was a fast-growing demand for radio operators trained in Morse code. At Marconi House – originally built as the Gaiety Restaurant, to the rear of the theatre (*see* p 52) – the firm ran courses and examinations. One or the other is probably shown in this photograph.

'K2' TELEPHONE BOX ((Sir) Giles Gilbert Scott, 1923), Ladbroke Grove, London W11, photographed by AAB in 1926 for Macfarlane's of Glasgow. [BL28503]

A variety of public telephone kiosks already existed before 1923 when the Post Office, by then the owner of the national telephone system, organised a competition for a new standard design. The competition was won by the architect (Sir) Giles Gilbert Scott with a design which, as the 'K2' model, would be continued with slight variations until the 1960s.

The first were installed in 1926, and from the fact that the iron-founders Macfarlane's of Glasgow commissioned the photograph, the one in Ladbroke Grove must have been among them. There is now a modern kiosk where this one once stood.

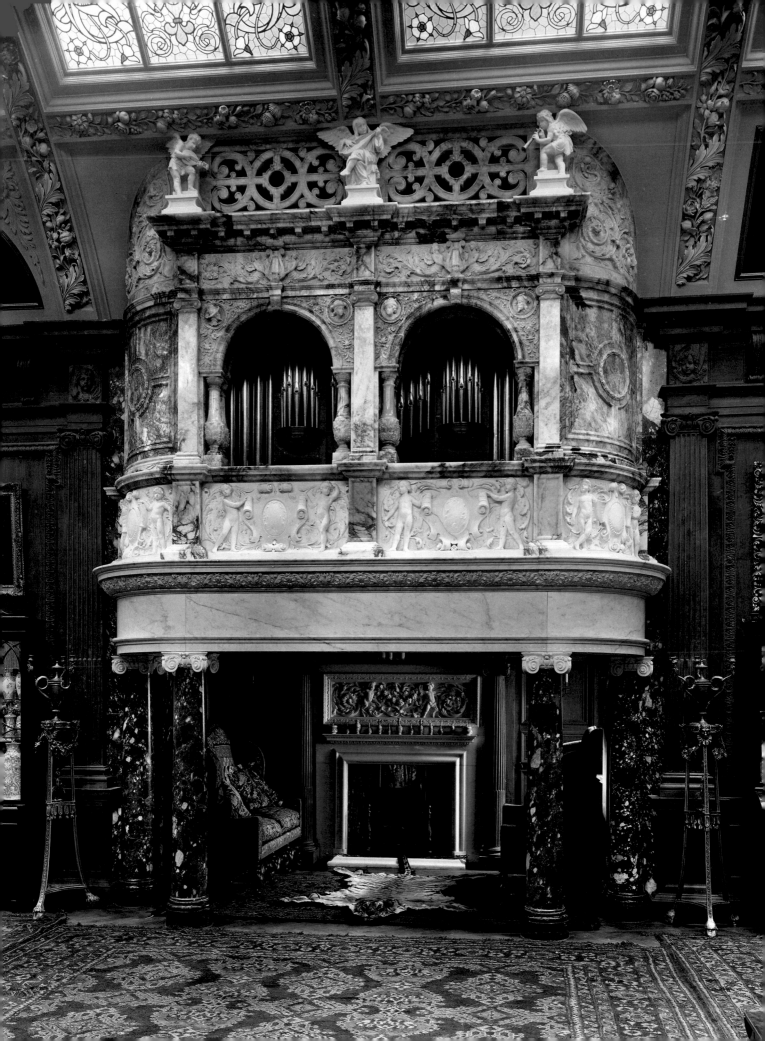

HOUSES

Bedford Lemere & Co photographed many houses, old and new, in London and in the country, in the smartest parts of town and in the suburbs and the provinces. Architecturally, houses and their internal decoration followed the same evolution as did other buildings of the time, progressing from styles that often treated historical precedents with a good deal of freedom, through the greater discipline provided by English classicism of the late 17th and 18th centuries, towards nostalgic re-creations of Old England. By 1920, to dream of a home in an older and less complicated world was to escape from the challenges of modernity and the horrors of the First World War.

Often commissioned by firms of decorators and furnishers, the company's interior photographs are a unique record of the range of houses occupied by the upper and upper-middle classes of late Victorian and Edwardian England. At the beginning of the period covered by the photographs shown here, a typical room was densely furnished, hung and upholstered with heavy fabrics, and with walls and ceilings thick with patterns and textures in paper, plaster and panelling. Furniture was often elaborately carved. The appearance of costly workmanship could by this date be readily produced by woodworking machines, but for a time such ease of manufacture led only to the creation of still richer and more intricate effects.

Between the 1890s and the 1920s there was a gradual reaction from this decorative excess. These changes did not proceed as a steady evolution; there would be significant variations in taste and in the speed of these changes as between town and country, London and the provinces, and depending on education and class. But by the end of the period a fashionable room would frequently have walls and ceilings that were quite plain and would often be quite sparsely furnished with furniture that was itself much lighter than it had been a generation before.

The firm's photographs document other changes in people's lives, including the acceptance of flats as homes by the higher classes, and – particularly after the First World War – the surrender of old houses to new occupants, the sales of old estates to new owners and the loss of many aspects of pre-war life which new forces had made unsustainable.

From time to time the photographer might be asked to photograph the people who lived in the houses he recorded, generally as group portraits in settings that tell much more about the sitters than studio portraits do.

THE FIREPLACE AND ORGAN GALLERY,
Music Room, Thornton Manor (Francis
Doyle, 1840–50 (house); J J Talbot, 1902
(Music Room)), Thornton Hough, Wirral,
photographed by HBL in 1903. [BL17556]

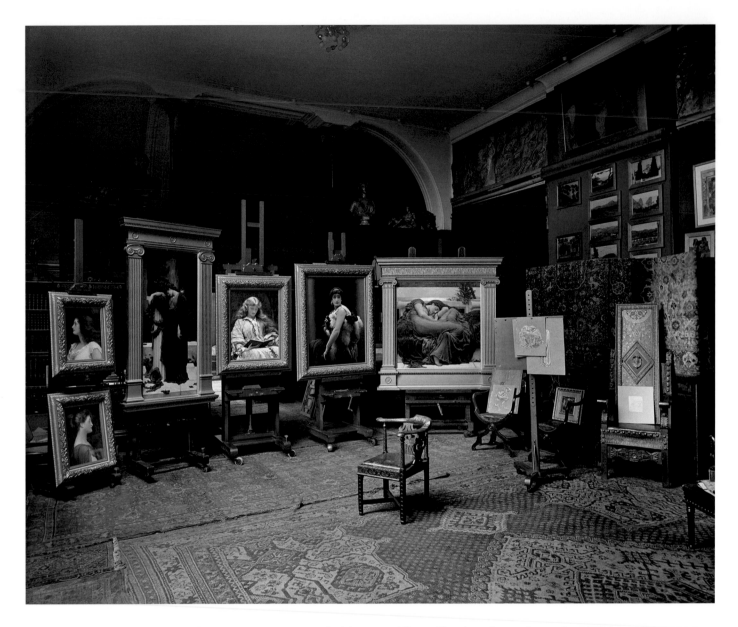

THE STUDIO, Leighton House (George Aitchison, 1866), Holland Park Road, London W14, photographed in 1895 for Sir Frederick Leighton. [BL13090A]

Leighton House was the home and studio of the President of the Royal Academy, Sir Frederick Leighton, who would be ennobled as Lord Leighton on his deathbed the following year. His last great painting is on the easel to the right – *Flaming June*, now in the Museum of Art in Ponce, Puerto Rico. Many of Leighton's paintings were virtually theme-less images in classical settings, and *Flaming June* is essentially an abstract composition, evoking in its colour and tones and in the drowsy figure the enervating heat of the Mediterranean summer.

Many leading artists opened their studios to visitors on Sunday afternoons and Leighton – by this time a celebrity – may well have done the same.

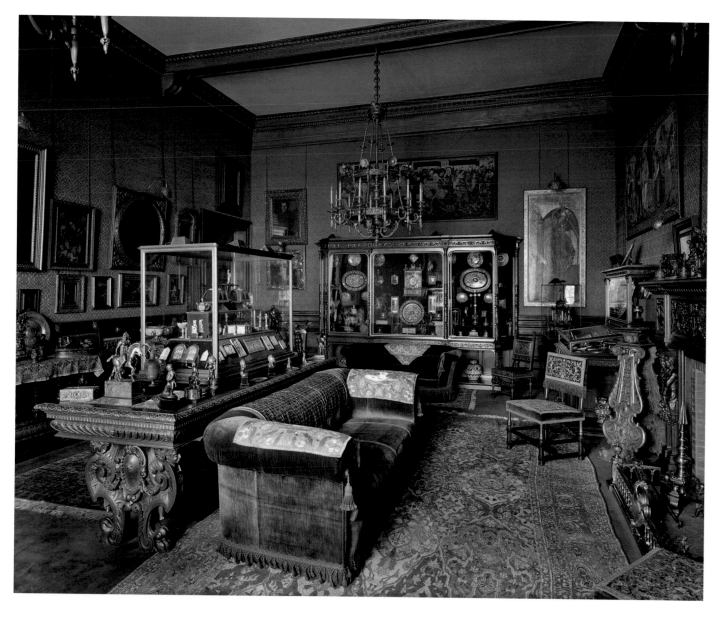

THE RED ROOM, Bath House (1821), 82 Piccadilly, London W1, photographed by HBL in 1911 for Sir Julius Wernher. [BL21165]

German by origin, Sir Julius Wernher had made an immense fortune in South African diamond mines and later in the gold fields: at the turn of the century, Wernher's partnerships controlled 50 per cent of the country's entire gold production.

A notable philanthropist and also a considerable connoisseur, a small part of his great collection is displayed in this room in his London house. At the right-hand end of the far wall is one of Sir Julius's greatest paintings – *St Michael Slaying the Dragon* by the 15th-century Spanish artist Bartoloméo Bermejo – which was acquired for the National Gallery in London in 1995. Many objects from his collection are now on display at Ranger's House, Greenwich, curated by English Heritage.

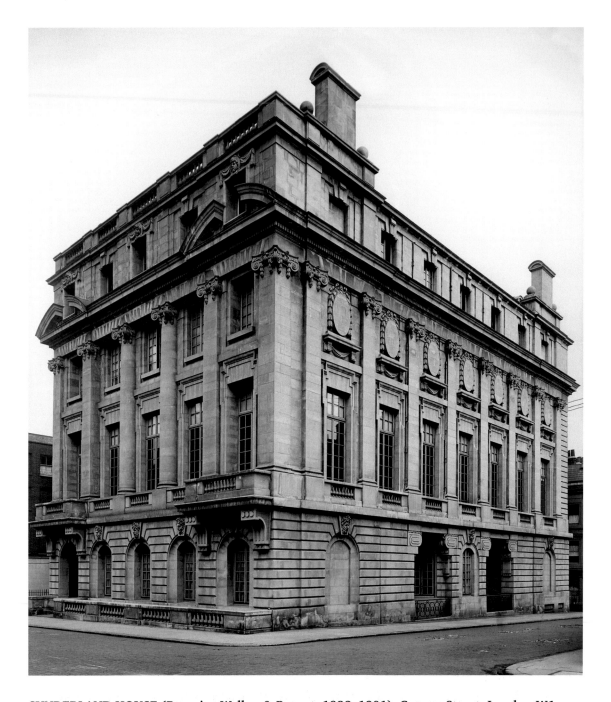

SUNDERLAND HOUSE (Romaine-Walker & Besant, 1899–1901), Curzon Street, London W1, photographed in 1904 for the 9th Duke of Marlborough. [BL18286]

Around the turn of the century a number of marriages took place between English aristocrats and American heiresses, repairing the fortunes of the former and establishing a high social standing for the latter. The most spectacular of these alliances was between Charles Spencer-Churchill, 9th Duke of Marlborough, and Consuelo, daughter of the American railroad tycoon William Kissam Vanderbilt, whose real wealth on his death in 1903 was certainly far more than the $100,000,000 that was declared. Vanderbilt money paid for the restoration of Blenheim Palace – the duke's ancestral home – and for the building of Sunderland House (now Lombard House).

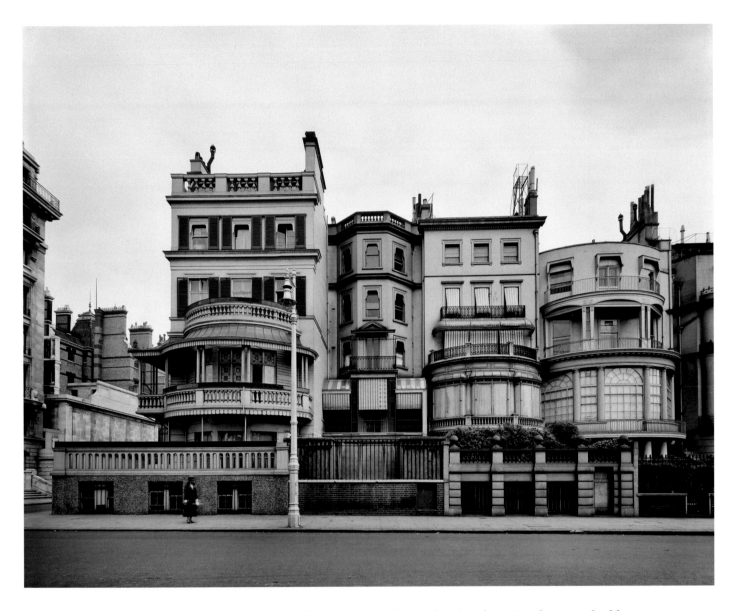

138 PARK LANE (*left*) **AND 20–22 DUNRAVEN STREET** (*right*), **London W1, photographed by AAB in 1926 for Edmund Wimperis.** [BL28420/002]

In 1926 the Surveyor to the Grosvenor Estate, Edmund Wimperis, commissioned Bedford Lemere & Co to take a series of record photographs of the Park Lane frontages of the houses on the estate. By this date it was becoming clear to the trustees of the estate – ground landlords of the most valuable residential properties in London – that there would never again be the same demand for large, grand, single family houses as there had been before the war and that redevelopment was inevitable if income was to be kept up. The decade saw the demolition of the virtual palaces of Aldford House, Grosvenor House and Dorchester House on Park Lane itself and their rebuilding as luxury flats and hotels, and Wimperis probably expected other houses to go. 138 Park Lane was converted into flats and a shop a few years after this photograph was taken.

Their outlook over Hyde Park made the houses of Park Lane among the most desirable in Mayfair and the occupants of this 18th-century block had been typical of the street's titled and moneyed residents. 20 Dunraven Street had been occupied by Lord Leverhulme and later by Lord Burnham, proprietor of *The Daily Telegraph*; when this photograph was taken 138 Park Lane was occupied by the widow of Lord Newborough.

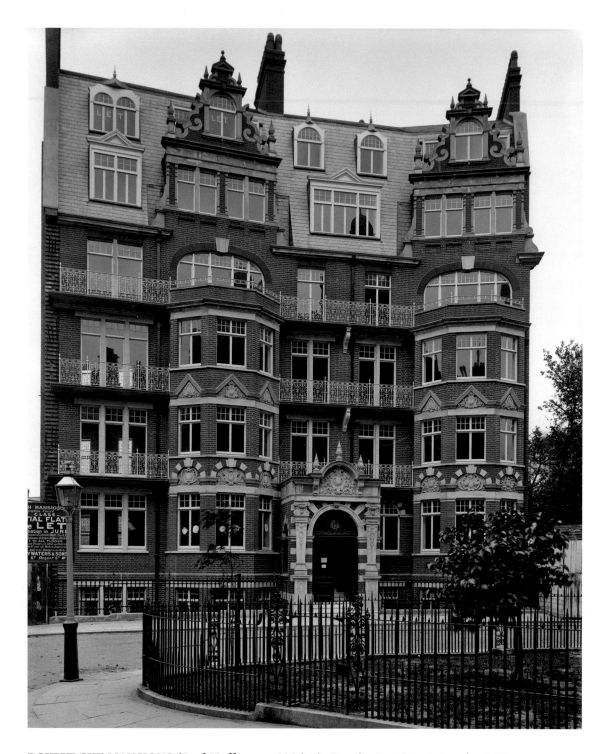

ROXBURGHE MANSIONS (Paul Hoffmann, 1896–8), Kensington Court, London W8, photographed by AAB in 1898. [BL14935]

Flats were almost unknown in London until the last quarter of the 19th century, but from then on they multiplied fast in many of the residential areas of town. Paul Hoffmann, born in Vienna, specialised in mansion flats and campaigned vigorously (and unsuccessfully) for the lifting of the restrictions on building heights that had been imposed by the London County Council after the building of the 14-storey Queen Anne's Mansions in 1873–89. The relatively modest Roxburghe Mansions is one of Hoffmann's more approachable buildings.

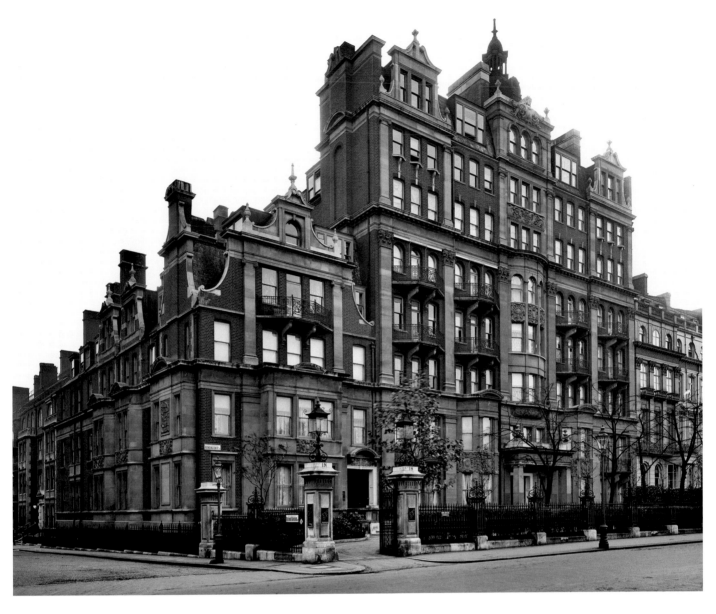

RUTLAND COURT (Delissa Joseph, 1901–3), Kensington Road, London SW7, photographed by AAB in 1912. [BL21849]

Luxury flats in a fashionable area of London, in a debased architectural style characteristic of all too many contemporary blocks of so-called mansion flats.

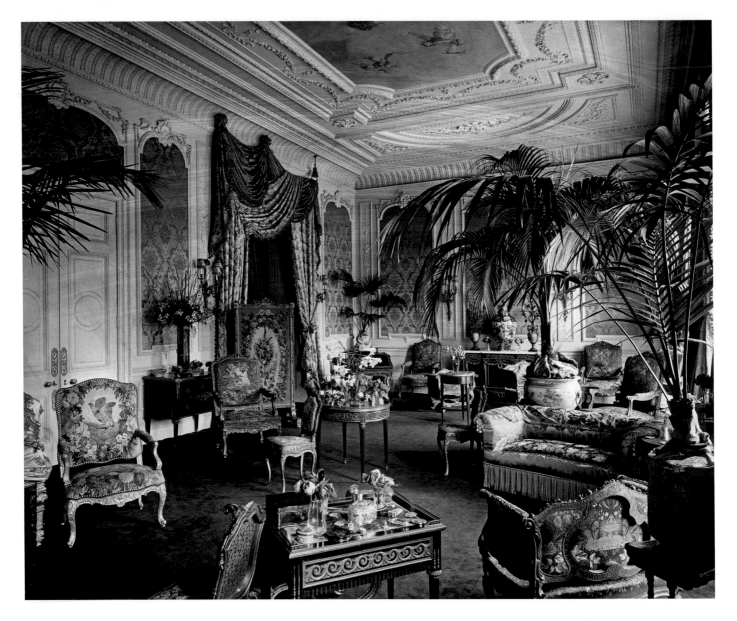

THE DRAWING ROOM, 17 Grosvenor Place (Thomas Cundy III, *c* 1868), London SW1, photographed by HBL in 1890 for Arthur Wilson. [BL10289]

A fashionable house in the heart of Belgravia, fitted up in a Louis XV manner by Joseph Joel Duveen for the shipowner, Arthur Wilson. The Wilson Line had been founded in the 1820s with sailings between the Port of Hull and Scandinavia, and by the time of Wilson's death in 1909 the firm was the largest private shipping company in the world.

The long association of France with style and fashion had given the French styles an enduring popularity among the rich, but like the decoration to walls and ceiling most of the pieces shown here were probably new. The fashion for draperies like those over the doorway would not endure much longer; indeed it is difficult to understand how they could ever have been tolerated when almost all heating and cooking was by coal fires and most lighting was by oil or gas, with all their smoke, smuts and fumes.

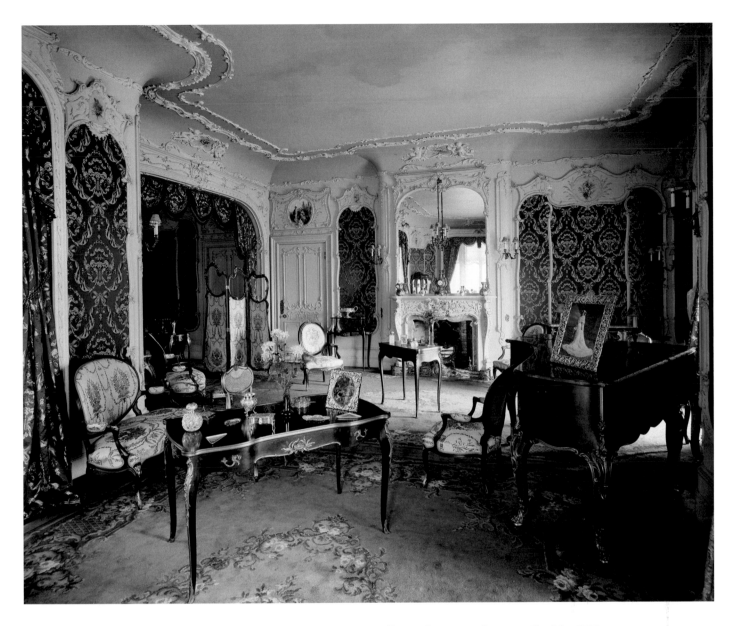

THE DRAWING ROOM, Moray Lodge, Campden Hill, London W8, photographed by HBL in 1904. [BL18085]

The drawing room of Moray Lodge (built in 1817) was furnished in a French rococo manner. The adaptation of period styles to modern forms often meant their application to items of furniture originally unknown. The screen and a grand piano would not have existed in the reign of Louis XV, nor would the room have been broken up with curtained 'fitments' of the kind that had been popular since the 1880s.

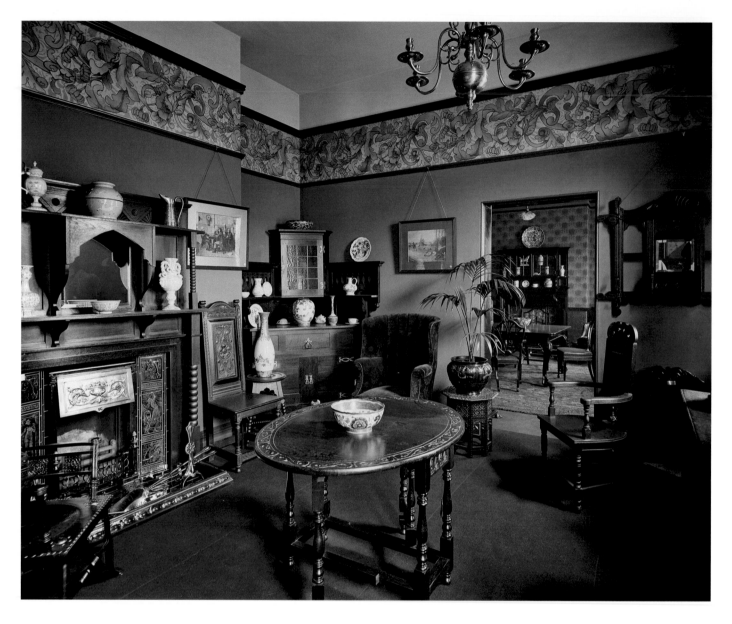

MORNING ROOM DISPLAY, S J Waring & Sons, Deansgate, Manchester, photographed by HBL in 1897 for Waring's. [BL14017]

A number of styles can be discerned here, and though all could have been considered 'artistic' none of these objects will have been expensive. The chairs and the gate-legged table are more-or-less of the English 17th century; an octagonal table and the arched mirror to the overmantel, Moorish; the angle fitment and the pottery in a manner that would probably have been described as 'quaint'. Few of the firm's middle-class customers would have questioned the aesthetic credentials of the styles claimed. (*See* Fig 14 for the negative from which this image was made.)

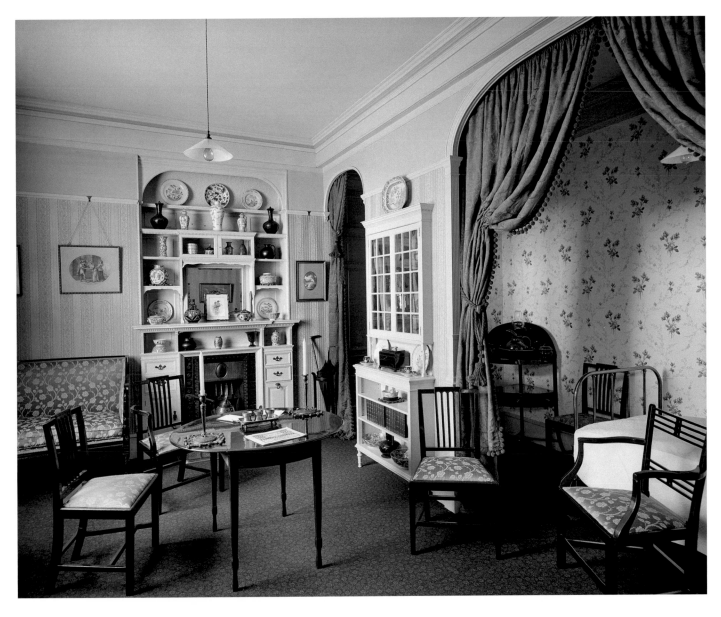

A ROOM DISPLAY, Heal & Son Ltd, Tottenham Court Road, London W1, photographed by AAB in 1897 for the firm's 1897 catalogue. [BL14002]

The furniture was probably designed by Ambrose Heal and the setting by Cecil Brewer. When compared with other showrooms photographed at the time, such as that in the preceding view, it is easy to understand contemporary criticism of Heal's 'severe simplicity'.

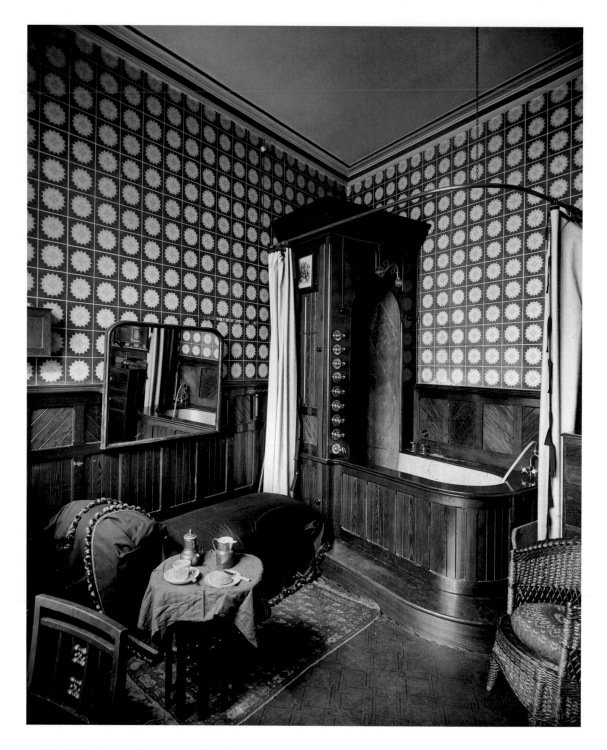

BATHROOM, 28 Ashley Place, London SW1, photographed by HBL in 1893 for Mrs Wallace Carpenter. [BL12335]

A state-of-the-art bathroom in a recently built block of luxury flats. The improvement of public water supplies in the second half of the 19th century had encouraged equal advances in the art of plumbing. Knobs on the casing of the hood control a variety of functions; 'shower', 'douche' and two marked 'wave' can be read in the original negative.

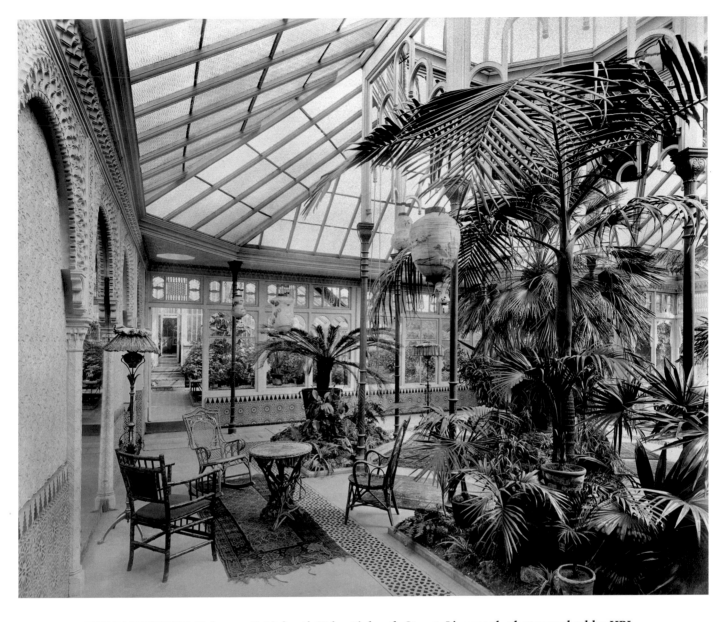

THE PALMHOUSE, Palmyra, 5 Aigburth Vale, Aigburth Street, Liverpool, photographed by HBL in 1896 for Samuel Waring. [BL13554]

Palmyra, built in the early 19th century, was the Liverpool home of Samuel Waring, furnisher and decorator, for whom Bedford Lemere & Co did a great deal of work. Palmyra was not a huge house but, like many contemporary houses even of quite modest size, had a large conservatory attached to it, leading here to a series of glasshouses. The full-length mirror framed in the arch on the left would have made the space seem larger.

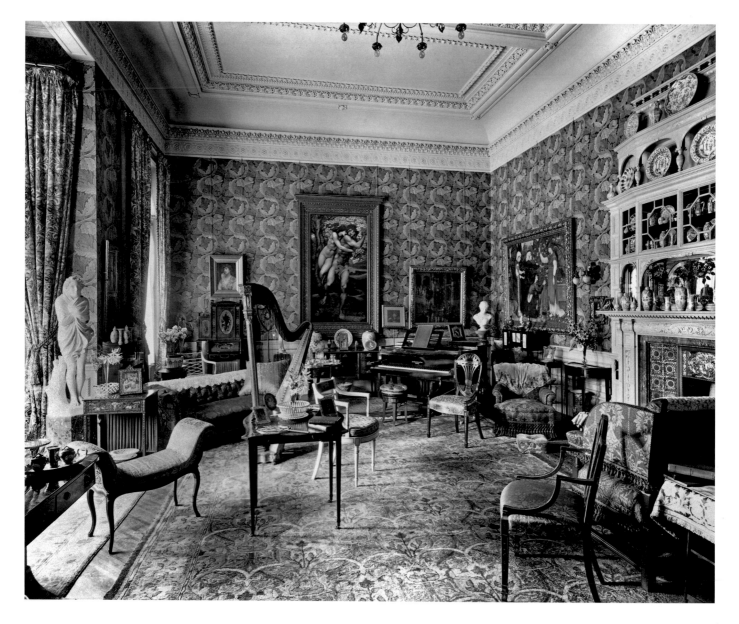

THE DRAWING ROOM, The Holmestead, Mossley Hill Road, Liverpool, photographed in 1902 for William Imrie. [BL16685]

The Holmestead – built in the 1840s by Samuel Holme – was later the home of William Imrie, shipowner and art collector, who in 1870 had joined his friend Thomas Ismay to form Ismay, Imrie & Co to manage the White Star Line. He died in 1906, leaving a substantial bequest towards the building of Liverpool Cathedral. His pictures, which he had continued to collect up to the time of his death, were put up for sale at Christie's the following year.

On the far wall is Edward Burne-Jones's 1882 painting *The Tree of Forgiveness*. Sold for £1,050 in 1907, it was acquired by W H Lever and is now in the Lady Lever Art Gallery at Port Sunlight. On the left of the fireplace is Spencer Stanhope's *Why Seek You the Living Among the Dead?*, now in the Art Gallery of New South Wales, Sydney, Australia. William Morris's 'Acanthus' wallpaper is on the walls and there appears to be a Morris carpet on the floor. At this date Imrie had not yet bought the best of his Rossettis – *Veronica Veronese*, now in Wilmington, Delaware – for which he paid £3,954 in 1903, at that time the highest price ever paid for a work by Dante Gabriel Rossetti and one that would not be matched for another 60 years.

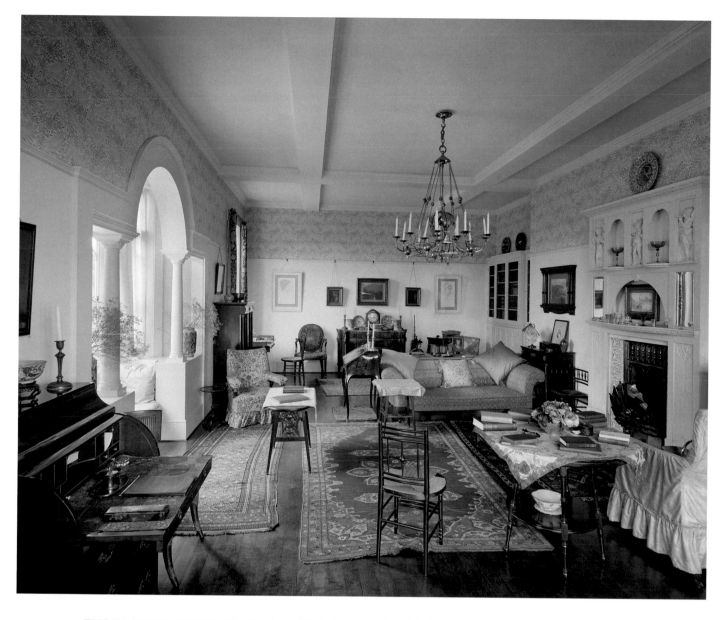

THE DRAWING ROOM, Windleshaw (W A S Benson), Withyham, East Sussex, photographed by HBL in 1911 for the architect. [BL21311/011]

Benson had been a founder member of the Art Workers Guild and became the first chairman of William Morris's firm, Morris & Co, after Morris's death in 1896. He had trained as an architect, but turned to metalwork – designed and initially made by himself – and was soon successful enough to be able to open a factory in Hammersmith and a showroom in New Bond Street. Benson successfully combined (as Morris had done) the design principles of the Arts and Crafts movement with commercial production. Windleshaw was Benson's own house.

Items included in this view and made by his firm include the chandelier, the brass screen in the fireplace and the electric lamp on the table by the sofa. The wallpaper and some of the furniture are by Morris & Co, blending successfully with antique pieces. There are portrait drawings by Edward Burne-Jones on the walls. 'Victorian clutter' is in retreat and a revolution in furnishings is well under way.

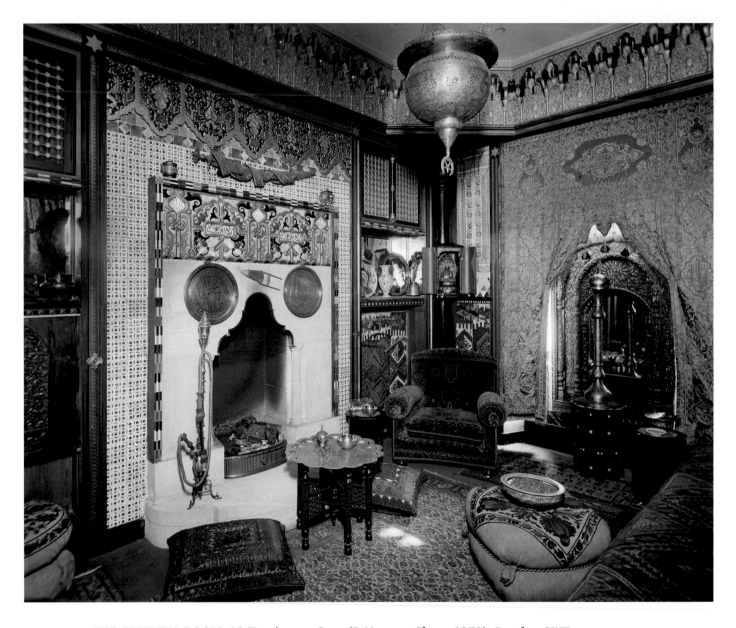

THE ORIENTAL ROOM, 13 Kensington Gore (R Norman Shaw, 1879), London SW7, photographed in 1914 for Montagu Pyke. [BL22546]

13 Kensington Gore was the home of Montagu Pyke, proprietor of a London cinema chain, several of whose theatres were photographed by Bedford Lemere & Co (*see* pp 222, 248 and 249). Turkish, Arabian, Moorish or Oriental styles (the terms were interchangeable in the furnishing trades) had long been popular for smoking rooms. This, however, is a late example, perhaps inspired by the recent success of Sergei Diaghilev's Russian Ballet, which had given a fresh lease of fashionable life to the exotic styles.

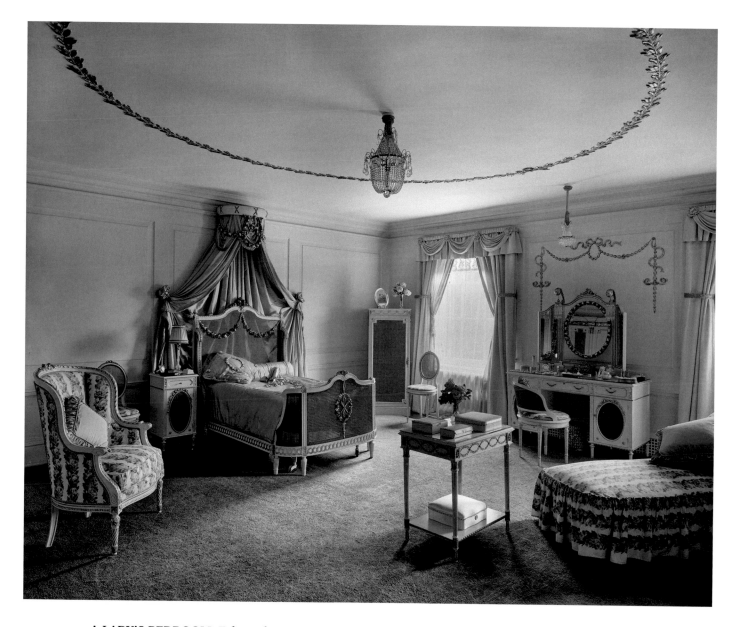

A LADY'S BEDROOM, Erlwood Manor, London Road, Windlesham, Surrey, photographed by AAB in 1915 for L Byron Peters. [BL23110]

With the taste for greater simplicity, the enduring fashion for things French has moved from the rococo of Louis XV to the neoclassicism of Louis XVI.

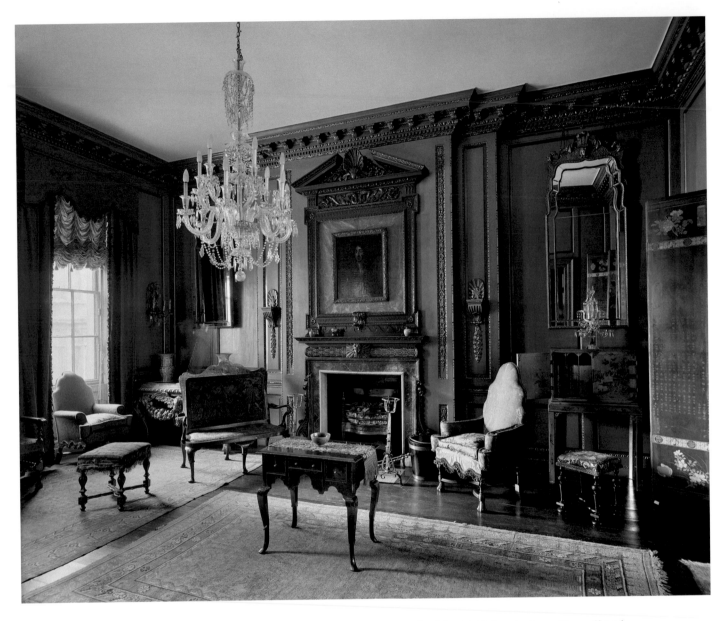

A SHOWROOM, 8 Clifford Street, London W1, photographed in 1915 for Andrew Russell Ltd, interior decorators. [BL23203]

The popularity of furnishing in English 18th-century styles had been growing fast since the 1880s, in parallel to the revival of English classical styles in architecture. But whereas 20 years earlier, furniture had often evoked a period in little more than name, greater knowledge had led to greater value being placed on authentic pieces and to a better understanding of how they might be used to furnish a room. 8 Clifford Street is an outstanding early Georgian house, with a hall probably painted by Sir James Thornhill. At the time of this photograph, the house was occupied by Andrew Russell Ltd, interior decorators, who redecorated it in what was felt to be an authentic manner (including ceiling paintings) and furnished it with antiques of the period.

The offices of Belcher & Joass, architects, several of whose buildings were photographed by Bedford Lemere & Co (*see* pp 63, 65 and 66), were next door.

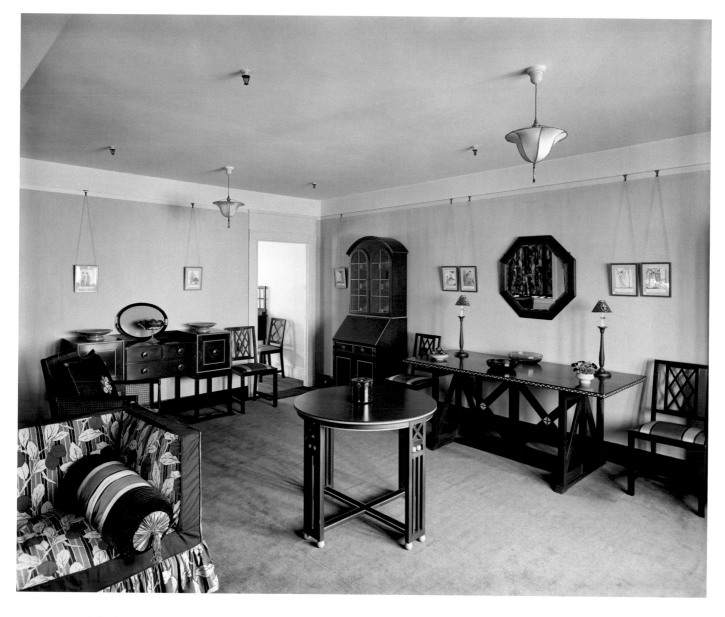

A SHOWROOM, Heal & Son Ltd, Tottenham Court Road, London W1, photographed by HBL in 1917 for *The Architectural Review*. [BL23812]

A room arrangement in the firm's new building, which was built by D Smith & C Brewer in 1912–17 and only completed after substantial delays caused in part by war shortages. The fifth floor of the building contained a picture gallery and a suite of rooms furnished as Drawing Room, Dining Room, Bedroom, Dressing Room and Day and Night Nurseries; it is likely that this is the first of these rooms, looking through to the second.

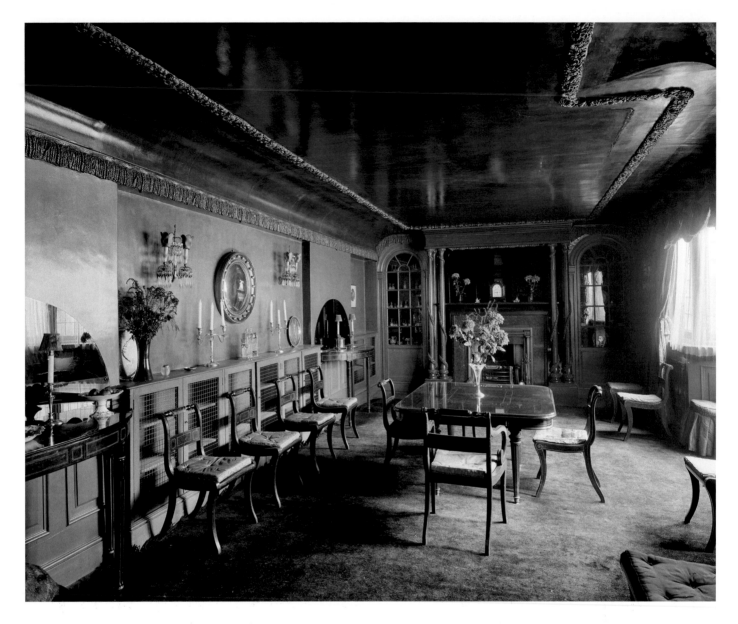

THE DINING ROOM, 4 Cumberland Terrace (John Nash, *c* 1827), London NW1, photographed by HBL in 1916 for Miss Van Brummer. [BL23282]

A room in a house in one of John Nash's Regent's Park terraces and an anticipation of stylistic elements that would be more characteristic of the 1920s and 1930s – the style that Osbert Lancaster would satirise as 'Vogue Regency'. Walls and ceiling are finished in a high gloss; there are no pictures. The cove to the ceiling, which might have originated in a rococo decorative scheme (*see* pp 186–7), is here reduced to an elementary form, merely outlined with narrow bands of stylised floral ornament that have no historic source. The Sheraton chairs and side tables are in the simplest of Georgian styles, and the latter are backed by plain, semicircular mirrors without frames.

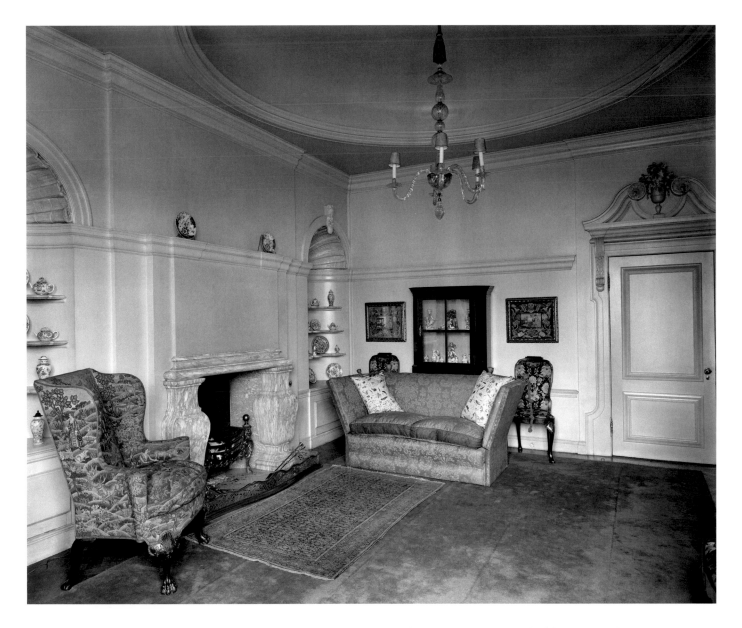

THE BOUDOIR, 15 Hill Street, London W1, photographed by AAB in 1924 for the National Trade Press. [BL27074]

Redecorated by Oliver Hill for Bruce Ismay, former chairman of the White Star Line (who had survived the *Titanic* disaster), and his American wife. With its rather stylised classicism, its plain walls and a few exquisite antiques, the room is a good example of contemporary, uncluttered upper-class taste.

Hill was a versatile architect who designed with flair in a number of styles, among them buildings with many of the characteristics of what would be called International Modernism, but he was never a doctrinaire modernist and his buildings above all reflect his own sensitivity to colours, forms and textures, and to the appropriateness of style to setting and purpose.

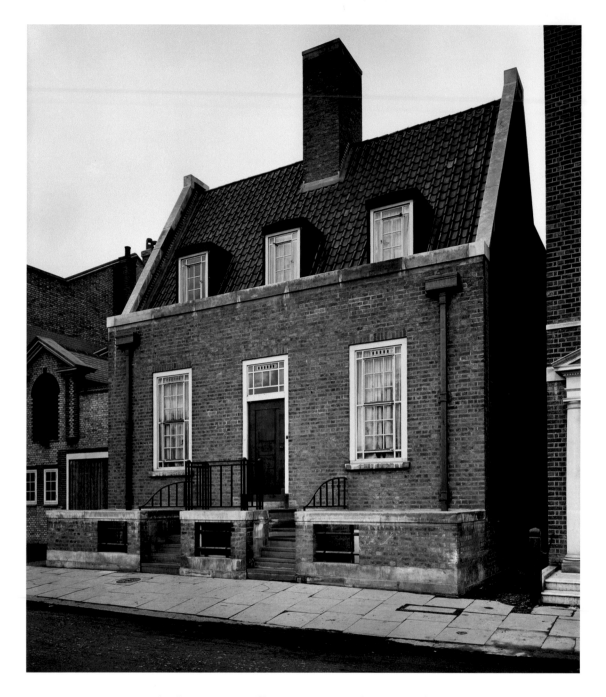

28 MALLORD STREET (Robert van 't Hoff, 1913–14), London SW3, photographed in 1914.
[BL22842]

Built for the painter Augustus John, with a staircase copied from Rembrandt's house in Amsterdam. The story goes that Augustus John went into a pub shouting 'if there's an architect here I want him to design me a house' and ran into van 't Hoff at the bar. However, two other houses in Mallord Street were designed by Ralph Knott, which besides sharing with no 28 a similar simplification of traditional forms also share certain details. It is possible that Knott was the executive architect for Augustus John's house in carrying out van 't Hoff's designs.

In 1934 the house was bought by Gracie Fields.

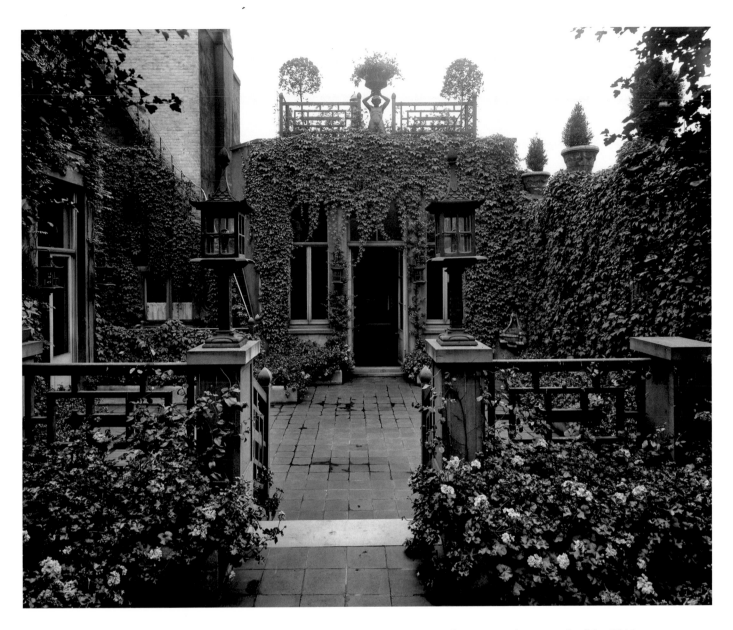

A ROOF GARDEN, 64 Rutland Gate (John Elger, 1853–9), London SW7, photographed in 1913.
[BL22281/003]

At this date roof gardens were very much a novelty, only recently having been made possible by the introduction of waterproof cements.

64 Rutland Gate was the London home of the banker Frederick Huth Jackson. Huth Jackson, a director of the Bank of England, was active on a number of important financial committees and also responsible for a scheme whereby the Government insured shipowners against war losses, without which it is difficult to see how the country could have been supplied with food in wartime.

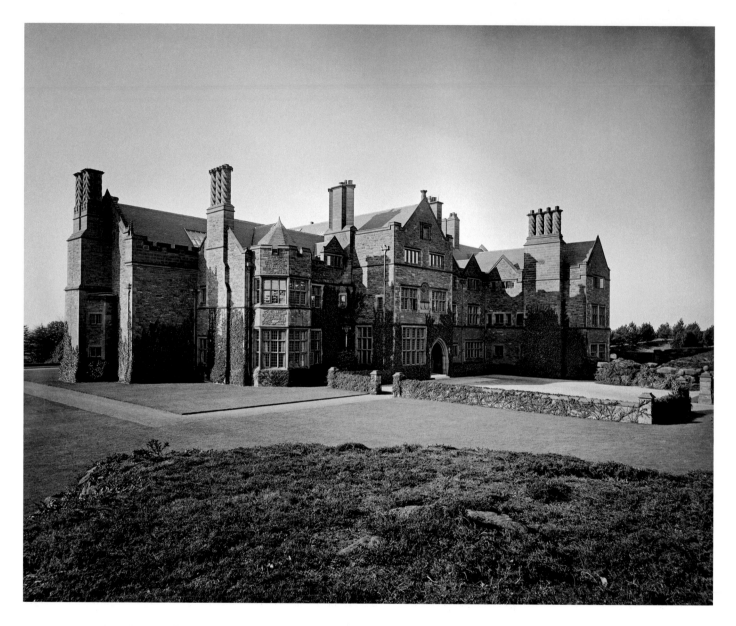

DAWPOOL (R Norman Shaw, 1882–4), Thurstaston, Wirral, photographed by HBL in 1896 for Thomas Ismay. [BL13481/008]

A huge, stern house, Dawpool was built for Thomas Ismay, chairman of the White Star Line. Its solidity required explosives to be used in its demolition in 1926, though parts of the building were saved. The upper part of the picture room chimney piece went to Portmeirion, the lower part to Iwerne Minster in Dorset, while the enormous dining room chimney piece was taken to house the box office in a Birkenhead cinema (now the Kingsland Cabaret Restaurant).

This view was taken for Ismay with the instruction that the photographs 'are all to be kept strictly private & not sold to anyone'.

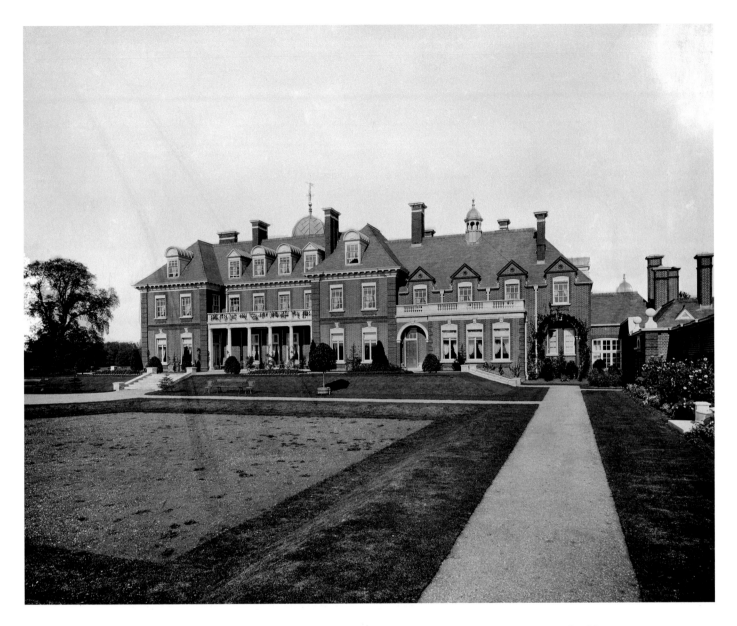

MONGEWELL PARK (R S Wornum, 1889–90), Crowmarsh, Oxfordshire, photographed by HBL in 1890 for the owner, Alexander Fraser. [BL10524]

Many architects in the 1880s and 1890s were looking for a style appropriate to their age. One direction that they would take would be towards the disciplines of 17th- and 18th-century English classicism. The garden front of Mongewell has Georgian sash windows, and a white painted loggia flanked by wings that were modelled directly on country houses of the period of Sir Christopher Wren – a style that would become ever more popular over the next 20 years.

The garden is only part finished, with the parterres in the foreground not yet planted out.

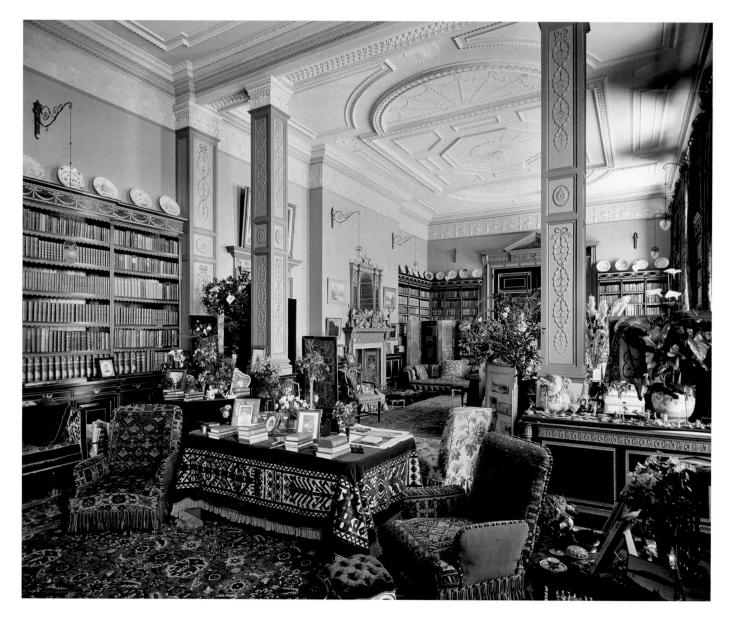

THE LIBRARY, Caversham Park (1850–2), near Reading, Berkshire, photographed by HBL in 1892 for W T Crawshay. [BL11451]

In the first half of the century the Crawshays of Cyfarthfa, Merthyr Tydfil, had been one of the two great dynasties of ironmasters in south Wales; their rivals, the Guests of Dowlais, were the other. Following the death of William Crawshay in 1867, the firm had declined through poor management, increasing competition from the north of England and abroad, labour troubles, and above all through competition from steel, which the company had been late to manufacture. However, the Crawshays' ascent to the English upper classes had already been set in motion with his purchase of Caversham Park in around 1850; what remained of the family business was sold off in 1902.

William Crawshay had rebuilt the house (with extensive use of iron) after its predecessor burnt down. However, it appears here to have been newly decorated after his grandson William Thompson Crawshay had recently made it his principal home.

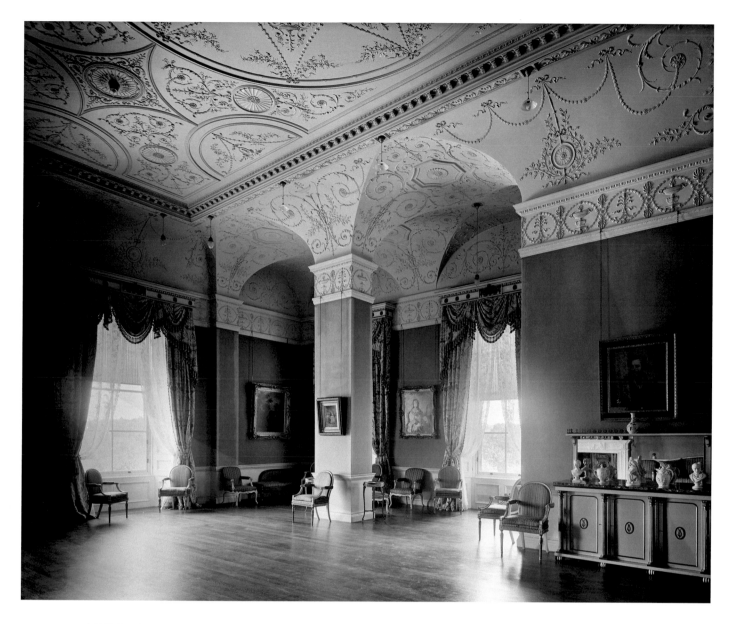

THE DRAWING ROOM, Bryanston (R Norman Shaw, 1890–4), Blandford Forum, Dorset, photographed by HBL in 1899 for Viscount Portman. [BL15440]

Shaw's Bryanston was epoch-making, breaking away from the styles that had characterised his earlier houses (such as Dawpool, *see* p 202) and finding inspiration in the English 18th century – the earlier part of the century for the exterior, and the period of James Wyatt and the Adams for much of the decoration. At this date very few other architects had made this leap, though very many would follow him over the next 10 years.

Built for the enormously wealthy Lord Portman, the centre of the house (in the manner of great 18th-century country houses) contained the state rooms, mainly used for entertaining; the family rooms were mostly in one of the wings. Too large for later generations, the house became a school in 1928.

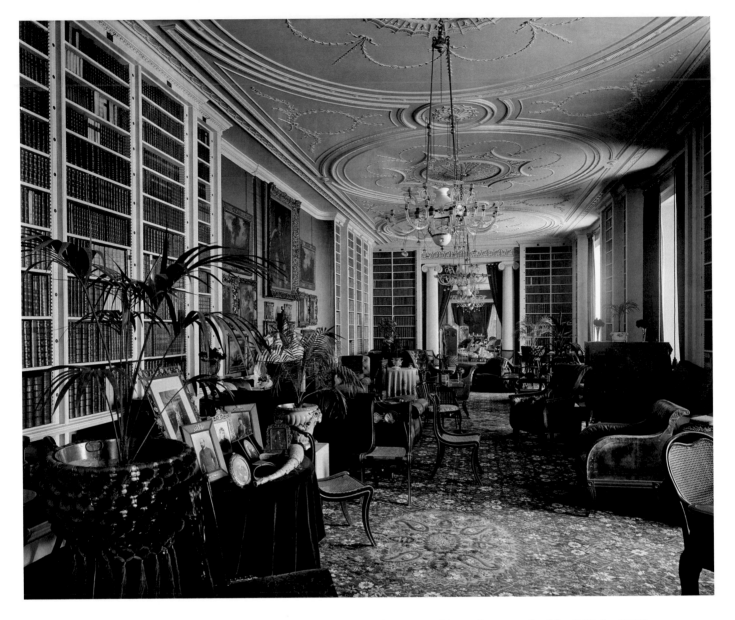

THE LONG LIBRARY, Althorp House, Althorp, Northamptonshire, photographed by HBL in 1892 for the 5th Earl Spencer. [BL11682]

A record of a famous collection. At the time, the library at Althorp was probably the finest private library in England – or perhaps anywhere. Mainly put together by the 2nd Earl Spencer (1758–1834), it contained 40,000 volumes, many of exceptional rarity, with copies of many of the earliest printed books in existence. Only a small part of the library can be seen in this photograph, though others of the firm's photographs show other book rooms.

In the year that Harry Lemere photographed Althorp, the library was bought by Mrs Enriqueta Rylands, to form a part of the collections that would be installed in the John Rylands Library in Manchester (*see* p 90), which she had founded in memory of her husband.

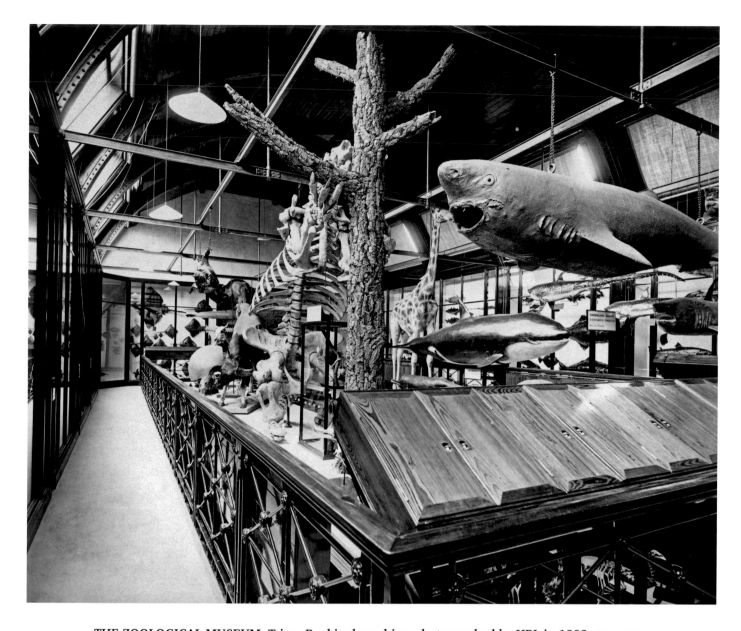

THE ZOOLOGICAL MUSEUM, Tring, Buckinghamshire, photographed by HBL in 1892. [BL11794]

Tring Park, built in the late 17th century by Sir Christopher Wren, was the home of Nathaniel Mayer, 1st Baron Rothschild, from 1879 head of the family firm of N M Rothschild & Sons. (Lionel) Walter Rothschild, his eldest son, preferred animals to banking, and his private museum (built on land given to him by his father as a 21st birthday present) was opened to the public in 1892. At Tring, Walter kept live animals in the park as well as dead ones in the museum; one of his keepers was sacked when it was discovered that he would take one of the wolves down to the Green Man in the town for dog fights – which it always won.

Walter, who succeeded his father as 2nd Baron Rothschild, was a dedicated and distinguished zoologist and on his death in 1938 gave his collections and the house to the Natural History Museum in London, which still maintains it as an outstation.

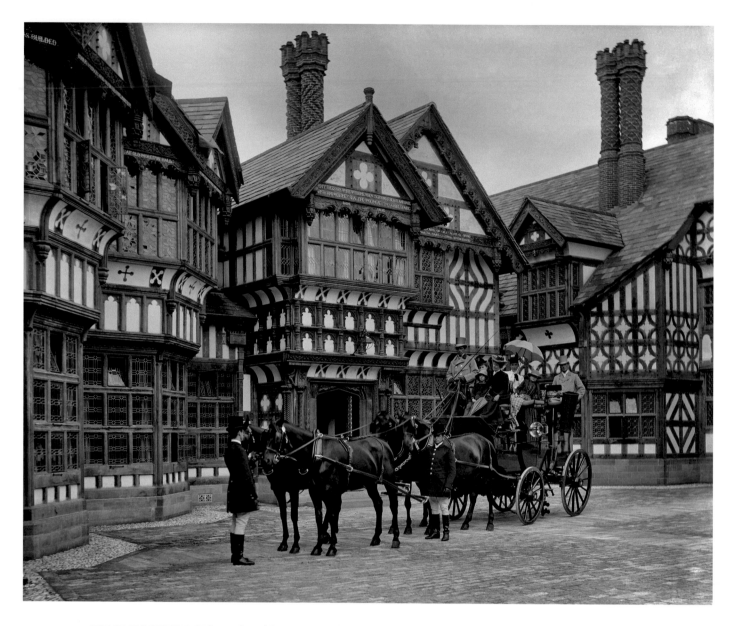

BIDSTON COURT (Edward Ould, 1891), Bidston, Wirral, photographed by HBL in 1894 for R W Hudson. [BL12855C]

With the spread of railways and before the arrival of the motor car, country roads were emptier than they had been for many years, and since the 1860s four-in-hand coaching had become a fashionable hobby among those who could afford the considerable expense of maintaining a carriage and a team.

Bidston Court was built for the soap manufacturer R W Hudson, and the elevation shown here was a close copy of the 16th-century Little Moreton Hall in Cheshire. In the 1904 edition of *Old Cottages, Farm Houses, and Other Half-Timber Buildings of Shropshire, Herefordshire and Cheshire* (p 39), Edward Ould wrote that 'given a suitable client, one who is worthy of the privilege of living in a timber house … it is an eminently suitable style'. A few years later Hudson would move south, from Birkenhead and the soap works, to live the life of a country gentleman in Berkshire (*facing page*). In 1929 a later owner would move Bidston Court itself to Frankby, 5 miles away, to replace a house of the 1860s. It survives, now known as Hill Bark.

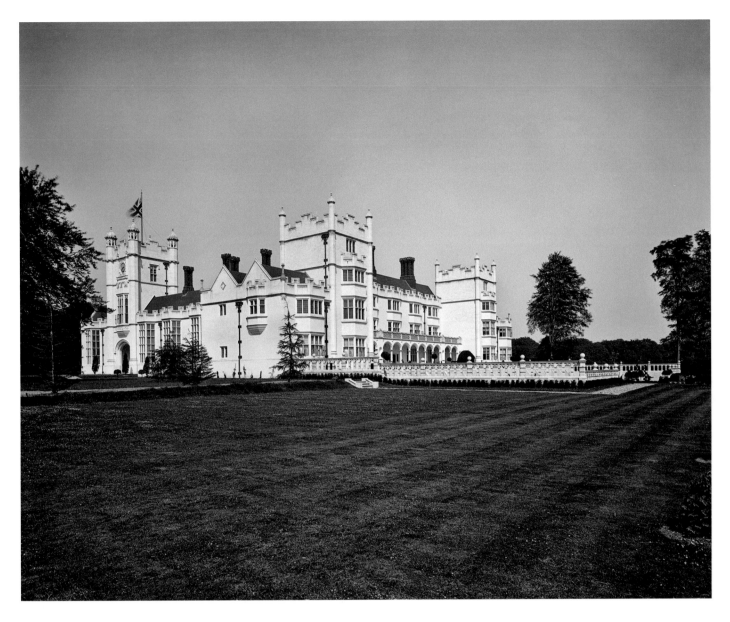

DANESFIELD HOUSE (W H Romaine-Walker, 1899–1901), Medmenham, Buckinghamshire, photographed by HBL in 1902 for R W Hudson. [BL17113]

A cheerful excursus into Old England for the soap maker R W Hudson. Hudson, from Birkenhead, bought the Danesfield estate in 1896, and in the next 14 years devoted himself to a career as a country gentleman as Chairman of the Shire Horse Society and breeder of a prize-winning herd of Berkshire pigs. He also amassed a collection of paintings, sold at great profit when he disposed of the Danesfield estate in 1910. Thereafter he seems to have lived mainly in London and Monaco.

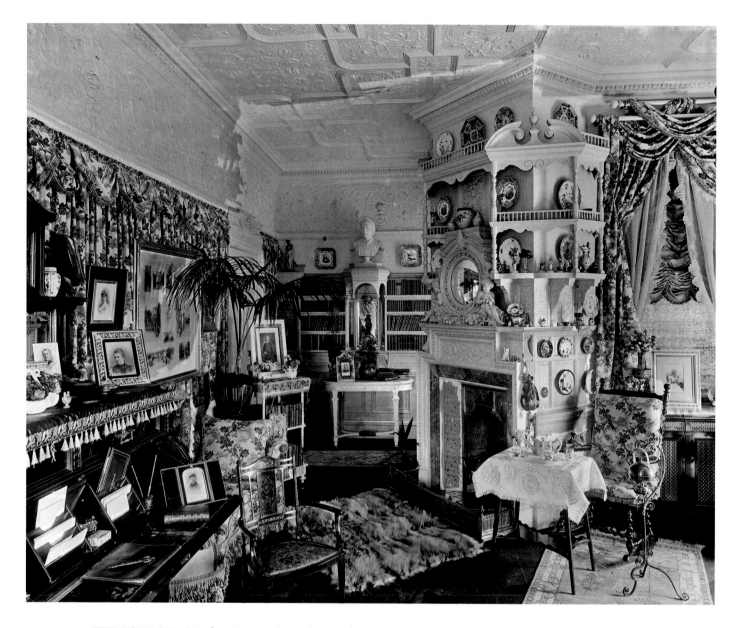

THE BOUDOIR, Trosley Towers (1887), Wrotham, Kent, photographed by AAB in 1891 for Sir Sydney Waterlow. [BL10904]

Trosley Towers was the late-Victorian home of Sir Sydney Waterlow. Waterlow had been an MP between 1868 and 1885, and Lord Mayor of London in 1872–3. In 1889 he gave another property – Lauderdale House in Highgate – with 29 acres of land to the newly formed London County Council as a public park, which is now named after him.

This room – dense with photographs, old china and *bibelots* – is probably the boudoir of his American second wife.

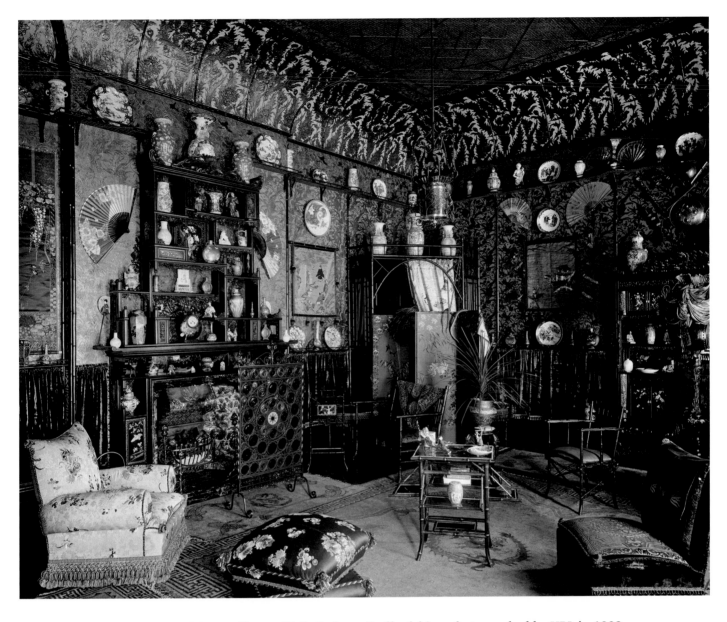

THE JAPANESE ROOM, Rolleston Hall, Tutbury, Staffordshire, photographed by HBL in 1892 for Sir Oliver Mosley. [BL11416]

The Japanese vogue began around 1870 and lasted into the 1890s. Generally, as here, a Japanese character was largely created by the assembly of Japanese objects – porcelain, silk, lacquer, arms and fans, and plenty of bamboo; otherwise the room is as full of things as any other room of the period. The room was fitted out by S J Waring & Sons.

Rolleston Hall was pulled down after the First World War.

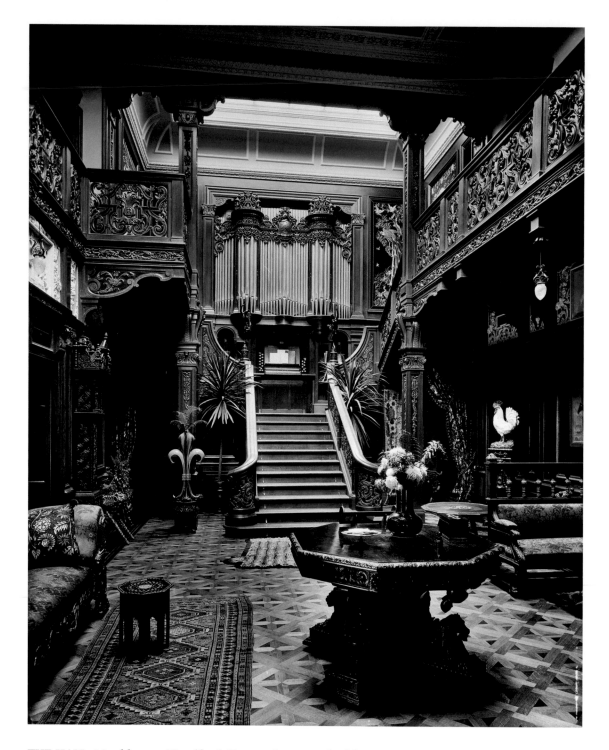

THE HALL, Monkhams, Woodford, Essex, photographed by AAB in 1893 for Arnold Hills.
[BL12541]

Monkhams had been bought the year before by Arnold Hills – a keen sportsman, the first president of the London Vegetarian Society and managing director of the Thames Ironworks, the largest shipbuilding firm on the river with a shipyard at Blackwall specialising in warships and liners. There he founded the works football team, which would later become West Ham United.

The house was a large, plain, white stuccoed house of the early 19th century. Hills spent a good deal of money on the grounds and on the house, redecorating the hall in a style that is difficult to describe.

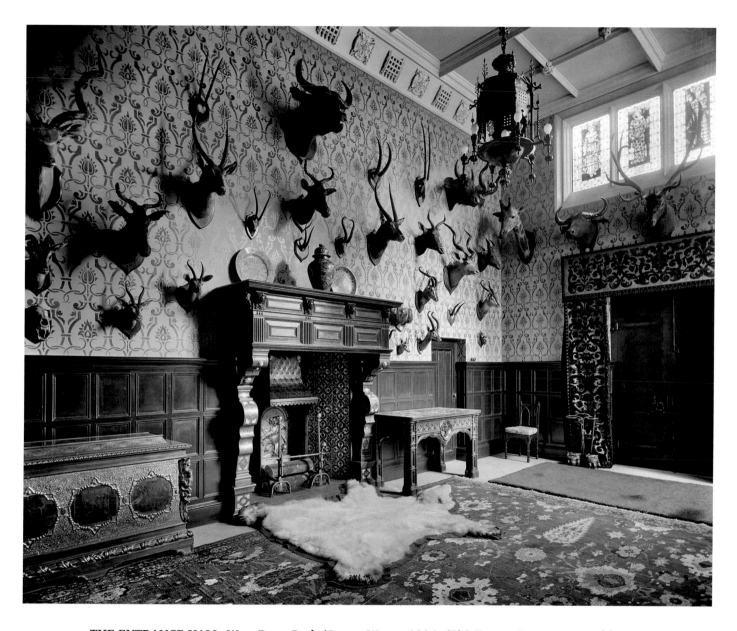

THE ENTRANCE HALL, West Dean Park (James Wyatt, 1804; (Sir) Ernest George & Harold Peto, 1893 (enlargement)), West Dean, West Sussex, photographed by HBL and AAB in 1895 for William James. [BL13342]

West Dean was an old house hugely enlarged for William James, millionaire and obsessive big game hunter. His wife preferred hunting social lions; both became friends of the Prince and Princess of Wales, and frequently entertained English and foreign royalty.

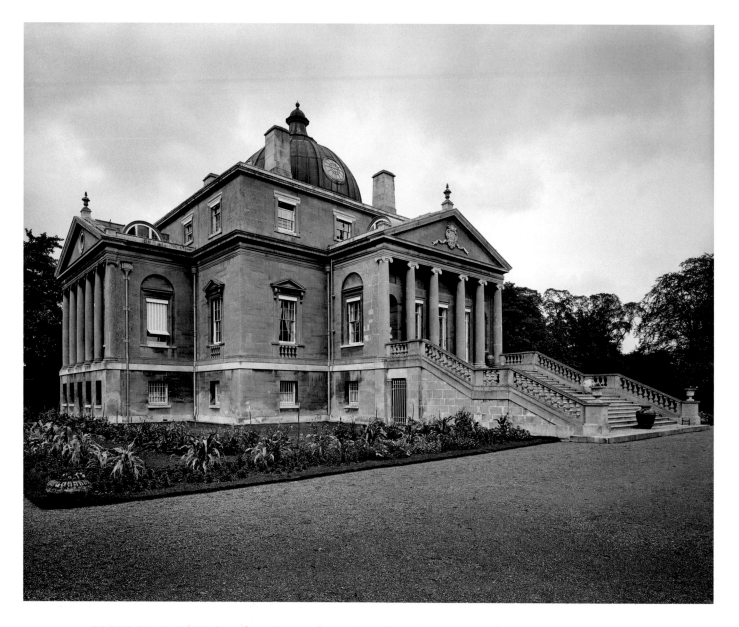

FOOTS CRAY PLACE (Matthew Brettingham, 1754 (house); R Frank Atkinson, *c* 1900 (restoration)), Foots Cray, Kent, photographed in 1900 for Samuel Waring. [BL16062]

Built in 1754, Foots Cray Place was one of only four country houses in England to be modelled on Palladio's Villa Rotonda, and like another of the four – Lord Burlington's Chiswick House – it was a villa in the 18th-century English sense of a highly sophisticated house of modest size within reach of town.

When photographed (inside as well as outside) Foots Cray Place had recently been bought and brought up to date by Samuel Waring. Atkinson was the architect for Waring's restoration. In his own *Who's Who* entry Waring described the decorative work of his firm as 'promoting a general recognition of the New English Renaissance' and his preference for a Georgian house is in keeping with current changes in taste.

The house was burnt down in 1949 and the site is now a public park.

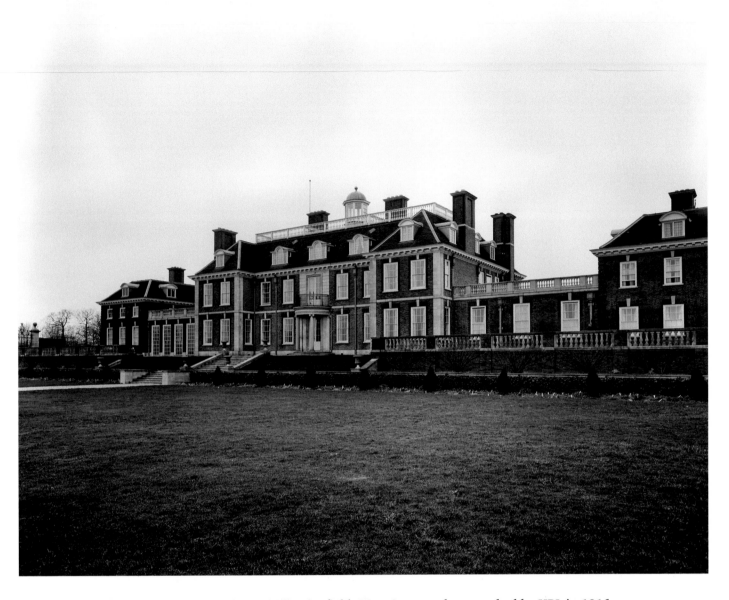

ARDENRUN (Ernest Newton, 1906), Lingfield, West Sussex, photographed by HBL in 1916 for Trollope & Colls Ltd, builders. [BL23361]

Next to his slightly younger contemporary, (Sir) Edwin Lutyens, Newton was arguably the finest country house architect of the period. All his houses have a directness and simplicity that, particularly in the early years of his career in the 1890s, placed him well ahead of his time. The William and Mary style of Ardenrun, built in 1906, would remain fashionable for the next three decades.

Ardenrun was built for the banker H H Konig (whose brother commissioned work by Lutyens at his own house, Tyringham). It was later the home of the racing driver Wolf Barnato, who financed the Bentley Motor Company in the 1920s. The house was burnt down in 1933.

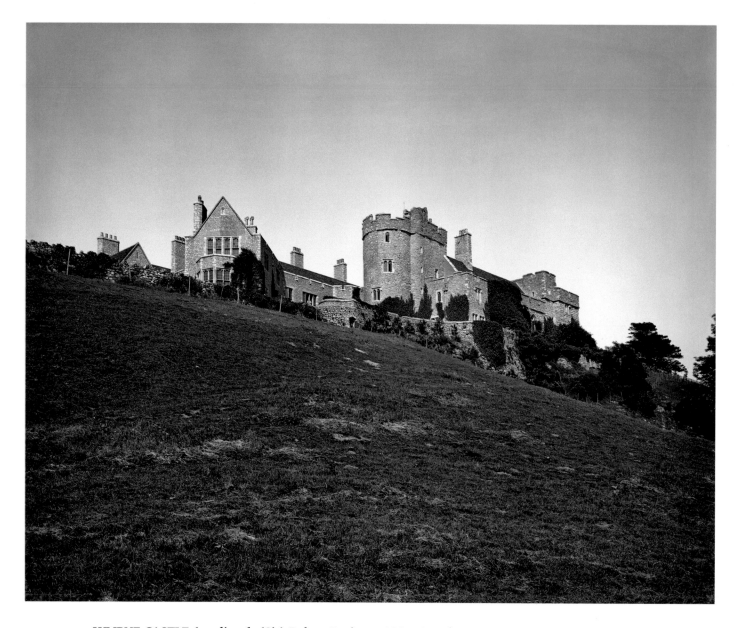

LYMPNE CASTLE (medieval; (Sir) Robert Lorimer, 1907–9 and 1911–12), Lympne, Kent, photographed in 1917. [BL23940/009]

A ruined medieval castle on a superb site high above Romney Marsh, made habitable and extended for the brewer F J Tennant in the 20th century. The old part is on the right in this view – a great hall with a tower at each end. Lorimer added the long range extending to the left, in what could be considered a rather homely style but culminating in a drawing room with a bow window to make the most of the prospect.

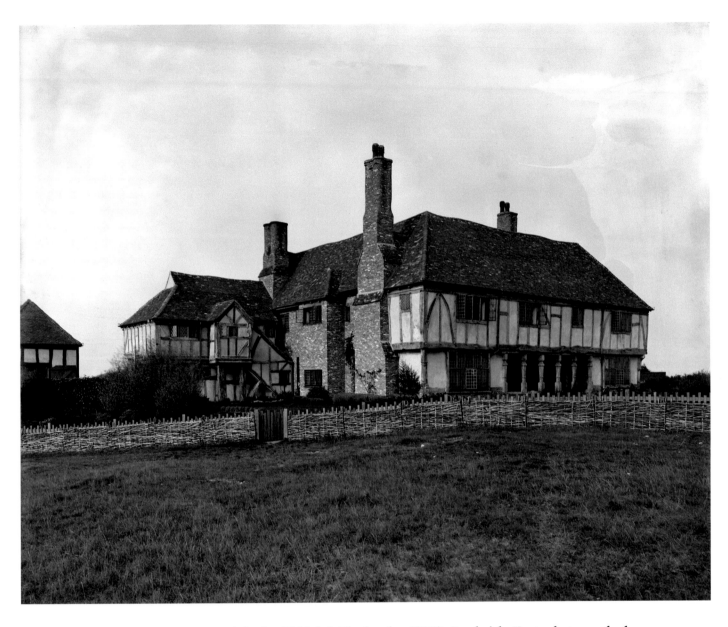

SMALL DOWNS HOUSE (Charles Biddulph-Pinchard, *c* 1920), Sandwich, Kent, photographed by AAB in 1920 for F Leverton Harris. [BL25151]

Post-war reaction from the pre-war confidence in progress reached its extreme with the building of new houses out of old materials, for which there was a large market. At Small Downs House there was perhaps a special poignancy to this nostalgia in that the house contained a small chapel evidently devoted to the memory of a son of the family, serving in the Navy and killed in the war.

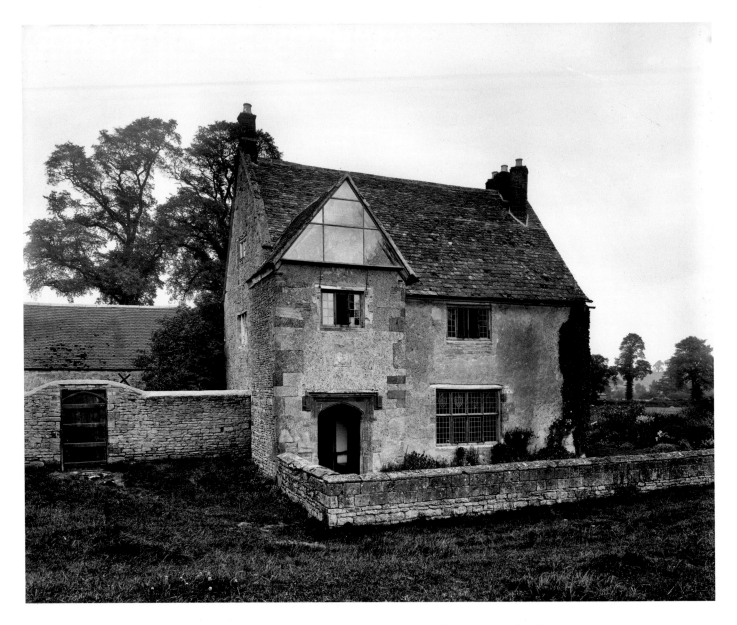

**SULGRAVE MANOR, Sulgrave, Northamptonshire, photographed by HBL in 1920 for
Gill & Reigate, furniture dealers and decorators.** [BL25040/002]

Sulgrave Manor was the English home of George Washington's ancestors in the 16th and 17th
centuries. Part of the house had been pulled down in the late 18th century and what remained had
been lived in by a farmer.

In 1914 Sulgrave Institutions had been founded in England and America to celebrate a century
of peace between the two countries and to promote closer relations, and among other activities
(which included endowing the first Chair of American history in a British university) they had
bought the house and repaired it. The National Society of Colonial Dames provided furnishings and
an endowment. In 1928 a plausible facsimile of the lost half of the house was built, designed by Sir
Reginald Blomfield. By that time the house was visited by 10,000 people a year, mainly Americans,
although Blomfield was a trifle cynical in his *Memoirs of an Architect* of 1932 (p 208): '[I]t is
improbable that [George Washington] ever heard of the place in far-distant Virginia, or if he had,
would have cared two straws about it.'

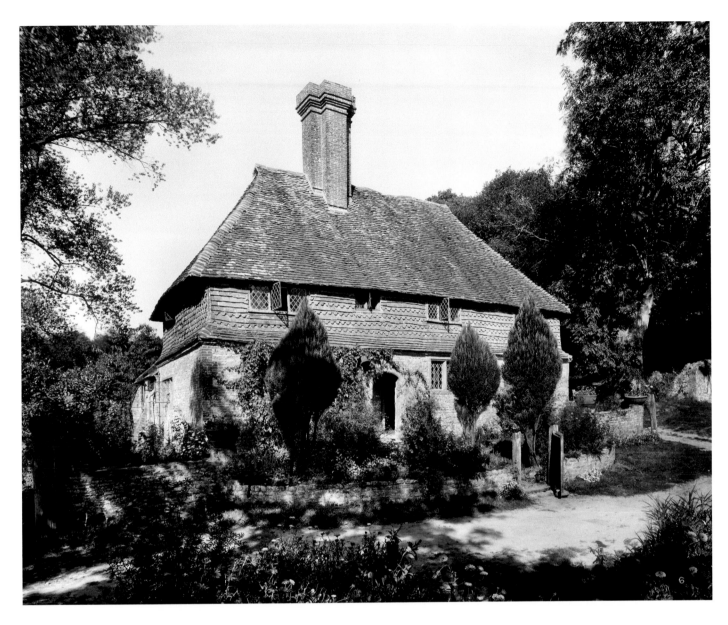

VALEWOOD, Bell Vale Lane, Haslemere, Surrey, photographed by HBL in 1926. [BL28611/006]

The 16th-century country cottage of the architect Oliver Hill, in a part of south-west Surrey that had been popular with artists, writers and musicians since the late 19th century. Hill might be seen as the original model for the stock figure of the architect who designs modern buildings but himself lives in a picturesque old cottage. But the contradiction is not so real as it might seem. Both could be regarded as expressing a concern with simplicity and with the appropriate use of materials – with the rational employment of the latest technologies in the case of the new building, and in the old house with how generations of craftsmen made the best use of the materials that were then available.

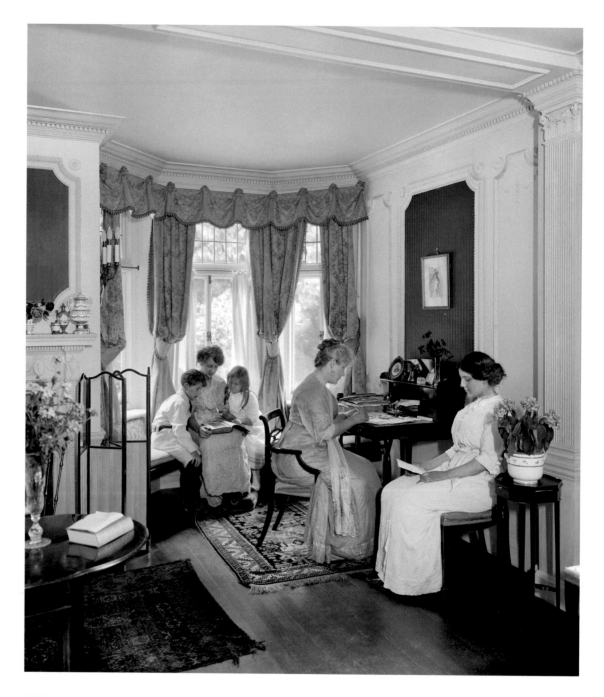

MEMBERS OF THE FRANKLIN FAMILY, The Grange, Goudhurst, Kent, photographed by HBL in 1912. [BL21807A]

The Grange was the home of Leonard Franklin, partner in the family bank of Keyser & Co. Sitting at the desk is probably his wife Laura (Ladenburg), while in the window sits Ruth, their eldest daughter, reading to the youngest children, Adrian and Adelaide. Their middle daughter sits reading to herself.

Franklin's father had been a business partner of the banker Samuel Montagu (born Montagu Samuel), 1st Lord Swaythling, whose sister he married. The Franklins and the Montagus were Liberal radicals in politics, active in a great many charities, Jewish and non-Jewish, and involved in a number of progressive political and educational movements. In 1923 Franklin was elected Liberal MP for Hackney Central but lost the seat at the next election.

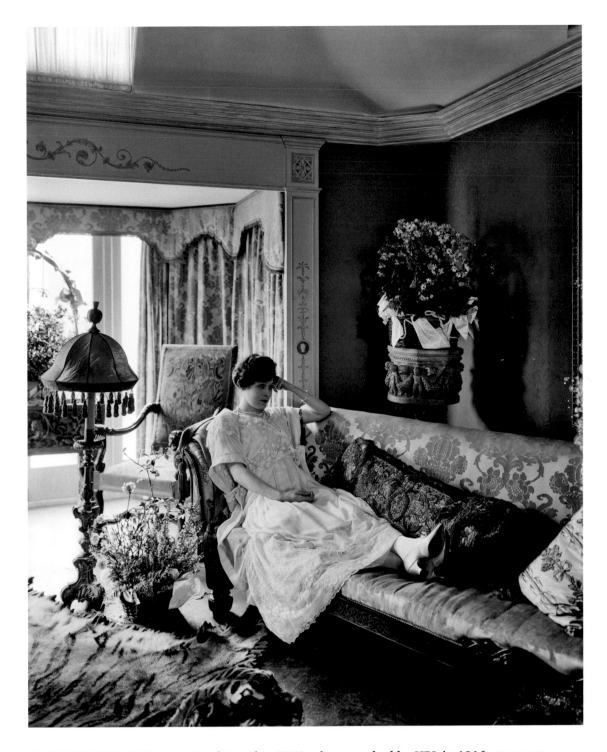

MRS FREEMAN, 45 Queens Road, London NW8, photographed by HBL in 1916. [BL23449]

Mrs Freeman has not been otherwise identified, nor why she should have been photographed reclining pensively on a Regency chaise longue. A Renaissance torchère has been converted into a lamp with a chinoiserie shade, flowers stand in basketwork cache-pots draped with silk and a fine tiger skin rug crouches on the floor at her feet.

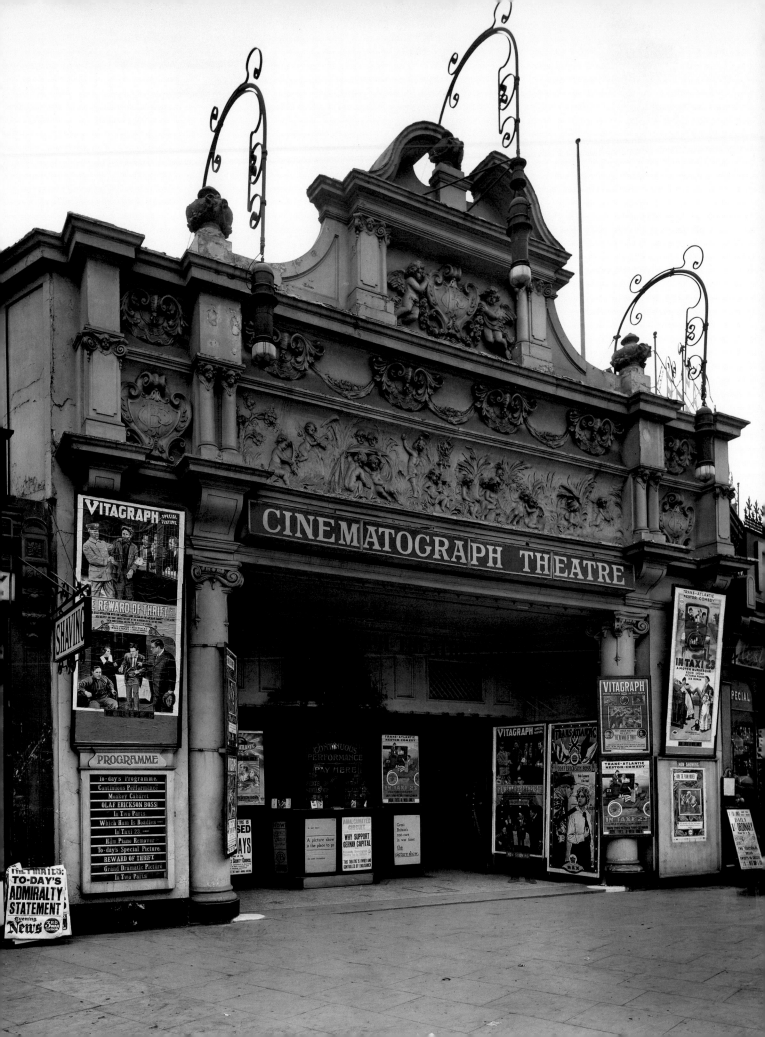

LEISURE AND ENTERTAINMENT

The latter part of the 19th century saw growth in every kind of entertainment. A high proportion of London's theatres were built or rebuilt in the decades before the First World War, and it was the golden age of the music hall. Grand hotels were becoming still grander, providing ever more luxurious surroundings for their residents and catering for their every need while they were staying. Hotels also provided some of the most opulent settings for diners-out, while restaurants themselves greatly increased in size and numbers and in the lavishness of their decoration. Catering for the masses expanded too, with tea shops that emulated the luxury of the smart restaurants at a fraction of the cost.

Perhaps the greatest revolution in mass entertainment in the new century was the coming of the cinema – in less than 15 years advancing from fairground sideshows to purpose-built structures seating over 2,000, where not only the films but the setting and amenities offered an escape from the routines of everyday life. And for the vast majority of the population whose holidays were short and still taken in England, the seaside and the zoo provided enjoyment and distraction.

**THE CINEMATOGRAPH THEATRE,
269 Seven Sisters Road, London N4,
photographed in 1915.** [BL22928]

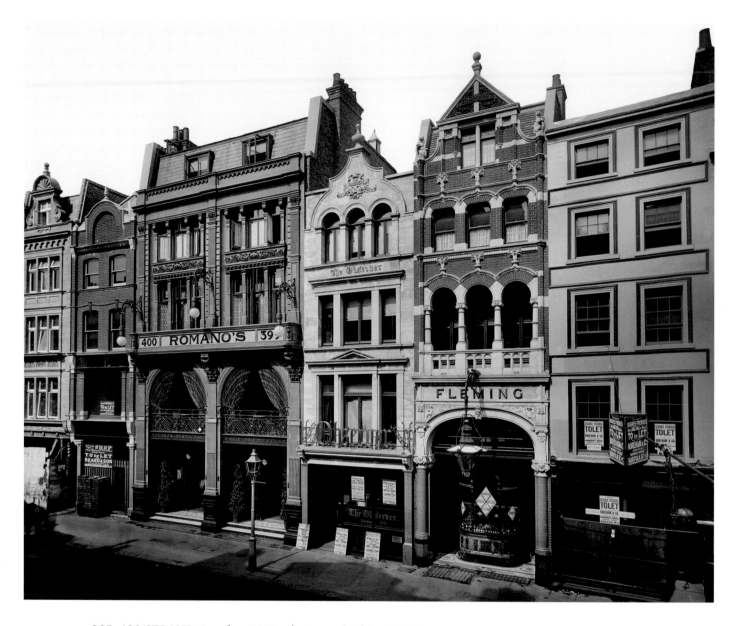

395–400 STRAND, London WC2, photographed in 1895. [BL13320]

Romano's Restaurant had been founded in 1874 and was particularly popular with actors, lawyers, journalists and the girls of the Gaiety Theatre close by. *The Observer*, whose offices are also seen here, was the oldest Sunday newspaper in the world; it was remarkable at this time for having a woman editor, Rachel Beer, the wife of its owner whom she had married in 1887. She herself bought *The Sunday Times* in 1893 and, for a time, edited both. The third building in the group was the premises of Albert Fleming, wine merchant.

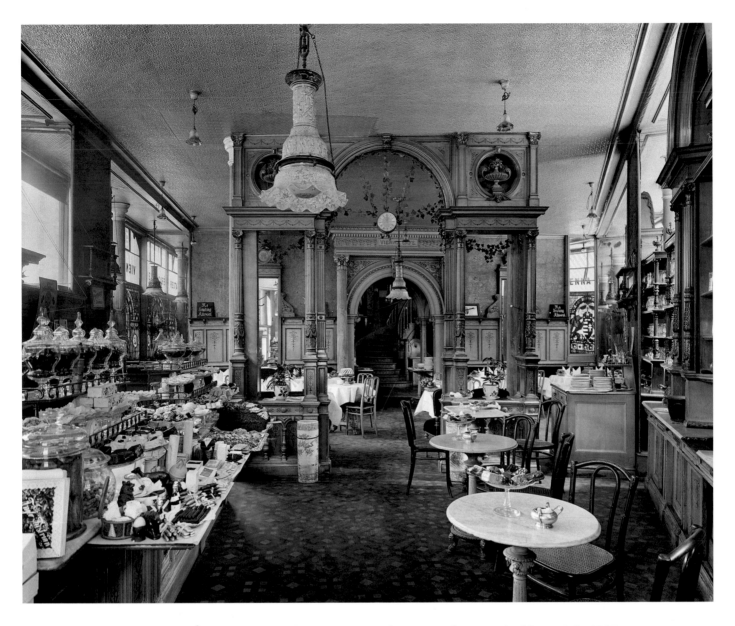

THE VIENNA CAFÉ, 24–28 New Oxford Street, London WC1, photographed by AAB in 1897.
[BL14069/001]

The Vienna Café, near the British Museum, advertised a ladies' dining saloon as well as billiard and smoking rooms, and was one of relatively few restaurants where unaccompanied ladies could go for a light lunch or tea.

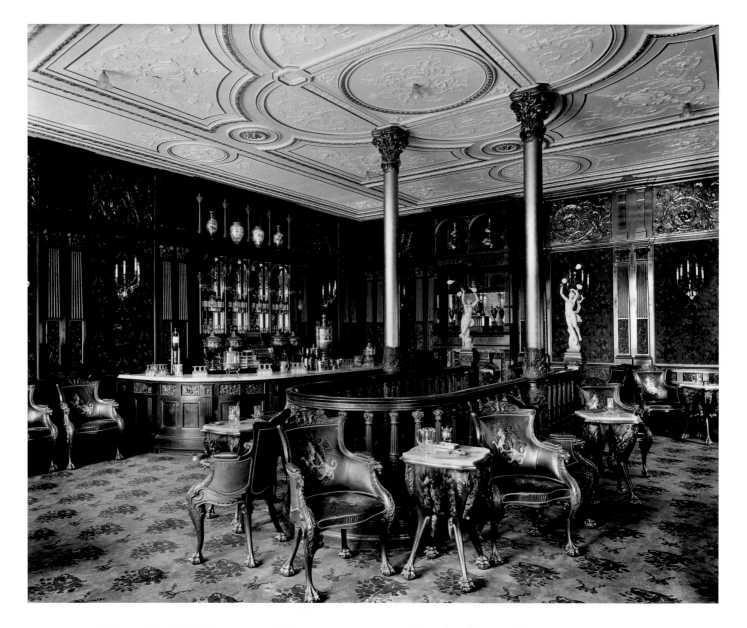

THE WINE ROOM OF THE LEICESTER PUBLIC HOUSE (Treadwell & Martin, 1886–7, 1895), Leicester Square, London WC2, photographed by AAB in 1895. [BL13152]

A superior and opulently furnished bar on the first floor of a public house close to Piccadilly Circus. Wall surfaces are patterned and textured in a rich variety of materials, with a three-zone decorative scheme of dado, filling and frieze and with 'art' vases on shelves. Behind the bar, flanking a very decorative cash register, are decanters, various bottles, boxes of cigars and a splendid row of spirit urns. On the tables are match stands and ashtrays. One would like to know how the decorators described the style of the furniture.

Leonard Treadwell and Henry Martin built up a large practice as public house architects, developing in later years a distinctive stylistic blend of Gothic and Art Nouveau.

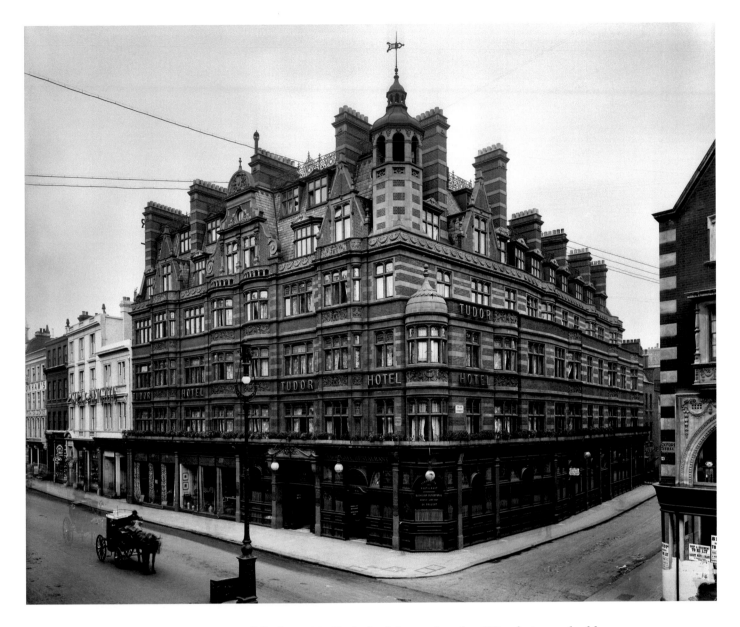

THE TUDOR HOTEL (P E Pilditch, 1898–9), Oxford Street, London W1, photographed by AAB and colleague in 1908. [BL20271/001]

In the last years of the 1890s a combination of factors encouraged an extraordinary boom in pub building, followed in 1900 by an equally dramatic crash. Fortunes were made and (very soon) lost, but in the meantime a great many large and spectacular public houses were built, largely in the hope of selling them on at a profit. The Tudor Hotel was built in a Flemish/Jacobean style whose ostentatiousness is typical of the genre. Little is known of the architect P E Pilditch, who like many public house architects may have specialised in the kind of cheerfully showy architecture that publicans demanded.

In a pub of this size there would have been a number of separate bars – Public, Private, Saloon, Snug, Ladies', Tap Room, Parlour – whose minute social gradations corresponded with those of society at large. There would also have been billiard and dining rooms. Presumably there were guest rooms as well, but in contemporary trade directories the Tudor Hotel is listed as a public house rather than a hotel.

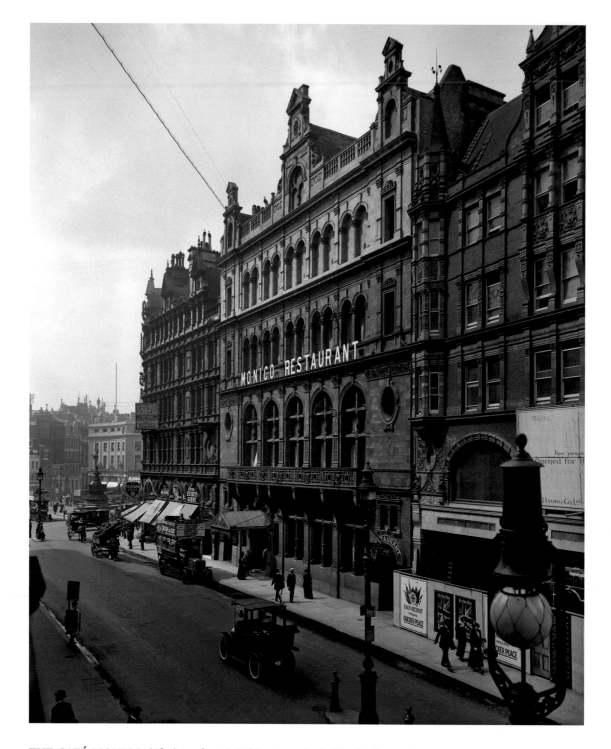

THE CAFÉ MONICO (Christopher & White, 1888–9), Shaftesbury Avenue, London W1, photographed by HBL and AAB in 1915 for A C Hutchins. [BL23061]

Shaftesbury Avenue was cut through Soho in the 1880s, when the Flemish Renaissance was a favourite London building style. The view shows the north side of the street, looking west towards Piccadilly Circus, with the Shaftesbury monument ('Eros') and the as yet un-rebuilt north-western quadrant of John Nash's Piccadilly Circus in the distance. The Café Monico had a secondary entrance from Piccadilly Circus (*see* p 31).

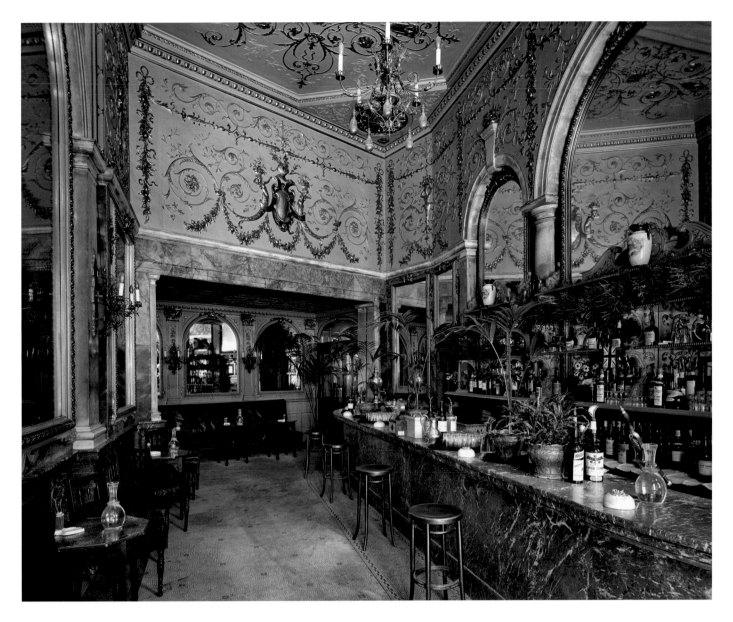

THE BUFFET BAR AT THE CAFÉ MONICO (Christopher & White, 1888–9), Shaftesbury Avenue, London W1, photographed by HBL and AAB in 1915 for A C Hutchins. [BL23065]

Like a number of the leading restaurants of the time, the Café Monico was a very large establishment: Bedford Lemere & Co's photographs include views of the Café Saloon, Winter Garden, Brasserie, Buffet, Grill Room, International Hall, Renaissance Room, Oriental Room, Louis XV Room, Louis XVI Room, Parisian Room, Regent Saloon, Masonic Temple and Chapter Room, all decorated in styles that met their descriptions. Many of these were private rooms available for hire.

Before the war there had been a German Beer Saloon. No doubt this had been done away with by 1915 when this photograph was taken.

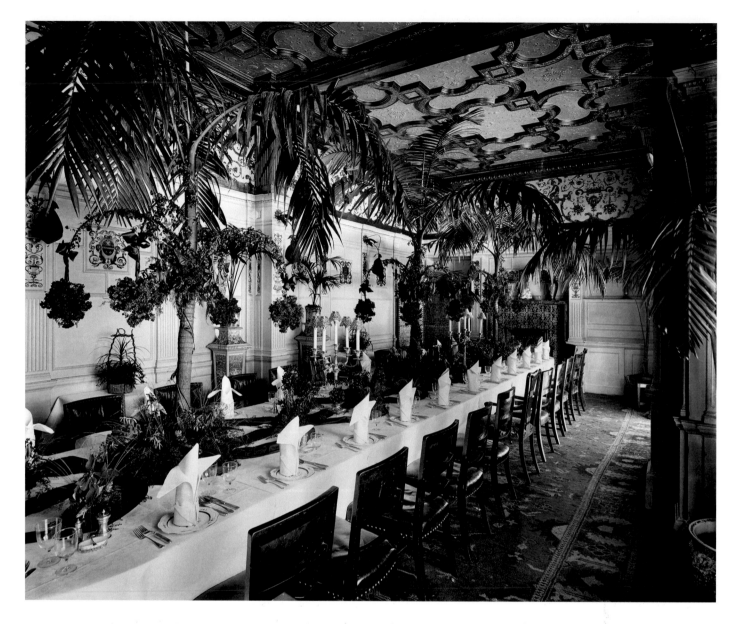

THE PINAFORE ROOM AT THE SAVOY HOTEL, The Strand, London WC2, photographed by HBL in 1895. [BL13428]

A remarkable display of table decoration set up for a private dinner. Described as 'red dinner table' in Bedford Lemere & Co's daybooks, the occasion must be a celebration, the coloured ribbons wreathed over the tablecloth perhaps relating to a win on the turf.

The photograph (like that of the coronation decorations at the Royal Automobile Club (*see* p 56)) is a good illustration of the inability of contemporary photographic emulsions to give a true value to the colour red, which in these photographs appears much darker than in life.

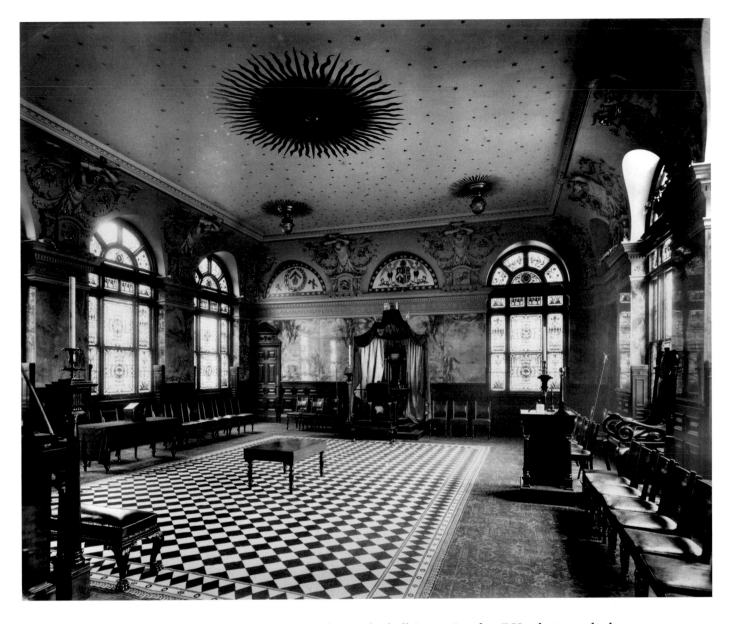

THE MASONIC TEMPLE, The Ship & Turtle, Leadenhall Street, London EC3, photographed by AAB in 1900. [BL16116]

A number of the larger hotels and restaurants had halls for meetings of Masonic lodges. The Ship & Turtle, an old and prominent City inn, was renowned for its oysters and its turtle soup – traditional City fare – and kept live turtles in an aquarium. A few doors away was the turtle merchant, T K Billis, whose advertisements announced that he imported live turtles from the West Indies every two weeks.

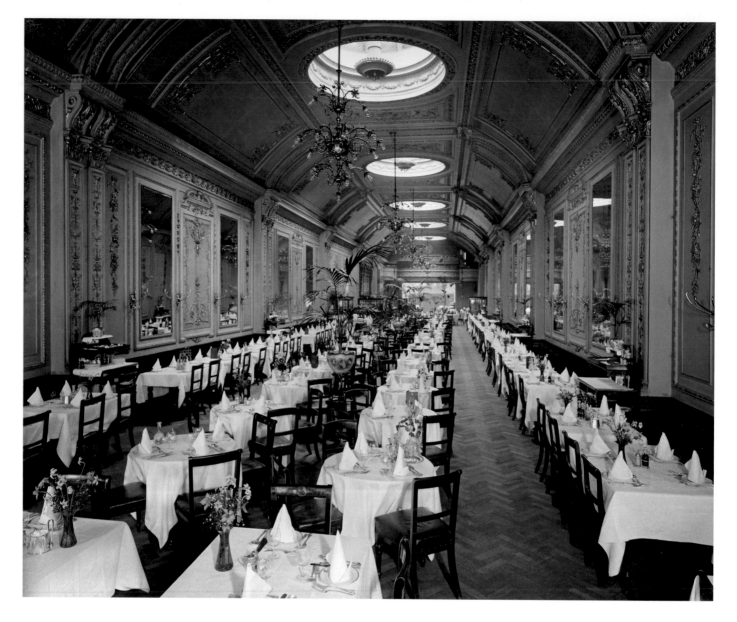

GATTI'S RESTAURANT, 436 Strand, London WC2, photographed in 1912. [BL21612]

One of the large restaurants characteristic of the age. Carlo Gatti, the founder of the firm, showed what might be possible for immigrants through the 19th-century growth of London. From the Ticino in Italian-speaking Switzerland, he had originally left home to join his brothers in Paris in the chestnut trade. He arrived in London in 1847, selling coffee and waffles, and chestnuts in winter, from a street stall. He soon expanded into chocolate making and business as a pastry cook, and then into the ice cream trade, importing ice from Norway. Long established in the Strand, in 1912 the company's restaurant on the corner with Villiers Street had recently been reconstructed. Gatti's is said to have been the first restaurant where a small orchestra provided music.

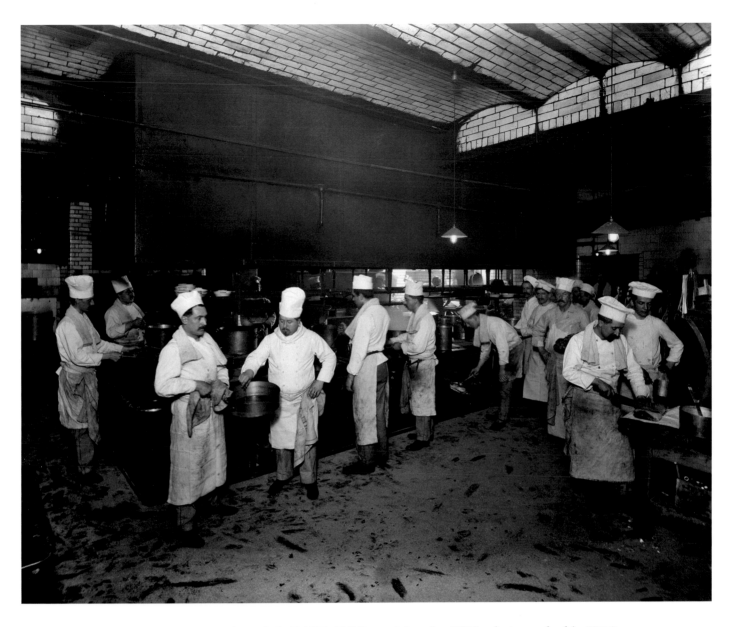

THE KITCHEN OF GATTI'S RESTAURANT, 436 Strand, London WC2, photographed in 1912.
[BL21616]

A sous-chef holds a pan while the head chef – in his tall hat – adjusts the seasoning. At this time traditional British cooking was a mainstay of Gatti's menus even though – as was true universally at the time – these were written in French. In 1914 the reassuring fare ranged from *Carbonade de Boeuf* at 1s 2d and *Lapin sauce Chasseur* at 1s 4d, to *Entrecote Marchand de Vin* at 2s 6d and *Demi Faisan en casserole* at 4s.

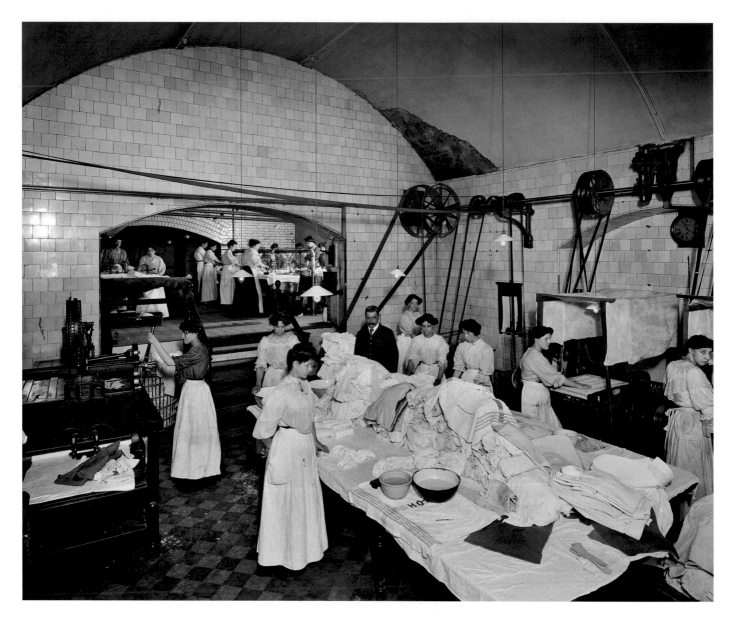

THE LAUNDRY OF THE HOTEL CECIL (Perry & Reed, 1890–6), Victoria Embankment, London WC2, photographed in 1907 for the hotel company's publicity department. [BL20041/002]

The Hotel Cecil was one of the largest and most luxurious of London hotels, extending from the Strand to the Victoria Embankment. Girls appear to be dealing with guests' laundry – including starching collars and shirt fronts – with the aid of the latest machinery.

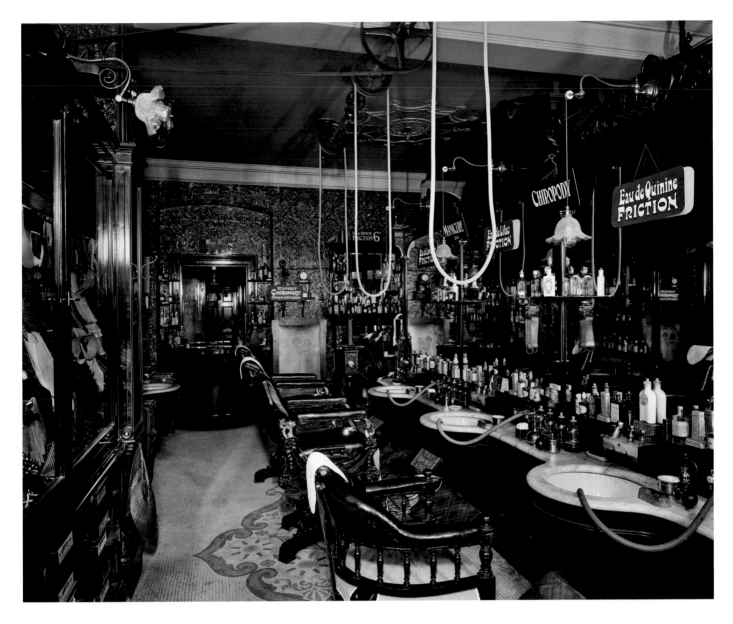

**THE GENTLEMEN'S HAIRDRESSING SALON OF THE HOTEL CECIL (Perry & Reed, 1890–6),
Victoria Embankment, London WC2, photographed by AAB in 1911 for the hotel.** [BL21090]

The Hotel Cecil had been promoted by the crooked financier Jabez Balfour, whose Liberator Building
Society crashed in 1892 leading to his being sentenced to 14 years penal servitude. It was probably
the model for the Hardingham Hotel in H G Wells's *Tono Bungay*, where the fraudulent patent
medicine millionaire at the centre of the story had his rooms. Nevertheless, when opened in 1896 the
hotel was considered to be the most magnificent in Europe; Emile Loubet, President of France, stayed
at the Hotel Cecil on a state visit in July 1903.

Taken over by the Air Board between 1917 and 1920, the hotel closed in 1930 and was replaced
by Shell-Mex House.

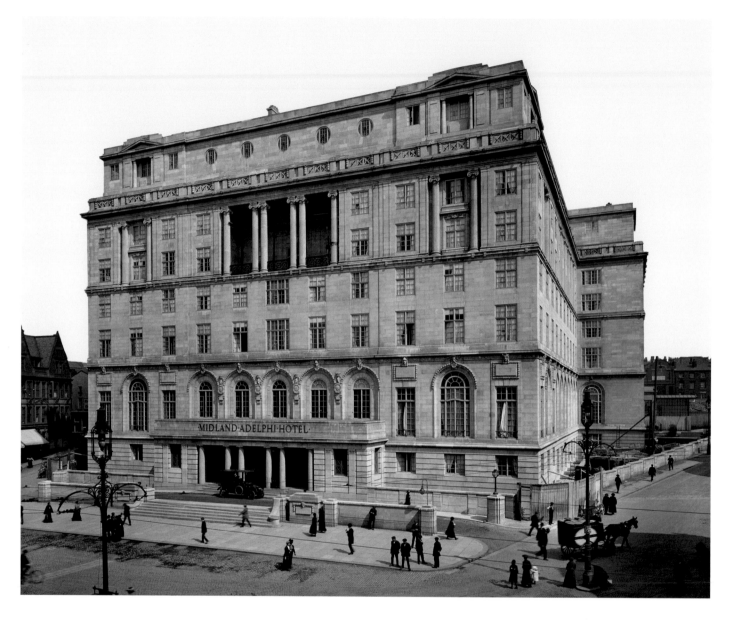

THE MIDLAND ADELPHI HOTEL (R Frank Atkinson, 1914), Ranelagh Place, Liverpool, photographed in 1914. [BL22609]

The newly built Midland Adelphi Hotel, a short distance from Lime Street Station, was the grandest hotel in Liverpool and the preferred hotel for transatlantic passengers. In its neoclassical simplicity, Atkinson's architecture has come a long way from his exuberant Waring & Gillow's building in London of 13 years before (*see* p 50).

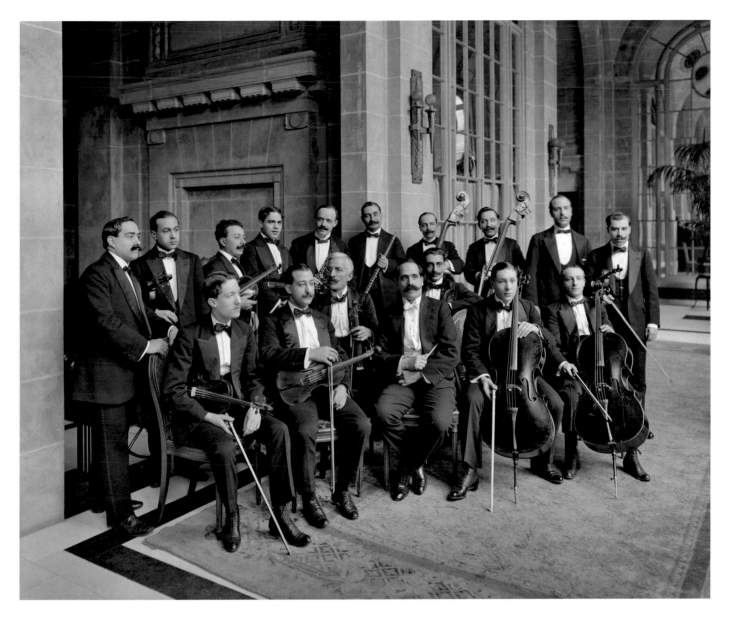

THE ORCHESTRA AT THE MIDLAND ADELPHI HOTEL (R Frank Atkinson, 1914), Ranelagh Place, Liverpool, photographed in 1914 for Señor José Gomez. [BL22620]

The Midland Adelphi Hotel had just opened as the most luxurious hotel in the city. In this photograph of the resident orchestra, the conductor, Señor José Gomez, is distinguished by his baton and his white waistcoat and tie.

The firm's daybook entry suggests that Gomez himself asked for two photographs of his orchestra to be taken while Lemere & Co were photographing the hotel for its owners.

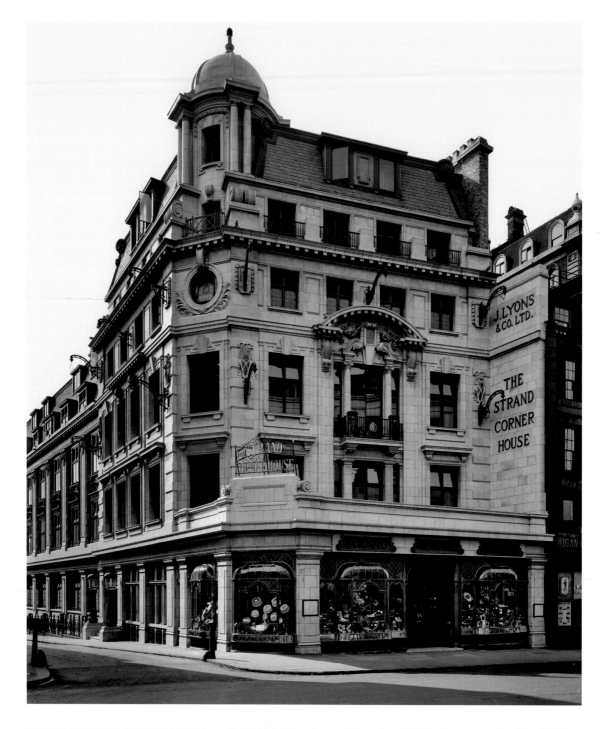

LYONS CORNER HOUSE (W J Ansell, 1915), The Strand, London WC2, photographed in 1915 for the Leeds Fireclay Company. [BL22997]

Lyons Corner Houses were a London institution for two generations – teashops and restaurants distinguished by their smart white exteriors in glazed terracotta with gold lettering, providing reliable catering for the middle-class masses. They maintained low prices by economies of scale and by producing as much as possible of the goods on offer at their own factory, Cadby Hall in Hammersmith (*see* p 121).

The terracotta decoration was provided by the Leeds Fireclay Company, a long-standing client of Bedford Lemere & Co (*see* pp 140, 155 and 173).

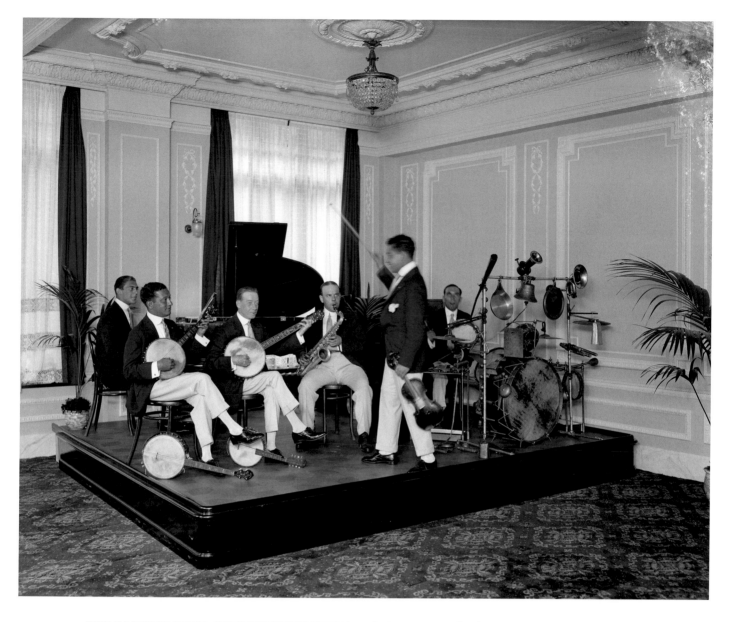

THE RAGTIME BAND AT THE MAISON LYONS RESTAURANT, Oxford Street West, London W1, photographed by HBL and AAB in 1916 for J Lyons & Co. [BL23648A]

'Maison Lyons' was Lyons' superior restaurant chain. The Ragtime Band includes two banjos, saxophone, piano and percussion, and a conductor who doubled on the fiddle. At this time, Lyons provided music in many of their larger tea shops and restaurants, and maintained a Band Department whose job it was to hire performers.

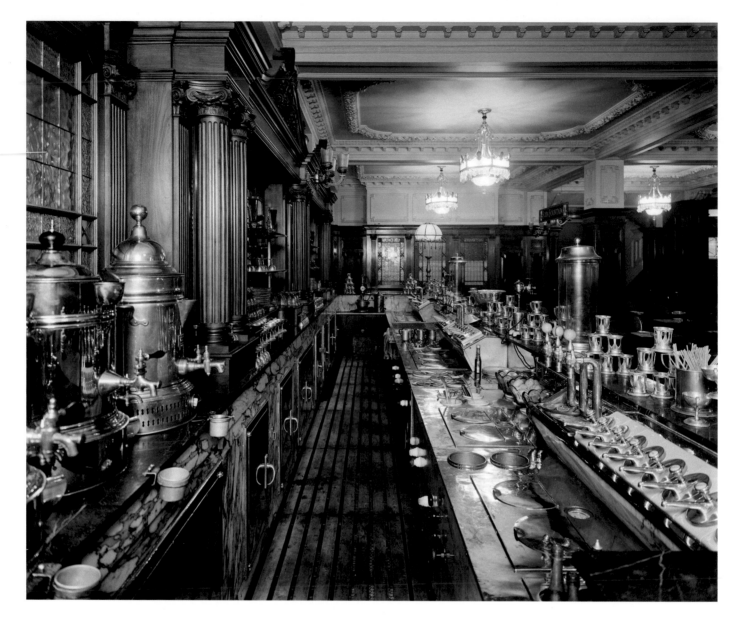

THE HOT FOOD COUNTER, Lyons Corner House, Coventry Street, London W1, photographed by AAB in 1923 for Laurie Price & Co. [BL26930/013]

This view was photographed as one of a series for Laurie Price & Co, refrigeration engineers, who presumably supplied much of Lyons' equipment. Refrigeration greatly facilitated centralised production for Lyons' restaurant chain, leaving as little as possible to be prepared on the spot.

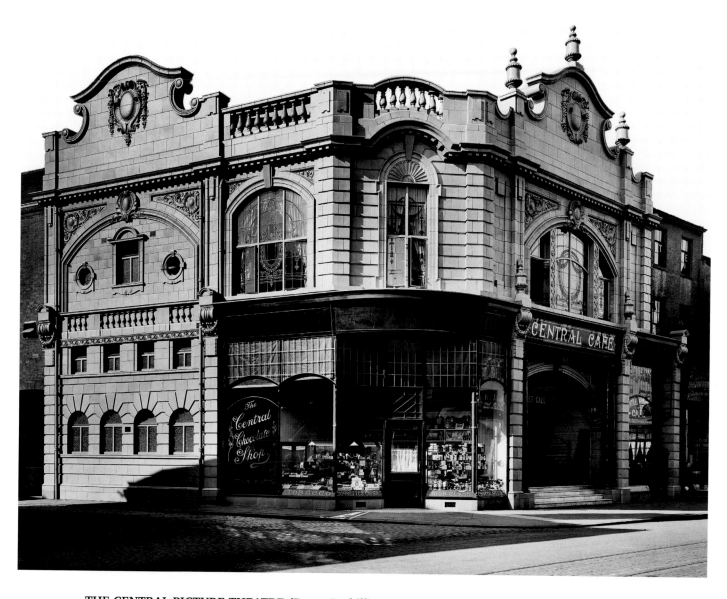

THE CENTRAL PICTURE THEATRE (Peter Gaskill), 47 Prospect Street, Kingston-upon-Hull, Humberside, photographed by HBL in 1915 for P S Newbound. [BL23301]

Cinema proprietors soon recognised that a visit to the movies could be more than just a visit to see a film. A chocolate shop on the corner and a smart café with palms and a piano within the cinema building helped to make a complete evening out.

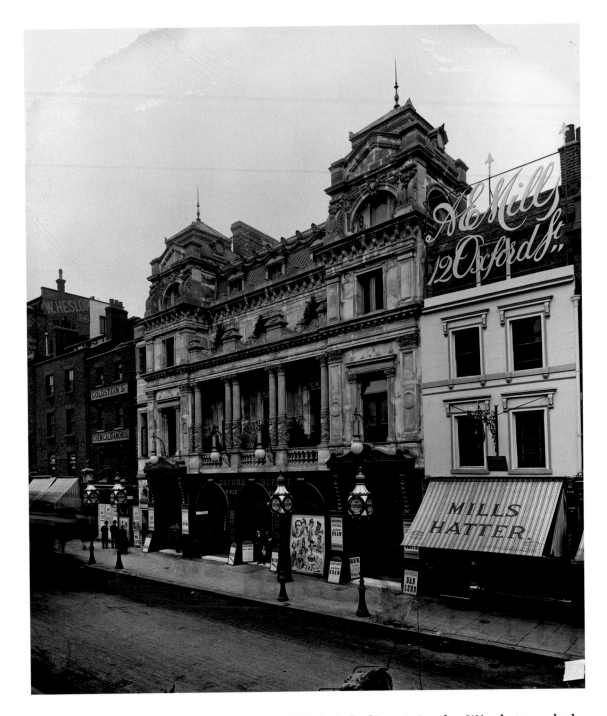

THE OXFORD MUSIC HALL (Wylson & Long, 1893), Oxford Street, London W1, photographed by AAB in 1893. [BL12092]

The successive rebuildings of the Oxford illustrated well the growth of the music hall in the later 19th century. Prior to 1861 the site had been occupied by the Boar and Castle public house, an ancient galleried inn, whose landlord had put up a shed for musical entertainment in the yard at the rear. A first Oxford Music Hall had been burnt down in 1868, a second in 1872, and Wylson & Long's building replaced the third. Wylson & Long also designed pubs.

The interior – fitted out with carved wood and plaster, mosaic and Venetian glass, and decorated in gold, blue and pink – was as overblown as the outside. The music hall was pulled down in 1926 to be replaced by yet another Lyons Corner House.

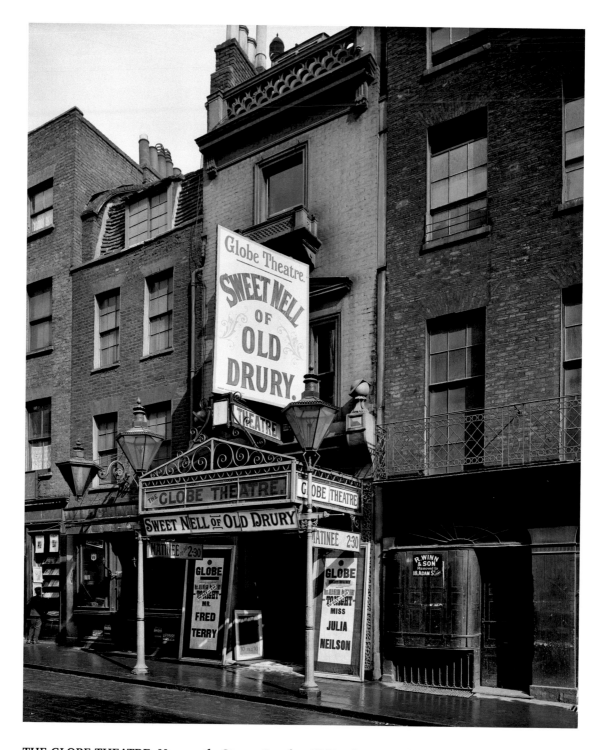

THE GLOBE THEATRE, Newcastle Street, London WC2, photographed by AAB in 1902. [BL16906]

The Globe Theatre opened in 1868 and was pulled down in 1902 for the Aldwych improvement scheme (*see* p 39). Adolphe Boucher's photograph shows the outside of the theatre at the time of its final production, Paul Kester's very successful *Sweet Nell of Old Drury* in which Julia Neilson played Nell Gwynne and Fred Terry played Charles II.

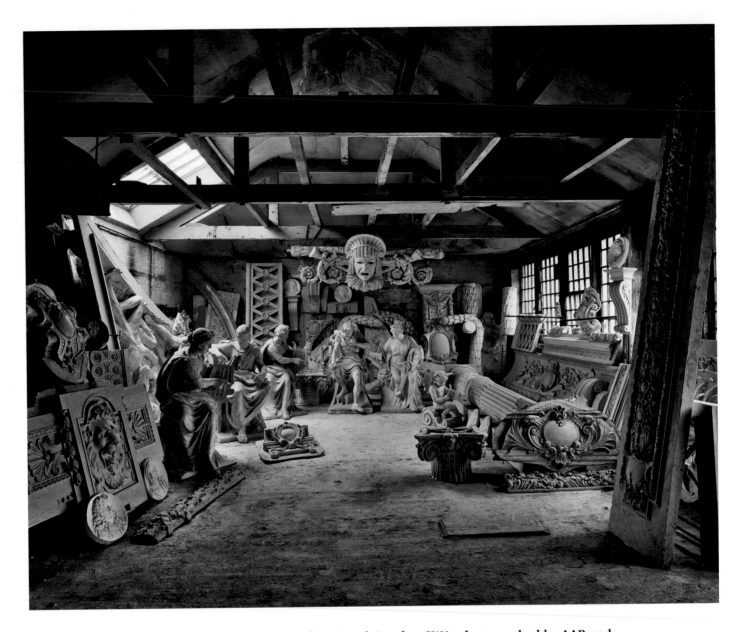

J TANNER & CO'S STUDIO, 45 Horseferry Road, London SW1, photographed by AAB and colleague in 1911 for the company. [BL21484]

The demand for lavish internal decoration created a strong demand for effects that could be achieved quickly and relatively cheaply, with sculpture and ornament carried out in plaster. J Tanner & Co was among the leading firms in this market, supplying ornament for public buildings, temporary exhibitions, private houses and theatres such as the London Opera House (*facing page*).

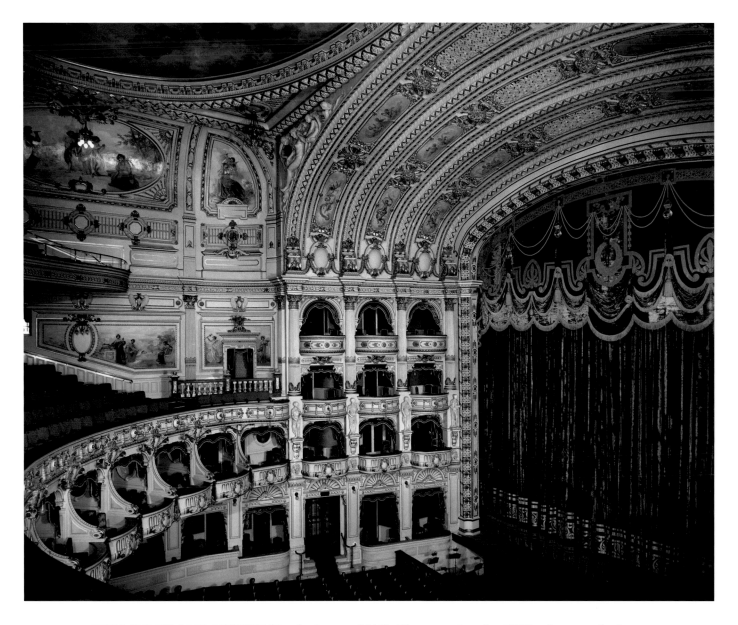

THE LONDON OPERA HOUSE (Bertie Crewe, 1910), Kingsway, London WC2, photographed in 1911 for J Tanner & Co. [BL21521/002]

Promoted by the American operatic impresario Oscar Hammerstein I, the London Opera House soon ran into financial difficulties. The opening production, in November 1911, was Jean Nouguès' *Quo Vadis*, but spectacular production and a celebrity audience on the opening night could not make up for the failings of an opera that has probably not been performed since. Unable to compete with the Royal Opera House's established repertoire and its star performers under contract, the London Opera House closed in 1917. For a time a cinema, then again a theatre (The Stoll from 1928), later performances included variety, musical comedy, ballet and ice shows. It closed and was demolished in 1957.

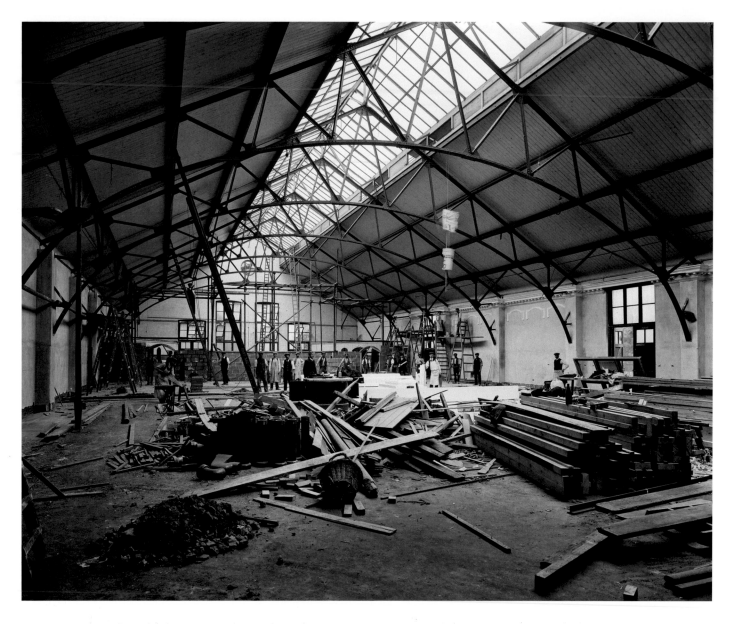

BUILDING THE AUDITORIUM, The Walpole Picture Theatre (John Stanley Beard, 1912), Bond Street, London W5, photographed in 1912 for Bovis Ltd, building contractors. [BL21680]

The Walpole Picture Theatre was converted from a roller-skating rink by an architect who would design several cinemas in the London area over the next 20 years. Easy structures to adapt, large numbers of skating rinks were converted in the early years of the cinema, as one popular craze gave way to another.

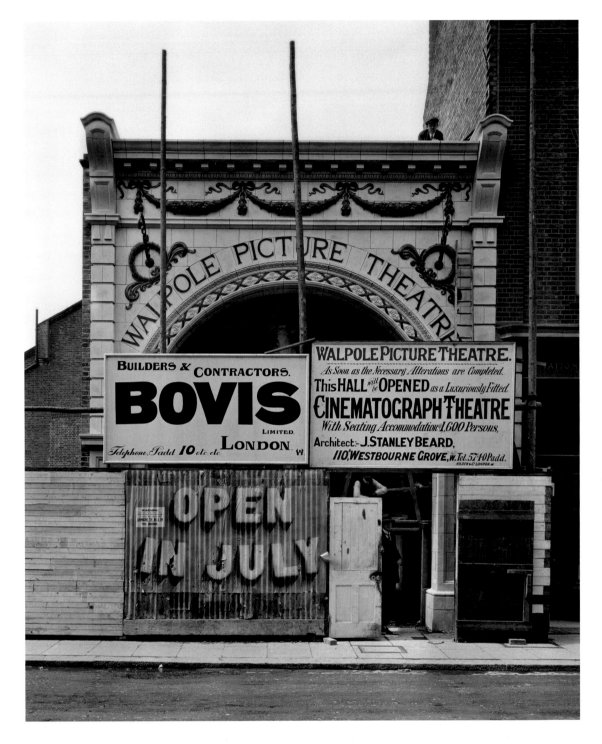

BUILDING THE ENTRANCE, The Walpole Picture Theatre (John Stanley Beard, 1912), Bond Street, London W5, photographed in 1912 for Bovis Ltd, building contractors. [BL21704]

The auditorium of the Walpole Picture Theatre remained fairly utilitarian after its conversion from a roller-skating rink, but a new entrance lured picture-goers inside. The façade, faced in polychrome tiles, was removed when the cinema closed in 1972 and now faces onto a car park in Mattock Lane.

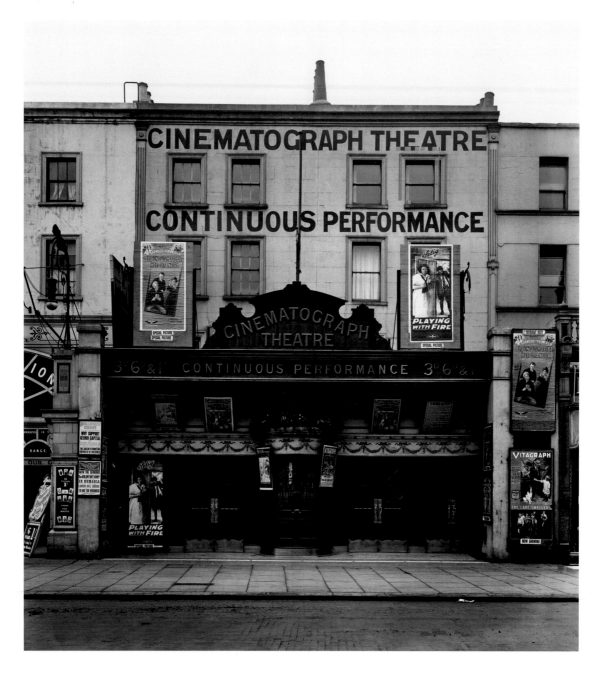

THE CINEMATOGRAPH THEATRE, 164–166 Edgware Road, London W9, photographed in 1915 for United Electric Theatres Ltd. [BL22922]

The rapid growth of the cinema led inevitably to much speculation and a fair amount of fraud. Typical of many early cinemas installed in former shops, the building photographed here in 1915 had been converted in 1909 for Recreations Ltd, managed by the cinema promoter Montagu Pyke. When in 1910 he launched a new company, Amalgamated Cinematograph Theatres, and invited subscriptions for shares, the Edgware Road cinema was described in the prospectus as 'splendidly equipped and magnificently appointed, situated in [one of] the very finest positions in London' (*The Times*, 27 June 1910). The new company promised dividends of 25 per cent, while Pyke is reputed to have paid himself an annual salary of £10,000 – amounts which not surprisingly got his company into difficulties and himself into trouble with the law. When the Edgware Road cinema was photographed, it had already passed into other hands.

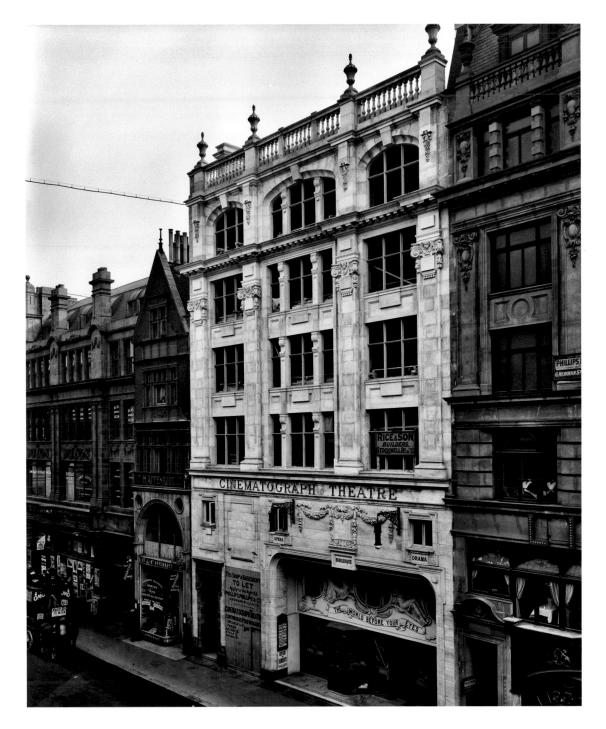

THE CINEMATOGRAPH THEATRE (Gilbert & Constanduros, 1909–10), 19–23 Oxford Street, London W1, photographed by AAB in 1910. [BL20792/001]

There had been numerous fires in the improvised premises where early films were often shown. The 1909 Cinematograph Act required there to be a fireproof barrier between the projection room and the auditorium, and by so doing provided a huge stimulus to the building of permanent, dedicated cinemas.

Montagu Pyke's Cinematograph Theatre, lavishly decorated and seating 350 people, was the first purpose-built cinema in the West End following the passing of the 1909 Act. Unfortunately it backed onto Crosse and Blackwell's pickle factory in the north-eastern corner of Soho, and at times the smell from the factory is said to have driven the audience from their seats.

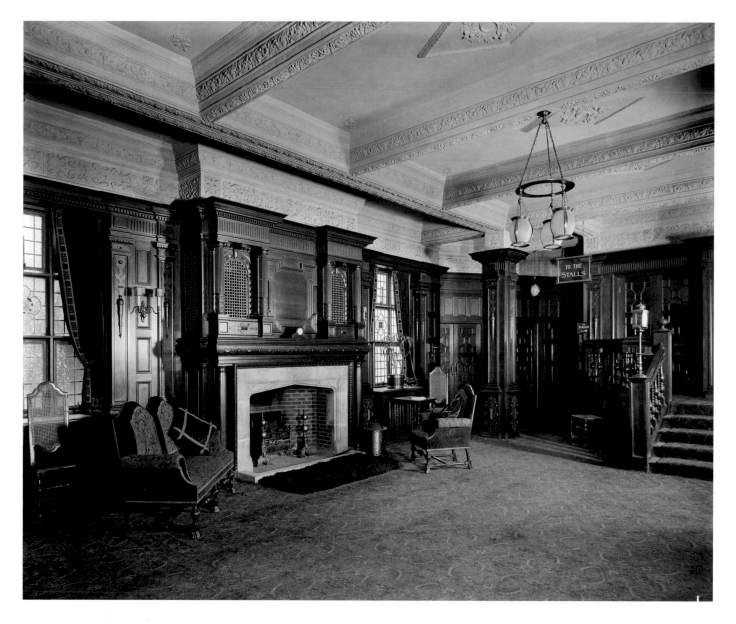

THE FOYER OF THE PICTURE HOUSE CINEMA (Browne & Clover, 1920), Bridge Street, Walsall, Staffordshire, photographed in 1920 for Provincial Cinema Theatres Ltd. [BL25240/001]

Promoters of the cinema flattered their clients by fostering an illusion of gracious living. In the foyer of the Picture House, patrons are welcomed by the open fireplace, the carved wainscot and the moulded plasterwork of some old English manor house. The decoration of the auditorium, however, was neoclassical.

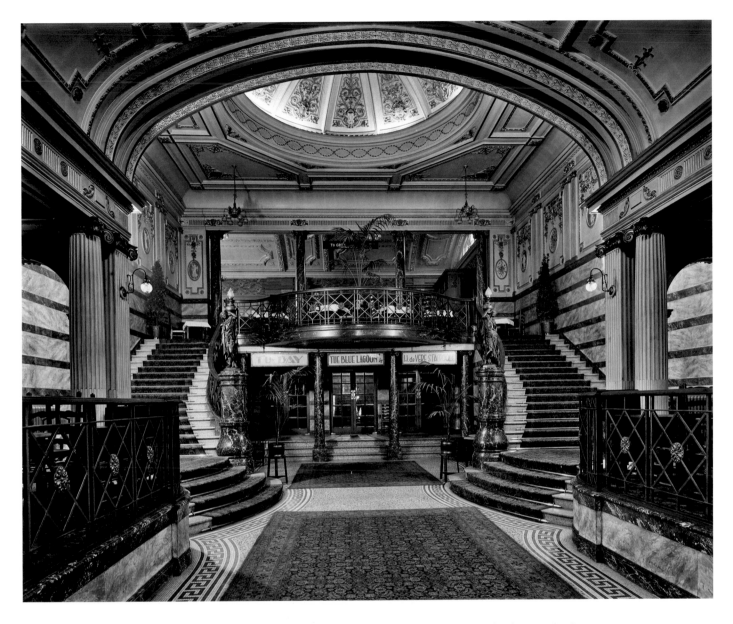

**THE FOYER AND STAIRS OF FINSBURY PARK CINEMA (E A Stone and others, 1909),
Stroud Green Road, London N4, photographed by AAB in 1923 for E A Stone.** [BL26831]

The Finsbury Park Cinema, later the Gaumont, was a union of two separate cinemas, created in what
had been separate parts of a former horse tram depot. Between 1915 and 1920 the two were brought
under one ownership and remodelled to give a capacity of 2,800 seats.

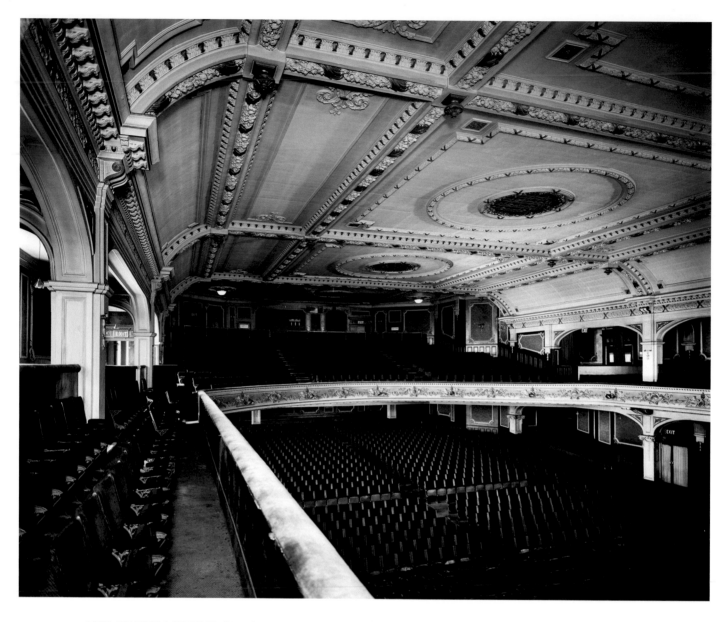

THE GRANGE CINEMA (E A Stone, 1914), 234 Kilburn High Road, London NW6, photographed by AAB in 1919. [BL24633]

Opening on the eve of the First World War, when built, The Grange (originally the Kilburn Picturedrome) was probably the largest cinema in Europe, seating well over 2,000 people. The gallery slips down the side were unusual.

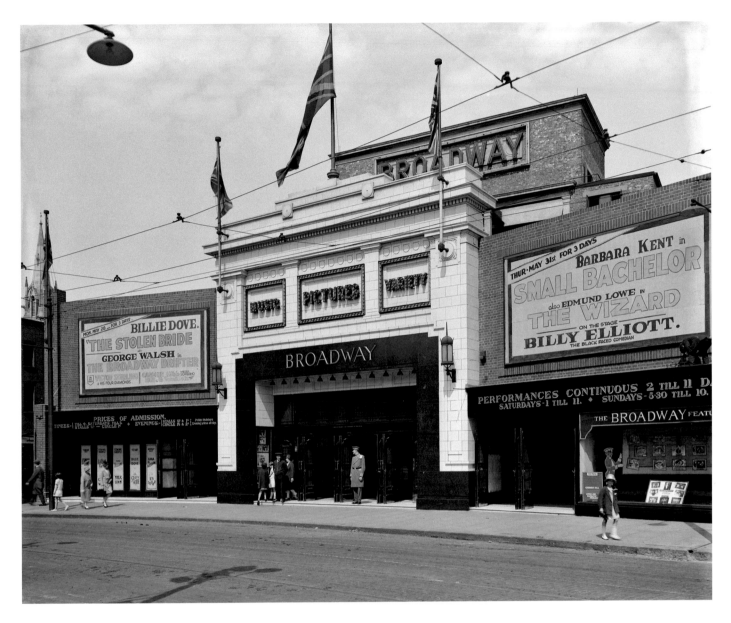

THE BROADWAY CINEMA (George Coles, 1927), Tramway Avenue, London E15, photographed by AAB in 1927 for Hathern Station Brick and Terra Cotta Company. [BL29278]

The size and grandeur of cinemas would continue to grow throughout the 1920s and 1930s. The façade of The Broadway was of white glazed terracotta, recommended by the architect for its ease of cleaning and its 'very festive appearance' when floodlit – both important considerations in the still smoky atmosphere of London. The interior was classical, with broad Arcadian landscapes painted on the auditorium walls.

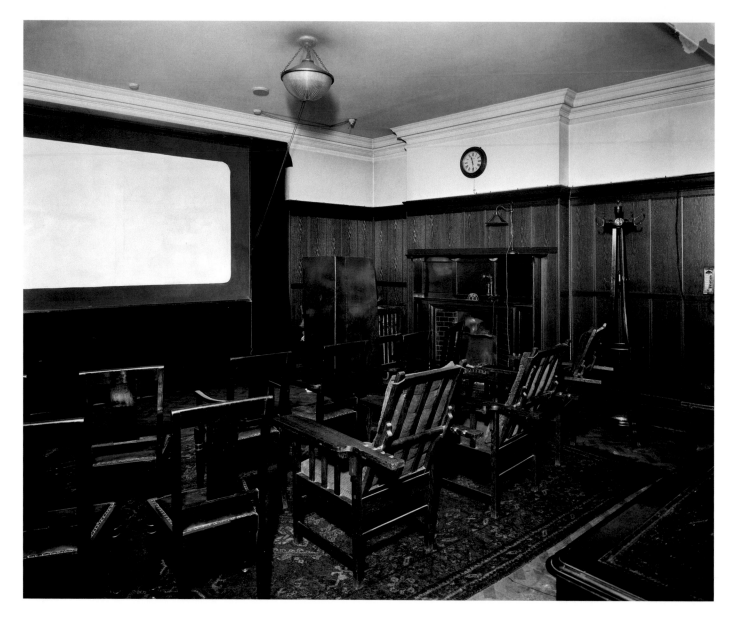

FILM PREVIEW THEATRE, 23–27 Cecil Court, London WC2, photographed by AAB in 1917 for the Pioneer Publicity Service, advertising agents. [BL23870/006]

Films needed to be sold to cinemas; cinema companies needed to see what was available. Charing Cross Road and its surrounding streets were the heart of the British film industry. Cecil Court, leading off it, was known as 'Flicker Alley'. The information about this commission in Lemere & Co's daybooks is slightly confusing, but it seems likely that this preview theatre was owned by the Pioneer Film Agency and rented by Lionel Phillips who described himself as a Cinematograph Film Agent.

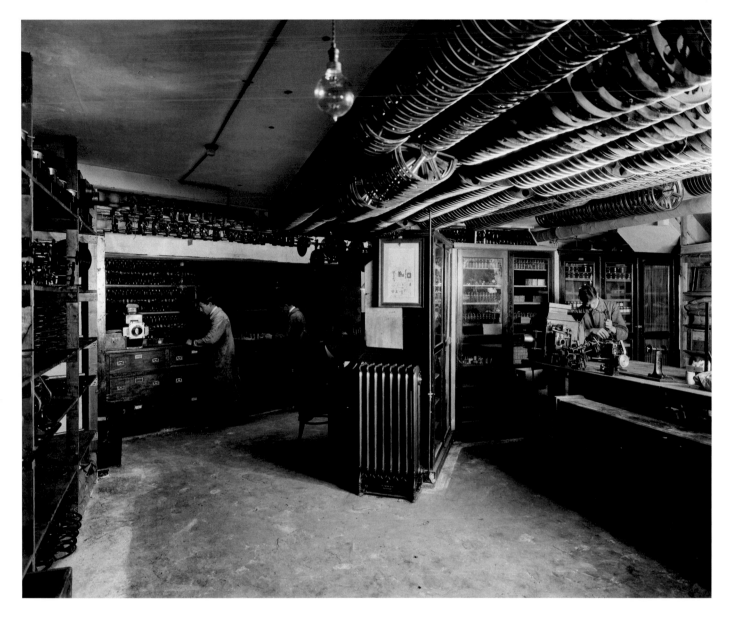

AN OFFICE OF THE BRITISH GAUMONT COMPANY, Sherwood Street, London W1, photographed in 1917. [BL24050/012]

The French inventor and entrepreneur Leon Gaumont began to manufacture film projectors in 1895, and in 1896 started to make films that could be shown on his equipment. The British Gaumont Company was set up the following year and the company would subsequently set up its own cinema chain (taken over by Odeon Cinemas in 1948).

In 1917, on the occasion of a visit by Gaumont to London, Bedford Lemere & Co took a number of photographs of the company's premises in Soho; in the office shown here, magic lanterns, spools, rewinders and projectors are available for hire or sale, while a technician is checking over a machine on the bench.

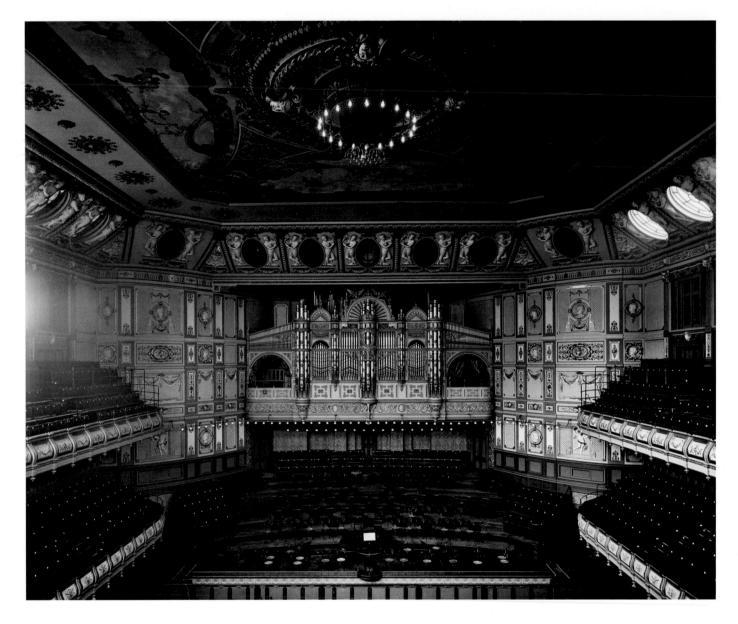

THE QUEEN'S HALL (T E Knightly, 1891–3), Upper Regent Street, London W1, photographed in 1894. [BL12576A]

The Queen's Hall was recently built as a concert hall. In 1894 the manager, Robert Newman, conceived of a programme of popular classical concerts and engaged Henry Wood as their conductor. The annual series of promenade concerts (The Proms) was introduced in 1895 and has been maintained ever since, with sponsorship from the BBC since 1927. In the early days the audience was allowed to eat, smoke and drink.

The building was destroyed by bombing in 1941 and The Proms have since been performed in the Royal Albert Hall (*facing page*), where until expert intervention the acoustics were as bad as those in the Queen's Hall had been good.

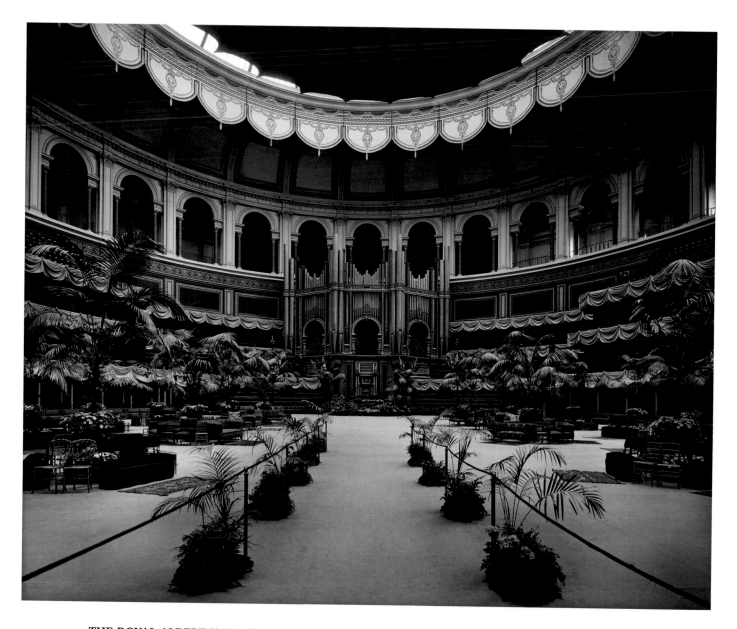

THE ROYAL ALBERT HALL (Captain Francis Fowke and Major-General H Y D Scott, 1867–71), Kensington Gore, London SW7, photographed by AAB in 1907. [BL19966A]

This photograph was taken in June 1907, on the occasion of the Conversazione – an evening party – held by the Institution of Civil Engineers in connection with their annual conference. June was the height of the London Season, and the 3,000 guests were not limited to the engineering profession but included the physicist Lord Kelvin, the sculptor Hamo Thornycroft and the distinguished naval architect Sir William White. Guests were received by the President, Sir Alexander Kennedy and music was provided by the string band of the Royal Engineers.

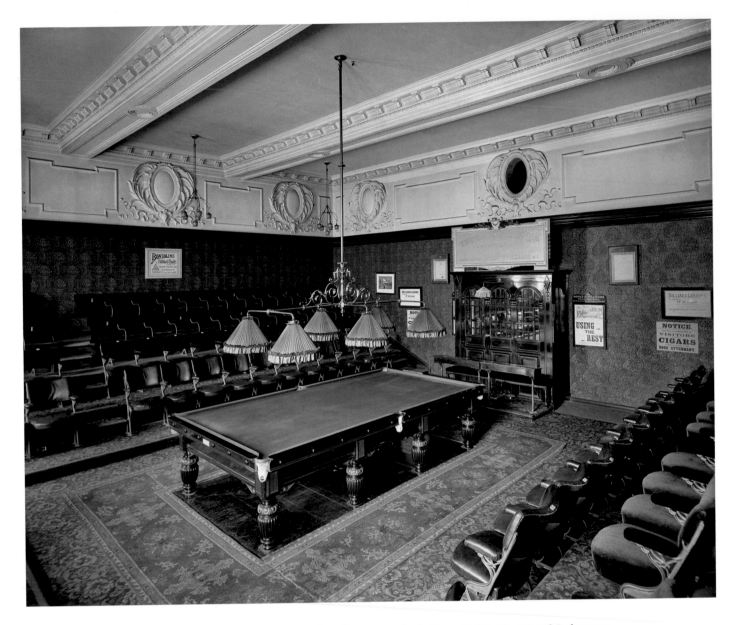

THE MATCH ROOM, Thurston's Billiard Hall (Wimperis & East, 1902–3), 45–46 Leicester Square, London WC2, photographed by AAB in 1903 for Thurston & Co. [BL17646]

Thurston's began business as furniture makers in the late 18th century, but from early in the 19th specialised in billiard tables, building up their reputation to the extent that at the century's end the Thurston table was recognised officially as the match standard. Long established in Catherine Street, Covent Garden, theirs was one of many businesses displaced by the Aldwych/Kingsway improvement scheme. The photograph shows the match room in their new Leicester Square premises.

It was only in the middle of the 20th century that snooker (probably invented in India in the 1880s) became more popular than billiards.

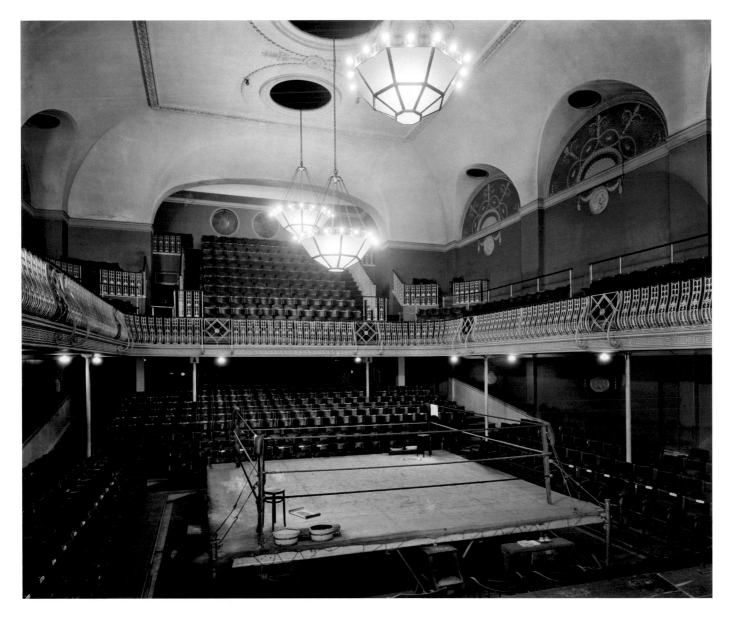

THE NATIONAL SPORTING CLUB, 43 King Street, Covent Garden, London WC2, photographed by AAB in 1922 for C Mewès & A J Davis. [BL26027]

The sport of boxing took many years to achieve respectability; as late as the early 20th century a death in the ring might still be followed by a charge of manslaughter. Boxing had long been associated with lower-class pugilists and upper-class rakes, and the National Sporting Club was founded in 1891 by a group of enthusiasts who wished to rescue the game from the somewhat disreputable aura that hung around the Pelican Club, which had for some years played the leading role in the arrangement of fights. The National Sporting Club was instrumental in improving boxing's image and remained the sport's regulating body until the establishment of the British Boxing Board of Control in the 1930s.

Hugh Lowther, 5th Earl of Lonsdale (known as 'the yellow earl' from the colours of his turnout at the races), who had been chairman of the boxing committee of the Pelican Club (and a powerful boxer himself), became the National Sporting Club's first president and presented the first Lonsdale Belts in 1909.

THE AQUARIUM (J J Joass, 1923–4) and the Mappin Terraces, London Zoo, London NW1, photographed in 1924. [BL27044]

Joass had designed a new shop for the jewellers and silversmiths Mappin & Webb in 1906–8 (*see* p 63) and he introduced J N Mappin to Peter Chalmers Mitchell, secretary of the zoo, as a potential benefactor. The mountainous terraces, seen in the distance, were built of reinforced concrete in 1913–14 to Mitchell's design, in order to provide a more naturalistic habitat for many of the zoo's animals. More prominent is Joass's aquarium, just completed and contained in part beneath the terraces. Little of his exterior now remains visible as the building has since been refaced.

This photograph was taken on what seems an unusually quiet day.

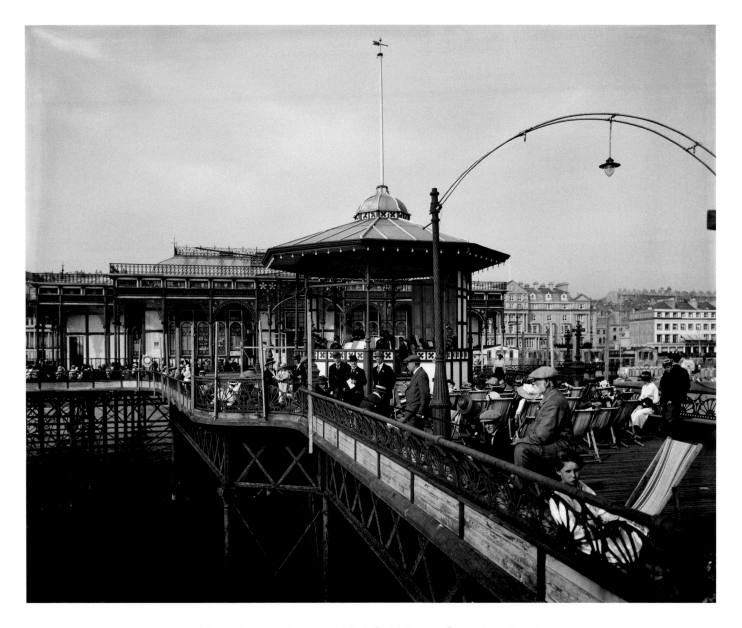

THE PALACE PIER (R St George Moore, 1888–91), St Leonards on Sea, East Sussex, photographed by HBL in 1919 for J H Gardner. [BL24676/010]

Escape to the seaside. The Palace Pier – typically of late Victorian piers – provided a wide variety of (almost) sea-borne entertainment and Harry Lemere photographed the concert hall, the dance hall (which was also used as a roller-skating rink), the café and the bar. In this view, holiday-makers are listening to a band in the bandstand.

Rebuilt in the 1920s and bombed in 1940, the pier's remains were demolished in 1951.

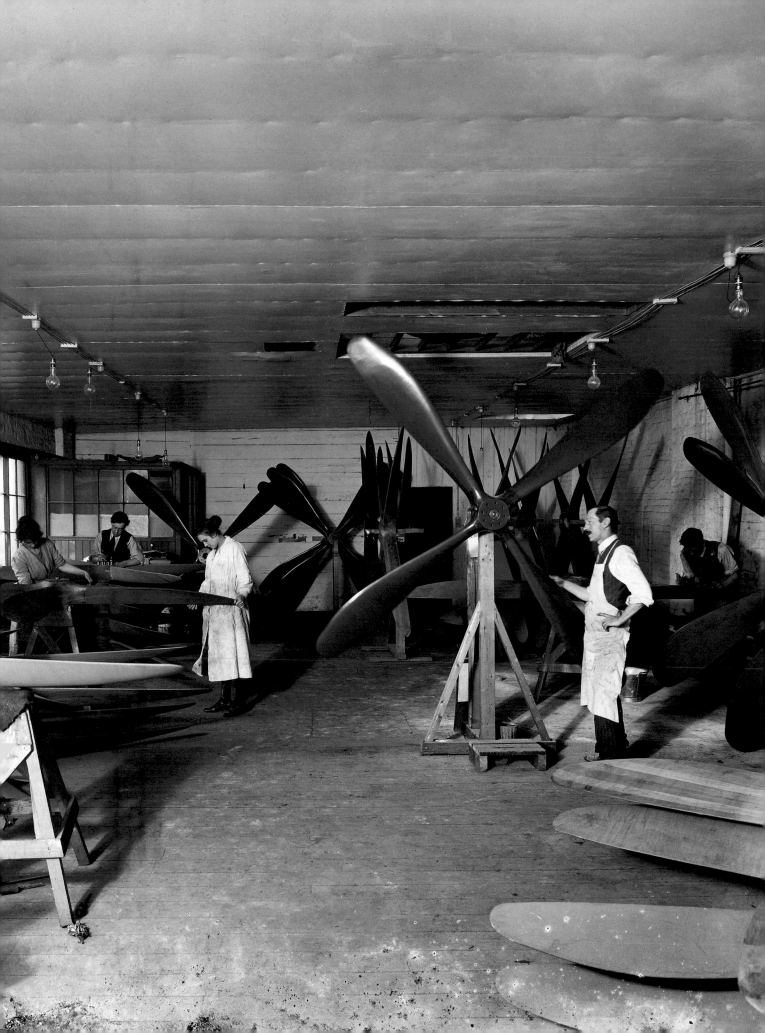

THE GREAT WAR

Bedford Lemere & Co's photographs record many of the ways in which the First World War affected life at home. Many of these were transitory – the servicemen who were everywhere, stationed at home or in England on leave, and the temporary buildings and factories adapted for wartime uses. Many of the businesses for whom the firm was already working became involved with the war effort. Furnishing firms such as Waring & Gillow and Hampton & Sons put joiners and cabinetmakers to making aeroplanes, and upholsterers and other workers to making bags and tents. Engineering turned from civilian markets to making guns and shells.

Other impacts of war were fundamental and lasting, such as the change in the status of women. It is estimated that two million men's jobs were taken by women during the war and the huge expansion of munitions factories created thousands of additional jobs that men were not available to fill. Many others volunteered as auxiliary nurses in the emergency hospitals set up for war wounded. The after-effects of the war were less obvious in terms of a visual record, but another of the war's consequences was the many estate sales that followed and a number of agents commissioned Lemere & Co to photograph property that was put on the market.

A number of the firm's wartime photographs are of Australian or Belgian subjects, almost certainly because the firm's studio was close both to Australia House and to General Buildings in the Aldwych, which served as a headquarters for Belgian refugees.

HAMPTON & SONS LTD, 43 Belvedere Road, London SE1, photographed by HBL, AAB and colleague in 1916 for the company.
[BL23561/039]

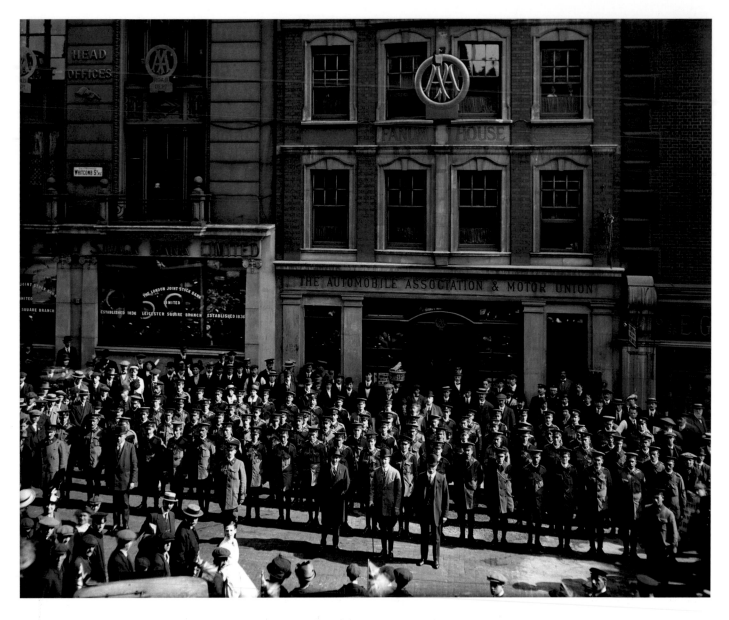

AUTOMOBILE ASSOCIATION SCOUTS PARADING PRIOR TO ENLISTMENT, Whitcombe Street, London WC2, photographed by AAB in 1914 for the Automobile Association. [BL22697]

Five hundred of the staff of the AA volunteered for service on the outbreak of war, many joining the 8th (Cyclist) Battalion of the Essex Regiment. Here they parade in front of the Association's offices before marching to Liverpool Street Station to enlist at the regimental depot at Colchester.

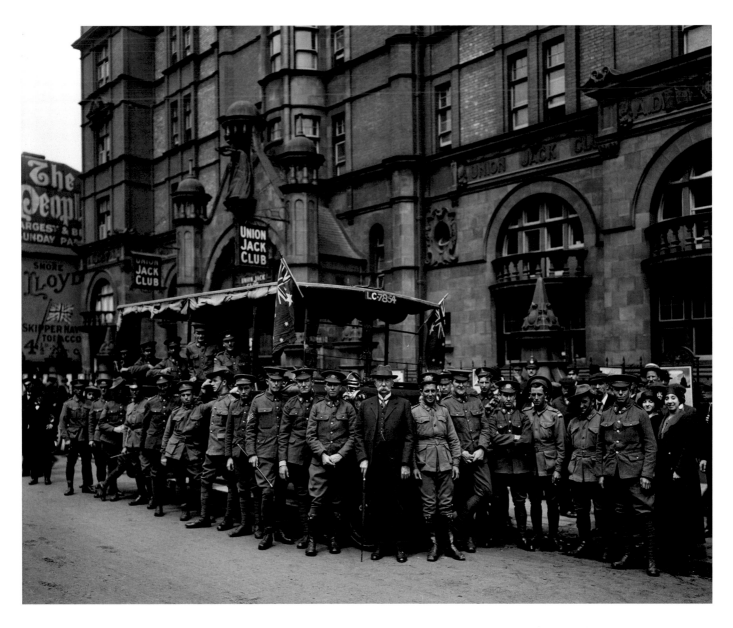

AUSTRALIAN SOLDIERS OUTSIDE THE UNION JACK CLUB, Waterloo Road, London SE1, photographed by AAB in 1915. [BL23031/001]

The Union Jack Club was founded in 1904 as a place where servicemen could meet, eat and spend the night; there were many service clubs open to officers, but until then there had been none for other ranks. It was especially heavily used during both world wars, and here a group of Australian troops gather with an army truck. A sergeant carries a swagger cane.

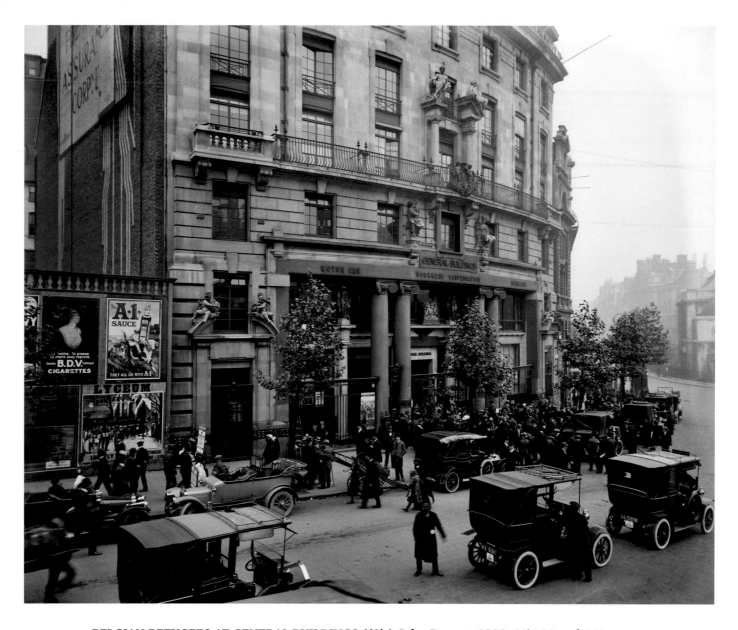

BELGIAN REFUGEES AT GENERAL BUILDINGS ((Sir) John Burnet, 1909–11), 99 and 101 Aldwych, London WC2, photographed in 1914. [BL22817/003]

General Buildings was built in 1909–11 for the General Accident Fire & Life Assurance Corporation. The company had enjoyed strong links with the Belgian insurance industry since the mid-19th century, and during the First World War its head office became home to the War Refugees Committee and the Belgian Labour section of the Ministry of Labour's Employment Exchange. This photograph was taken in October 1914; in the previous month *The Times* had reported that between 300 and 400 Belgian refugees a day were passing through General Buildings. By the end of hostilities over 200,000 Belgians had sought refuge in Britain.

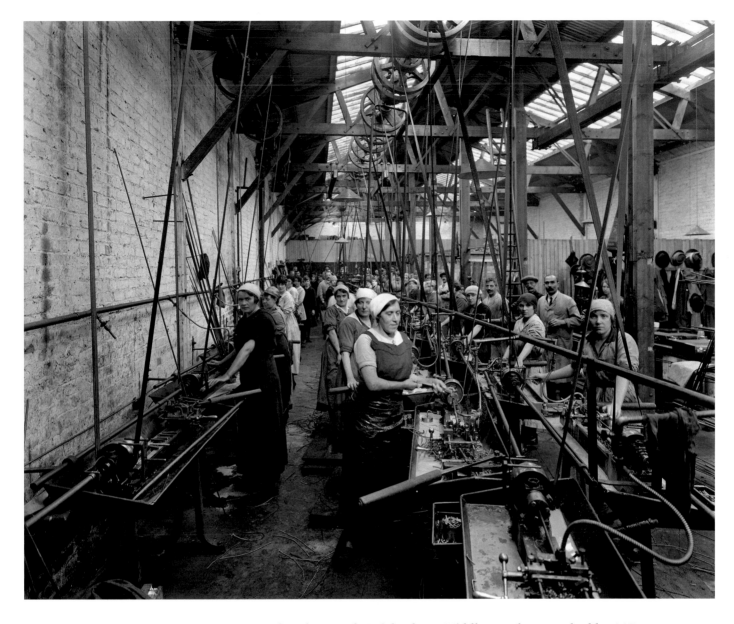

BELGIAN MUNITION WORKS, Clevedon Road, Twickenham, Middlesex, photographed by AAB in 1918 for A F Varley. [BL24380/009]

At the outbreak of the war, it was not anticipated that there would be labour shortages at home. However, it was soon realised (even before the huge expansion of munitions manufacture from 1915 onwards) that enlistment was seriously depleting the ranks of skilled factory workers. Belgium was an industrialised country as Britain was, and in January 1915 labour exchanges were instructed to obtain lists of employable Belgian refugees whose conditions of employment were to be equal to those of British workers. One refugee, the engineer Charles Pelabon, established a munitions factory at Teddington and soon expanded the operation to a nearby roller-skating rink opposite Richmond on the banks of the Thames, where a Belgian labour force made hand grenades and artillery shells and where a sizeable Belgian community soon developed.

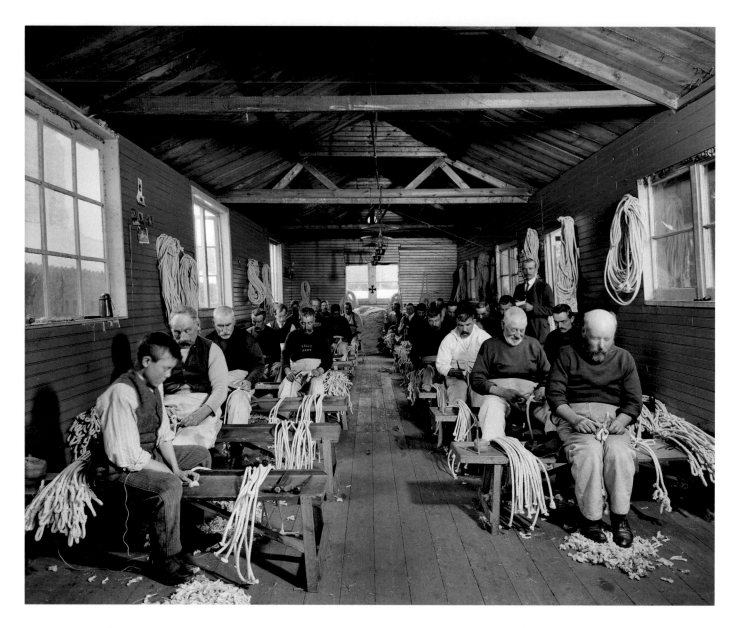

THE SPLICING ROOM, T T Nethercoat & Co, Burnham-on-Crouch, Essex, photographed by AAB in 1915. [BL23246]

T T Nethercoat & Co were chandlers and sailmakers, and like numerous firms applied their specialist skills to suitable war work. They commissioned a series of photographs that recorded the making of canvas buckets, with the process broken down into separate stages. Here, old men and lads are making rope handles. The purpose of the buckets is not known, but from the lack of metal in their construction and the enormous numbers apparently being made it seems likely that they were to be used to carry explosive charges.

The labour force was made of women and girls (shown in other photographs), lads too young for the services and elderly seamen, many of whom wear jerseys with the names of yachts on their chests. In peacetime, men whose deep-sea voyaging was over often crewed rich men's boats.

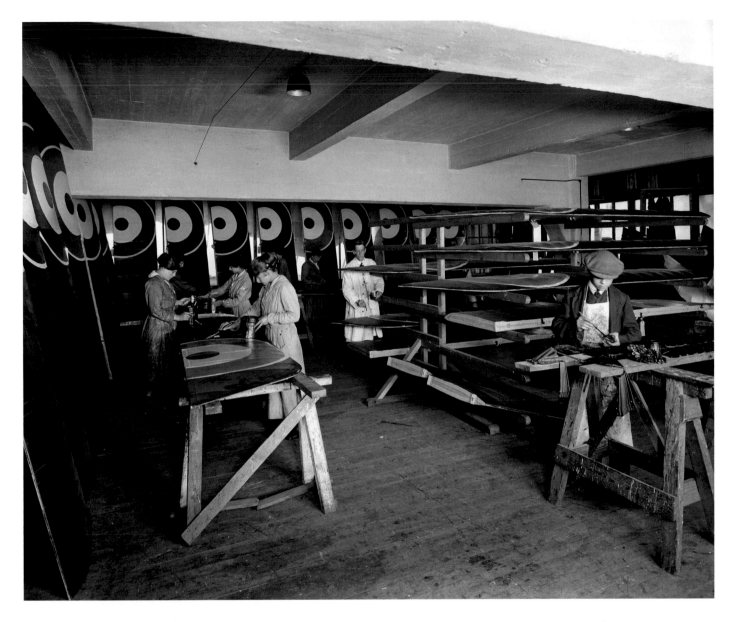

DOPING AIRCRAFT WINGS, Waring & Gillow's aeroplane factory, Cambridge Road, London W12, photographed by AAB in 1916 for the company as part of a series. [BL23701/012]

During the First World War, Waring & Gillow's Hammersmith furniture factory was used to build aircraft, making good use of the joinery skills of the firm's workforce. Here men and women are varnishing ('doping') wings, possibly for the DH4 two-seat, single-engine bomber.

Later in the war the factory was at the heart of an industrial dispute, which led to a strike of aircraft workers at munition factories throughout the London area. This was only resolved after Winston Churchill, as Minister for Munitions, invoked legal powers under the Defence of the Realm Act for a government takeover of the Hammersmith factory.

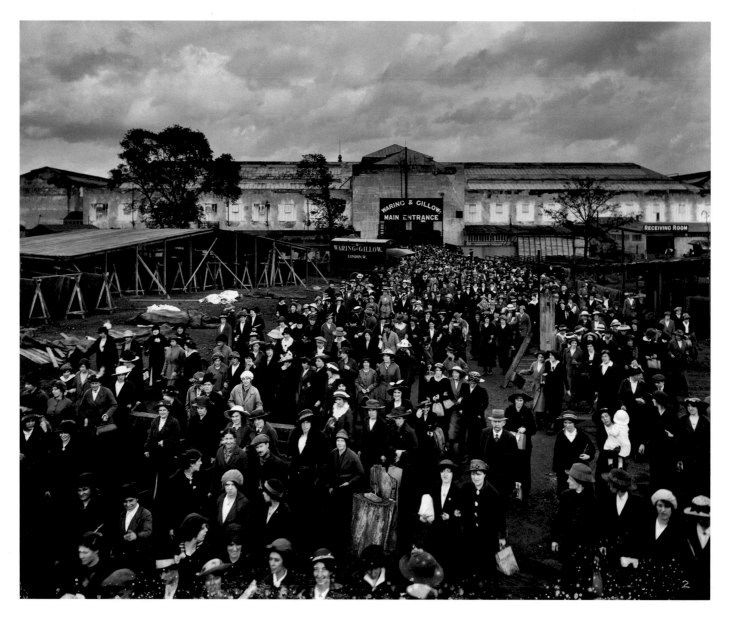

WORKERS AT WARING & GILLOW'S WAR EQUIPMENT FACTORY, White City, Wood Lane, London W12, photographed by HBL and AAB in 1916 for Waring & Gillow. [BL23600/002]

In August 1916 Bedford Lemere & Co undertook a commission from the furniture manufacturers Waring & Gillow to photograph the company's war equipment factory at White City, which produced valises, respirator satchels, horse nosebags, machine-gun belts and tents – items that sat well with a workforce skilled at furniture upholstery.

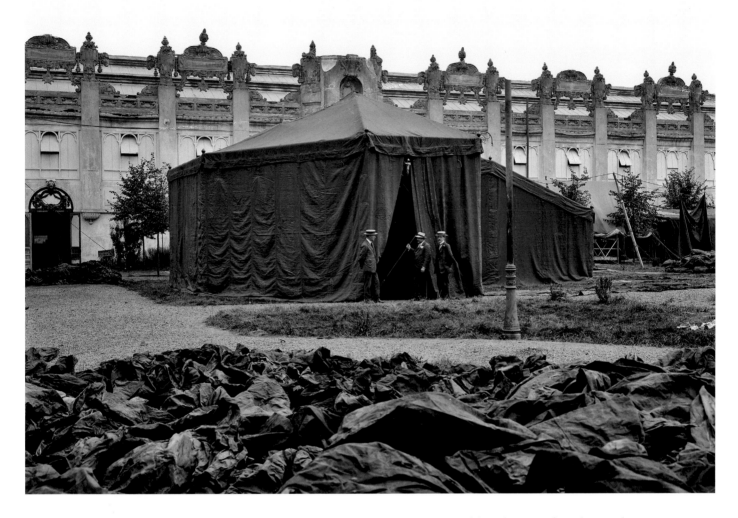

A TENT AT WARING & GILLOW'S WAR EQUIPMENT FACTORY, White City, Wood Lane, London W12, photographed by HBL and AAB in 1916 for Waring & Gillow. [BL23600/022]

White City had been laid out over 140 acres in 1908 as a dedicated exhibition site, and before the war had been the setting for the very successful Franco-British exhibition that year, the 1908 Olympic Games and a Japanese-British exhibition in 1910. Some of the exhibition buildings – largely with plaster decoration and already in poor repair – can be seen in the distance, providing a strangely exotic background for the large tent put up in the grounds. Other temporary buildings were added to meet the needs of the factory.

A soldier, whose letter of August 1917 was published in the company's staff magazine, *The Wargill Pocket Magazine & Club Chronicle* (no 1, p 12), wrote: 'It may please you to know that the tentage of the troops on this station bears the name of Waring and Gillow, the tents are all under my charge, and I have not had a single complaint through all the storms of sand, wind and rain.'

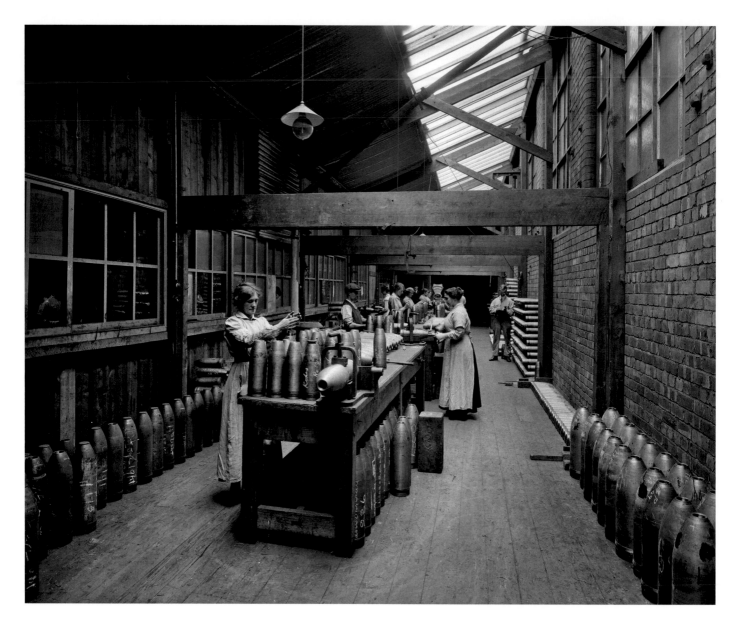

THE CUNARD SHELL WORKS, Rimrose Road, Liverpool, photographed by HBL in 1917.
[BL24001/023]

Harry Lemere's photographs of the Cunard Shell Works are the fruit of a political crisis. By the early months of 1915 dreams of a quick war – 'Berlin by Christmas' – were well past and the inabilities of a peacetime economy to support the war effort were becoming clear. In particular, when in May 1915 the British Commander-in-Chief Sir John French blamed a shortage of shells for recent failures on the Western Front, the ensuing furore brought down the government.

Prior to the building up of huge new munitions factories at Gretna, Silvertown and elsewhere, many other businesses were pressed into service. The Cunard Shell Works was established in June 1915 in a former furniture factory recently acquired by the Cunard Steamship Company. Here the Shell Works made 4½in, 6in and 8in shells, the processes speeded up by the breakdown of manufacture into a sequence of separate individual processes that could be undertaken by unskilled or semi-skilled labour. By the end of the war, three-quarters of the work force were women. In this view they appear to be cleaning and checking screw threads for the subsequent fitting of fuses.

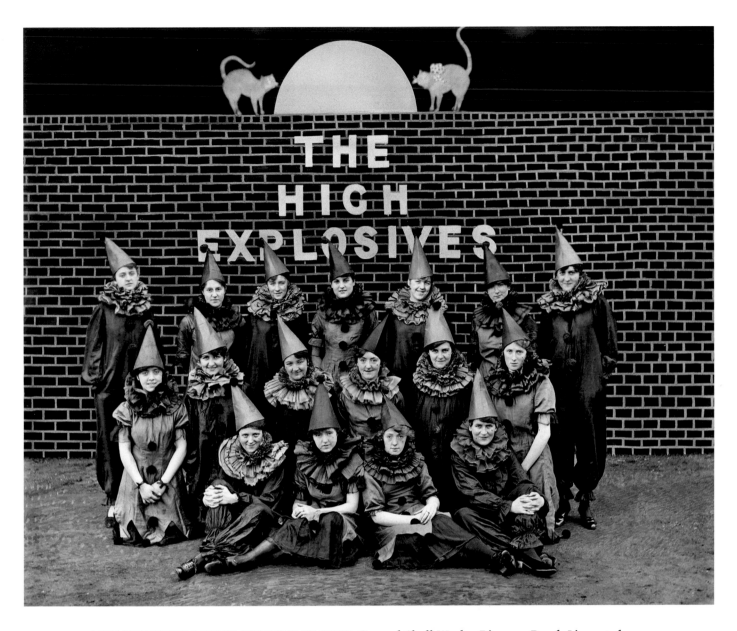

'THE HIGH EXPLOSIVES' CONCERT TROUPE, Cunard Shell Works, Rimrose Road, Liverpool, photographed by HBL in 1917. [BL24001/126]

Bedford Lemere & Co's series of 140 photographs, showing every stage in the making of shells and many aspects of factory life, was probably the largest single commission that the firm ever received. This photograph is of the factory's concert party in costume for a show.

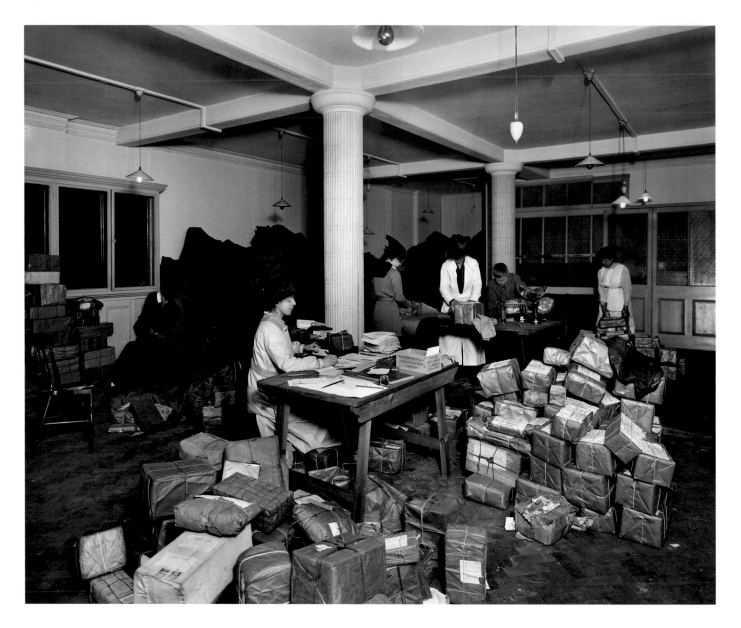

THE RED CROSS PRISONERS OF WAR PARCELS DEPARTMENT, 15A Pall Mall, London SW1, photographed by HBL in 1917 for Mrs Rivers Bulkeley. [BL23710]

The Red Cross and the Order of St John of Jerusalem formed a Joint War Committee in order to serve prisoners of war and the sick and wounded. Harry Lemere's photograph, showing the packing and dispatch of parcels for POWs, was taken for Mrs Rivers Bulkeley, who was invested as a Lady of Grace for the Order of St John of Jerusalem following the death of her husband. T H Rivers Bulkeley, whom she had married in 1913, had been killed in action in October 1914 serving as a captain in the Scots Guards.

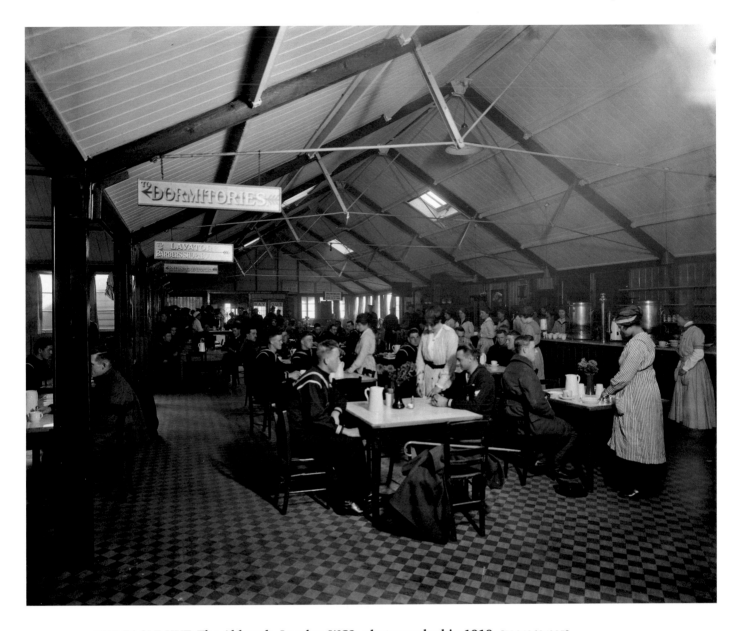

THE EAGLE HUT, The Aldwych, London WC2, photographed in 1918. [BL24268/005]

The United States declared war on Germany on 6 April 1917. Although it would be some time before US troops reached Europe, and well into 1918 before significant numbers were trained and equipped for active service, by the end of the war there were 1,800,000 American servicemen in France – almost exactly the same number as the British.

Once they arrived in Europe, London was an obvious destination for US soldiers on leave from France and for sailors serving on American ships attached to the Grand Fleet. The Eagle Hut was erected in September 1917 by the American YMCA, on a still-vacant lot at the Aldwych (*see* p 39). There, US and other servicemen would find company and refreshment, provided by American ladies living in London.

BOOKSTALL AT AN UNKNOWN LONDON UNDERGROUND STATION, photographed by HBL and colleague in 1916 for William Dawson & Sons. [BL23606/001]

In this July 1916 photograph, newspaper placards mention Jellicoe's Jutland Despatch and the Somme, and twice promote the rabble-rousing journalism of the (ultimately to be jailed) fraudster Horatio Bottomley. A long line of *Vogues* hangs above the counter, *The Saturday Evening Post* and *The Smart Set* below, a placard for *The Gentlewoman* advertises an article on 'Gentlewomen as Munition Workers', and there are plenty of escapist novels for sale.

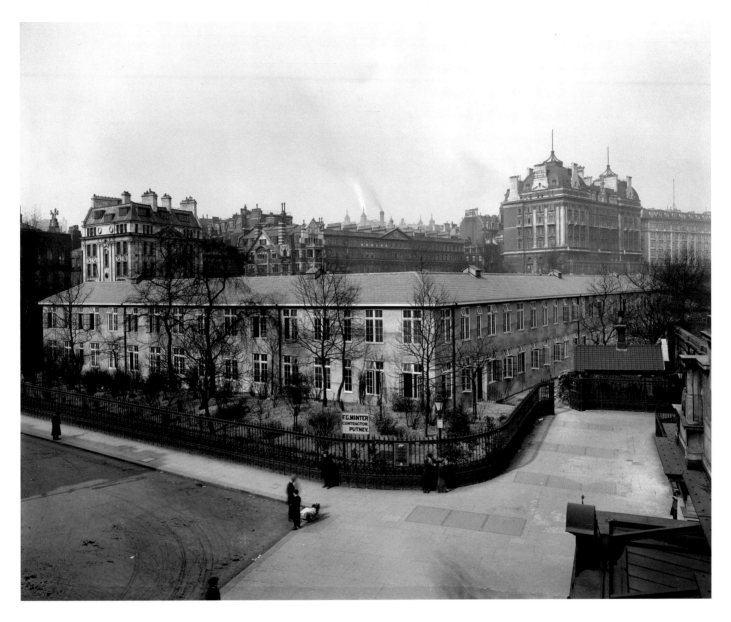

TEMPORARY BUILDINGS FOR THE WAR OFFICE, Victoria Embankment Gardens, London WC2, **photographed by HBL and AAB in 1917 for F G Minter.** [BL23781/001]

The war had vastly increased the administrative load on the military authorities. The War Office had taken over the Hotel Cecil, seen in the distance, as additional offices for the Air Board; the range in the foreground was built to provide still more office space in the Victoria Embankment Gardens below the hotel.

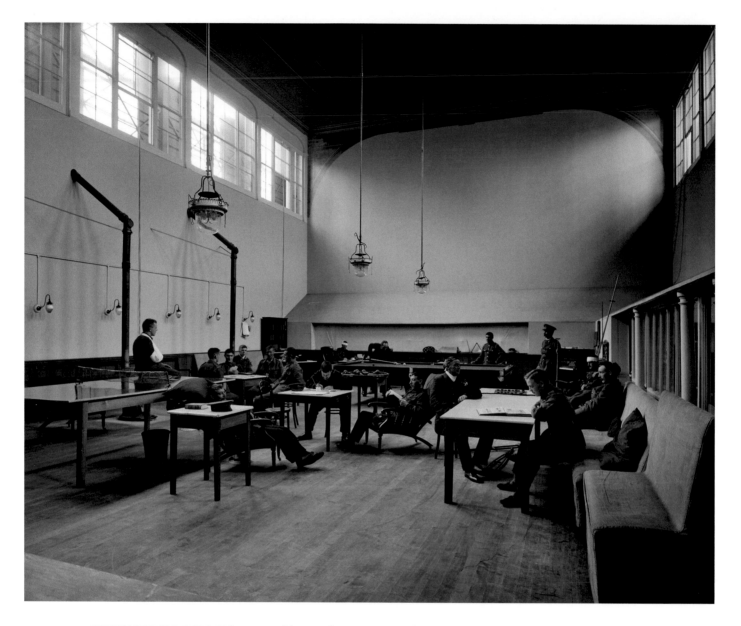

RECREATION ROOM, Voluntary Aid Detachment Hospital, Woburn Abbey, Woburn, Bedfordshire, photographed by HBL in 1915 for the Duchess of Bedford. [BL23131]

During the war all kinds of buildings – large country houses, town halls and many others – were pressed into service as military hospitals, including Woburn Abbey, which served as a VAD hospital. Woburn Abbey was the home of the Duke of Bedford, and the recreation room shown here was set up in the real tennis court.

The Voluntary Aid Detachment already existed as a body of largely unqualified, auxiliary nurses working with the Territorial Army; with the outbreak of war the service expanded hugely, with great numbers of women volunteering to join the service.

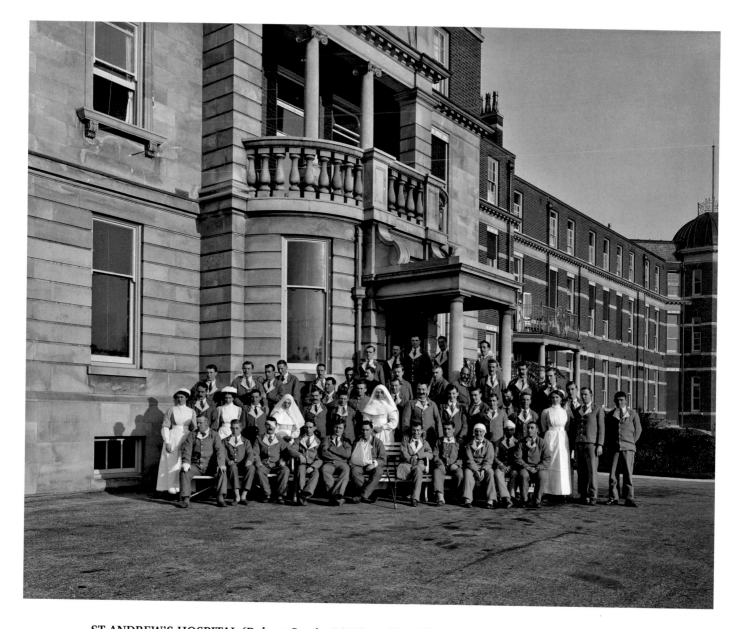

ST ANDREW'S HOSPITAL (Robert Curtis, 1913), Dollis Hill, London NW2, photographed by AAB in 1916 for Monsignor M E Carton de Wiart. [BL23681]

St Andrew's Hospital was established in 1913 for Roman Catholic patients by the Catholic Diocese of Westminster, financed by Marguerite Amice Piou and staffed by Sisters of the Little Company of Mary. Shortly before it opened in 1913, it was described in *The British Journal of Nursing* as comprising 'everything of the best and newest in hospital structure'.

Already photographed in 1914 when newly completed, Adolphe Boucher visited it again when it was occupied as a war hospital, at the request of the treasurer and chaplain, Monsignor M E Carton de Wiart. The monsignor was brother of the Belgian Minister of Justice (later Prime Minister) and cousin of the British war hero Adrian Carton de Wiart who had been awarded the Victoria Cross the previous month.

The hospital never became a part of the National Health Service, and it closed and was demolished in 1972.

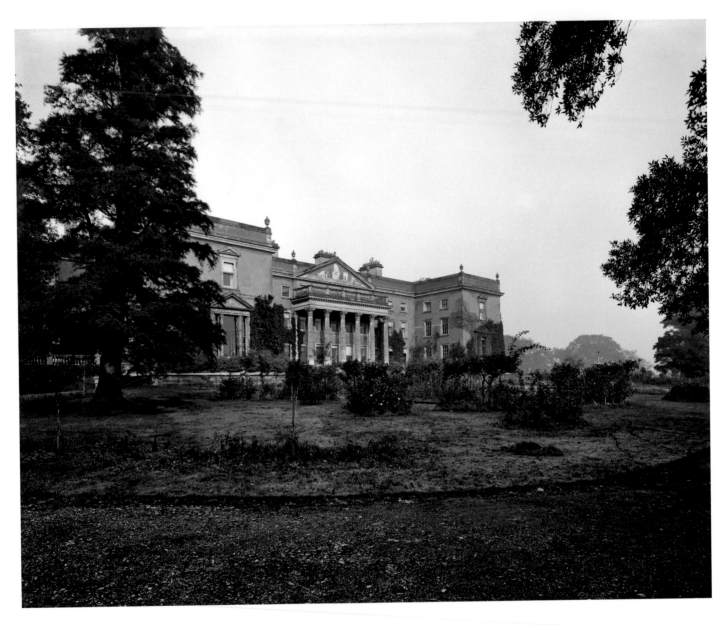

GOPSALL HALL, Twycross, Leicestershire, photographed in 1918 for Samuel Waring.
[BL24390/003]

Gopsall Hall illustrates the fate of many great estates and their houses after the First World War, when, after a generation of agricultural depression, many landowners sold up to take advantage of a temporary recovery of land values and pay off debts that had been incurred in the 19th century when farming had been more remunerative. The Gopsall estate, property of the 4th Earl Howe, had been in his family since the late 17th century; the house had been built c 1750-60, possibly by John Westley. The house and estate were sold in 1919, the house and park being bought by Samuel Waring (of Waring & Gillow and the Waring-White Building Company). Waring had done well out of the war, was given a baronetcy in 1919 and ennobled as Lord Waring of Foots Cray in 1922. It is likely that he bought Gopsall as little more than a place to entertain friends, and he sold it again in 1927; the house was pulled down in 1951.

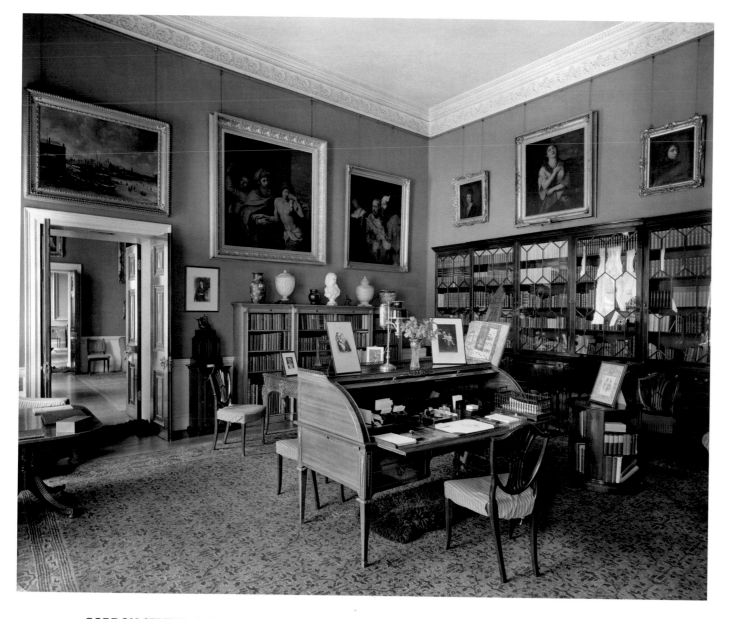

GORDON SELFRIDGE'S ROOM, Lansdowne House, Berkeley Square, London W1, photographed in 1921. [BL25525]

Lansdowne House – built by Robert Adam in 1762–8 and the family home of the Marquesses of Lansdowne – was one of many aristocratic London houses that their owners found hard to maintain in the difficult economic times after the First World War. Eventually Lansdowne House (like Devonshire House, Dorchester House and others) would be sold off and pulled down, but in the meantime a lease would be taken by Gordon Selfridge, the self-made, megalomaniac American retail entrepreneur.

When Selfridge first sought to purchase and develop the Oxford Street site of his store, Samuel Waring offered to invest in the enterprise – an offer he later withdrew, leading to a falling-out between them. In the meantime, however, Waring had made Selfridge a kneehole desk which Selfridge only paid for (£350) after a rapprochement many years later. This may be that desk.

SOUTH WARNBOROUGH, Hampshire, photographed by AAB in 1921 for Daniel Smith, Oakley & Garrard, estate agents. [BL25475/003]

It has been estimated that in the three years following the end of the First World War a quarter of the land of England changed hands. The South Warnborough estate of 1,200 acres was one of an enormous number to come on the market at this time.

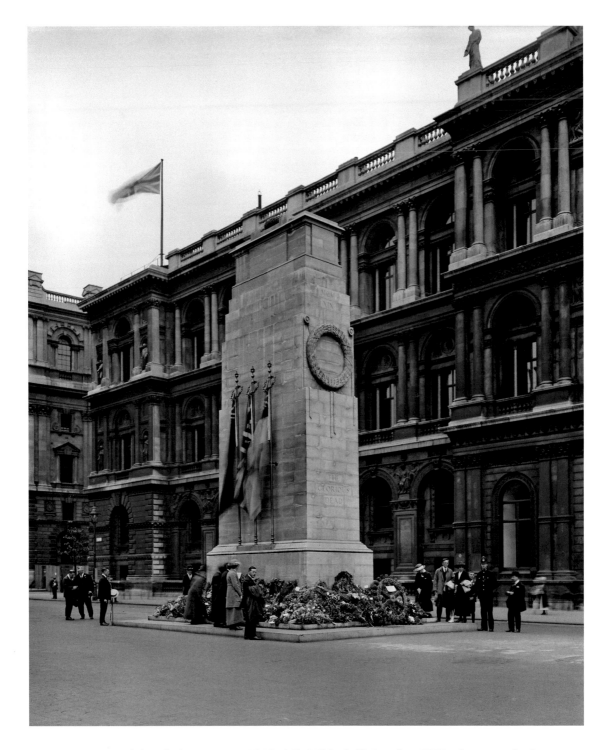

THE CENOTAPH (Sir Edwin Lutyens, 1919–20), Whitehall, London SW1, photographed on 22 June 1921 for the Rotary Club of London. [BL25601]

Harry Lemere was a keen member of Rotary. It was therefore natural that the firm should have photographed the wreath that had been laid at the Cenotaph by Rotary Club delegates from the United States on the previous Sunday.

THE BEDFORD LEMERE & Co
COLLECTION AT ENGLISH HERITAGE

The majority of Bedford Lemere & Co's surviving photographs are held by English Heritage in its public archive. The collection comprises over 21,800 large-format glass negatives and around 3,000 unique prints. Ranging in date from the 1860s to the 1950s, the majority of images date from between 1890 and 1930. The collection also includes some albums, a few signed mounted presentation prints and the company's daybooks, which provide an invaluable record of the firm's activities. The daybooks record, in some cases, the initials of the photographer undertaking each job. Although it has not been possible to identify the photographer in every instance, we know that Harry Lemere and Adolphe Augustus Boucher were responsible for most of the photographs included in this book.

The collection at English Heritage represents one-quarter of the firm's estimated total output of 100,000 images and is by far the most important surviving corpus of its work. Other caches of Bedford Lemere & Co's photographs are held by the Royal Commission on the Ancient and Historical Monuments of Scotland, the Guildhall Library in the City of London, Westminster City Archives, the National Maritime Museum, the Victoria and Albert Museum and the Royal Institute of British Architects. Many of the missing and often unique Bedford Lemere & Co prints may still exist in archives in Britain.

English Heritage has the largest publicly accessible archive in Britain dedicated to the historic environment, with an unparalleled collection of images, old and new. It comprises more than 12 million photographs and other archive items (including measured drawings and survey reports) relating to England's architecture and archaeology. It continues to accept major collections of national importance and is a repository for the work of English Heritage's staff photographers.

English Heritage is undertaking a major project to conserve, catalogue and scan the Bedford Lemere & Co collection of negatives, with the aim of making the images accessible on the internet. At the time of publication around 7,450 of the firm's photographs may be viewed, free of charge, at www.englishheritagearchives.org.uk. The collection may also be consulted by prior arrangement at English Heritage's offices in Swindon (telephone 01793 414600 for details).

FURTHER READING

**General works on architectural photography
(both of these volumes contain bibliographies):**
Elwall, R 2004 *Building with Light*. London: Merrell
Pare, R 1982 *Photography and Architecture 1839–1939*.
 Montreal: Canadian Centre for Architecture

**Works specifically discussing the work of
Bedford Lemere & Co:**
Anon 1927 'Architectural Photography: A Chat with Mr
 Bedford Lemere'. *The Photographic Journal* **67** (Jul), 310
Anon 1931 'Croydon Camera Club'. *British Journal of
 Photography* **78** (13 Feb), 96–7
Blackmore, A 1989 'Photographs by Henry Bedford Lemere'.
 History of Photography **13**, 369–71
Cocroft, W D and Leith, I 1996 'Cunard's Shellworks,
 Liverpool'. *Archive* **11** (Sep), 53–64
Elwall, R 1994 *Photography Takes Command: The Camera
 and British Architecture 1890–1939*. London: RIBA
Elwall, R 2006 'Lemere, (Henry) Bedford', *Oxford Dictionary
 of National Biography*. Oxford: Oxford University Press
Haile, R N 1944 'Obituary: Harry Bedford Lemere'.
 British Journal of Photography **91** (6 Oct), 357–8
Leith, I 1990 *The Streets of London: A Photographic Record.
 Vol I: Westminster Photographed by Bedford Lemere*.
 Liverpool: Editions
Leith, I 2003 'A century of picture making: The Bedford
 Lemere Archive'. *Collections Review* **4**, 134–8
Lofthouse, T A 1944 'Obituary: Harry Bedford Lemere'.
 The Builder **167** (15 Sep), 218
MacMaster, D 1943 'H Bedford Lemere (Hon Fellow)'.
 The Photographic Journal **83** (Dec), 423
Seddon, J P 1872 'Photographs from the Architectural
 Museum'. *The Architect* **8** (30 Nov), 297
Seddon, J P 1873 'Photographs from Selected Casts in
 the Architectural Museum'. *The Architect* **9** (14 Jun), 314

**Selected recent books that reproduce photographs
by Bedford Lemere & Co:**
Barker, F 1996 *Edwardian London*. London: Laurence King
Cooper, N 1976 *The Opulent Eye*. London: Architectural Press
Hobhouse, H 1971 *Lost London*. London: Macmillan
Service, A 1979 *London 1900*. London: Granada Publishing
Service, A 1982 *Edwardian Interiors*. London: Barrie
 & Jenkins

**There are numerous books about late Victorian and
Edwardian architecture, both general works and books
on particular architects, buildings and building types.
The latter are far too many to list; among the former are:**
Crook, J M 1987 *The Dilemma of Style: Architectural Ideas
 from the Picturesque to the Post-Modern*. London:
 John Murray & Chicago: University of Chicago Press
Fellows, R 1995 *Edwardian Architecture: Style and
 Technology*. London: Lund Humphreys
Goodhart-Rendel, H S 1953 *English Architecture Since
 the Regency*. London: Constable
Gray, A S 1985 *Edwardian Architecture: A Biographical
 Dictionary*. London: Duckworth
Service, A 1975 *Edwardian Architecture and its Origins*.
 London: Architectural Press

**The following are indispensible introductions to
any history of London topography in the period
covered by this book:**
Bradley, S and Pevsner, N 1997 *London 1: The City of London*.
 London: Penguin
Bradley, S and Pevsner, N 2003 *London 6: Westminster*.
 New Haven and London: Yale University Press
Cherry, B and Pevsner, N 1983 *London 2: South*.
 Harmondsworth: Penguin
Cherry, B and Pevsner, N 1991 *London 3: North West*.
 London: Penguin
Cherry, B and Pevsner, N 1998 *London 4: North*. London:
 Penguin
Cherry, B, O'Brien, C and Pevsner, N 2007 *London 5: East*.
 New Haven and London: Yale University Press
Clun, H P and Wethersett, E R 1932 *The Face of London*.
 London: Spring Books
The Survey of London, 65 vols (1900–present)
Weinreb, B 2008 *The London Encyclopaedia*, 3 edn.
 London: Macmillan.

ACKNOWLEDGEMENTS

It gives me great pleasure to acknowledge the help I have had from staff of The Engine House, Swindon where these photographs, the property of English Heritage, are housed and made available to the public. I am particularly indebted to Anna Eavis, who initiated the project and who commented usefully on the text at every stage; Gary Winter, who did much work on the preliminary selection, drafted several of the captions and saved me from many mistakes in others (those that remain are my own); Anne Woodward, who carried out additional research; Tony Rumsey, who provided valuable commentary on Harry Bedford Lemere's photographic techniques; Ian Leith, who has written previously about Bedford Lemere and who knows more about the archive and its history than anyone; Ian Savage, whose team produced new photographs from the original negatives; Mike Evans, who provided advice and commented on early drafts of the text; Robin Taylor, who advised on getting the material ready for publication; and René Rodgers and Rachel Howard, who have patiently seen the book through from manuscript to publication. I should also like to thank Simon Thurley, Chief Executive of English Heritage, for his foreword.

Within English Heritage many other people have contributed to this project. The Cataloguing Team included Jennie Anderson, Kate Bevan, Rachel Cope, Ruth Grundy and Anne Wiggans. The Curation and Conservation Team included Sarah Allen, Keith Austin, Jo Beach, Liana Briggs, Amy Darby, Jenny Hodgson, Cynthia Howell, Ian Leonard, Saya Miles, Danielle Mills, Irene Peacock and Lyndsay Walker. The Photographic Services Team included Steven Baker, Michael Evans, Elizabeth Fife, Rachel Gale, Paul Marks, Jonathan Proudman, Amanda Rowan, Ian Savage, Robert Tims and Shaun Watts. Brenda Forward worked on the Bedford Lemere & Co daybooks.

Thanks are also due to Emma Hardy, Collections Manager (Care and Access) at the Geffrye Museum in London; Tom Samson, former employee of Archie Handford Ltd; and Steve Gill and Mike Samworth, who helped identify our Fitch portraits.

Finally, the images on pp 12, 18, 21 and 22 are reproduced courtesy of Tom Samson, the image on p 17 is reproduced courtesy of Gary Winter and the images on p 26 are National Media Museum/SSPL.

INDEX

Index to the main places and subjects illustrated, along with related architects and clients where known